COCTEAU

First published in English by
Paul Holberton publishing
37 Snowsfields
London SE1 3SU
www.paul-holberton.net

This is the English-language version of the
catalogue accompanying the exhibition
Jean Cocteau, sur le fil du siècle at the Centre
Pompidou, Paris, 25 September 2003–
5 January 2004 and at the Montreal Museum
of Fine Arts 6 May–29 August 2004

Translated from the French by Trista Selous

Typesetting of English edition by Matt Hervey
Printed in Italy
Distributed in Europe by Greenhill Books
Distributed in the United States and Canada by
University of Washington Press

Back cover:
Germaine Krull, *Cocteau,* 1930

Jean Cocteau

Jean Cocteau, sur le fil du siècle

Centre Pompidou, Galerie 1, Paris
25 September 2003–5 January 2004

Montreal Museum of Fine Arts
6 May–29 August 2004

≋ **Centre Pompidou** *php*

Centre national d'Art et de Culture Georges Pompidou

Bruno Racine
Président
Bruno Maquart
Directeur général
Alfred Pacquement
Directeur du Musée national d'art moderne-
Centre de création industrielle
Dominique Païni
Directeur du département
du Développement culturel
Jean-Pierre Marcie-Rivière
Président de l'Association pour le
développement du Centre Pompidou
François Trèves
Président de la Société des Amis
du Musée national d'art moderne

CHIEF CURATOR
Dominique Païni

CURATORS
François Nemer
Isabelle Monod-Fontaine
assistés de **Valérie Loth**

SCIENTIFIC COMMITTEE
Pierre Caizergues
Pierre Chanel
Annie Guédras

The exhibition « *Jean Cocteau,
sur le fil du siècle* » has been
made possible by the support
of *Cartier*

the aid of the Comité Jean Cocteau,
of the Musée Jean Cocteau, Milly-la-forêt,
of la Région Île-de-France and the
participation of the Institut national de
l'Audiovisuel (INA)

The exhibition is presented at the
Montreal Museum of Fine Arts,
Jean-Noël Desmarais pavilion,
from 6 May to 29 August 2004.
Curators for the Montreal venue:
Guy Cogeval, Director,
The Montreal Museum of Fine Arts
Nathalie Bondil, Chief Curator,
The Montreal Museum of Fine Arts
Design of the exhibition in Montreal:
Christiane Michaud

Thanks

We are profoundly grateful to the
following museums, institutions, private
collectors and artists who have lent works
to the exhibition:

• Bibliothèque historique de la Ville
de Paris, Jean Dérens, Claudine Boulouque
• Bibliothèque de l'Université Paul-Valéry,
Centre d'études du xxe siècle, Montpellier,
Elisabeth Perez, Francis Ramirez,
Christian Rollot
• Bibliothèque de l'Image et du Film,
Marc Vernet
• Bibliothèque littéraire Jacques-Doucet,
Paris, Yves Peyré, M. Froger
• Bibliothèque nationale de France, Paris,
Jean-Noël Jeanneney, Laure Beaumont-
Maillet, Antoine Coron, Sylviane Dailleau,
Jean-François Foucaud, Noëlle Guibert,
Catherine Massip, Pierre Vidal
• Cartier International
• Ciné Costum', Paris, Romain Leray
• Cinémathèque française, Paris,
Marianne de Fleury
• Conservatoire Chanel, Paris, Marika Genty
• Comité Jean Cocteau et Musée
Jean Cocteau, Milly-la-forêt, Pierre Bergé,
Stéphane Chomant, Louis Gautier
• IMEC, Olivier Corpet
• Les Amis de Jean Cocteau, Paris,
Claude Séférian
• La Fondation Erik Satie, Paris, Ornella Volta
• Musée Carnavalet, Paris, Jean-Marc Léri
• Musée de Grenoble, Guy Tosatto
• Musée des Beaux-Arts de la Ville
de Rouen, Laurent Salomé
• Musée national de la Coopération
franco-américaine, Anne Döppfer
• Musée Gaumont, Neuilly-sur-Seine,
Corinne Faugeron
• Musée national d'art moderne,
Centre de création industrielle
et la Bibliothèque Kandinsky
• Musée national Picasso, Paris, Gérard
Régnier, Dominique Dupuis-Labbé,
Laurence Madeline
• Neue Nationalgalerie, Berlin,
Dr. Heinz Berggruen
• Phoenix Art Museum, Jim Ballinter
• Société des Manuscrits des Assureurs
français, Paris, Gérard Formel

• The Harry Ransom Humanities Research Center, Austin, Thomas F. Staley, Linda Ashton
• The Henry and Rose Pearlman Foundation, Inc., Princeton University Art Museum, Suzanne Taylor
• Galerie Dominique Bert, Paris, Dominique Bert
• Galerie Anne Julien, Paris, Fanfan Berger
• Galerie der Moderne, Munich, Stefan Vogdt
• Galerie Farideh Cadot, Paris, Farideh Cadot
• Galerie OBSIS, Gennevilliers, Annie et Didier Grandsart
• Waring Hopkins, Paris, M. Hopkins
• Parico, Emmanuel Basse
• M. et Mme Pierre Belfond, Paris
• André Bernard, Paris
• Claude Berri, Paris
• Anne Bertrand, Bordeaux
• Lucien Clergue, Arles
• Frédéric Daniel, Paris
• Niklaus Kinzel and Christian Schilling, Basle
• Gérard Langlet, Maisons-Lafitte
• Bernard Minoret, Paris
• Liliane and Etienne de Saint-Georges, Saint-Pieters Leeuw
• Marie-Yvonne de Saint-Georges, Saint-Pieters Leeuw
• Philippe de Saint-Georges, Saint-Pieters Leeuw
• Jean-Frédéric Schall, Paris
• Rosine Seringe, Paris
• Serge Tamagnot, Paris

• Alice Anderson
• Mark Brusse
• Michael Brynntrup
• Markus Raetz

And similarly all those who have preferred to remain anonymous.

Our very particular thanks go to M. Pierre Bergé, who has given us his unreserved confidence and friendship during the preparation of the exhibition. We thank Mme Claudine Boulouque, responsible for the Fonds Cocteau in the Bibliothèque historique de la Ville de Paris, for her exceptional helpfulness. We would also like very warmly to thank all those whose names follow for their contribution to the preparations, trusting that they will appreciate how deeply we are grateful to them.

• M. and Mme Jean Babilée
• Yann Beauvais
• Laurence Braunberger, Les Films de la Pléiade
• Michel Brunet, Studio Canal
• Anne Carles
• Daniel Cendron
• Mia Chen Chalais
• Philippe Chevassu, Connaissance du Cinéma
• Stéphane Dermit
• Renée Franck
• Patrick Frémeaux, Frémeaux & associés
• Michel Frizot
• Jean-Luc Godard
• Monique Holvek, MK2
• Anne-Sylvie Hubert
• Lorette Hugo
• Hopi Lebel
• Jean-Jacques Lebel
• Jacques Le Glou
• Nathalie Morena, Archives du CNC
• Martine Offroy, Gaumont Cinémathèque
• Manuela Padouan, Gaumont Cinémathèque
• Michel Rager
• Sylvie Richard, INA
• M. and Mme Robert Rubin
• Marc Sandberg
• Mme Santo Domingo
• Annette Serrasson, Connaissance du Cinéma
• Léo Scheer
• Michel Schmit, Studio Canal
• Mme Schuchmann, INA
• Rutger Smith
• Pierre Ternay
• Gaëlle Vidalie, Cinémathèque française
• Alain Weill
• M. Weinberg
• Carole Weisweiller

Our thanks are also due to all those who aided us in our research and enquiries, in particular:
• Christian Bouqueret, ARDP
• Carole Callow, Lee Miller Archives
• Cyril Chazal, BnF
• Delphine Desveaux, Roger-Viollet
• Albert Dichy, IMEC
• Hélène Favard, IMEC
• Stéphane Mirkine
• Monique Moulène, BnF, département des Estampes et de la Photographie
• Catherine Rouvière, Magnum

We offer our thanks with equal warmth to our colleagues at the Centre Pompidou, whose assistance, at every point during the preparations, was invaluable – in particular to: Marc Audoin, James Caritey, Eric Daire, Emmanuel Gentilhomme, Valérie Guillaume, Irène Gutkind, Viviane Jaminet, Marie-Laure Jousset, Véronique Labelle, Patrig Le Jeanne, Daniel Legué, Jacky Lethery, Clélia Maieroni, Jean-Marc Mertz, Valérie Millot, Michel Naït, Jean-Claude Perraut, Catherine Quiriet, Christiane Rojouan, Alain Sayag, Didier Schulmann, Nicole Thébert.

The Montreal Museum of Fine Arts wishes to thank Quebec's Ministère de la Culture et des Communications for its ongoing support.

The Montreal Museum of Fine Arts international exhibition programme received financial support from the Exhibitions Fund of the Montreal Museum of Fine Arts and the Paul G. Desmarais Fund.

Contents

Forty years after Jean Cocteau's death, it seems he could still be our contemporary – indeed, paradoxically, certain aspects that link him to late nineteenth-century Symbolism correspond to certain trends in art today.

Yet Cocteau has never been accorded the recognition merited by the diversity of his work and the turbulence of his life: he is too well-known, and as a result not properly known, as he himself often lamented.

For all that his name remains so familiar, or even popular, public institutions seem to have neglected him since his death, or at least have ceased to pay tribute to him. His reputation – and one could say he suffered from being too famous in his lifetime – actually obscured the boldest aspects of his inventiveness.

For the Pompidou Centre in 2003, his topicality is obvious. Borrowing from all the arts, espousing them all, playing them all false, Cocteau unquestionably embodied a different form of 'bachelordom' from Marcel Duchamp's – while Duchamp decided not to touch anything any more (officially, except for failures), Cocteau, a poet, film-maker, novelist, choreographer, dramatist, photographer, graphic artist and musician, touched everything, 'having a finger in every pie'.

Cocteau was a precocious precursor of the multidisciplinary utopia. It is only right that the rediscovery of this prolific artist, witness to a century, whose work is strangely absent from public collections, should be initiated at the Pompidou Centre.

That rediscovery owes a great deal to those responsible for his moral inheritance, first and foremost to Pierre Bergé and the Comité Jean Cocteau of which he is president, to the private collectors who had long reserved their treasures for such an occasion, and to libraries and literary collections, institutions that had never forgotten the friend of Orpheus.

The exhibition could never have been mounted on its present scale without the outstanding support of Cartier, loyal to the memory of the man who, by wearing Cartier's '*Trois Ors*' [Three golds] ring, made it famous, and I warmly thank M. Bernard Fornas, the chairman and managing director of Cartier, for that support. I am likewise grateful to M. Jean-Paul Huchon, President of the Conseil régional d'Île-de-France, whose cooperation has also been crucial, as well as to M. Emmanuel Hoog, President of the Institut national de l'Audiovisuel, who has as always allowed us to benefit from his expertise. Our very sincere thanks are due to them.

Bruno Racine
Président du Centre Pompidou

Forty years after his death, Jean Cocteau is being honoured by a major exhibition at the Centre Georges Pompidou. That is no more than justice. Categorized as a *touche à tout* [a dabbler, having a finger in every pie], throughout his life he was liable to be misunderstood. The surrealists looked down on him. He followed a lonely path, which led him to a kind of fame that often did not seem to reflect well on him. He started by writing some mediocre poems, which he quickly removed from his acknowledged oeuvre, then strove to keep abreast of his time and often to be ahead of it. He built up a body of work that has an inimitable elegance. Today it is possible to assess his importance, which is considerable. A protean artist, he explored every creative shore. The merit of this exhibition is that it shows us all aspects of his work, as well as remedying some oversights.

In a kind of way Jean Cocteau was the illegitimate son of Edmond Rostand and Anna de Noailles, but like all infant prodigies he quickly gave his parents the slip to embark on forbidden paths. Playing truant was his catechism, disobedience his credo. He regarded rebellion as a virtue. He adhered faithfully to those rules throughout his life. He enjoyed success, but discovered Jean Genet and defended him without fail. His life was known to everyone. He never concealed it. He made puns, but his plays on words were plays on woes – a way of hiding his suffering, alleviating his anguish. For he was well aware that not everyone admired him, that he was not as highly regarded as Eluard or Aragon, that Picasso's friendship served to protect him rather than bring him recognition. And yet he had been involved in all the creative activity of his day, from the Ballets russes to the Nouvelle Vague, which owed so much to him. Had he played on too many tables, taken too many risks? Just as Jean-Henri Fabre's phasmids look like twigs to camouflage themselves better, he had often assumed the mask of someone else – of someone who offers you fame all the better to confound you. Sometimes he had lost his way, but it was only a pretence. The real Cocteau remained on watch, ready to swoop on a new prey. When we see it today, his work is immense, covering a large part of the twentieth century. The exhibition at the Georges Pompidou Centre enables us to discover it. The reproaches that may have been levelled at him have disappeared. His drawing, thought to be superficial, conceals the power of Artaud and Michaux. He wanted his entire œuvre to be seen as poetry. And it is poetry. It is made to be on close terms with youth and to converse with it. If he was faithful to anything, it was to youth, in which he invested all his hopes. He knew that from time immemorial, from the time Villon and of Rimbaud, youth and poetry had been ambling along, that we only had to wait and they would inevitably meet up.

The time has come. Everything is now ready for that meeting to take place, for Dargelos to throw his snowball, and step forward with bare hands in search of Jean Cocteau. May he do so fearlessly: surely we should not be afraid of poets?

Pierre Bergé

Cartier, Cocteau ... a precious link

In 1924 the very first mention of a ring with a singular shape appeared in the Cartier registers. This piece, which at the time was a modernist manifesto, is formed of three rings entwined, one platinum, one red gold and the other yellow gold.

This date marks the beginning of the creative collaboration between Jean Cocteau and Louis Cartier, of whom Cocteau wrote: "Cartier, a subtle magician, who fastens moon fragments to sun wire". A few years later, in 1945, at the time of the shooting of *La Belle et la Bête*, Cocteau asked Cartier to lend him the diamonds that would represent the tears of Belle, played by Josette Day, one of the jeweller's more important customers. This request expresses the rigour of a perfectionist in art, who is said to have declared at the time, "A fake diamond emits no fire; only a real diamond glitters".

The trusting friendship between Cartier and Cocteau was affirmed once again in 1955, when Jean Cocteau was admitted to the Académie Française. On becoming an 'immortal' in the famous green dress, cocked hat and cape, Cocteau also had to wear a sword for the occasion. His was no ordinary blade; it had been commissioned from Cartier by a group of friends and made to a design by Cocteau himself. Today this unique piece, which is part of the heritage of our House and the Art de Cartier collection, remains a testament to a lasting connection.

I am very pleased that this exceptional relationship of inspiration and friendship has once again enabled us to be of service to a poet's dream, through our support for the exhibition that the Pompidou Centre is now devoting to the oeuvre of Jean Cocteau.

Bernard Fornas
Président directeur général de Cartier International

My admiration for Jean Cocteau is not new. It began with seeing *Beauty and the Beast* as a child, and grew over the years as I discovered the libretti for the operas *Oedipus Rex* and *La Voix humaine* and read the *Rappel à l'ordre* and the *Essai de Critique indirecte*. A gifted man of the theatre, an accomplished film-maker, friend to Diaghilev, Picasso and Piaf, and openly homosexual in the days when that was not easy, Cocteau was akin to the rhapsodists of antiquity, poets whose genius for improvisation expressed itself in assembling – literally *sewing* together – scattered fragments from widely differing traditions. With the perspective of the years, critical opinion now does justice to that other "collator of dreams", whom dogmatic surrealists dismissed as a popularizer.

In North American eyes Cocteau stands at the centre of the rediscovery of those artists who in the twentieth century smashed the boundaries separating the arts. The Montreal Museum of Fine Arts exhibition *Cosmos* was an initiative in this respect, as was our show *Hitchcock and Art*.

We were delighted by the opportunity to work once again with the Centre Pompidou, which presented the latter exhibition in France. Furthermore, focusing on artists whose work involves a confrontation between artistic disciplines is part of a long-standing commitment of the Museum.

In the twentieth century, images composed of time and movement constituted new additions to the invention of drawing. In this respect Cocteau was the most modern of the moderns in that he ranked the arts of drawing, writing and film-making equally. The raw material of his work, what he put on stage and screen, was his whole life. It represents an ideal road map for those who wish to revisit his century.

I wish to thank Bruno Racine, chairman and director of the Centre Pompidou, for his unfailing support for this project, the director of the Musée national d'Art moderne and his staff, and Dominique Païni, for whom this exhibition is the realization of a long-cherished dream.

Guy Cogeval
Director, The Montreal Museum of Fine Arts

Lost and found

For Nicole Stéphane

The problem is sizeable and contradictory: how do we stand up and defend a figure who was, in a way, too much loved? Indeed an affectionate, idolatrous community loves him too much still, its touchy dissatisfaction corresponding in degree to the disdain with which many institutions have regarded him for over fifty years. Museums and universities leave Jean Cocteau to one side (other than as an inevitable witness to every crucial moment in the twentieth century). Only the schools have 'used' him – a few selected texts are perfect for lyrical yet tricky dictation exercises.

Our own period has little taste for decorative variations in art; it prefers conceptual approaches that are wary of metaphor, favouring tautological irony and resisting anything that might be identified as poetic ostentation. It certainly has intelligence, but modestly displayed, restrained, reserved, and generally expressed using minimalist means, whether in music, on screen or on the page. Of course opposites co-exist and, as we embark on a new century, the landscape also features artists who deploy hyperbole, hallucination and even kitsch. Nowadays, however, these artists use quotations and set things at a distance; they represent the positions they have adopted as just that, reminding us that they have not fallen under their spell. Their approach has a critical, not to say theoretical element. This is nothing to complain about: our period invites us to engage in dizzy speculation around form, thought and the processes by which thought becomes form. This is precisely what Cocteau was seeking in cinema, "a powerful weapon for projecting thought itself into a crowd that refuses to think".[1]

Quite apart from the current artistic context, which does not encourage us to revisit the work of a man frequently accused of "frivolity", our task is made no easier by the fact that Cocteau has neither been collected by the great museums nor studied in institutions responsible for updating the literary canon. It is almost certainly cinema alone which has kept the good reputation of Cocteau's work alive, its contemporary relevance having been determinedly reasserted by recent retrospectives, and also by film-makers such as Jean-Luc Godard and Pedro Almodovar.[2]

1 Jean Cocteau, *Entretiens autour du cinématographe*, recueillis par André Fraigneau, Paris, André Bonne, 1951.

2 See the essay by Marie-Anne Guerin in the present catalogue, p.73. Pedro Almodovar frequently recalled that Cocteau was a kind of model for him at the time of the now legendary *movida*. In *The Law of Desire* two characters are seen in a theatre rehearsing *La Voix humaine*.

Seen too much, loved too much, ever present everywhere from the years after World War II to the 1960s, it may be that, with clandestine mastery, Cocteau himself arranged the disappearance he so longed for, the purgatory he so feared. His incomparable ease and apparent success rendered him suspect. He has been thought to have insufficient rigour, insufficient depth, insufficient morality, insufficient economy, insufficient modesty, insufficient everything. Jacques Doucet called him "a wire puppet"; Julian Green described him as a "talker", adding that "the best of him went into his conversation, though that best was ungraspable". Out of such truths and clichés Cocteau created subtle embroideries around himself, frustrating all conclusions with his own penetrating insight.

His insufficiencies seemed confirmed by the fact that he had a finger in every pie. It was a thing he was proud of, indeed he theorized on it as a deliberate principle and virtue. Worse

– or better – still, he was aware of this blanket criticism, as of all the other criticisms that flowed from it. He used it to devise a complex dialectics of exhibitionism and invisibility, worldly prestige and suffering solitude, lightness of being and unremitting self-analysis, a supple readiness for anything that might come up and obsessional retreat into self-portraiture. Cocteau was one of those monsters in whom sincerity is inseparable from cunning; he was a Janus engendered by the dizzy relief at losing self-consciousness and an excess of self-awareness.

Self-awareness was one of Cocteau's first drugs, in the sense later articulated by Roland Barthes in his lectures at the Collège de France in 1978: "Excessive awareness, hyperaesthesia of awareness: a drug which acts, or rather is, without anything having to be swallowed, which defies all legislation". Then, commenting on Paul Valéry's *Monsieur Teste*, "That which is hallucinated: the self: defined as a reflexive power of self-knowledge, as an enormous tautology; today it is this self that seems out of date in Valéry's work, since it is generally understood as an (idealist) psychological entity. But in fact Valéry treats the self as an anomaly, an abnormality".[3] There is something of Teste in Cocteau.

I used the word 'supple', but oscillating might have been nearer that mark. In the highly 'ideological' 1970s the disquiet produced by oscillation was recalled by that decade's most subtle mouthpiece – Barthes once more: "The intelligentsia puts up very strong resistance to Oscillation, while easily accepting Hesitation. Gide's Hesitation, for example, was easily tolerated because the image remains stable: Gide produced, we might say, a stable image of that which was shifting." Barthes makes this reference to Gide, Cocteau's close and faithful enemy, in a discussion of the ex-avant-gardist of *Tel Quel*, Philippe Sollers. Later on he says that Sollers wants "to prevent the image from taking shape [...] to prevent in advance any formation or stabilisation of an image"; he rejects the last possible image, that of "one who tries out different directions before finding his definitive path" (noble myth of the path, of initiation). "After much wandering, my eyes have been opened". He becomes, finally, "indefensible".[4]

Cocteau was indefensible because he swung this way and that, "balancing on the public, on death, on ridicule, on bad taste, on inappropriateness, on scandal, without falling". These words describing Cocteau, spoken by the trapeze artist and transvestite Barbette, are inscribed around a self-portrait in the series *Le Mystère de Jean l'oiseleur*.

To some extent the arrogant, unthinking dismissal of Cocteau (by such, for instance, as Jean Genet) carried the day, but to some extent only. For, once the project for the present exhibition had been announced, secret debts to Cocteau, cases of denied yet secretly maintained admiration, of fascination repressed because of surrealist factionalism, or through homophobia, have been uncovered, conceded and confessed. It was perhaps necessary to wait a generation before Cocteau's renaissance could be accepted and explored. Grandfathers give better counsel than fathers.

"He has been lost and found", Emmanuel Berl once said. The same is true today: for us Cocteau has been lost and found. In practice he is "almost certainly the least-known and most famous of poets [....] His visibility, formed by all sorts of silly stories, protected his invisibility, encased him in thick, sparkling armour that rendered all blows harmless."[5]

Although he repeated this view, and also denied it, Cocteau was hurt. He could not bear the idea of not being loved. This was probably his main weakness, giving rise to mistakes, unfortunate blunders, a drive – relentless to the point of nausea – for the recognition and self-satisfaction that are bestowed and fostered by all kinds of authorities. The present exhibition does not avoid his murky patch during the German occupation of France but, through a juxtaposition of images, seeks to understand why and how the "desire to be loved too much" betrayed Cocteau's weak points, even when he had art and artists all around him for protection. He was to emerge from this period as an even more complex figure. His almost

3 Roland Barthes, *Le Neutre, notes de cours au Collège de France, 1977-1978*, Paris, Seuil/Imec, 2002, p. 132f.

4 Roland Barthes, *Œuvres complètes*, t. III: *1974-1980*, Paris, Seuil, 1995, p. 964.

5 J. Cocteau, *Journal d'un inconnu* [1953], Paris, Grasset (*Les Cahiers rouges*), 1983, p. 20.

Socratic instability, his refusal to commit, both strengthened his reputation as a writer – even though he might be light and fickle, but also, of course, warm – and added to one of his main personality traits, that of self-contradiction.

Both as a man and an artist Jean Cocteau was untouched by dialectics. Although he could not avoid the objective, biological opposition of life and death to which every living being must submit, the opposing forces underlying his character never synthesized as they should have done dialectically. The distance that brought suffering carried him over the contradictions and made him move on. The pain that drove him to seek escape (opium or sleep) carried him past the reconciliation of opposites that might have given him a better view of the world. Cocteau never got close to synthesis, even though he described free will as "the result of a minute co-existence between opposites that marry together, become entangled, form a unity. Man believes he is free to choose because he hesitates between alternatives that are all of a piece, but which he separates for his own purposes [....] He seems to be choosing one of these antagonistic directives, which form a complex knot fixing his being, which only apparently changes."[6]

Le Grand Ecart [The splits] was not just any old title of a first novel; it heralded a project that Cocteau would constantly rework and extend in his work, as he sought to describe and – vainly – to ease his own difficulty of being. His work mines a failure of self-reconciliation always masked by its apparent opposite, a high-society existence bordering on frivolity. In *La Difficulté d'être* [The difficulty of being] the chapter 'On Frivolity' immediately follows the chapter 'On Death'. Of frivolity Cocteau accurately stated that it "is a crime, in that it apes lightness". Though torn apart, entirely lacking in dialectics, he loved nuances, paradoxes, minute etymological and conceptual shifts, and could not help flirting with the very thing for which he was criticized: "I condemn frivolity, frivolity is odious, it constitutes a lack of heroism and goes hand in hand with lamentable whimsy".[7] Lastly, he was too keen to confess: "I have not observed such prudence often enough."

How can we first understand and then accept the pride – even if it might be his own personal dialectic – with which he claimed that he was borrowing the very "frivolity" that which he wished to deny, in order not to be a banal protester, not to be a man of wisdom, not to be a conformist intellectual?[8] His reflections mirrored each other into infinity, creating an endless loop of concerns about appearance, as this desperate, meticulous producer of himself sought to make himself loveable and to love himself. Hence his unlikely profile – unloved because hard to believe and so lacking credibility – with its sharp yet sinuous edges, so succinctly encapsulated by Colette: "His angular grace disturbs nothing".

Another trait of his personality was, in appearance, more accessible. A constant output was essential to him. Cocteau may have had a finger in every pie, but he was always intense, always a specialist. He was fully a writer (admirable and still little-known, not really read), film-maker (six major films),[9] graphic artist (thousands of drawings), set designer and choreographer (a few, crucial works), photographer (a few, remarkable photographs) and playwright (less successful: never the right thing at the right time). Was he ever a painter? This activity has been bitterly disputed, with good reason. The hypothesis according to which Cocteau internalized a prohibition and so failed to understand colour is one I would be prepared to support. His film *La Villa Santo Sospir* would thus be symptomatic of this repression. His only film in colour, it is about painting, frescos and ceramics – hobbies, effectively, indicative of a certain slackening, a conscious or unconscious reduction of the obsessional rigour he maintained elsewhere.

One cannot fail to be struck by Cocteau's sharp awareness of the diversity of his creativity, the multitude of different activities he pursued at the same time, and of the polymorphousness engendered by the different media he used. In the later part of his life, in 1952,

6 *Ibid.*, p. 24.

7 J. Cocteau, *La Difficulté d'être* [1946], in *Romans, poésies, poésie critique, théâtre, cinéma*, Paris, L.G.F. (*La Pochothèque*), 1995, pp. 919–22.

8 "The public doesn't like it. For them the artist is a serious man who listens to Beethoven with his face in his hands. So the element of play that comes into any revolutionary movement makes it suspect to them" (J. Cocteau, « Carte blanche », *Le Rappel à l'ordre*, Paris, Stock, 1926, p. 117).

9 For me, the films most fundamentally his are the following: *Le Sang d'un poète*, *La Belle et la Bête*, *Les Parents terribles*, *Orphée*, *Le Testament d'Orphée* and ... *Les Enfants terribles*, on which the stamp of the official director, Jean-Pierre Melville, has always seemed to me touched – to paraphrase Mallarmé – by "*l'aile indubitablement en lui*" [the wing indubitably within him] of Cocteau.

he remarked, "the disparate nature of his undertakings has saved him from becoming a habit". This disparateness, using extreme means which pretend to be nothing of the kind, would seem to have confounded casual observers. Thus Cocteau was regarded as a dilettante who avoided effort, whereas in fact "he was turning his searchlight round and round in order to illuminate, from different angles, different forms of being and of free will". We have returned to that 'free will', which one might confuse with the spirit of dialectics. I shall not discuss further what is now the most salient and ultimately most attractive aspect of Cocteau's heterogeneous, prolific activity. It is part of the way most people perceive him. On the other hand I shall pause for a moment to consider the causes of what still today hinders the exploration of any Cocteau other than that of the last years of his life, the 1950s, which have long distorted our image of the man, his rigour and his dedication to his work.

In the face of such manysidedness, how can we separate, emphasize, select, re-evaluate? Yet these are the four processes through which the present exhibition has evolved. The criteria of good and bad taste, success and failure, originality and reproduction, invention and borrowing were all undermined by Cocteau himself through his perfect control of the issues, of the emotions involved in them – he confused, disturbed, upset, overturned, contradicted.

How can we categorize and evaluate such a profusion of works when their author intended them to be disquieting, inopportune, lame or uncomfortable,[10] when the only beauty that really mattered to him was accidental, arising out of an "effect of surprise inexplicably provoked by a crack that opens unexpectedly"?[11] "Fantasy and poetry do not concern me", he said. "They have to ambush me. My itinerary must not make provision for them".[12] This was an idea he repeated in many different ways. Uttered over and over in a kind of rhythmical refrain, the denial becomes poetry itself, which is what Cocteau both sought and feared.

But, still more difficult, how does one deal with a self-confessed forger, a drug-addict?

The forger imitated the effects of the original for the cover of *Les Mystères de Jean l'oiseleur*, publishing an edition of 142 copies with the complicity of the editor Edouard Champion and the marvellous lithographer D. Jacomet. On each the grease stain or coffee stain, thought to be accidental, is the same. The bibliophile is deceived, and doubly so, since, beyond the illusion, Cocteau was distorting and re-developing the use of the accidental which he himself advocated: he programmed it, reproduced it, pretending to be the organizer of all chance events. Reproducing everything was another obsession for Cocteau, who made constant use of replicas, who is known for his radio broadcasts, but also made recordings, cinema and, in his last years, television. By his actions, by his reproductions, this contemporary of Walter Benjamin and André Malraux definitively dissolved the aura surrounding the arts. In Cocteau's view drawing was the ultimate end of printing and drawing was a matter of repeating the same line.[13]

We come at last to Cocteau the drug-user. Here we may find one reason for the mistrust with which he has been regarded by both public and scholars, the former seeing him as depraved, the latter as lacking self-control. This was despite the fact that drugs have a healthy presence in the history of art. However, Cocteau talked about them more than others did; he talked about them too much, as ever. He stripped drugs of all their romanticism, of that epic dimension attained by a mind transformed by opium – perhaps this is something for which he can never be forgiven. It is no surprise that, in the theatre and in film, in ballet and in his novels, Cocteau so often portrays death. Yet he did not want to grow old, or to die, this Dorian Gray. Probably because drugs had made his heart beat to the point of stillness, resembling speeds which attain immobility,[14] or which have no movement,[15] Cocteau continually made himself die in order to imagine himself dead, to imagine death, to lessen his fear of death.

10 J. Cocteau, *Entretiens autour du cinématographe, op. cit.*, p. 102.

11 J. Cocteau, *La Difficulté d'être, op. cit.*, p. 892.

12 *Ibid.*, p. 343.

13 On this subject see the text by François Nemer in the present catalogue, p. 23.

14 "*Vitesse immobile. La vitesse en soi. Opium: la vitesse en soie* " [Immobile speed. Speed in oneself. Opium: speed in silk], *Opium* [1930], in *Romans, poésies, poésie critique, théâtre, cinéma, op. cit.*, p. 684.

15 J. Cocteau, *Discours du grand sommeil*, in *Romans, poésies, poésie critique, théâtre, cinéma, op. cit.*, p. 254.

What can you do when you are afraid of death to such an extent? You can intoxicate yourself and so slip from being a modernist into being a socialite, you can get drunk on jazz or in low places, you can allow yourself to be engulfed in a sad parade of private views,[16] to throw carnations at the Cannes film festival – or you can dream of your own death, picture the face of death in advance. Through the realism (rather than the fantasy effects) of cinema, *Le Sang d'un poète*, *Orphée* and *Le Testament* were to be the vectors of this experience. In Samuel Beckett's *Molloy* the character also wants to picture death: "An opiate for the life of the dead, that should be easy. What am I waiting for then, to exorcize mine? It's coming, it's coming. I hear from here the howl resolving all, even if it is not mine. Meanwhile there's no use knowing you are gone, you are not, you are writhing yet, the hair is growing, the nails are growing, the entrails emptying, all the morticians are dead."[17]

This later expression of modernism presents an undeniable equivalent of the torn bodies drawn by Cocteau when he was in the grip of withdrawal, which forces the body to live on, unbearably. For those who imagine it, death is accompanied by a procession of forms of suffering. What is incredible in Cocteau is this inconceivable co-existence between two different ways of dealing with the same fear of death, its prefiguration on the one hand and its denial by activity on the other. However, Cocteau was certainly one man, in whom the apostle of the lightness of youth cannot be distinguished from the man haunted by death and mummification as he contemplates a sleeping face:

> *Dieu qu'un visage est beau lorsque rien ne l'insulte*
> *Le sommeil copiant la mort,*
> *L'embaume, le polit, le repeint, le resculpte,*
> *Comme Égypte ses dormeurs d'or.*[18]
> [God, how beautiful is a face when nothing insults it
> Sleep copying death
> Embalms, polishes, repaints, resculpts,
> As Egypt its sleepers of gold.]

16 J. Cocteau, « *Carte blanche* », *Le Rappel à l'ordre, op. cit.*, p. 99.

17 Samuel Beckett, *Molloy, Malone Dies, The Unnameable: A Trilogy*, trans. from the French by Patrick Bowles in collaboration with the author, Paris, Olympia, 1959, p. 31.

18 J. Cocteau, *Un ami dort*, in *Romans, Romans, poésies, poésie critique, théâtre, cinéma, op. cit.*, p. 403.

19 "*Les nerveux (normaux) s'éteignent le soir. Les nerveux (opiomanes) s'allument le soir*" [The highly strung (normal) die down in the evening. The highly strung (on opium) light up in the evening], *Opium* [1930], edn 1993, *op. cit.*, p. 617.

20 J. Cocteau, *Le Chiffre sept* [The number seven], Paris, Seghers, 1952.

This fear of death is also an expression of the desire for death, of the attraction of all kinds of escape and of the delicious pleasure of return. Cocteau's "phoenixology" is well known. However, I prefer other, less mythological and more familiar images: the man on edge who becomes impatient[19] when he does not find the unknown at every step, the existential Don Juan attracted to what he senses but cannot yet see, the unsatisfied man fulfilled by a lack that condemns him to experimentation and new conquests.

Any heterogeneity and disorder in Cocteau is only apparent. He was a complex of alternations, of opposite tendencies combined in swift strokes. Or, one could say, he was a dotted line that never breaks, a turbulence with an inertia ensuring steady momentum. Accordingly the exhibition closes with quotations, homages and reminiscences from artists who are very much alive at this new century's beginning.

Such are the oxymorons embodied in one man, which this exhibition aims to make visible in seven stages.

Appropriately seven, this being Cocteau.[20]

The Cocteau image[1]

"Flat, rolled eternity"
Jean Cocteau, "*La Toison d'Or*" [The Golden Fleece], *Opéra*[2]

1. Cocteau is flat

"And all those things, pictures, drawings, plays and films, are so much time and space cut out, a great folded thickness of time and space. This thickness resists being cut. It reveals only notches, slits, holes, unrelated to each other. Inside the fold these holes, slits and notches form a lacework, a geometry. The folded time and space would have to unfold for us to see them. This is why I admire Picasso's passion for cutting up this thickness, for unfolding what cannot be unfolded, his rage against surfaces. This rage drives him to break everything, to turn it into something else, to break something else because he's in a rage, to make files, to saw and twist the bars of his prison. What can people who think art is a luxury understand of our revolt? Do they know that we are penal colonies? Do they know that our works are convicts escaping hard labour? Do they know that it is for this reason that we shoot at them and let the dogs loose? And I'm also enraged by my ink, my pen and the poor vocabulary in which I turn round and round like a squirrel who thinks he is running."[3]

It is usual to be 'strict' with Cocteau's oeuvre, more than anyone would dare to be with, let's say, parts of Gide's, Picasso's or Hitchcock's, even though Cocteau is criticized for failings that are not so different from those for which we might criticize these others. Facility, naiveté, smugness and pomposity are all rocks on which Cocteau's work sometimes founders, in the plays more than in the poetry and in drawing rather than in cinema.

Cocteau also had black periods, such as his general creative drought of the 1930s, following the prodigious effervescence of the 1920s. Yet more strangely, while in the 1940s and 50s his cinematography attained an unsurpassable and sustained purity, his graphic art went into an inexplicable decline. Stylization became schematization, loud colour broke in, the pen was often replaced by felt-tip and, above all, subjects disappeared to be replaced by a single type, indefinitely repeated, a neo-Greek, male face, in profile, with a straight nose above a prominent pout and the eye of a dead fish.[4] There are also fauns and satyrs in the same vein. Meanwhile the newly acquired media, the pottery and oil paintings in great flat colours, betray an amateurism in the worst sense of the term, in which the later Cocteau wallowed.

Sadly, this graphic output enjoyed a quantitative explosion to match its qualitative collapse, coinciding with Cocteau's accession to the rank of media star, Fourth Republic-style. Academic honours, obsequiousness, infantilism and interviews with Catherine Langeais all became his. In the last decade of his life the man who, in the prime of youth, had described himself as haunted by "the cowardly, profound, fierce desire to please"[5] encountered that most absolute and efficient of pleasing machines, the modern media system, which in the 1950s had just been invented. For him this was a drug even more perverse and satisfying than opium. He could not resist the need to provide what was expected of him. He was seen

1 All the images mentioned in this essay are reproduced in the present catalogue: see the list of reproductions on p. 402.

2 Jean Cocteau, *Romans, poésies, poésie critique, théâtre, cinéma,* éd. présentée et annotée par B. Benech, Paris, L.G.F. (La Pochothèque), 1995, p. 330.

3 J. Cocteau, « Des libertés relatives », *Journal d'un inconnu* [1952], Paris, Grasset, (Les Cahiers rouges), 1990, p. 119.

4 We see this face emerging in *Le Livre Blanc* (1928), with the features of the schoolboy Dargelos: "His face with its slightly thick lips, its slightly slanting eyes, its slightly snub nose, showed every last characteristic of the type that would become dangerous to me. It was a ruse on the part of fate, which disguises itself, gives us the illusion of being free and, ultimately, always drops us into the same basket."

5 J. Cocteau, *Le Farouche Désir de plaire*, poèmes de jeunesse inédits, in *Œuvres poétiques complètes,* Paris, Gallimard, « La Péiade », 1999, p. 1523.

on television, 'improvising' his drawing for the 20 centime stamp – a man with a Greek pro-file and a Phrygian cap – on a glass, in the way Picasso had earlier been filmed performing. He was seen, sometimes with a rather haggard expression, hanging around gala events and shaking infinite numbers of hands. The Cocteau of the 1950s was a man whose presence, rather than his work, was mentioned. It was this man who remained in the memory, obscur-ing the other.

Cocteau only ever thought of himself in the present, even in his epitaph: "I'm staying with you". Decade after decade, from 1910 to 1950, he destroyed and reconstructed suc-cessive incarnations of his public image, just as he was said to screw up the paper and start a drawing all over again rather than correct a poor line. That said, his long artistic career is littered with justifications, denials and demands in the form of polemical tracts, novels, *Portraits-Souvenir*, autobiographical essays sharing their tone with Montaigne or Rousseau and 'private' diaries. But these works, which include some of the most fascinating Cocteau pro-duced – *Opium, Le Journal d'un inconnu, La Difficulté d'être* – were not intended to clarify or deepen understanding. One way or another they were all intended as apologiae, assembling evidence for the defence in a imaginary – or real – trial of the author's person and oeuvre.

"A very long time ago", he confided in his *Entretiens autour du cinématographe,* "in a cata-logue of novelty items for weddings and banquets, I saw an 'object hard to pick up'. I don't know what the object was or what it was called, but I like to think it exists and to imagine it. A work should be 'an object hard to pick up'."[6] These words are fascinating not only because they describe the work as a found object of which the poet is not the inventor, but also in the double meaning of the French word *ramasser*, meaning to pick up, but also to gather together. Cocteau does not help us in this. For five decades his literary, graphic and cinematic output is traversed by the same expressions, avowals and ellipses. Childhood, dreams and sleep, angels and phantoms, the figure of the poet as medium, suffering, tragic and "invisible", are so many threads continually interweaving into a fabric that runs through-out Cocteau's entire oeuvre. However, this superabundant yet cowardly network of expla-nations in the form of ruminations and fragmentary, ill-joined images never goes below the surface. It is a net, a package, a self-portrait in wire, like the one that revolves in *Le Sang d'un poète*. What is contained within these threads? What fearsome entities people this void, this "invisible" of which Cocteau draws only the outline? Did he ever really dare to bring his own night "into the daylight", as he so often claimed?

Defences, avoidances, masks upon masks, a Ferris wheel of images, reflection and reflec-tions, some brilliant, others extraordinarily moving: the oeuvre is indeed hard to pick up or to gather together, hard to understand or embrace. This difficulty of constituting his oeuvre is a perfect echo of Cocteau's "difficulty of being" and is the heart of the matter. In reality, there is no object to pick up, at least nothing that one can analyse, take to pieces or exhaust, nothing with innards that can be examined. The oeuvre extends across a large area, but it has no equivalent depth. It allows all kinds of juxtapositions, contradictions, plays on words and 'splits'. When it starts to reason, all is pretence, dead ends and aporia. It does not start by building foundations, followed by the different floors and then the roof, in the proper order. Here there is a roof on the ground, there a wall all on its own – this is the style of the "faceless" portraits – or a door opening on to a void into which no one will set foot, the hiding-place of the unspoken.

Cocteau's oeuvre is all surface, however multiform, layered and fragmented. Its images cover other images, as though they had all been stuck anyhow on a wall, and the whole is not greater than the sum of the parts. It is an oeuvre without transcendence, if not without mystery. However, its mystery is endless, formless, inconsolable and incurable. It is an oeu-vre of contradictions than can never be overcome, of which the author speaks only, and end-lessly, to himself. As a result it is an oeuvre which overturned many habits of thought and

6 Although here Cocteau gives a very prosaic gloss on this phrase as flatly elitist (sheltering the work from vulgarity, although Cocteau tended to flatten out his best phrases in his later years), it had been pursuing him since at least 1922: "*Objet difficile à ramasser*" [Object hard to pick up] is the title of one of his poems in *Vocabulaire*, in a far more open sense.

scales of value, and continues to do so. Today we live in a whirligig of images and representations without hierarchy; reduced to their most minimal meaning, they come and go, attractive, threatening, disturbing, in a continual and unavoidable process of channel-hopping. This makes us better equipped to understand Cocteau. We, the heirs to the twentieth century, are in a position to accept an oeuvre like his, in two dimensions, since, for better or for worse, this is the shape of our contemporary culture of the image. Let us look through the catalogue.

2. Cocteau cheats

Grec! [Greek] The dry elegance of this word, its brevity, indeed its rather abrupt snap, are all qualities that can quickly be applied to Jean Cocteau. The word is already a precious work of cutting out, so it refers to the poet who is disengaged, freed from a style of which he has sent the shavings flying. The poet – or his work, but thus himself – remains a curious fragment, brief, hard, sparkling, comically unfinished – like the word grec – and containing virtues I want to enumerate, particularly its luminosity. First comes a uniform, cruel light, precisely revealing the details of a landscape apparently without mystery: this is Hellenic classicism. For the poet's intelligence illuminates his work with a light so white and raw that it seems cold. The work is elegantly disordered, but each of its casks and plinths has been vigorously worked, then, it seems, broken and left where it was. Today it is visited by beautiful foreigners. It bathes in an atmosphere that is very pure, very blue.[7]

L'ami Zamore de Madame Du Barry [Mme Du Barry's Friend Zamore] in Opéra[8] is a dreadful play on words, for which Cocteau was much criticized; because "L'ami Zamore" sounds like "la mise à mort" the title can also be understood as "Mme Du Barry's execution". The work thus titled is extremely condensed (another meaning of the French word ramassé). Unfolded, rather than simply translated, it encompasses an entire narrative in one line, from the story's beginning (Mme Du Barry's betrayal by her valet Zamore, who delivers her to the guillotine) to her archetypal 'last words', "Just one more minute, Executioner". In Opium Cocteau comments, "Opéra is a device for distributing oracles, a speaking bust, an oracular book. I am excavating. My spade encounters something hard. I uncover and clean it. 'L'Ami Zamore de Madame Du Barry' is fate. It is not a play on words."

Gradually, as his work asserted its personality, Cocteau constructed an aesthetics of the fragment, of the found object. This was not the deliberately minimal object of the cubists, which could stand 'on a café table', nor some chance, 'objective' encounter in the manner of the surrealists. Rather Cocteau's were cultural objects, representations which seemed to emerge from limbo fully armed, as Athene did from Zeus' head. Genre pictures, vignettes of mythological subjects, scenes from fairy-tales, things he had seen, Cocteau picked all of them up and worked with them as time had made them. Contrary to the methods of the dadaists, for whom the evacuation of everything cultural was a necessary condition of their enterprise of liberation,[9] Cocteau's work is strewn with references. These references are not taken from the further fringes of Western culture, but from its main, classical and academic trunk, the one that underpins the public education system and provides illustrated dictionaries with their imagery. They suggest not so much the elitist arrogance of a son of the cultivated bourgeoisie as the rather confined atmosphere and gentle nostalgia of a floor littered with open books, holiday souvenirs, photographs of friends and family and postcards in a sick child's bedroom.[10]

Cocteau's oeuvre combines and superimposes the everyday and the peculiar, the trivial and the personal, and elements of the collective and individual unconscious, in an entirely non-hierarchical way. More precisely, Cocteau often seeks out juxtapositions, or sometimes

7 Jean Genet, « Hommage à Cocteau », Empreintes (Bruxelles), n° 7-8, « spécial Jean Cocteau », mai-juin-juillet 1950, p. 23.

8 « Trousse contenant 12 poésies de voyage », n° 10, Opéra, in Œuvres poétiques complètes, op. cit., p. 547.

9 The surrealists on the other hand opted for the "subversion" of culture, hence one of Aragon's first great pieces in this vein, Les Aventures de Télémaque [The Adventures of Telemachus].

10 "The boy wants a bedroom, to gather his toys and his loves there. He hates all that scatters. He favours illnesses that group and cosset." J. Cocteau, Portraits-souvenir: IV, in Romans, poésies, poésie critique, théâtre, cinéma, op. cit., p. 751.

concatenations, of the general and the particular. While shamelessly appropriating many classical myths, he preserves their mythological nature. They remain explanatory systems (whether or not it has been forgotten what exactly it is that they explain), based on stock characters, adventures and non-rational narratives (or rather pre-rational narratives, *mythos* preceding *logos*); they do not form coherent and articulated systems; they outlive the loss of their original meaning. To these cultural myths Cocteau adds personal myths constructed along similar lines, demonstrative but obscure, subject to variation and at the same time astoundingly consistent. These personal and cultural mythologies support and strengthen each other, as illustrated by the theme of the angel, on which Cocteau gives many a disquisition, or the successive incarnations of Heurtebise, who is a fearsome angel in poetry,[11] a comic character in the play and just an extra in the film. But whether found or created, the myth always undergoes the same treatment in Cocteau's work. Once integrated into the work it is shaped, simplified and ultimately digested, allowing Cocteau to extract its most schematic traits. Characters have their own attributes: Orphée has his lyre, Oedipus his blinded eyes, the Sphinx is a woman. Often the attributes sum up the character's type: *Orphée*'s Death is a woman wearing gloves; the Heurtebise of the play is dressed like a glazier while in the film he wears the livery of a chauffeur; Jocasta's scarf is lethal like that of Isadora Duncan.[12]

Cocteau's novels are littered with images and scenes which are often echoed in the series of drawings that accompany his publications, produced after the writing. These drawings (for *Le Grand Écart* or *Thomas l'imposteur*, for example),[13] which include Cocteau's strongest graphic work, never explain the text and do not systematically comment on the strongest points in the narrative. The literary and graphic images complement each other with no redundant elements, as though each were harking back, not to the other, but to a common, hidden referent. Cocteau's work sets up a perpetual balance between metaphoric images and scenic images, between linguistic and visual play. He has many ways of expressing convergence between the literary and the graphic, including the generic and not very explicit phrase, "poem by…".[14] In the dedication to the album of *Dessins* from 1924, made partly during the summer when *Thomas l'imposteur* and *Le Grand Écart* were written, Cocteau indicates a new path: "Poets don't draw. They untie writing and then tie it up again differently."[15] So, according to him, writing by hand and drawing – and why not a roll of film?[16] – share the same metaphorical materiality (if we may use such a term). The same idea can be seen in the prefatory poem of *Opéra*:

> *Toute ma poésie est là: je décalque*
> *L'invisible (invisible à vous).*
> [All my poetry is here: I trace
> the invisible (invisible to you).]

The theme of tracing does not appear by chance. A metaphorical echo of Cocteau's process of fishing for references, it is also one of the supports of his graphic art, one of his favourite working methods. "The practice of tracing", explains Pierre Chanel, "enabled drawing to reach the desired state of completion through successive stages. […] When this decanting process evolves without becoming dry, it purifies a graphic theme to an archetypal state."[17] Cocteau was always happy to trace, and above all to trace his own work. To cite only one example, we can mention the extraordinary series of *Le Mystère de Jean l'oiseleur*, which he drew in the summer of 1924. At the time he was spending his days in front of his wardrobe mirror at the Hotel Welcome in Villefranche-sur-mer, after the death of his friend Radiguet the previous winter had sent him plunging into an almost continual haze of opium. These thirty-one self-portraits are entirely repetitive in form and composition: a face is seen from the front, staring at the viewer, with a piece of writing arranged around the drawing or in the spaces

11 J. Cocteau, *L'Ange Heurtebise*, Paris, Stock, 1925.

12. Jocasta, Oedipus' mother and wife, hanged herself; Isadora Duncan was strangled to death by her own scarf when it caught in the wheel of her convertible.

13 From 1926 and 1927 respectively, whereas the two novels date from the summer of 1923.

14 "Poetry of the novel", "graphic poetry", "poetry of cinema", "poetry of journalism" etc – every genre in which Cocteau worked was classified in this way for posterity.

15 J. Cocteau, *Dessins*, Paris, Stock, 1923 (dedicated to Picasso).

16 A comparison between the line and a length of film may seem forced, since film is only a supporting medium. However, Cocteau very often worked with film in the same way that he treated his line in drawing, with loops (images the right and wrong way round) or hatching (cutting). The graphic nature of Cocteau's editing deserves further exploration.

17 Pierre Chanel, préface à la réédition de J. Cocteau, *Maison de santé* [1926], Fontfroide-le-haut, Fata Morgana, 2000.

on the paper. Yet the series expresses a range and power of inspiration that sometimes literally bursts out of the frame. Remarkably the trope of obsessional repetition peculiar to the drug does not in this case lead to some sinister and pitiful aesthetic failure, but to renewal, clarification and progress. In Cocteau's work tracing and repetition are liberating. Two strong images should be mentioned here. One drawing in the series *Maison de Santé* (1925–26),[18] inspired as much by opium and the suffering of the detoxification process as by the poetics of *Opéra*, shows two identical faces, traced, spaced and superimposed – two self-portraits in clear lines. In the first the eyes are closed, as though in meditation, in the second the eyes are open and without pupils, apparently open to the invisible. The same approach can be seen in two of the *Vingt-Cinq Dessins d'un dormeur* (1929), variations on the theme of the sleeping lover, in which Cocteau presents a drawing and its copy, one with eyes closed, the other with eyes open. This is the paradox of the sleep that awakens: like drugs, obsessional repetition fights anxiety; like hypnosis, it lifts barriers and inhibitions. And it is in a purely graphic technique, playing with an image, playing with a mirror, that this repetition finds its most perfect expression.

So now all that is required is to pull the thread. For this reason the Dargelos myth, a long-standing element in Cocteau's imaginary world, is embodied many times in his oeuvre. At least one poem, two novels, an essay and two films return to the same place and, in this place, to the same scene, and in this scene, to the same words. It was in a Paris courtyard, in winter. Children were playing, "That evening it was snow."[19] Dargelos, the "school cockerel",[20] "beautiful with the insolent beauty that is accentuated by dirt",[21] made a snowball "as dangerous as Spanish knives",[22] which struck the narrator "a dark blow. The blow of a marble fist",[23] "and starred his heart".[24] This slightly adventurous montage reveals the concentration of the scene in a few lines, a few images which in their almost incantatory repetition reinforce the crystallization of the story into myth. By repeating, replaying this scene, Cocteau generalizes it, without stripping it of its singularity. As has often been said, Cocteau was a great producer of personal myths and all of them can be schematized into scenes, in an exemplary manner. The scenes themselves are drawn in a few lines, such as Diaghilev turning round one day in a Paris street with the challenge, "Astonish me"', or the angel Heurtebise, born in Picasso's lift. A few people also accede to this mythical status. Foremost among them are Picasso, archetypal artist, and Radiguet, prodigal and prodigious son. Both are celebrated in a great many drawings, essays and poems. Others include Dargelos (who really existed), as Eros incarnate, Diaghilev, as the father figure, Proust, Anna de Noailles,[25] and of course we need hardly mention Cocteau himself, as the supreme Narcissus.

Graphic stylization pushes the effort of simplification to its limits: Apollinaire is identified by his bandaged wound, Picasso by his round eyes and thick hair, Diaghilev by his eyes of a jealous bull, Anna de Noailles by her nose like an eagle's beak, Radiguet by his thick lips, Desbordes by his sailor's dress, Dargelos by his enormous penis and Cocteau himself by his pointed nose and chin and his hair standing up on end. Once again, they all have their own attributes. At the peak of Cocteau's stylization, paradoxically, the portraits without faces avoid all salient features, all details, retaining only the general shape. This shape is all the more convincing because it seems to be a good likeness although one cannot tell why. The same is true of the many *Autoportraits sans visage* [Self-portraits without a face] in the juvenilia of the 1910s and 1920s, portraits of Satie, Anna de Noailles (without her beak) and Coco Chanel. All these scenes and mythified characters portrayed in a few lines form the cards of a personal Tarot pack which Cocteau reproduces again and again. Their figures are so recognizable that all the reproductions can stand in for each other, just as a Jack or Queen of Hearts remains a Jack or Queen of Hearts, however they are drawn. Everything is contained in this metaphor of the pack of cards. It is a collection of perfectly identifiable figures, the meaning of which is concentrated into a few strictly codified lines. Each card

18 J. Cocteau, « Max, Pierre, priez pour moi », n° 25, *Maison de santé, ibid.*

19 J. Cocteau, *Les Enfants terribles* [novel, Paris, Grasset, 1929], in *Romans, poésies, poésie critique, théâtre, cinéma, op. cit.*, p. 108.

20 Cited in these terms in *Le Sang d'un poète ; Les Enfants terribles, ibid. ; Portraits-Souvenir: VIII*, in *Romans, poésies, poésie critique, théâtre, cinéma, op. cit.*, p. 782 ; « *Cadence, l'élève Dargelos* », *La Fin du Potomak*, Paris, Gallimard, 1939, p. 107.

21 Cited in *Portraits-Souvenir, VIII*, in *Romans, poésies, poésie critique, théâtre, cinéma, op. cit.*, p. 782.

22 Cited in *Le Sang d'un poète, ibid.*, p. 782 ; *La Fin du Potomak, op cit.*, p. 109.

23 Cited in *Les Enfants terribles*, in *Romans, poésies, poésie critique, théâtre, cinéma, op. cit.* ; « *Le camarade* », *poème en marge d'Opéra*, in *Œuvres poétiques complètes, op. cit.*, p. 562. Cited again by Cocteau at the end of *Opium*, in *Romans, poésies, poésie critique, théâtre, cinéma, op. cit.*, p. 684.

24 *"Le Camarade"*, a poem attached to *Opéra, op. cit.*. We should note in passing that Cocteau adopted first a heart and then a star as signature monograms.

25 There is in fact no maternal figure. His mother Eugénie was the only person close to him whom Cocteau ultimately never portrayed in any kind of physical or psychological portrait, except on her death-bed! Here is meat and drink for the psychoanalysts.

has a symbolic, magical power; the cards foretell the future, reveal destiny. They incarnate the freedom and stability of combinatory play: the rules may change, but the symbolic system does not. "What is a poet? He is a man who changes the rules of the game."[26]

Cards are everywhere to be found in Cocteau's work. Apart from his frequent representations of friends or sailors playing cards and their presence in a great many symbolic compositions, there are many drawings suggestive of playing cards through the symbolism of their suits – clubs, diamonds, hearts or spades – and effects of symmetry. The drawing *Je ne me compare à aucun des princes de la Terre* [I do not compare myself to any of the princes of the Earth] from *Le Secret professionnel* and many works in the album *Dessins* from 1924, not to mention the entire series entitled *Maison de Santé*, resemble imaginary Tarot packs. In the film *Orphée*, when Death is shown wearing a black dress in one shot and a white dress in the next, one thinks of the eponymous Tarot card.[28] Lastly, cards play an active role in *Le Sang d'un poète*: the poet plays cards with the animated Statue, he cheats by stealing an ace of spades from the dead child's pocket and kills himself. Cocteau explains this as follows: "[...] I could tell you that the battle of the snowballs is the poet's childhood and, when he plays this card game with his Glory, with his Destiny, he cheats by taking from his childhood what he should find in himself."[28] Cocteau always cheats at cards.

3. Cocteau is afraid

"'Your Picasso', he said – it is Persicaire speaking – 'glimpsing a cardboard dice painted and folded by the painter, protected under the glass of a green box hanging by my bed, your Picasso creates enigmas that seem to be enigmas and which, however, are enigmas. He clouds the issue. His insolence goes beyond bounds. Is this not the most solitary of all positions? Enigmas! Real enigmas that deceive people. Real enigmas that look fake. What a funny tragedy. What a funny imbroglio.' And Persicaire pointed to the dice in the box. This dice loaded the perspectives. On its brown and white faces it had a number of inexact points. It resembled the dead end of some seedy street in a small Italian town by moonlight. It resembled what childhood locked in the lavatory sees by keeping an eye to the keyhole. It resembled a necrophagous insect. It resembled a card trick. It resembled a deaf lantern. It resembled a death's head. 'To play with this dice', prophesied Persicaire, 'You should play with the devil and cheat, or don the red glove of murder and play with yourself and your own life should be the stake. You are right to keep it under glass. Do not leave that object free. I should not like to know it was outside.'"[29]
Jean Cocteau, *La Fin du Potomak*.

"N'être, de l'inconscient, que des aides."
"Faire la moitié du travail. Le reste se fera tout seul."
"Si notre inconscient se refuse, ne pas insister. Ne pas penser. Se mettre à un travail manuel."[30]
[Be no more than aides to the unconscious.
Do half the work. The rest will do itself.
If our unconscious refuses, we should not insist. Not think. Turn to manual work.]
Jean Cocteau, *Journal d'un inconnu*

There is a magpie aspect to Cocteau. More than just a tendency to grab what is 'in the air' of a period and appropriate it, it is a penchant for "gathering up" any element encountered by chance that could be included in his work of the moment – or provide it with stock for future use. This ability to ennoble rubbish, which Cocteau so admired in Picasso – to hunt around in the studio, gather together a few old nails and bits of screwed-up paper and turn

26 J. Cocteau, « *Cinéma, un œil ouvert sur le monde* », Entretiens autour du cinématographe, Paris, André Bonne, 1951.

27 Cocteau constantly read his own cards, just as he was a fan of talking tables. In some popular versions of the divinatory tarot, Death represents an extreme event, a major upheaval for good or ill, depending on whether the card is the right way up or upside down. Similarly the Princess in the film *Orphée*, who is Death in love, both kills and gives back life.

28 Cited by Francis Steegmuller, *Cocteau (A Biography)* [1973], French edn, translated by M. Jossua, Paris, Buchet / Chastel, 1997, pp. 298–301.

29 J. Cocteau, « *L'appartement des énigmes* », La Fin du Potomak, Paris, Gallimard, 1939, p. 101–02.

30 J. Cocteau, Journal d'un inconnu, op. cit., p. 213.

31 Pierre Chanel, *Jean Cocteau, Poésie graphique*, Paris, Jacques Damase éditeur, 1987.

32 We are showing six of these works in this exhibition, and in the catalogue. Time has not been kind to these survivors. In a final irony, we have fifty-one titles and six objects, but no key as to how to link them.

33 "Tact in audacity, how far one can go too far" (*Le Coq et l'Arlequin*). A phrase liberally used by Cocteau, pinched from Péguy.

34 "[...] Theatre of cruelty means theatre that is difficult and cruel in the first place for myself. And, at the level of representation, this is not the cruelty that we can exert against each other by mutually tearing our bodies to pieces, sawing up our personal anatomies or, like the Assyrian emperors, sending ourselves sackloads of painstakingly severed human ears, noses or nostrils through the post, but of the far more terrible and necessary cruelty that things can exert against us" (Antonin Artaud, *Le Théâtre et son double*, Paris, Gallimard, 1939).

35 Sent by Cocteau to Picabia's wife Germaine Everling and preserved in the Jacques Doucet collection.

36 *Au moment de plonger*
 sous les vagues du songe
Tu sembles hésiter ;
Craindrais-tu, par hasard, qu'à ta suite
 je plonge
Et du même côté.
Ne crains rien, nos sommeils
 ont une différence,
Car lorsque je m'endors,
Le cauchemar te mêle aux lieux
 de mon enfance
Avec mes amis morts.
[On the point of diving beneath the waves of dreaming
You seem to hesitate;
Are you afraid, by any chance,
 that I will dive after you
And in the same direction.
Fear nothing, our slumbers are not the same,
For when I fall asleep
Nightmares merge you into the places of my childhood
With my dead friends.]
J. Cocteau, *Plain-Chant*: II [1923], in *Romans, poésies, poésie critique, théâtre, cinéma, op. cit.*, p. 296.

them into a Picasso – is at the extreme end of this tendency. Cocteau tried it once. He soon realized that such 'cards', while undoubtedly symbolic, were also material, three-dimensional and not so easy to handle.

In the summer of 1926, in the Hotel Welcome at Villefranche-sur-mer, Cocteau embarked on a strange "cuisine", collecting, as Pierre Chanel tells us,[31] drawing pins, hair pins, a candle, matches, sugar lumps and vermicelli stars: "From morning till night and from night until morning", he wrote to his mother, "I stick, I cut, I brush, I crush pastels, I melt walnut stain, I mix lipstick and sealing wax, etc." The exhibition of these "objects" at the bookshop and gallery Les Quatre-Chemins, run by Raoul Leven and Maurice Sachs on the Rue Godot-de-Mauroy, comprised fifty-one pieces, the titles of which are listed in its catalogue. Of these little known and extremely fragile works, probably fewer than ten have survived.[32] They include three-dimensional collages creating the sets of an imaginary theatre, similar to the retouched drawings for the play *Orphée* (*Le Mystère des chambres vides* [The mystery of the empty rooms]), where, in the darkness of the background, one can just make out family photographs; a woman's body schematically drawn, stretched out in a position of sacrifice; the head of a Greco-Roman statue cut out from an encyclopaedia, arms and legs cut off, with bloody stumps, blood in bright blue sealing wax pouring from a wound in the neck. Many of others are more innocent; not all exude such violence, such a sense of threat, and the *Tête aux punaises* [Drawing-pin head] seems very anodyne, insofar as it can be anodyne to stick in so many drawing pins, one by one.

Cocteau never repeated this experiment – at least not with such intensity. Perhaps here he had gone beyond "how far he could go too far".[33] Perhaps it was too much physical involvement, too direct a confrontation with matter too appropriate for staging a 'theatre of cruelty',[34] something he always kept at a safe distance. Yet Cocteau's graphic art is often cruel, with its images of mutilation, severed arms, legs and hands, eyes put out and open wounds. The drawings of *Opium* or *Maison de Santé* on the personal side of Cocteau's mythology, on the cultural side the illustrations for the play *Orphée* or for *La Machine infernale*, a rewriting of the Oedipus myth, are often extremely crude. The erotic and pornographic drawings – including the extraordinary *Bébé aux extremités phalliques* [Baby with phallic extremities] – and the hyperbolic obscenity of the drawings for Picabia,[35] reflect Cocteau's impressive lack of inhibition. However, contrary to the principles laid down by Artaud, this cruelty is not directed against himself – in reality it is not directed against anyone. Cathartic and liberating, his graphic crudity is nevertheless affected, polished and staged. Even the drawings of *Opium*, which have an expressionism sometimes reminiscent of Artaud, reveal a sureness of line that is scarcely compatible with the agonies they are intended to portray – the cold turkey of the opium addict. Here again all is staged to set violence at the right distance, in retrospect. By contrast many of the "object-poems" of 1926, which seem at first sight more anodyne, are manifestations of a threat, an immediate and present state of disquiet. There are bad presences in those boxes.

So what paralysing danger was Cocteau facing? His obsession with death, which he mentions on numerous occasions, was not a pose. The fact that his life was punctuated by dramatic disappearances is more than just another personal myth. His father's suicide, followed by that of a friend on the steps of La Salute in Venice, and the deaths of Jean Roy on the front in 1914, Radiguet, "shot by the soldiers of God" in 1923, Marcel Khill in 1940 and Jean Desbordes at the hands of the Gestapo, were all real enough.[36] Systematically stripped of any mystical or metaphysical considerations, but probably loaded with many complexes and feelings of guilt, the idea of death is present throughout the introspective side of Cocteau's oeuvre. In 1922 he revealed a real "professional secret":

"Poetry in its raw state makes the person who feels it live with nausea. This mental nausea comes from death. Death is the other side of life. The result of this is that

we cannot imagine it, but we are always obsessed by the sense that it forms the weft of our fabric [....] Imagine a text of which we cannot know the sequel, because it is printed upside down on a page we can only read the right way up. Upside down and right way up are useful for expression in the human way, having doubtless no meaning in the superhuman, that vague other side, which hollows a void around our actions, our speech, our every movement, turning the soul as some parapets turn the stomach."[37]

As we have seen, Cocteau would take care to distance himself as far as possible from this "raw state" of poetry, while remaining connected to it as a source of anxiety, disgust and inspiration. He maintains the link by means of repetition, staging and distancing,[38] and also, as we read explicitly in these lines, through a binary, two-dimensional representation of the world, in a vain attempt, but the only one within our grasp, to deal with the disappearance of people into the invisible, that inevitable, threatening "other side". Thus in *Opéra* the classic comparison of sleep and death, always suggested and never made explicit in Cocteau's work, takes the form of a card trick:

> *Le sommeil est une fontaine*
> *Pétrifiante. Le dormeur*
> *Couché sur sa main lointaine*
> *Est une pierre en couleurs.*
> *Dormeurs sont valets de cartes,*
> *Dormeurs n'ont ni haut ni bas,*
> *De nous un dormeur s'écarte,*
> *Immobile à tour de bras.*[39]
> [Sleep is a petrifying fountain.
> The sleeper,
> Lying on his distant hand,
> Is a stone of many colours.
> Sleepers are jacks of cards,
> Sleepers have neither top nor bottom,
> A sleeper moves away from us,
> Immobile at full speed.]

We should note that there are no corpses in Cocteau's work.[40] The dead either disappear from the image, like Eurydice in Orphée's rear mirror, or else they lie down merely to come back to life.[41] Appearance and disappearance, black and white, surfaces and reflections, countless mirrors: beyond this binary alternation of existence and absence which forms the weft of the real as it is known to us lies the unknowable synthesis that Cocteau cannot, does not know how to, does not want to imagine. It is the idea of a world that is indifferent to his existence and the existence of those who are dear to him, indifferent to his work and to all human production, indifferent as Cocteau's angels sometimes are, or at least would be if they did not sometimes agree to meet challenges from a chosen few in the way of a classic 'combat with the angel'. It is the idea that one can be nothing more than a material, mortal thing among material things and, like them, destined to become rubbish.

From this point of view Picasso's dice as described by Cocteau in *La Fin du Potomak*,[42] a cubist object cubed, a three dimensional dice folded out flat, seems to him to be a concrete image of fate mastered, because reduced to two dimensions. But this dice which does not roll, which says nothing of the future or destiny, could, however, do so if it were refolded and returned to its original shape. In its victory over substance and its dematerialization of

37 J. Cocteau, *Le Secret professionnel* [1922], in *Romans, poésies, poésie critique, théâtre, cinéma, op. cit.*, p. 511.

38. This is an almost Brechtian approach. Cocteau often deliberately highlights sets, wires and methods (hence his special effects in the cinema), preventing the reader or viewer from passively following his rhetoric. Obviously the objectives of these two playwright-poets were very different.

39 J. Cocteau, « Le modèle des dormeurs », *Opéra*, in *Romans, poésies, poésie critique, théâtre, cinéma, op. cit.*, p. 341.

40 Thus Cocteau avoided Radiguet's last moments and did not attend his funeral.

41 Rather than the death of the twins in Melville's *Les Enfants terribles*, Cocteau would have preferred an apotheosis in which the two heroes would fly up "to the heaven of tragedies", rolled up in the same sheet – as at the end of *La Belle et la Bête*. Melville won the argument.

42 See the quotation above, note 29, and its reproduction in the present catalogue, p. 377.

reality, this object, which potentially contains its three original dimensions, is felt by Cocteau to be a perpetual threat. He has his character say, "Do not leave that object free. I should not like to know it was outside". This power of Picasso's to tame and transform the material world is one of the sources of Cocteau's admiration for him.[43] Unable to grab matter firmly in all its thickness (though not for want of trying), Cocteau remains on the surface. It is through lines, images, myths, literary and graphic stylisation and combinations of figures and cards that he fights his demons.

4. Cocteau plays and wins

"To describe this trap would be difficult. For a start, who has seen it? No one. In our opinion (and certain indications prove this) the trap, an assemblage of living parts requiring several centuries of discipline or complicity, was rather a single flat thing folded with a masterly sense of space.

"In order to surround the unfortunate victim and obtain depth at this lonely street corner, it probably played on the phenomenon by which the feet of a person walking at night on the pavement on the left can be heard on the pavement on the right, and used these two apparently inoffensive parallel pavements like the dual photography of the stereoscope. Be that as it may, in the wink of an eye the man was seized, led away, stripped, scalped, castrated, skinned alive, blinded and covered in an Oedipus costume, in the midst of gales of laughter above which rose a fresh voice crying, "'Well done!'"

Jean Cocteau, "Le Théâtre grec" [Greek theatre], "Musée secret" [Secret museum], from Opéra[44]

[...] But this is also the function of the poet, a constant, exhausting effort to reduce the two warring faces of reality. It is on the gap between the two worlds that poetry builds its three dimensions, like the stereoscope. It is also because of this that the cinematograph is becoming the best vehicle for poetic exploration. We cannot pass through the mirror. We cannot pass through the screen. Yet we do pass through the screen, we live the life of the on-screen characters, we inhabit the on-screen world. The film becomes the furthest point, the most advanced outpost of demiurgy.

Chris Marker, Esprit, November 1950

Almost by chance, it would seem, in 1930[45] with Le Sang d'un poète Cocteau discovered the evocative, distancing powers of the cinematograph. From "object-poems", with their rather too active symbolism, he turned to other, not dissimilar devices, which enable us to watch for forbidden things, in which we sink into the dark and the unknown, in which we are threatened by femininity, in which we die and come back to life. 'We' do these things, yes, but not personally: they are done by the other, the Poet. Significantly this commission from the des Noailles was addressed to Cocteau the graphic artist: he was asked to create a cartoon animation set to music by Auric. But although Cocteau then suggested a different sort of 'graphy' on which he could get a better grip, the details and approaches of Le Sang d'un poète evoke the cinema of animation.[46] This taming of the image – in the broadest sense – in three dimensions, which cinema ultimately represented for Cocteau, had its source in his work as a graphic artist rather than as a playwright (he was already the author of Antigone and Orphée, not to mention the post-war ballets). Later Cocteau would film theatre, conscientiously and methodically, producing masterpieces of the genre such as L'Aigle à deux têtes and particularly Les Parents terribles. But clearly this is a quite different form of cinema from that of Le Sang d'un poète and later of Orphée, La Belle et la Bête and Le Testament d'Orphée. These films are fully and literally cinematographic.

43 "One day I was ill, he sent me a cardboard dog cut out all of a piece and so wonderfully folded that it stood on its legs, raised its tail and moved its head. I felt better at once. Since then I have compared my dog to Yseult's fairy dog Petit-Cru." J. Cocteau, « Picasso », Le Rappel à l'ordre, in Romans, poésies, poésie critique, théâtre, cinéma, op. cit., p. 547. "On the floor there was a pile of junk which Picasso was gradually raising to the dignity of service. Picasso's bestows far more admiration on things that will be useful to him than on finished beauty. It's thanks to him that 8I waste less of my time in open-mouthed contemplation of things that cannot be useful to me, and that I understand that a street song, listened to from this selfish viewpoint, is worth The Twilight of the Gods." J. Cocteau, ibid., p. 559.

44 J. Cocteau, Romans, poésies, poésie critique, théâtre, cinéma, op. cit., p. 337–38.

45 Or perhaps with Un Chien Andalou, in 1929, which Cocteau never admitted seeing at its première, although his name figures on the guest list.

46 See on this subject F. Nemer, Cocteau s'amuse, Paris, Cinéma 04, 2002.

Le Sang d'un poète also gave a home to a great many 'leftovers' from Cocteau's visual output of 1926, in a systematic process of recycling. The self-portrait in pipe-cleaners inhabits the poet's room and spins above his head, while the "chariot driver", also made in pipe-cleaners, takes the poet's place during his return journey from the other side of the mirror. The "sacrificed woman" mentioned above[47] is a cousin of the Hermaphrodite seen through a keyhole in the hotel of the Folies-Dramatiques – s/he whose genitals are covered, in her feminine phase, by a sign reading "Deadly Danger". The theatre sets of *Histoire amoureuse*, *Orphée à l'opéra* and *Baigneuse se coiffant* find an echo in the boxes from which the "socialites" applaud the poet's death. References to the stage, to both theatre and music hall, are, moreover, ubiquitous in *Le Sang d'un poète*, from its structure in a series of acts to the rhythmic pacing of the action by Auric's drums and trumpets and Cocteau's diction of a street-market salesman. Visually these references have their source in the set for the play *Orphée* and other drawings for theatre sets made at the same time (*La Mort et ses aides* [Death and its assistants]), all dating from 1926. For what is a theatre (at least the Italian-style stage Cocteau had in mind) if not another kind of 'box' in which a unique, concise drama can be played out?

In *Le Sang d'un poète*, as in the theatre, the topography is entirely a matter of convention and asserted as such. As in the theatre the action unfolds in a space with no outside: a bedroom, then a corridor with no perspective. Like shoe-boxes in which dolls are kept in a child's bedroom, none of these 'places' is physically linked to any other – indeed two of them occupy the same space: a snow-covered courtyard is also a theatre. Cocteau returned to this deliberately unrealistic use of space in *La Belle et la bête*, where the magic glove has the same power of instant transportation as the mirror in *Le Sang d'un poète*. Belle's relocation without movement in the corridor of the veils (perhaps a childhood memory of a magic lantern effect, like the Poet's movements on the flat sets in the hotel and those of Orphée and Heurtebise in the Zone)[48] reinforce the compartmentalization of these places, which do not fit into any space and which are not separated by any distance that can be measured – even by pacing it out. In *Orphée*, the pursuit of the Princess through the streets is a montage of short sequences shot in different parts of Paris, whereas the plot unfolds in an idealized provincial town. Cocteau deliberately dismembers the film's spatial coherence and, as a result, the absolute linearity of the plot is contradicted by the fragmentation of the filmed space. Here are his own words, striking their blows like the Poet smashing the statue: "The hundred and eighty degree rule. The hundred and eighty degree rule is taboo, sacrosanct. When I make the decision all the faces fall. My assistant and the trainee assistant tell me that they won't take responsibility for it. When the Rolls that carries off Orphée's body of stops on the road, having three hundred and eighty degrees [*sic*] all at once made my young assistants' hair stand on end. To be fair, after the edit they acknowledged that I'd been right and our getting the images was all due to this heresy. First image: the Rolls stops, surrounded by its motorcyclists. Second image (180°), looking the other way, one of the motorcyclists goes up to the car door and asks Heurtebise a question. Third image (180°): the camera shows Orphée from the other direction, lying on the car seat. Fourth image (180°): close up, again looking in the opposite direction from the last shot, showing Orphée's dead face hanging off the seat. The Rolls drives away and the camera, shaken by the movement from Orphée's head to a general shot, shows the car and motorcyclists driving off down the road."[49] As Cocteau was so fond of repeating, he filmed reality, but his was a kaleidoscopic reality, a broken mirror all along the way. The reality which makes its way into the film is subjected to unusual violence, and its "fabric", its "weft", to use Cocteau's own metaphor cited above, is disrupted as a result. Upside down and right way up, life and death (this is one of the meanings of Orphée) become combined in this pulp. Such is the doubtful victory of the poet over unavoidable fate.

Significantly, it is by confusing things that Cocteau rediscovers the rich materiality of reality in his films. Orphée's passage through the mirror in *Orphée* was filmed using a meticulous

47 The title of the object has been lost.

48 In *Le Sang d'un poète*, the poet advances with difficulty from one door to the next down the corridor of the Hôtel des Folies-Dramatiques, as though the co-ordinates of space had been overturned – in fact he was moving on a set placed flat on the ground. We find exactly the same approach when, in *Orphée*, Orphée and Heurtebise pass for the second time – illicitly – into the Zone. Similarly, and again in *Le Sang d'un poète*, the "theft lesson" shows a child stuck to the ceiling – in reality a floor with a naked lightbulb standing up on its wire like a tulip.

49 J. Cocteau, *Entretiens autour du cinématographe, op. cit.*

method in which a real mirror was followed by a phantom mirror lent reality only by the sound track, a simple pane of transparent glass, and lastly by a tray of mercury into which Jean Marais's gloved hand plunges, radically violating the essentially two-dimensional nature of the mirror-object. Let us dwell for a moment on this mercury, and its many ambiguities. Physically it is the only metal that is liquid at room temperature, a liquid mirror in the proper sense and the quintessential alchemical ingredient. In mythological terms, Mercury is also known as Hermes Psychopompos, messenger and god of travellers and cross-roads, who accompanies the souls of the dead on their last journey. Over and above the special effects themselves, Cocteau invents a mechanism to produce a vision combining both the most concrete physical reality and myth – the consolatory and liberating power of which we have already seen. In this way the immediacy of matter (which Orphée touches!) meets the eternity of myth.[50]

Such is the power of cinema: *Orphée* shows much more than the 1926 play of the same name could tell: "I'm telling you the secret of secrets", says Heurtebise. "Mirrors are doors through which Death comes and goes. Don't tell anyone. Besides, look at yourself all your life in a mirror and you will see Death at work like the bees in a glass hive."[51] What Cocteau did throughout his life was, literally and metaphorically, to look at himself in a mirror. The *Autoportraits sans visage* or the drawings of *Le Mystère de Jean l'oiseleur* all ask the same question – how does death do its work? – and garner the same response: it works We can take literally the famous definition of the line in *La Difficulté d'être*: "What is the line? It is life. A line should live at every point of its journey in such a way that the presence of the artist can be felt more than that of the model. The crowd bases its judgements on the line of the model without understanding that this line can disappear in favour of that of the painter, as long as his line lives its own life. By line, I mean the permanence of personality [...]."[52] From this we can deduce that Cocteau invested his graphic work with some vital function which his literary work, trapped between apologia and rhetorical virtuosity, could not meet. The gradual drying up of his graphic art after the 1940s may have been counterbalanced; the life which was withdrawing from the drawings may have flowed into his cinema. Let us follow the "lifeline" of the traced drawing from tracing to animation, from animation to the cinema. "With film you kill death, you kill literature; you make poetry live with direct life."[53]

To kill Death, or to make it fall in love, to seduce it, in other words, etymologically speaking, to divert it (*Orphée* again), is of course not so simple. One can twist reality and reverse time for the space of a film, but victory is always an illusion. And making a film is such an effort. Cocteau could not always summon the heroism he showed during the shooting of *La Belle et la bête*: "[...] I'm tearing this tale out of nothing, by surprise. If fate goes against me I shall fight it. I shall invent some card trick to play on it." Here are the cards again: in the face of sickness, the elements, or blind fate, Cocteau diverts and distracts his attention with some conjuring trick, aims obliquely at his target.

And finds it.

March 2003

50 See the quotation from *Opéra* at the opening of the present essay.

51 *Orphée*, scène VII.

52 J. Cocteau, « De la ligne », *La Difficulté d'être* [1946], in *Romans, poésies, poésie critique, théâtre, cinéma*, op. cit., p. 962.

53 Paper given at the Théâtre du Vieux-Colombier, 20 January 1932, before the screening of *Le Sang d'un poète*. Quoted by Jean Touzot, *Jean Cocteau*, Lyon, La Manufacture, 1989, p. 330.

Portrait of the artist in Ariadne's thread

The metaphor of the thread returns constantly throughout Cocteau's writings.[1] It unrolls apparently without end, its unpredictable loops and zigzagging leaps following the contours of his life, his writing and above all the countless drawings he made from his adolescence at the dawn of the century to the 1960s.

His letters, poems, books, travels and souvenirs are all accompanied by irrepressible drawings. The sketches show daily life and the layers and recurrences of memory. The caricatures and portraits depict friends, lovers and simple acquaintances. The stylistic exercises preserve traces of important meetings and extremely varied (too varied) objects of admiration or fascination. The finest have a visionary quality, reworking hallucinations born out of pain and withdrawal symptoms (*Opium, Maison de santé*). Together they form a complete, highly perfected system of recording, held together by a thread.

The original ball of thread, which Ariadne gave to Theseus when he was about to enter the darkness of the labyrinth, connected the hero as much to the Minotaur (also one of Picasso's disguises – in the 1930s he made it the hero of a an autobiographical epic – and perhaps also a figure related to the Beast of *La Belle et la Bête*) as to the beautiful lady longing for his return. If Cocteau chose to see himself in Orpheus, the intrepid but distracted speleologist and charmer who ultimately suffers great pain, I cannot help seeing the indivisible three-fold figure – bound by a single thread – of Ariadne, Theseus and the pathetic Minotaur as another eminently Cocteauesque motif of authentication, one of several possible keys to his activity as a multiform graphic artist.

Likeness / caricature / stereotype

Paradoxically, the "almost magical sense of likeness"[2] which the young Cocteau attributed to himself when he began drawing portraits led to the stereotypes that multiplied throughout the 1950s and 1960s. These include the profile of an androgynous Marianne with her cockade, a design for a 20 centime stamp drawn in 1961. The well-used, hackneyed motif has been cleaned and smoothed until it almost attains the "invisibility" which Cocteau constantly advocated. We might even suggest that at this time the thread was particularly free of tangles. Cocteau had certainly foreseen such a thing in 1923, when, in a paper given at the College de France entitled, "Of an order regarded as anarchy", he gave the following justification for having already changed a great deal: "Since [...] I am trying to untangle a ball of thread by lightly touching it, I shall not bore you with the sicknesses brought about by transformation. There is nothing less simple, less clear than the birth of a clear and simple state of mind. But gradually one can distinguish a single thread emerging."[3] By 1961 it is a case of mission accomplished, thread untangled, and indeed flat calm, with no discernible shadow or malaise.

Greatly influenced by the caricaturists Capiello and Sem, the young Cocteau signed himself first Japh and then Jim (fashionable pseudonyms of the day, which in their slender elegance anticipate Henri-Pierre Roché, his novel *Jules et Jim* and, inevitably, François Truffaut). For some time he practised identifying salient features and capturing funny faces and grins,

1 See the preface to *Dessins* (1923) and the oft-quoted words: "Poets do not draw. They untie writing and tie it up again in a different way", as well as the reference to the acrobat: "It is not by thinking of the life of the whole towards which the lines are moving that the draughtsman makes a living work, but by sensing that his line is in lethal danger from one end of its journey to the other, the danger of an acrobat." (J. Cocteau, « Picasso », [1923], in *Romans, poésies, poésie critique, théâtre, cinéma*, éd. présentée et annotée par B. Benech, Paris, L.G.F. (*La Pochothèque*), 1995, p. 547).

2 Note by Cocteau (in 1962) on the back of a portrait of his brother Paul, quoted by Pierre Chanel in « Mille traits de poésie », *Le Magazine littéraire*, October 1983.

3 J. Cocteau, « *D'un ordre considéré comme une anarchie* », reprinted in *Le Rappel à l'ordre* [1926], in *Romans, poésies, poésie critique, théâtre, cinéma, op. cit.*, p. 531.

the gesticulations of socialites and sportsmen, the paunches of musicians and the staggers of barflies, using the most concise line possible, lightly enhanced with a few touches of colour.

It must be said that these drawings are fairly clumsy in terms of likeness, and little developed. The least commendable among them recall sketches by Marquet and Matisse from the same years 1902–03, in which each tried to outstrip the other in creating an almost instant record of street life or figures from the cabaret. The resemblance between the drawings of these three artists is merely a reflection of the period in which they were working. However, at a later date Cocteau's "clear line" would once again rejoin that of Matisse, notwithstanding the decisive influence of Picasso, which can immediately be traced after their first meetings in July 1915.

A year after their meeting Cocteau and Picasso went walking in Montparnasse, one fine day in 1916,[4] with Roché, Max Jacob, Modigliani, Kisling and a certain Pâquerette. Then, in the spring of 1917, Cocteau again met up with Picasso (along with Diaghilev, Massine and the little American girl, the Russian dancer Maria Chabelska) in Rome to prepare *Parade*. These travels are littered with drawings, caricatures and portraits, produced in great numbers, exchanged with or distributed to this person or that. In among them are the precious photographs that enable us to verify likenesses, as well as the climate of osmosis and Cocteau's capacity for absorption. Thus Picasso drew Cocteau on Easter Sunday 1917, a fine profile in the pure, dry, 'neo-classical' style of the end of the war. Cocteau always kept this portrait with him.[5] On the same day Cocteau drew himself, and also Picasso in profile, his hair falling over his large eye, in a striped vest, looking like a hoodlum. This profile would be re-used many times, sometimes enhanced with cubist ornamentation – stippling or various kinds of geometrization. Other burlesque sketches record life behind the scenes during the stay in Rome, and when Picasso designed an acrobat's costume (very tight with blue scrolls), Cocteau drew the dancer in costume; they are almost the same with almost, but not quite, the same line. Of all the lessons he learned through contact with Picasso, and a fascination that was close to love, the main visual element is undoubtedly the curving, classical line, at once agile and calm, which Cocteau adopted from then on. At the time Picasso was interested in Ingres and in photography.[6] Rosalind Krauss notes the coldly mechanical, mechanized character of the drawings he was then doing; these were often based on photographs, such as the 'bouquet' of seven dancers (1919), adapted from an advertisement for the Ballets Russes. It is significant that Cocteau adopted the "clear" line in the context of this exploration of pastiche; the line that plays on the transparency of space can express and describe everything, feigning the simplicity of the obvious and the unruffled attitude of an entomologist.[7]

The album *Dessins* [Drawings], published by Stock in 1923, brings together the best of this "clear" post-war output. We should note that Cocteau had asked Picasso to approve the selection of drawings. On 29 April 1922 he wrote to him: "I have collected all my drawings for an album and I shall publish only what you regard as possible – come quickly and see me".[8] The friends (including one of the "Roman" profiles of Picasso mentioned above, with a pipe in his mouth) are present of course. There is Auric and his trumpet of a nose, an overly suave Poulenc, an unflattering portrait of Radiguet with his bushy eyebrows, Diaghilev, Bakst, and many anonymous men with moustaches, some decorated, others not. Above all we find a carefree procession of bars and dancehalls – dancers of indeterminate sex, drinkers round a table and a hilarious Spanish dancer with castanets – which in their verve and acidity are reminiscent of contemporary German masters such as Dix. Here the clear line lacks neither tone nor cruel humour. Trembling slightly (whether for reasons of coquetry or for stylistic effect), it describes, for example, a whole bar scene, with the pianist in the background, a disorientated bourgeois couple and details of the interior. The album ends with a joyously disordered series of fantastical visions, in a spirit that might be thought

4 Saturday 12 August, to be precise. See Billy Klüver, *Un jour avec Picasso: le 12 août 1916*, Paris, Hazan, 1994.

5 Thirty years later, on 8 April 1947, Cocteau wrote to Picasso from Milly, "I am looking at the portrait of me that you drew in Rome on Easter Sunday 1917 and I'm writing to tell you that I think of you every day and every minute" (Archives du Musée Picasso, Paris).

6 See on these matters Rosalind Krauss's remarkable 'Picasso, Pastiche', in *The Picasso Papers*, London, Thames and Hudson, 1998.

7 In *Dessins* (1923) there is a "pastiche of a pastiche" – a grotesque parody of Picasso's ballerinas, a group of five cancan dancers. The foreground shows, not the graceful Olga, but an unknown lady of mature years doing the splits.

8 Jean Cocteau, letter to Picasso, Archives du Musée Picasso, Paris (APCS 1198).

surrealist, a kind of poetic automatic drawing, full of quotations (fragments of school imagery, postcards)[9] and collages of dreams of the 'exquisite corpse' variety. From time to time Cocteau brings himself into this disparate world, in the form of a few self-portraits, or symbolic, self-referential drawings such as the (artist's) hand drawing a foot or the (writer's) hand within a hand on the same sheet of paper.

But whether his references are expressionist or surrealist, Cocteau the graphic artist never manages to be dangerous, nor even truly disturbing. There is strangeness, certainly, but no unease, causticity rather than cruelty; the theatre he depicts always remains gracious, as though powdered with icing sugar. These drawings, all of which clearly tell stories, are accompanied by laconic, often witty captions. However, the frustrated reader-observer (*Dessins* is a book) would like to know much more about the sources and hidden keys. Twelve years later, whether by chance or design, the publication of the delicious *Portraits-Souvenir* lives up to precisely this twofold expectation, with written memories to satisfy the reader's nostalgia and drawn portraits to be looked at. "The man who looks back" invents the retrospective sketch, the album of a return journey to youth – he is then no older than forty-six, the ideal age to play at Orpheus. Each sequence describing his *belle époque* has a commentary of casual drawings, like life-drawings of memories. Not unrelated to the early caricatures, these vignettes with their studied carelessness are flashbacks to a Paris Cocteau shared with Proust and Paul Morand.

"One had to reflect", said Cocteau, "like those mirrors that do not reflect, to take mirrors out of one's pocket and hastily put them back again, blindly carrying away the imprint of the boxer on the canvas of the boxing ring, the reflection of a smile in the frame of a glass, drawing a pencilled outline round the shadow of a profile on the wall [...]".[10] It is the sensation of speed, of fragmentation, the syncopated rhythm of the serial and the lightness of the draughtsman's tools that matter here. All contribute to restoring the hop and skip of memories projected in fast motion, in disorder.

Tracing / repetition / recovery

The motif of going back to something, so central in Cocteau's work, has more than symbolic value. In drawing he used one of the most elementary of tools, transparent tracing paper, which he began using professionally very early, with his first drawings published in magazines. For Cocteau going back to a drawing almost always meant doing it again "identically" – either quite simply to perfect it, or to re-work it and give it new life, or to reproduce it with tiny variations and give it a kind of ubiquity.

One example of this procedure is the curious genetic manipulation that transformed 'Eugènes' into 'Boches' and *vice versa*, via borrowings from the cubist vocabulary, during the war (in 1914–15).

The many studies for the journal *Le Mot*, and the definitive versions of the caricatures published in it, include improvisations on the theme of the proliferation of a malevolent breed (the 'Eugènes'), linked to the development of *Le Potomak*, are the young Cocteau's first real exercises in style. It was in a language which borrowed its more or less geometrical signs (arcs, broken lines, sharp angles) from cubism that Cocteau described the monsters he had invented, the long-toothed Eugènes who devoured Mortimers. They were easily transformed into Boches; all it took was the addition of a point to their oblong skulls, which opportunely prefigured the shape of a helmet. In perfecting the "Eugènes of war" (in the series known as *Atrocités* [Atrocities] published in *Le Mot* in 1915), Cocteau had already become a master of tracing, launching one of the leitmotifs of his practice as a graphic artist, in the form of the closed loop and repetition. Opposing the 'Eugènes', who are all angles and teeth, we can observe the appearance, in both *Le Mot* and *Le Potomak*, of the terrifying 'Gossips' ("sniffers"

9 As an example, I have found one of these kitsch postcards, retouched with colours, showing women shrimpers dressed in the fashion of 1900 and frolicking on the rocks. It was sent to Picasso from Le Piquey on 21 September 1921, with the following comment, "A fine card. I should be happy if you based a painting on it [...]" (Archives du Musée Picasso, Paris, APCS 1192). But in fact it was Cocteau who made use of it for at least two of the drawings in his album *Dessins*.

10 J. Cocteau, quoted by Pierre Georgel in his preface to the new edition of *Portraits-Souvenir: 1900–1914*, suivi de *Articles de Paris*, Paris, Le Livre de Poche (*Pluriel*), 1977, p. 27.

and other bloodthirsty shrews), all wearing curly wigs – of whom Marge Simpson might be a contemporary descendant. We shall return to these curls, drawn here as huge crossings-out.

Of course this system of winding a thread into a ball, losing the 'original' in a proliferation of successive versions which cannot be properly classified or dated, is not peculiar to Cocteau. It was also connected to the fact that he was drawing for publication, that his drawings were fundamentally designed to be reproduced. But paradoxically his intensive use of tracing paper played a large part in rendering more opaque (or dulling?) his own image as an excessively prolific graphic artist. One need only look at the series of drawings re-made in the 1950s from his original illustrations for *Thomas l'imposteur* (1923) or *Les Enfants terribles* (1929). The second series, using different materials (such as felt-tip pen or ball-point pen), inevitably appears weaker, or is at any rate less trenchant than the 'original', known primarily in the form of reproductions. Cocteau seems to have enjoyed this endless play of mirrors, and did not try to ring the changes.

In this light his use of the metaphor of the rubber[11] (of the Elephant brand) to stigmatize "habit", the disenchantment of repetition and the resulting void of oblivion, seems paradoxical. One might think this a true metaphor of an artist who draws in pencil. In fact we have to ask ourselves whether Cocteau ever used such a rubber. He preferred repetition to rubbing out and his drawings almost never show any signs of erasure, those greyish pentimenti that indicate time spent doing something again on the same piece of paper. What matters to him is the freshness of the first draft – reproduced where necessary by tracing – the appearance of a line so quick and thin that it barely breaks the transparency of the white paper.

Cocteau refined his use of tracing in two of his most important works of graphic poetry. The series *Le Mystère de Jean l'oiseleur* [The mystery of Jean the bird-catcher], drawn in 1924, is a spidery construction on the theme of the self-portrait, here repeated over thirty times. By this time he had already drawn himself and repeated himself on many occasions, as his narcissism demanded. At times this self-portraiture took the form of caricature, elsewhere he "absented" his face, surrounded by hair with an eminently recognizable outline[12] (series of 1916–17). In *L'Oiseleur* the outlines of the thirty or so drawings seem to be superimposed, but do not merge. What keeps them distinct is not so much the quality of the line itself, as the thread of the writing, which runs here and there, in loose or tight curls around the face (which is always essentially the same), and thus plays a decisive role. Things are slightly different in the remarkable *Vingt-Cinq dessins d'un dormeur* [Twenty-five drawings of a sleeping man] (1929), which are full of motifs of alternation (or inversion): sleep and wakefulness (the same drawing traced in an exact copy, one with eyes open, the other with eyes closed, or the same face several times with one eye open and one eye closed); full face and profile; bare neck and sailor-suit collar; a hand shown and hidden. All is organized around the obsessively repeated "portrait" of Cocteau's young lover of the time, Jean Desbordes.

In this series of variations on the theme of a boy in the pose of an odalisque, Jean Cocteau paradoxically intersects with certain motifs used by Matisse (and Picasso) in the 1930s. But the figure of the beautiful sleeping man – not only Jean Desbordes but also Radiguet, Marcel Khill and Cocteau himself photographed by Berenice Abbott – haunts his oeuvre, and not just because of its Proustian and sensual implications. Sleep is certainly a 'little death', but it is also the sleep of the angels;[13] it is the two-way mirror that protects the sleeper's invisibility while making him transparent to his own dreams; it is the half-sleep of the opium addict; it is the Elephant eraser of pain.

Andy Warhol may possibly have been interested in this kind of drawing. In the years 1955–57 Warhol was using a blotted-line technique to transfer fragile profiles of beautiful young men, often enhanced with gold leaf. Warhol used ball-point pen (hence the equal and particularly fluid line) to produce another, equally Cocteauesque series of portraits of young men, including James Dean and Truman Capote, and other, more intimate portraits of

11 *"Gomme 'Éléphant'"* is the title of one of the *Articles de Paris* published from March 1937 to June 1938 in the newspaper *Ce Soir*. It ends with the following words: "Kill habit. Learn to look, to hear. Don't accept in advance the 'Elephant' rubber that erases everything and prevents you from living" (re-issued with *Portraits-Souvenir*, *op. cit.*, p. 329).

12 This hair was given its own portrait in *La Difficulté d'être* (1947): "My hair, in losing its thickness, has kept its rebellion. The result is a sheaf of locks that contradict each other and cannot be combed. When flattened, they make me look pathetic. When they stand up, such a dishevelled style seems to be the mark of an affectation" (« De mon physique », in *Romans, poésies, poésie critique, théâtre, cinéma, op. cit*, p. 873).

13 See the text written and spoken by Cocteau for the film *La Légende de Sainte Ursule* (1948), directed by Luciano Emmer, about a sleeping girl who is visited by an angel and has a premonitory dream, as she was painted by Carpaccio: "Sleepers are swimmers who have neither top nor bottom. They move away from us, motionless, and so fast that they beat the speed of the blind fish of the deep seas [...]" (« Les mots du film », encart joint, *Zeuxis*, n° 9, December 2002).

models naked or sleeping. We might also mention the pencil portraits (from photographs) of Ginger Rogers, Hedy Lamar and Joan Crawford (1962), or the silkscreen print of 1965 showing the same young sleeper twice, entitled *Large Sleep*.[14]

Divisible / indivisible / twins / excrescences and symmetries

There is no need to recall the importance of the motif of the twin and the double in Cocteau's writings, notably in the type of the couple formed by a brother and sister, two complementary and inseparable figures of beauty. This motif becomes dominant with *Le Grand Écart* in 1922, inaugurated by the slightly grotesque appearance of Tigrane d'Ybreo and his sister Idgi.[15] A few pages later this first couple, with their improbable given names, multiply, as in a play of mirrors: "Germaine had a rich lover, so rich that his name alone signified wealth. He was called Nestor Osiris, like a box of cigarettes. His brother Lazare was keeping Loute, Germaine's younger sister."[16] Embodied with far greater power and intensified to the point of incandescence, the same symmetrical motif lies at the heart of the magnificent tragedy that is *Les Enfants terribles* (1929). In the mythified space of the bedroom the "twin" figures of Paul and Elizabeth confront each other, doubled by their sidekicks Gérard and Agathe – the latter also the double of the schoolboy Dargelos, who first unleashed all Cocteau's myths – "The family resemblance of the faces in the bedroom was a fact".[17] We could find many more examples of this "logic of splitting"[18] or doubling at work in almost every domain in which Cocteau was involved.

"The family resemblance" affects not only the characters in the novels or the heroes of the films, but also a sizeable proportion of the drawings. It is certainly present in all those drawings that refer to the founding myth of a fused being (of Paul and Élizabeth Cocteau said, "They live like two souls in a single shell")[19] formed of two figures side by side who cannot be separated other than by cutting into their living flesh. In *Maison de santé* [Nursing home] (1926), several illustrations explore precisely this theme of surgical separation – although the drawings are done in such a clear, clean line that they seem to contradict the gory cruelty that such an operation implies. The whole series of *Maison de santé* is thus full of double heads with bandages (a memory of Apollinaire and his famous wound),[20] of silhouettes bristling with pins, crutches and other aids to the wounded. Sometimes the lines even become electrodes, or trace the trembling outline of a huddled creature shouting (literally, the words are written), "It hurts!"

Though drawn in similar circumstances (a rehabilitation programme, a second attempt to escape opium, on which Cocteau had become dependent after Radiguet's death), the forty drawings that accompany *Opium* (1928–29) prove to be quite different. Before Michaux and his mescaline-influenced drawings, and in a manner less systematic and certainly more artificially revised and corrected, Cocteau provides "graphic equivalents of the modifications of perception brought about by opium"[21] or by withdrawal from it, in particular because "the smoker is of a piece with the objects around him. His cigarette, a finger, fall from his hand."[22] The hybrid figures that spring from his pen are characterized by the incorporation of foreign elements, distortions and threats of dislocation. Others are constructed from rolled shapes, cones or tubes reminiscent of the opium pipe. In this strange Meccano – returning as a leitmotif in *Opium* – elements may contain each other, or be unpacked, to infinity, following a principle of automatic proliferation.

Another, more literal series of hybrids emerges in 1936, during a summer spent at Jean Hugo's farmhouse in Fourques. These are the "mandrakes", root-like forms in which the human (hand) combines with the animal (lizards and horses). Their strong sexual connotations are accentuated by an approach to drawing that is exceptional in Cocteau's graphic work. Far from being transparent, these drawings are marked by the weight of clearly indicated shadows, creating a sense of volume.

14 On this series of drawings see the catalogue *Andy Warhol, A Retrospective*, exhib. cat., ed. Kynaston McShine, New York, The Museum of Modern Art, 1989, and notably the text by Marco Livingstone.

15 J. Cocteau, *Le Grand Écart*, in *Romans, poésies, poésie critique, théâtre, cinéma, op. cit*, p. 31.

16 *Ibid.*, p. 42.

17 J. Cocteau, *Les Enfants terribles*, in *Romans, poésies, poésie critique, théâtre, cinéma, op. cit.*, p. 149.

18 See in this catalogue p. 66, observations by Francis Ramirez and Christian Rolot: "In Cocteau's work the motif, whether narrative, dramatic or graphic, is always liable to undergo a kind of parthenogenesis. It splits, divides and gives birth to another that is at once the same and different." In relation to *La Belle et la Bête* they highlight the "logic of splitting" and introduce the notion of a "nest of identities".

19 *Jean Cocteau: Entretiens avec André Fraigneau* [1951], Paris, U.G.E.(*Bibliothèque 10/18*), 1965, p. 77.

20 Cocteau described the wounded Apollinaire as follows: "A device made of bandages and leather gave him a kind of turban or small helmet. You might have thought this little helmet was hiding a microphone, by which mediation he heard what other people cannot hear and secretly monitored an exquisite world. He transcribed its messages" (« De Guillaume Apollinaire », *La Difficulté d'être* [1947], in *Romans, poésies, poésie critique, théâtre, cinéma, op. cit,*, p. 934).

21 Pierre Chanel, « Mille traits de poésie », *Le Magazine littéraire*, October 1983.

22 J. Cocteau, *Opium*, in *Romans, poésies, poésie critique, théâtre, cinéma, op. cit*, p. 613.

Curls and rolls: Jean Cocteau's closed Antiquity

Some of the tube drawings of *Opium* link the two themes of opium pipes (the main subject of the book) and Antiquity. This is a reinvented Greece, cruelly or amusingly dismantled, its great store of myths reassembled using the theatrical, musical, novelistic and ultimately cinematographic means to which Cocteau ceaselessly devoted himself after *Opéra* (1925–27), to such an extent that Jean Genet described him as "Greek!".[23]

The eight lines of *"La Toison d'or"* [The Golden Fleece], a poem published in *Opéra* (it follows *"Eurydice"* and *"Oedipe Roi"* [Oedipus rex]), condenses if not all of Cocteau's Greece, at least all its elements as a setting for plays and drawings. *"Bouclée, bouclée l'Antiquité. Plate et roulée, l'éternité. Plate, bouclée et cannelée, j'imagine l'Antiquité. Haute du nez, bouclée du pied. Plissée de la tête aux pieds. Plate et roulée, l'éternité. Plate, bouclée, l'Antiquité. Plate, bouclée et annelée ; annelée et cannelée. Ailée, moulée, moutonnée. La rose mouillée, festonnée, boutonnée et déboutonnée. La mer sculptée et contournée. La colonne aux cheveux frisés. Antiquité bouclée, bouclée: jeunesse de l'éternité!."*[24] [Tightly curled Antiquity. Flat, rolled eternity. Flat, tightly curled and fluted, I imagine Antiquity. High of nose, curled of foot. Folded from head to foot. Flat, rolled eternity. Flat, curled Antiquity. Flat, curled and annulated; annulated and fluted. Winged, moulded, woolly. The wet rose, festooned, buttoned and unbuttoned. The sea sculpted and skirted. Curly-haired column. Close, close curls of Antiquity: youth of eternity!]

This praise of curls is reflected over and over in graphic form throughout Cocteau's oeuvre. Besides the masked figures in tunics of *Opium*, mentioned above, there are drawings and virtuoso calligraphic ornamentations in a "continuous line" (in *Portraits-Souvenir* for example), reminiscent of similar little arabesque drawings by Picasso in the years 1918–20; there is the curly hair of angels and fauns and even the wigs and flowing blood, drawn as scribbled deletions or as entwined balls of endless thread (the drawing *Par la bouche de sa blessure* [Through the mouth of his wound] dated 1928 in *Opium*).

On the subject of curls, and to end on a note of revelatory associations, here is another anecdote taken from Cocteau's golden legend of Picasso: "Watch your handwriting, close up your letters, join them up, don't write a t that could be a d. The height of inelegance is to have an illegible signature.

"One day I was writing an address at Picasso's, he looked at me and said, with a special smile, 'Oh, you too?' I was in the process of joining up the letters of the name I had just written. Picasso knows everything; naturally he knew that too."[25]

Joining letters with loops, is that still writing or already drawing? By tying and untying threads we come back to our starting point and that eminently Cocteauesque aphorism, "What is a line? It is life". A little later he explains, "This writing face being ultimately my true face. The other, a shadow that fades. Quick, let me build my lines of ink to replace those that are departing."[26]

Together Cocteau's multitude of drawings form one vast face, a self-portrait.

23 Jean Genet, [article in] *Empreintes* (Bruxelles), n° 7-8, « spécial Jean Cocteau », May/ June/ July 1950, p. 23.

24 J. Cocteau, *Opéra*, in *Romans, poésies, poésie critique, théâtre, cinéma, op. cit*, p. 330.

25 Id., *Opium*, in *Romans, poésies, poésie critique, théâtre, cinéma, op. cit*, p. 670.

26 Id., *La Difficulté d'être* [1947], in *Romans, poésies, poésie critique, théâtre, cinéma, op. cit*, pp. 963 (« De la ligne ») et 966 (« D'un mimodrame »).

The ghosts of Villefranche

In the summer of 1950 James Lord[1] and I rented a small flat in Villefranche-sur-mer, where we naively thought we could relive the great 1920s. The young are often radical; they either scorn the preceding generation or they mythify it. We had opted for admiration, and this vicarious pilgrimage was a kind of magical act. The famous guests were long gone from the Hôtel Welcome, but its decor was still there. The Midi's deceptive somnolence and the fact that so much had remained in place – the quay with its bistrots, the Rue Obscure, the citadel and the sheltered moorings of the *darse* – allowed us to play games with memories. When the warships came into port we were even treated to the usual quarrels between sailors. One of these, half-drunk in the traditional way, got himself ejected from a café and, in front of the watching crowd, threatened the owner with the Shakespearean phrase, "Do you want to see a French funeral?"

But missing, of course, was the man who had used the charm of words to transform a sleepy little port into a playground for the chosen few. With fishermen as their audience, Jean Cocteau's friends and disciples had sought to spend their days in an atmosphere of passion and intimacy, in keeping with the poet's teachings. Yet their endless round of opium, intrigues and love affairs did not stop Cocteau regarding Villefranche as a working retreat. It was here, he told André Fraigneau twenty-five years later, "that I at last found my personal mythology [...] and this hotel [the Welcome] became a meeting place not just for people who loved each other, but for a great many new ideas".

During the 1930s Cocteau was drawn to other places and other attachments and seldom went to Villefranche, yet the place remained the symbol of his life. Indeed he used it in his last film, *Le Testament d'Orphée*, where we see him wandering the Rue Obscure like a man suffering hallucinations, a pathetic, ambiguous figure, meeting his double and hearing his companion Cégeste address him with the marvellous words that cruelly sum up his life, "You spend your time making a great effort to be, that's what keeps you from living".

After the Second World War Picasso, the great master, seemed to have left Paris for good and reigned over Vallauris from La Galloise, a villa in the suburbs. In a Midi devoted to journalism every eye was upon him. As Villefranche was only thirty kilometres away, James Lord and I would go over fairly often to venerate the great man. At the Liberation James had been 'his' American, in memory perhaps of the 'lost generation' whom Gertrude Stein had led to him after 1918. Picasso was immediately drawn to the carefree ingenuity of this shameless young admirer who had pushed his way in, and James instinctively understood that the artist found his behaviour amusing. It was a refreshing change from the servility of his usual courtiers. For James, Picasso was undoubtedly a painter of genius but, as the days went by, he had also become a conjuror, pulling out of his pocket some scrap of paper napkin covered in sketches that he had made over lunch. Theirs was a cat-and-mouse friendship which, beneath a gruff exterior, was often a source of little gifts: sometimes the mouse ended up getting a drawing from the cat.

"As you're in Villefranche", said Picasso one day, "go and see Jean Cocteau for me. He's living in a friend's house at Cap-Ferrat. Yes, yes, it will be an interesting thing for young people to see" But the parting shot was already coming: "That way you'll save yourselves some money. You won't have to buy his next book. He'll have tried out all his effects on you in conversation."

1 An American writer living in France, the author of biographies and memoirs on Giacometti, Picasso, Gertrude Stein and others.

Of all names, that of Picasso was by far the most revered by Jean Cocteau. It was the name of the supreme combatant. I immediately understood what an extraordinary opportunity we were being given. This apparent snub from Picasso had opened our way directly to something I would never have dared hope for, a meeting with the writer who had stripped the scales from my eyes at the age of fourteen. I had opened *Thomas l'imposteur* by chance and, thinking I understood nothing, closed the book having understood everything.

Like the phoenix he so loved to evoke, Jean Cocteau has passed through so many false deaths and resurrections that he springs up where you least expect him. No matter which discipline he turned to, he knew very well that he would leave his mark on the most hackneyed subjects. His influence may not have been explicit, but it resounded like an echo that even the most rebellious ear could not escape. Intoxication turned to irritation. In my youth we were still living with his commands, his expressions, his mythologies. Angels and mirrors belonged to him, as did Death itself. The imaginations of cohorts of adolescents were struck by the "bedrooms of murder", "the lies that speak the truth" and "the styles of the soul". All had dreamed of drinking "the good soup of robbers".

There is nothing more consistent than the work of Jean Cocteau. He can be identified at every turn, whether he is writing, mounting the boards or drawing a profile. This may be either good or bad. However, very early on his enemies accused him of spreading himself too thin because they sensed that this mobility was a grace from heaven of which they themselves had been deprived. This privilege of ubiquity had to be got up to look like reprehensible flightiness, the caprice of a man who must put a finger in every pie. Serious work, of course, required one never to leave the gloom of one's study.

Cocteau's last metamorphosis, the cinema, once again gave the lie to the disturbing rumour. He had won the respect of the greatest of the film critics, André Bazin, and, more astounding still, that of fierce young men such as Truffaut and Godard. On screen *Les Parents terribles*, which his enemies regarded as the height of calculated bawdiness, became a model of inventiveness and cinematographic rigour for the new generations who, sometimes unjustly, scorned what was then known as its "French quality" (*la qualité française*).

As it turned out James and I did not have to disturb Cocteau in order to meet him. One afternoon we saw three people unconcerned walking towards us in the distance, apparently coming into Villefranche to shop. I instantly recognized Cocteau. He was with a frail-looking, elegant young woman and a good-looking boy with a solid, peaceable air. I realised these two were Francine Weisweiller and Edouard Dermit.

"Let's speak to him. Now's our chance!" I said to James with some agitation.

However, James, whom the poet's image left fairly cold, seemed unwilling. I took my courage in both hands. Grand introductions aside, I knew that the author of *Les Enfants terribles* was always pleased to be spoken to by young people. It was even part of his ethics. And I was at an age when, though feeling at a loss when faced with illustrious elders, one secretly preserves an inner awareness of the unstoppable advantage of youth.

In the event Cocteau was charming. When the great painter's name was uttered the effect was instantaneous. We were at once invited to Cap-Ferrat for a drink the following day. Thanks to the delicacy of his hostess, who at that time was doing all she could to please him (a temporary visit was gradually to turn into a stay of more than ten years), Jean Cocteau was allowing his ship to founder gently on the banks of wealth. There had been so many peregrinations and storms. In this respect too his reputation was undeserved. Having profited from the capabilities of the de Noailles (*Le Sang d'un poète*) and a few others, he had nevertheless distanced himself from the wealthy lifestyle since reaching maturity. We need only recall how he moved from small two-roomed apartments to hotel rooms, to an entire winter spent in Switzerland on a bed in Mme Markévitch's drawing-room, to the rat-holes of Toulon.

So the next day we were welcomed at Villa Santo Sospir in the late afternoon. The atmosphere was good-natured and cheery. The airy simplicity of the drawing-room, with its wicker furniture, bore no resemblance to the salons you see in bad films, where the Riviera's *nou-*

veaux riches go about their affairs surrounded by stucco. With youthful glee, Jean Cocteau was quick to show us the frescos with which, as he put it, he was "tattooing" his new friend's house. In particular, up the ceiling of a fairly narrow stairway, he had painted a figure stretching and falling, with peculiar, striking insistence. It would be possible to see a secret kinship between this desire for controlled disorder and the subtly lame prosody of *Clair-Obscur*, the collection from the same years.

Cocteau's attitude to Edouard Dermit was a model of affectionate attentions and precautions. One day during that summer I heard him rescuing "Master Doudou" (as he sometimes called him) from his naiveté with journalists: "You see, these ladies are asking Doudou what he likes to read. So to poke fun at them he replies, 'Cartoons'. The idiots took him seriously, of course. That's today's journalism for you!"

Initially, Cocteau's conversation lived up to his legend. We know that he often cited Baudelaire on Victor Hugo: "He then began a monologue which he called conversation". Aside from the famous pentimenti, where he suddenly stopped himself the better to draw you back in – "What? What did you say?" – he was capable of giving exaggerated importance to some phrase you had thrown out at random, giving it special status in a vast, kindly trick to imply that he, too, was listening to you.

The attraction lay first in his voice. At once warm and nasal, it was the voice of a schoolmaster seeking to establish a cosy complicity. Unexpected, sometimes staggering effects would emerge from a complex jigsaw-puzzle of ideas and images, incongruous points of view, shifting references and allusions to the past, all raining down at once. Yet beneath the mask of gravity or humour, and often indirectly, sometimes even very distantly, he would always return to a veiled self-defence. The wounds inflicted by others had never healed over. One felt that he was in the grip of an obsession beyond his control. Like the Delphic oracle, he was always having to rid himself of thoughts that regularly took him over. He had to justify himself, put on an instant parade, paper over the cracks – and only the intoxication of words could calm his anxieties. Hence his seamless repetition of the same fateful themes for weeks on end. Infinitely reprised before a charmed, but sometimes surprised audience, the obsession would eventually fade, exhausted by words.

At the time I was too young to grasp the moving aspect of this struggle. I saw it simply as an indulgent pleasure in repeating oneself. Besides Cocteau did not help others to understand him; for his agility, his poetic inventiveness and comic gifts, all his qualities in fact, undermined the seriousness of the tragedy in which he had lived his life. But his clumsy efforts at last to gain the esteem of his peers often caused him to fall into inexplicable pathos, with the rhetoric of "nobility" and "purity" to which any visitor at that time would be treated.

Perhaps this man haunted by Greek tragedy had discovered that, like his heroes, he was a prisoner of the character he had been given. His unfortunate appeals and overly transparent justifications fixed him ever more firmly in a bad role. The worst role of all is to try to be like the people you want to convince.

In press photographs this face all in angles – a perfect model for the cubists – sometimes shows a hunted expression, cruelly emphasized by the flash.

Over the following weeks we went back several times to bathe and eat at Santo Sospir. Jean Cocteau was extremely kind and Francine Weisweiller graciously went along with him. The woman who "thought with her heart" (dedication of *Bacchus*) had found the three best reasons to make her life more busy: having the most diverting of great men all to herself, bathing in a new social glory as a result and sharing the affection of the poet's companion. We should also not forget that this happy trio were gently floating on the wings of an artificial paradise

With the instinct of an old campaigner, Jean Cocteau had sensed that the inoffensive newcomers that we were might be useful to him in his razor-sharp relations with Picasso. Despite the obstinate hostility of the surrealists, his companion in *Parade* had always retained a slightly paternal affection for Cocteau and his boundless devotion. Cynicism had not made him forget how much he owed this man in terms of social success. His Andalusian peasant

side, which he exploited so well, had felt a certain admiration for the savoir-faire of the bour-geois young Cocteau and for the poetic ingenuity with which this spokesman had proclaimed his genius as a painter in every corner of Paris.

But for years now the title of 'poet laureate' had been held by Paul Eluard and the ties between Eluard and Picasso had been further strengthened when the latter joined the Communist party. It was plain for all to observe: since he had arrived in the Midi, Cocteau had not seen Picasso. Yet he went on worshipping at the artist's altar, never forgot to sprin-kle the name that obsessed him through everything he wrote, always citing Picasso as an example, the ultimate reference in every field, from aesthetics to morality.

Gradually we realised that our role as modest go-betweens and messengers was allowing a spark to pass between Santo Sospir and La Galloise, enabling a friendship to re-establish itself at a distance, though everything was still at the stage of vague promise. However, after a few weeks, without anything having really been made explicit, Jean Cocteau came with us one morning to Vallauris in the English car Mme Weisweiller had kindly lent to him. Picasso was very welcoming to the author of *L'Ode à Picasso*. The presence of Françoise Gilot and chil-dren gave the meeting a family atmosphere. And how could Picasso have given a harsh recep-tion to an old friend who arrived with an arsenal of humour, inventiveness and memories?

After a while we went to the studio on the other side of Vallauris, accompanied by a Scandinavian photographer who had suddenly appeared out of nowhere. Depending on his mood Picasso loved either to pet or to torture such snoopers, some of whom went so far as to try and make off with an item from the bric-à-brac in the studio. This time, to the aston-ishment of all, the stranger seized a large, beautiful drawing lying on a table and, outright, asked Picasso to sign and give it to him. Picasso at once graciously agreed. No doubt it never entered this northern barbarian's head that he owed his extraordinary gift to the presence of Jean Cocteau.

For Picasso's mood had changed during the course of the visit. There, at his side as he showed us his most recent works, was this wonderful talker, deploying his paradoxes and mak-ing ingenious, brilliant comments on the pictures, and such a well brought-up person, too. Without having planned it, Picasso took advantage of this opportunity to strike a double blow. Immediately after he had given a valuable drawing to a stranger, he led Cocteau into the sculpture studio and there, digging around on a messy shelf, took out a broken piece of pot-tery, the neck of a vase that was vaguely reminiscent of the male genitalia. "Here, Jean", he said, "I have to give something to an old friend as well. You know how much I like making pottery at the moment."

Cocteau accepted the comical, worthless object with no more than polite enthusiasm. Throughout the rest of the interview he kept it in his hand, as though he had just picked it up off the ground. But in the car on the way back to Nice, where we were going to have lunch, the blow had clearly registered. He did not really try to get his own back, but I admired the artfulness with which he indirectly poked fun at Picasso and told stories in which the genius was always forgiven for having such a mean, dried-up personality. However, Cocteau's devotion to the artist he most sincerely, profoundly admired was too great for any lasting trace to remain. Later, after Eluard's death, he would be restored to his place by Picasso's side, sitting hieratically next to the great man at bullfights, with Francine Weisweiller and Jacqueline Roque thrown in for good measure.

Cocteau sometimes invited us to lunch in the prosperous restaurants of the Côte d'Azur, where sun and wine ultimately convince you that the food is exquisite. He always came alone and I think it was a welcome distraction for him to talk about himself to young men who were distantly reminiscent of those he had known thirty years before.

However, it was my very admiration for the author of *Plain-Chant* that prevented me from getting any closer to him. James Lord could be simple and natural because for him Cocteau, his work, his history and the legendary events of his life preserved by the faithful were no more than a flattering fog. Naively believing in 'genius' alone, he could behave with

the freedom of indifference in the presence of a writer whose most obvious merit to him was that he had once been a close friend of Picasso's.

The misunderstanding between Cocteau and myself came from a certain stiffness of youth. The more James opened up, playing along with Cocteau with an entirely clear conscience and an air of complete conviction, the more I appeared awkwardly reserved, in a way that was quite out of place. One day, out of a desire to please, I made things much worse. In an effort to prove that I knew not only his entire oeuvre but also the particularities of its context, I took a blind leap and asked him what he thought of Claude Mauriac's book, *Jean Cocteau ou la vérité du mensonge* [Jean Cocteau, or the truth of the lie]. "It's appalling", he replied blankly, turning his head away.

In my fascination with Cocteau the book's perfidious conclusions had passed me by. I had remembered only the phenomenon of his glory radiating in all directions. But later I understood that here again the betrayal of the younger Mauriac had hurt Cocteau. Given his egotism, it would have taken a simultaneous invasion by German troops at the very least to make him forget this further condemnation.

On several occasions Cocteau was particularly kind. In my fervour I had overspent at Matarosso, the great book-lover's bookshop in Nice, to buy a first edition of *L'Ange Heurtebise* with the "photograph of the Angel by Man Ray" as the frontispiece. In response to this youthful enthusiasm, Cocteau came to our three rooms overlooking the port and did a huge drawing across a double page of the book: the Angel flying over the bay of Villefranche. Of course people will say he was never mean with his pen, but he showed a natural generosity that went far beyond the need to please.

One memorable day that summer was the official unveiling of *L'Homme au mouton* [Man with sheep], Picasso's gift to the town of Vallauris, under the auspices of the French Communist Party. The Peace Movement was at its height. We were installed on a balcony overlooking the little square in Vallauris with the Cocteau trio, like a family. The atmosphere was that of a southern operetta played out on the barely concealed stage of politics. The officials were on a platform, but Picasso was sharing the starring role with Laurent Casanova, the 'French Jdanov', whose mission was to bring the Paris intelligentsia back into line. Jean Cocteau gave friendly little waves to Picasso and Eluard as they arrived. Charming, noisy girls were going to and fro, up and down, getting everyone to sign the famous Stockholm Appeal, which called for the banning of the atomic bomb until the Russians had it. This cohort of progressive young ladies had not yet turned their attentions to us and I was wondering rather anxiously what our welcoming poet would do when faced with their assault. I feared the worst. But when they started on him with cries of "Oh M. Cocteau, do be nice, please make us happy and sign, you'll see, it's for world peace!" despite his unswerving love for Picasso and the evident consensus of all around, he had the strength to resist, escaping with a worthy pirouette: "As you very well know, my dear children, I never sign anything, I've never signed anything in my life."

Back in Paris I saw Cocteau every now and then. I had the pleasure of visiting his famous *pied-à-terre* in Rue Montpensier, with its Bérard-style red walls, which saw a procession of devotees, friends and enemies, all hanging on the watchwords of the day, issued in a small room twelve metres square. As he uttered them Cocteau was sometimes mocking, sometimes indignant, but almost always inspired.

One fine October day we went to have lunch at Milly-la-forêt in the company of Lise Deharme, formerly a great friend of the surrealists, and the object of André Breton's unrequited passion. Cocteau was pleased that this muse to the opposition had bowed to "Jean"'s charm and could now be chalked up on his tally of friendships. They had seen each other a great deal during the Occupation, when Lise had given dinners that enabled Cocteau to meet "right-thinking people". At the time of the Liberation he maliciously nicknamed her "the Queen of the Resistance". Cocteau was amused by the style of this seductress "with the heliotrope voice" as he put it, who managed to be at once intense and twee. On that morning at Milly, though,

Jean Cocteau, Francine
Weisweiller and Bernard Minoret
in front of *L'Homme au mouton*
[Man with sheep] by Picasso in
Vallauris, July 1950

he greeted us with news of the death of Misia Sert. Perhaps the sudden disappearance of this close, life-long friend had erased his memory of her acts of meanness, her instinct of a predator scenting blood; she would use a hatchet to pass judgement on Cocteau, giving a nod to the 'greats', Picasso, Diaghilev or Claudel. It was hard to know what Cocteau felt that day. Before the meal he showed us round the whole house and we discovered a bizarrely ordered world. All that could serve as memory to a life in movement was there, but classified, arranged and enclosed. Where was the man who had lost or sold so many things, who had had more stolen than anyone else? Madeleine Castaing's decoration, a mix of fake simplicity and furnishings too luxurious for the country, gave the impression that the house had been arranged for Cocteau, and not according to what he himself was. Yet, for a man on the verge of old age, there was undoubtedly something calming in the contemplation of fragments of his life, miraculously preserved and arranged in a way that made them sacrosanct.

In the years that followed I saw Cocteau only rarely. I have a memory of a party held at the home of Marie-Laure de Noailles, whose love-hate relationship with Cocteau had lasted thirty years, where I was surprised to meet him, since he never came to see her. He was not wearing a costume but, in deference to the rules of the genre, had placed the odd little hat of a tipsy party-goer on his head. My last great image of Cocteau dates from the evening of the dress rehearsal of *Bacchus* at the Théâtre Marigny, or more precisely of the supper that followed it, given at the Place des États-Unis by Mme Weisweiller. The play had met with a cool reception. It was not one of Cocteau's masterworks, but it did not deserve François Mauriac's bigoted reaction to it – which, moreover, Cocteau would try to use to save his play. At Mme Weisweiller's everything had been prepared for an evening of triumphant success, but, to my enormous surprise, the beauty of the surroundings, the organization of the supper, the orchestra playing Bach and, above all, the complicity of all the guests created an atmosphere in which there was no perceptible difference between success and failure. Only Jean Cocteau, putting on a brave face for the gallery, must have been truly in pain, and already preparing the parade with which he would once again have to justify himself.

To the Belle Epoque
Most affectionately

Halte pélérin mon voyage
Allait de danger en danger
Il est juste qu'on m'envisage
Après m'avoir dévisagé
[Halt pilgrim my journey
Was moving from one danger to the next
It is right that my face should be called up
After being stared down]
Jean Cocteau, *Requiem*

Requiem was published in 1962. It is very long for a French poem and Cocteau's longest, at over four thousand lines. It is also a great poem. The 1960s were rich in fine poems, such as *"Je me souviens ..."* from Louis Aragon's *Le Fou d'Elsa* [Elsa's Madman], André Frénaud's *Il n'y a pas de paradis*, René Char's *La Parole en archipel*, Pierre-Jean Jouve's *Moires* and Henri Michaux's *Vents et poussières*. Meanwhile Saint-John Perse, Ponge, Guillevic and Jabès were also on fine form. Perhaps the figure of Jean Cocteau, born ten years before Mallarmé's death, was fading into the past.

If Chronos could die, it might be said that the century was looking old. At any rate Jean Cocteau was seventy-three. The angel's wings had turned white; a year later they would cease to beat.

I was in my thirties, a member of the Gallimard editorial committee. I think I remember that we were both individually and collectively aware of this publication, but that it did not constitute an event in the cultural or social spheres to which it related. Why not? It is this that I shall now try to understand.

Time is a factor here. If, forty years later, at the age Cocteau was then, I am now wondering how poetry passes on its witness, it is because I am disturbed by this issue of relaying described as "from one generation to the next".

The academic takes almost no interest in Cocteau – though he was an academician, but of course that is not the same. I have not consulted the Internet, but I have spent enough time in universities to guess that there are not many courses, theses or any other kind of work devoted to the oeuvre of Jean Cocteau. The same is generally true of the official sphere as a whole, in the broad sense of offices and honours and the entire 'recognition' apparatus – aside from this commemoration, in which I have joined and which has provided a counterweight to the void I have just described. It is true that his surname does not easily adapt to the adjectival form: 'cocteauesque' does not roll off the tongue, and this matters.

In 2002 Gallimard's prestigious series *La Bibliothèque de la Pléiade* devoted a volume of 1642 pages to an *Anthologie de la poésie française: XVIIIᵉ siècle, XIXᵉ siècle, XXᵉ siècle* [Anthology of French poetry: 18th century, 19th century, 20th century]. Cocteau's publisher does not leave him out: he is given pages 959 and 960, plus sixteen lines on page 961. Five lines on Cocteau are found in the notes on page 1499, with another twenty or so on page 1500. It is true that in 1999 Cocteau's *Oeuvres poétiques complètes* [Complete poetic works] (1938

pages) had been published in the *Pléiade* as part of Gallimard's comprehensive programme of French literature. It was the 460th title of the *Pléiade*. My concern here is not whether French publishers should maintain the tradition of publishing a writer's entire oeuvre, but what sort of symptom or sign this is (certainly not, of course, to consider whether it is a 'reproach' to academics). Forty years after his death, in other words two generations after his glory, a poet's oeuvre has been abbreviated from two thousand pages (his complete works) to two (the roll of honour of French poetry).[1]

In quotation at the beginning of this article I have placed the epitaph with which Cocteau himself concluded his great testament. Now here is the one inscribed on his anthological tomb by its editor: "The great themes of the love lyric meet in these two consecutive poems, which are merely an extract from the long melopoeia of *Plain-Chant*, in which, in neo-classical lines, sensuality combines with the anxiety of loss".

With the help of the passing centuries, which poetic oeuvre could not be reduced to such a label on a bottle of elixir? "Neo-classical, sensuality, anxiety, loss", this is surely an epitaph for all of French poetry.

For poetry to be received today, a 'cultural' event is required. (I am speaking of the public life of poetry. Of course there are all kinds of exceptions, how could it be otherwise? There is no need to come crying, 'What about me?' In the secrecy of bedrooms and hearts there will undoubtedly always be people – numerous therefore countless – who read in the way Ambrose taught Augustine or the way that good students all down the centuries smuggle books out of libraries – for themselves, *more antiquorum*.) Let me rephrase my sentence: either the circumstance of school or that of a so-called 'cultural manifestation' is required. Of the former I have only one thing to say: if by some misfortune this form of memory were to disappear – a catastrophe of manners and government, but not impossible to imagine, since learning by heart has already succumbed – poetry would cease to exist in a few years, since it survives by being taught from school to university. (The same is true of music: everything depends on the Conservatoire.) Of the latter I shall say this: those whose hands touch a few books each year are no longer reading poetry. People no longer read poetry as they read ordinary books (novels). Do we set aside an hour, in the evening, on a train, do we turn the pages and, following the words line by line, as you would with a Goncourt winner – or an old Goncourt winner – read *Requiem* without skipping, with understanding and pleasure? We don't do that any more, not with Victor Hugo's *La Légende des siècles*, nor Racine's *Mithidrate*, nor du Bellay's *Les Antiquités*, nor *Requiem*. It is precisely for this reason that we (that entity called 'we') like, or say we like, recitals, festivals – the 'oralization' of poetry. It means we don't have to read. We go to such events as to the theatre (no one reads plays any more). Poetry has fallen outside the scope of reading and into festivals, into performance. ('A series of actors will carry out a round-the-clock relay-reading of the complete works of Victor Hugo at the Centre Pompidou', etc.) We no longer have the time to read. Opening our ears to the vociferations of the actor or author, we no longer need the text before our eyes. We do not re-read as we read. In other words we do not read, since reading involves being able to reread: in order to read I need to retain a close power over what I have just read, the lines and pages before, to be able to go back. If I can't go back I don't understand.

So what happens is an operation of recognition. We like to – and do – recognize poetry, the poetic text, by certain signs, by what is called 'gnosia'. 'Oh, it's poetry!' Sometimes I close my eyes to these signs, sometimes my ears. The exclamation does not change, but its tone does, sometimes beatific, sometimes disappointed. 'This evening we went to hear some poetry, we're happy.' It's even better when it's international; we know it's poetry, Tamil, Hungarian, Portuguese or Chinese. It's wonderful; we don't understand a word (at

1 One need only look through the many anthologies of twentieth-century French poetry to discover what the figure – today we would say the image – of Jean Cocteau has been reduced to.

any rate we don't speak those languages), but it's wonderful. In truth it's wonderful because we don't understand.

In the old days the signs (gnosia) included rhyme, caesuras, a little enjambement or *contre-rejet*, stichomachia and so on. Today it is the absence of rhyme, a general lack of iteration, puns, stochastic paronomasia, jumbled-up words (parataxis), degrammaticalization, an absence of narration, and other privations besides.

So in a way what Jean Cocteau was doing, in *Requiem* or *Plain-Chant*, is no longer received because it's no longer readable; it belongs to a very recent old world; transmission has broken down. There is no longer any possibility of pleasure – of pleasure in a long poem, with its sentences of a kind that would never be spoken, or cannot easily be recited, in which de-punctuation (or, at almost the same time, over-punctuation) marks an emergent state (*status nascendi*; "which bubbles and smokes", as Victor Hugo would say) – a de-punctuation which Cocteau, rather strangely, credited Emily Dickinson for first using.

There is anonymity in the twelve-syllable line that is the French alexandrine. I like the way the *Pléiade* anthology opens the French eighteenth century with an anonymous sonnet. It is surprising and interesting. In the same way we often preface a quotation with the words, 'as the poet says', or 'as the bard said', without giving the name, making the rumble of the twelve syllables (the "*rail*" as Michon called it) part of the great murmur of unattributed poetry. If I quote Cocteau to you 'at random', you will not be able to attribute the words to him.

This does not mean that we do not hear the voices of the great poets very clearly; it is precisely this that makes them exceptional, the principle of their identifiability: we recognize them at once in the crowd. For example, however old the alexandrine may be, however many hundreds of thousands of such vehicles (plus conventions) have been driving around for centuries, when those I am about to name 'borrowed' the 'dodeca', none of us had yet heard what they would make us hear. Their design, their melody and the song of their sense are all singularly and immediately recognizable: 'It's by' Hugo, Mallarmé, Rimbaud, Apollinaire, Péguy (who knew how to bore as Péguy did with an alexandrine?) or many others equally good. Yet this great anonymity I mention is precisely what Cocteau is recalling in relation to music when he slips the following words into the preface to *Requiem*: "There is something timeless in Bach's work which does not coincide, as in Mozart's, with the style of his period. This musical theory that leads to the theory of jazz has always influenced me in my work."

So there are two polarities that must be mentioned together, without snubbing or praising one more than the other. On the one hand there is the alexandrine from the depths of time ("[…] *le meilleur témoignage que nous puissions donner de notre dignité / Que cet ardent sanglot qui roule d'âge en âge* […]" [the best reflection we can give of our own dignity / This ardent sob rumbling from age to age], the line that carries (or carries away) lyric (sixteenth-century), tragic (seventeenth-century) and epic (sixteenth–nineteenth-century) poetry. On the other hand, at the opposite pole, the distinct tone and absolutely singular expression of Racine or Apollinaire, similarly inscribed in the alexandrine and justified to the last millimetre.

'Neo-classical' is a 'dumb' term. But here it raises a serious question. Bear in mind that classicism is always intrinsically neo-classicism. I'll summarize the matter crudely: the history of an art, if not of art itself, and perhaps in any case of an artist, runs at two speeds: there is the speed of 'it's up to us now', of the experimental, of the 'avant-garde', of conquest; then there is the speed of consolidation, of possession, of maturity and 'classicism', be it in a person, a generation or an age. Sometimes entire oeuvres or creative movements or phases of a life can be shared between all these contrasting and complementary headings. To characterize the polarities very rapidly, Picasso would be permanent revolution, Raphael the reign of serenity. Where Cocteau is concerned there is

To the Belle Epoque. Most affectionately

no doubt that after *Le Cap de Bonne-Esperance* and *Escales*, poems of his youth which pride themselves on "breathing freely" in the manner of Picasso and thumbing their noses at "alexandrine arithmetic",[2] the perpetual motion of that very arithmetic reasserts itself. Cocteau returns to the mainsteam, lets his own torrent flow into the great river where the alexandrine, swollen by countless spring floods, dominates the swirling counter-currents of octo-, deca- and hexasyllables.

Sometimes it is from one generation to the next that the move from Revolution to Empire occurs, or from Empire to Revolution, depending on how historians prefer to read the parabola. Playing with the analogy we might say that Cocteau is to Apollinaire what Valéry was to Mallarmé, just as *La Jeune Parque* can be seen as the "neo-classical" daughter of *L'Hérodiade*. Whose son is Cocteau? The new continent was conquered by Apollinaire. Here, through fertile lands, well watered by meandering streams, there wind a thousand non-Euclidean species of alexandrine fluidity, an "elastic undulation" as Baudelaire would say, on which modern topographies imprint 'impossible' transformations.

By Cocteau's own admission, "And despite everything my pen was taken over by the divine gobbledygook whose syntax was taught to us by Góngora, Rimbaud and Mallarmé".[3] This is an amusing way to advocate hermeticism. He tells us that he stopped trying "to sew up" – to follow the "thread that would bind together the unstitched."[4] We find him complex, certainly, but not as discontinuous nor as entangled as all that.

He found the path a hard one. To make manifest its intrigue and intricacies I would compare *Voile* (p. 1483) or *Mythologie* (p. 597) with the grand motif of *Requiem*:

> *"J'étais là... je croyais que les beaux dieux antiques*
> *Ivres d'azur torride et de célestes vins*
> *Étaient encore, Seigneur, vos archanges divins*
> *Et que leur opulence escortait vos cantiques."*
> [I was there ... I thought that the fine gods of the ancients
> Drunk with torrid azure and celestial wines
> Were still, Lord, your divine archangels
> And that their opulence accompanied your songs]

So begins *Le Voile*, with a happy syncretism of well-woven mythologies ("the Jordan's water flowed like the water of the Ganges"), which the Christian sinner's conscience, in a state of permanent conversion, so to speak, "incapable of sanctifying random fault", tears to pieces, blurring the figures in the magnificent veil.

Here is the other injunction (p. 1142):

> *"Et voici que je projette*
> *D'écrire les ordres en clair*
> *Et de braver la colère*
> *De l'Apollon Musagète*
> *Car il exige que l'ode*
> *Soit transmise par son code*
>
>
>
> *Relâche et brusque abandon*
> *De toute ma mythologie*
> *Tumulte ailé quadrige aérien*
> *Je reste seul avec ma honte*
> *Puisque le mot d'ordre est Rien* [...]"

2 Jean Cocteau, *Œuvres poétiques complètes*, Paris, Gallimard (*La Pléiade*), 1999, *préambule*, p. 21.

3 Preface of *Requiem* (ibid., p. 30).

4 Elsewhere he compares himself to Dante: "*Et pareillement à Dante / Surpris par le nombre des bolges*" [And just like Dante / Surprised at the number of *bolges*].

[And now I am proposing
To write the orders clearly
And to brave the anger
Of Apollo Musagetes
For he requires the ode
To be transmitted through his code.
...
Release and sudden abandonment
Of all my mythology
Winged tumult chariot of the air
I remain alone with my shame
Since the order given is Nothing.]

From Scarron to Meilhac and Halévy (*Requiem* includes an interlude for Offenbach), the comic-heroic tradition transcribes – in other words transmits and disguises – myths. Parody is the way the ode keeps in being. The heritage is also passed on by this means, and this has many advantages. It makes a space for homosexuality; it allows erudition to indulge in smiling debauchery; in it various kinds of euphemism, usually for death, are made to poke fun by not mentioning it, or referring to it by its opposite. A Spanish theme, including fluttering mantillas and bullfighting (*tauromachie*) crops up again in *Requiem*, in which the *danse macabre* refrain repeats, "He was loved by the lady". Madam Death, I look at you and do not name you; I circle and celebrate you; under a pseudonym you are my favourite figure of speech. The period – the Belle Epoque – went to the bullfight with Picasso; it had not yet been deafened by the booing of the Society for the Protection of Animals. It deceived death by dressing up in costumes of gold. With the horns it paraded it had something of Artemis and Apollo. The Angel is the great figure and the great extra in Cocteau's theatricals. He moves through film sets, drawings and novels; the Muses pass him round between themselves and he inhabits and haunts the life of Jean Cocteau. We know that in Jean Marais he found his aspect as a Beast and as the Prince of Cleves, and as poems in the book.

Heurtebise is one of the Angel's alibis, a charming oxymoron – or oxymoronic charm. A powerful, painful presence and voracious parasite, he dispossesses (how Jean Cocteau managed to be rid of him in a poem must be read) and never plays to the gallery.

We could say the angel was magic, but, as a powerful operator of syncretism, in both name and image, he is an "original print" (to borrow Mallarmé's term) – an alloy condensing the attractive and repellent forces of strong magnetization, the profiles of Garros and Radiguet, the Auriga and Christ (the Christ of Rimbaud and Apollinaire, thief of energies and aviator of *Zone*) – and a few others. In his preface to the *Oeuvres poétiques complètes* Michel Décaudin pulls no punches: the angel, lame and winged, embodies all contradictions. Then he quotes, "Poetry is a religion without hope".

Cocteau's Angel is not that of Rilke; the *terrible* of the *Enfants* is not the *schrecklich*. The steep terrace above the sea of the princes of Turn-und-Taxis is not like the cabaret Le Boeuf-sur-le-toit or the de Noailles's salon. One could continue. Or perhaps, since dawn of the twentieth century, it has been better for poetry to come from elsewhere, 'in translation' – which then has value because of its foreign provenance – and preferably from the North or East. It should pass through the Babel wall of a great language like the surprising hand of divine dictation, 'in translation'. In this way it retains its status as foreign, as if from the Muses, an inspiration, a source; the 'trans' of its prefix retains that of transcendence. The enormity of the 'translator's task', the strangeness of the interminable, inexhaustible exchange between the superhuman creatures that are idioms, preserves respect for poetry as a grave mediation, the "space of infinite relations" (to quote Hölderlin's expression, dear to

Heidegger). It keeps poetry as special, 'not for sale', Mallarméan, for ever – or, let's say, for a long time longer. Poets cannot be very great in their own country. The word comes to visit us.

Cocteau allowed himself to be led time and again to travesty, to the comic-heroic. He abandoned himself to it, did not hesitate to call Castor and Pollux "*lascars*" [rascals] – set off by an anagram or assonance. I leave it to the reader to seek out how many times he does this. The other side of such cultivated, affectionate and ironic recourse to myth – where knowledge demands the very thing whose absence suits belief too well – is familiarity. The well brought-up man becomes badly brought-up, the cabinet of antiques opens on to the cabaret. In the end cinema becomes the purveyor of epiphany.

Syncretism, both happy and unhappy, is dying out. If sickness, drugs, mourning, pain, the "difficulty of being", the sense of sin and a lacerating Christianity had not constituted the "serious" (Sartre's word) aspect of this "*vie de fête*", the undeserved portrait of Cocteau as an entertainer would win out – in the way it has already prevailed in his 'legend', of fashion and ballet, night-life and decors, in which jealous worship of Paris life tarnishes instantly at the first suggestion of any dwindling in the desire for 'parisianism'. Culture has become something far too serious to be left to the elitist cosmopolitanism of the Belle Epoque, during which time socialites had compared their 'worldiness' to that of the Enlightenment *philosophes*, to their "*mondanéité*". The Second World War, the end of surrealism, the shipwreck of utopias, the democratization of education (and many other events) fostered the metamorphosis of modernism (the modernism of Chaplin's *Modern Times* and the *Temps modernes* of Cocteau, then of Sartre) into post-modernism. The post-revolutionary period was ushered in, to be soon followed by a shift from a 'cultivated' culture to culture 'globalized'.

Orphic self-portraits

Halte pélérin mon voyage
Allait de danger en danger
Il est juste qu'on m'envisage
Après m'avoir dévisagé
[Halt pilgrim my journey
Was moving from one danger to the next
It is right that my face should be called up
After being stared down]
Jean Cocteau, *Requiem* (1962)

"Stared down", misunderstood, unknown, invisible, this is how Jean Cocteau described himself, despite his brilliance and the laurels of official recognition. The only portraits in which he expected his as yet "faceless" readers of the future to discover his true face after his death were his own works, which ran with "the red ink of his heart". This was the secret, nocturnal blood that gives life to his statues and colours his masks and which he transfused into the written or filmed bodies of his imaginary creatures. "Life sculpts me [...] It is making a masterpiece", exclaims the poet persecuted by the Bacchae in the epilogue to the *Orphée* of 1926, echoed by the protagonist of the 1950 film: "What are the thoughts of the marble from which a masterpiece is being sculpted? It thinks, I'm being hit! I'm being ruined! I'm being insulted! I'm lost! Life is sculpting me, Heurtebise, leave it to finish its work." Cocteau's entire oeuvre expresses the idea that his truth can be born of both his occult life and his life in the light, exposed to suffering, injustice and inquisitions. This unique truth will emerge in the countless forms of Cocteau's own language, "Neither living nor dead, which few people speak and few understand".[1] He gives it the title of poetry and signs it with a star.

With his omnipresent, multiform voice, his own thinly spread presence and that of his doubles, he is always there, haunting the echo chambers of his subterranean oeuvre. His work is a beehive with communicating cells through which he moves like a sleepwalker, like a follower of the cult of Orpheus, seeking the shades of the dead as much as his own fleeting shadow. It is a misleadingly profane architecture, half fairground stall, half film studio, to which he indicates the entrance with an outstretched arm in the prologue to *Le Sang d'un poète*: "The author, masked but for his eyes, a plaster hand in his hand, the real hand and the wrist of the other covered in a draped cloth, announces that the film is starting before a background of studio lights". We can understand the film as a strip-tease show in which, from one act to the next, Cocteau delivers up the fantasies and phantoms of his night, the living substance that has been invoked to aid the transmutation of appearances and his assumption of his "glorious portrait".[2]

Cocteau is masked like no other artist; like the painter and poet who is the protagonist of his first film, he goes forward in a combined state of strangeness and familiarity, surrounded by the emblems, self-portraits, masks and mysterious, unfinished effigies that people his studio. There are many faces here, from the eyes, curved nose, wavy hair and neck draped *all'antica*, which he struggles in vain to capture in charcoal on white canvas, to the mobile head

1 *Le Testament d'Orphée*, film (1960).

2 "We serve only as a model for our glorious portrait", *Opium*, 1930, in J. Cocteau, *Romans, poésies, poésie critique, théâtre, cinéma*, éd. établie par B. Benech, Paris, L.G.F.(*La Pochothèque*), 1995, p. 634.

Orphic self-portraits

hanging from the ceiling – "a kind of chariot driver" (is this the first appearance of the Delphic Auriga?) or, as André Fraigneau described it, a "flayed cage"[3], in brass wire, spinning in space. Also spinning in this studio is a disturbing little two-faced mask, with a diurnal white face and a concave nocturnal, funereal face with eyes that weep tears of milk and a starry forehead; then we see the profile of Cocteau in white plaster, and lastly the insistent upturned face of a dead or sleeping man with the painted eyes of a statue. At the start of *Le Testament d'Orphée* the film-maker is once again in costume and make-up; returning to his contemporary suit and face after a detour through the eighteenth century, he must, like Oedipus, confront his inner sphinx and the personal enigma of his poetic duality. An easel is again present, covered with a huge sheet like a funerary monument. This sheet is suddenly sucked upwards by an inexplicable gust of air and then flies away as though grasped by invisible angels, successively uncovering two linked oil-paintings: the large *Blind Oedipus and his Daughters* from 1954 and, in a smaller format, the *Head of Dead Orpheus* from 1951. These decidedly unwieldy shadows from Greece cling to his every step, possibly compromising his search for renewal and irritating him. "Always that Orpheus, always that Oedipus! I had thought that by changing castle I could change ghosts and that here a flower would put them to flight."

Greece / theatres of cruelty / masks

"It's your fault, Peloponnese. Other dangers are threatening you, for at night the statues don black singlets and murder travellers"
("*Le Théâtre de Jean Cocteau*" (1926) in *Opéra* (1927) and *Le Testament d'Orphée* (1960)).

Cocteau's narcissistic ceremonial is haunted by the mythical figures of Oedipus and Orpheus, whom no spell, no disenchantment can "put to flight". They are dominant figures, the only ones capable of establishing a poetic hold, line or destiny: "My life is unrecountable", declared Cocteau to Roger Pillaudin on the set of *Le Testament*. "Too fertile in meanders and obstacles. And the films on Colette, on Gide, on Mauriac in no way reflect the fundamentals of what they are."[4] Cocteau drew on many mythologies, from Egypt to the Celtic forests and from the Tibetan Book of the Dead to gypsy rituals. But hysterical Greece, with its theatres of red and gold, its misleadingly still marble statues in three dimensions, its dizzy descents into labyrinths, its furies, its decapitations, its incest, its loves and monstrous births, is the only world that can compare to the wild, organic forces of whose fearsome power Heurtebise reminds the Poet: "Do not forget that you are a nocturnal amalgam of caverns, forests, marshes, red rivers, an amalgam peopled by gigantic, fabulous beasts that devour each other. There's no reason to act clever."[5]

Shadow, night, monsters sacred and profane, angels and personal myths entwine with Greek myths to form the basso continuo that sounds almost unchangingly in the distant voice of Athene, "the key to dreams. The sad column. The virgin in the iron mask", from "*Le Théâtre de Jean Cocteau*", the 1926 poem from *Opéra*, to the filmed *Testament* of 1960. Perhaps this is the lesson of De Chirico: only Greek theatre has the power, the three-dimensionality and a sense of the detail in dreams – the primitive dreams of childhood which, "far from being naive, are Atreid and feed on tragedy".[6] It is here rather than in the writing of dreams that the buried, unconscious world of the passions is encountered; this is the world in which Cocteau claims to have carried out repeated "excavations", on a par with the surrealists. "On leaving sleep the dream fades. It is an underwater plant which dies out of water. It dies on my sheets. Its reign intrigues me. I admire its fables. I take advantage of it to live a double life. Never do I use it."[7] As in the work of Fellini, but with different dangers, Cocteau's descent into the inner shadows and labyrinths has more in common with the poetic journey of Orpheus than the trivial detective work of Freud, although Oedipus is never far away. "The night I speak of should not be confused with the one into which Freud invited his patients

3 "On the bookshelf he showed me a singular object in stainless steel wire, a kind of flayed cage in which his draughtsman's line, freed from the paper, drew something between drawing and sculpture in space; (This character was to play a part in the film *Le Sang d'un poète*)": related by André Fraigneau (*Cocteau*, Paris, Seuil, « Écrivains de toujours », 1987, p. 14).

4 Roger Pillaudin, *Jean Cocteau tourne son dernier film. Journal du « Testament d'Orphée »*, Paris, La Table ronde, 1960, p. 55.

5 *Le Testament d'Orphée, op. cit.*

6 *Opium*, J. Cocteau, *Romans, poésies, poésie critique, théâtre, cinéma, op. cit.*, p. 667.

7 J. Cocteau, *La Difficulté d'être* [1947], in *Romans, poésies, poésie critique, théâtre, cinéma, op. cit.*, p. 898.

to descend. Freud burgled poor apartments. He took out a few mediocre pieces of furniture and some erotic photographs. He never consecrated the abnormal as transcendence."[8]

Transposed to the heightened level of tragedy, of the theatre in general, Cocteau's life dons a disguise, undergoes a metamorphosis and transcends itself. Its characters acquire an unusual aspect and hieratic grandeur, they gain an element of shadow. Hence, literally, the outsized shadows of the Princess and Heurtebise who, in the last shot of *Orphée*, are projected on to the tragic ruins of the Zone for their last passage to the blind, off-screen space of the hell to come. But the same is true of most of Cocteau's creatures. For anyone who watched the 1950 *Orphée* it was surely impossible for the gendarmes on motorcycles to remain no more than simple everyday motorcyclists. Despite the film's deliberate realism, theatrical effects were everywhere to be felt. In Cocteau's work poetry "replaces narrative with facts" through the "externalization of internality"[9] using stage techniques (placing it at the opposite pole from the work of Robert Bresson) and an emphasis on the succession of actions rather than images. "This active poetry is very shocking" Cocteau noted in relation to his stage version of *Orphée*. On the other hand, through a succession of theatrical turns which, in the first *Orphée* as in *Le Sang d'un poète*, have elements of farce, tragedy and circus, this poetry in actions enables the characters, sets and objects themselves to take on a three-dimensional life which becomes suddenly suspect; they are potentially different from what they seem.

Beyond heightening, enhancing and disorientating, the presence of theatre was part of a conscious strategy of *déniaisement* in relation to fables. The word *déniaiser* means to render something less stupid or inane; the *déniaisement* of fables involves presenting them in a more knowing way. Cocteau's *déniaisement* of genres and myths would later often be taken up by others (Tarkovsky, for one, adopted the term *déniaisement* to characterize his work in the film *Solaris*). In Cocteau's work as in Stendhal's, the rule is keep things dry, to mention a truth in preference to a sigh. Childhood is "terrible", angels are "brutal", like those of Michelangelo and El Greco. As for the elegiac sentimentality associated with the fate of Orpheus and Eurydice and with lyricism, this is overturned and treated in a new style sometimes bordering on the grotesque.[10] Above all, there is not one work by Cocteau which, beneath its guise as folktale, fable, family saga or piece of popular theatre, does not suddenly reveal itself to be a murder scene, a theatre of cruelty, or a ritual killing. This fundamentally "elegant"[11] and ironic approach, more likely to arouse fear than pity, is by its nature inherited from Greece:

> GRÈCE
> *Où de cruels oiseaux posaient des devinettes*
> *Où le navire était hérissée de houlettes*
> *Où le berger battait les aigles libertins*
> *Où l'inceste sans cœur, monté sur des patins*
> *Persécutait les rois, les reines de théâtre*
> *Avec ses cris de folle, avec ses yeux de plâtre…*[12]
> [GREECE
> Where cruel birds set riddles
> Where the ship bristled with shepherds' crooks
> Where the drover beat libertine eagles
> Where heartless incest, on skates
> Persecuted the kings and queens of theatre
> With her madwoman's cries, her plaster eyes]

Under the supervision of a blind statue with enamel eyes, an Auriga, an angel with wings of glass, a distant voice or even a judicial mechanism with codes as sadly bureaucratic and abstract as those of Kafka's *Trial*, from the first act to the last, the characters are subjected

8 J. Cocteau, « De l'invisibilité », *Journal d'un inconnu*, Paris, Grasset, 1953, edn 1996, p. 39.

9 Bresson's phrase in *Cahiers Jean Cocteau*, n° 3 (Gallimard), 1972.

10 See the meal scene after Orphée and Eurydice's return home.

11 The word used by Jean Genet who, at the beginning of his profile of Cocteau, published in *Empreinte* in 1950, describes him as "Greek!": "*Grec!* The dry elegance of the word."

12 « Par lui-même » in *Opéra*, Stock, 1927; in *Œuvres poétiques complètes*, Paris, Gallimard (*La Pléiade*), 1999, p. 517.

to a series of ordeals and metamorphoses which lead them towards the secret future of death. Each time the names of the officiators at the tragic ceremonial are elevated to the power of myth. Dargelos, Heurtebise, and Athene – these trisyllabic names resound like the three blows of a theatre of murder, before the curtain rises on a set in which the bloody episodes will be played out. Such sets include the Monthiers courtyard in *Les Enfants terribles* and *Le Sang d'un poète*, where a black angel with the small, vibrating wings of a bee lies on the dead body of a child and, turning over, looks at the audience with the eyes of a dying animal; Euridyce's bedroom, where Death, wearing make-up and draped in the long dress of a tragic actress, comes to look at Orphée before turning her gaze to her future victim, Euridyce; Orphée's double room, intermittently filled with phosphorescence light for a combat between Heurtebise and the Princess – ferocious insects facing each other across their prey, the one trying to keep him alive, the other to carry him off to death. In a vast identical movement, the same slow process of putting to death is repeated, from the snow-filled "ghost salon" of *Les Enfants terribles* to the open-air quarries of Les-Baux-de-Provence in *Le Testament d'Orphée*, uniting executioner and victim forever. So we find the schoolboy Dargelos perched on "a kind of platform", preparing to throw a snowball as deadly as a stone, in a courtyard transformed into a theatre – the childhood theatre of *Les Enfants terribles*, or the high-society theatre of *Le Sang d'un poète*. In *Le Testament d'Orphée* the scene is played out in a bullfight arena, before a box containing Pablo Picasso, Jacqueline Picasso, Lucia Bosè and Luis Miguel Dominguin. Here the goddess Pallas Athene, in a black diver's suit, with blind, enamel eyes and an enormous helmet "in the shape of a swan, made of mica, salts of gold and turkey feathers",[13] similarly hurls her javelin at the Poet – Cocteau himself – who collapses, pierced, saying distantly over and over, "How dreadful! How dreadful! How dreadful!"

Death / mirrors / doubles

"Sometimes, without getting dirty, heaven touches men"
(Jean Cocteau, "*Raymond Radiguet*", *En marge d'Opéra*).
Whatever the setting, be it a circus, a lion's cage, a conjuror's salon, a room in a seedy hotel, a theatre of war on the shores of the livid North Sea, or a modern street in any old modern town, Death is the poetic and Orphic theme to which Cocteau invariably returns, which he endlessly reworks. Its lightning bolt seizes, freezes, photographs, transfigures and reveals. It is present in apocalyptic landscapes and settings – the trenches of the Somme, sector 131, a "mixed strip", a "zone that strikes with lightning", seen by the phosphorescent light of flares, where disembowelled villas collapse like dominoes beneath the moon in the *Discours du grand sommeil* and *Thomas l'imposteur*; it is in the Zone of *Orphée*, the ruins of the Saint-Cyr-l'Ecole barracks, bombed during the Second World War and criss-crossed by the same intermittent light. It is also in the faces and figures of friends and doubles, like Apollinaire seen for the last time transfigured on his death-bed: "Gradually, through the magic of a candle, the gloom of silence, his face rising alone from the sheet becomes indistinguishable from the severed head of Orpheus".[14] Then there are the rebel angels Raymond Radiguet and Jean Desbordes, too beautiful for Death not to "dress them up" and carry them off, who are also transfigured and baptized with the names of angels: Heurtebise, Cégeste. Last of all comes the transformation of Cocteau himself, the prince of frivolity, long enamoured of colours and "recalled to order" after the First World War by the presence of mortality which, ever since his father's suicide by a bullet in his temple in 1898, has continually lengthened the list of "his" dead.

13 R. Pillaudin, *Jean Cocteau tourne son dernier film, op. cit.*, p. 67.

14 « Apollinaire » [1954], J. Cocteau, *Poésie critique I*, Gallimard, 1959, p. 96.

Jean va
où
la longue brèche commence
[...]
Tu seras le témoin de la tempe:
L'endroit solonnel
où bat l'artère,
l'endroit dur et mou de la tête,
de chair et d'os.
Les écailles d'acier, les bosses, la dune
caméline. De lieu en lieu
s'incruste l'artillerie
où miroite la lune.[15]
[Jean, go
where
the long breach begins
[...]
You will be the witness of the temple:
The solemn place
where the artery beats,
the hard and soft place in the head
of flesh and bone.
Steel scales, bumps, the
humped dune, here and there
encrusted with artillery
on which the moon shimmers.]

The Orphic domain of poetry becomes the between, the breach between brilliant light and deepest night, between life and death, dream and reality, hanging

dans un silence de stéréoscope
de musée Grévin, de boule
en verre où il neige, de chloroforme,
d'aérostat[16]
[in the silence of a stereoscope
of a waxworks museum, of a glass
ball in which it's snowing, of chloroform
of an aerostat]

in which the poet advances as in a dream, "by angelic means", limping, with one foot on solid ground and the other sometimes sinking into death. By such a gait can those who have crossed the lines and plunged into their night be recognized. It is this initiatory journey, this baptism of fire that separates the languid narcissism of the symbolists from Cocteau's conquering modernism.

In *Water and Dreams* Gaston Bachelard recalls the existence of this "active narcissism, too much neglected by classical psychoanalysis [....] We can always ask someone standing in front of a mirror a two-fold question: for whom are you mirroring yourself? Against whom are you mirroring yourself? Are you aware of your beauty or your strength?"[17] The mirrors into which the Poet of *Le Sang d'un poète*, a motionless swimmer, illicitly dives before moving into the distance no longer have anything in common with the smooth surface of still water

15 J. Cocteau, *Discours du grand sommeil (1916-1918)*, Paris, Gallimard, 1925, in *Œuvres poétiques complètes, op. cit.*, 1999, p. 408.

16 *Ibid.*, p. 435.

17 G. Bachelard, *L'Eau et les rêves. Essai sur l'imagination de la matière*, Paris, Librairie José Corti, 1942, edn 1984, p. 32.

"frozen in its setting by *ennui*" in which the disciples of Mallarmé's *Hérodiade* became fixed. In Cocteau's work the Orphic entering of mirrors, of the image, takes on a transgressive role as an ordeal. "I'm telling you the secret of secrets", says Heurtebise in the play of 1926 and the film of 1950. "Mirrors are doors through which death comes and goes. Besides, look at yourself all your life in a mirror and you will see death at work like the bees in a glass hive." Certainly, as Cocteau was to say – and after him Pasolini and many others – mirrors, mechanisms for looking in general and cinema in particular, record "death at work"; however in Cocteau's work the active, violent modulation of the motif gives it the extraordinary power to bring about crossings, metamorphoses and resurrections, tormented and heretical as these may be.

Nothing better expresses the conflictual dynamics of Cocteau's 'orphism' than the way his characters are by turns driven, slowed, hindered, raised or beaten down by mysterious forces. In *Le Sang d'un poète* every illicitly glimpsed, stolen scene is linked to the intermittent portrayal of the poet's difficult progress along a corridor until the moment when he finds himself projected backwards in the water of the mirror, "expelled", reborn. Similarly in *Orphée*, special effects created with the aid of much scaffolding erected in space, false perspectives, optical illusions and acrobatic filming (high-angle shots of the protagonists filmed from trolleys hung from the flies of a theatre)[18] are intended to make us feel the revelatory strangeness of this way of moving: "It is neither swimming nor flying. It is something different, which is not like anything else. Slow motion is vulgar. So I had the sets nailed to the floor and shot the scene flat. The character drags himself instead of walking, and when you turn the scene on its side, you see a man walking with extreme difficulty in an extremely strange way, whose muscles are moving in a way that does not correspond to the effort he is making to walk." The same maniacal meticulousness can be seen in the development of the special effects to show "the beautiful, immobile movement" of Heurtebise, swept along by gusts of light and air, whom Orphée is struggling to join: "You seem to be walking without moving [....] There isn't any wind. Why do you look as though you're walking into the wind?" Conversely, the last two descents are made against the influx of an invisible wind, an "inexplicable breath", which pins the protagonists to the floor, lifts them up and blocks their progress through time and the image.

Perhaps inspired by certain devices used in great popular novels – we are reminded of Gaston Leroux's *Phantom of the Opera* – Cocteau's mirrors reveal a secret, backstage world of fantasy and taboo. In this mental theatre *tableaux vivants* detail a series of surprising scenes spied by the poet of *Le Sang d'un poète* through a keyhole, the risqué, voyeuristic device of the Hotel des Folies-Dramatiques and its attractions. These include the "Mexican" scene of an execution staged and unstaged, filmed backwards; the improbable lesson in theft given by an old brothel madam to a little girl dressed as an acrobat; the scene of an opium den shown in shadow-play; the metamorphosis, to an accompanying drum roll, of a hermaphrodite wearing a seventeenth-century wig; the poet's suicide and resurrection, his temple dripping with blood, a laurel crown on his head. In the film of 1950 access to otherness and prohibition is even more evident (and freely perverts the myth of Orpheus). Here, rather than enabling the protagonist to find and save his Eurydice, the mirrors twice allow him to find the Princess[19] with whom he is in love and who will herself be judged and condemned for the crime of loving.

The defeated Oedipus, a blind pariah, and the triumphant, all-seeing Orphée are the two figures whose identities provide the key to Cocteau's work. He brings them together, or rather they meet in passing, at the end of *Le Testament*; however, only Orphée is granted the privilege of cinematic representation and glory. Indeed not only does Cocteau give this character a more pronounced air of victory, abandoning any portrayal of his decapitation and dismemberment, shown in the 1926 play, he also endows him with near-heroic status. This even includes *hybris*, when Orphée voluntarily exposes himself to death in order to pursue to

18 J. Cocteau, *Entretiens autour le cinématographe* [1951], edn Belfond, 1973, as *Entretiens sur le cinématographe*, pp. 74–75.

19 For whose character Cocteau took inspiration, among various sources, from the trapeze artist in drag Barbette, discovered in the Paris Casino in November 1923 (see "Le Numéro Barbette", Paris, Gallimard, *nrf*, 1926 and the story "Barbette", *En marge d'Opéra*, in *Oeuvres poétiques complètes, op. cit.*, p. 561).

its end the tragic conspiracy of which he is victim. How should we then take the contradictory and highly un-heroic epilogue of *Orphée*, in which the poet returns to his wife Eurydice and the promise of a drab, down-to-earth conjugal happiness? "Orphée ends up in slippers", says Jacques Aumont, "slippers he had never worn before 'returning' from his death."[20] This was an unenviable fate as Cocteau himself admitted, justifying his decision to leave Cégeste in the kingdom of the dead in recognition and "recompense" for a poetic authenticity which he seems not to have granted to his Orphée:

> *La mort nous vient en aide et nous trempe, Cégeste,*
> > *Dans le même élément.*
> *Conduit jusqu'à ces bords par une autre science*
> > *Orphée en fraude alla*
> *Mais en revint tout seul. C'est votre récompense*
> > *Que je vous laisse là.*[21]
> [Death comes to help us, plunging us, Cégeste,
> > Into the same element.
> Led to its edge by a different science
> > Orphée illicitly went
> But came back alone. It is your recompense
> > That I leave you there.]

But the author may not be the best person to reveal his characters' fate and truth. He himself admitted this when asked about the sacrifice of the Princess in *Orphée*: "It is beyond me and is no more my business than the rites of the beehive or the termite heap, funereal rites of which the enigma has never been resolved by the entomologists."[22]

There remains the oeuvre, the only true portrait of the artist. More than a portrait of Orphée, or of Cocteau wearing the mask of Orphée, the Orphic films very precisely reflect the work making itself, and the poet making himself through and by his work, with a necessity peculiar to each creation, each poem. Born of a powerful conspiracy of external and internal forces, the film can "trap" its author, as happens in *Le Sang d'un poète*, turning against him, giving him a distorted or, as in the epilogue to *Orphée*, strangely trivial reflection of the image promised by the myth, which is thus duly *déniaisé*, made more knowing. Life also wove its thread into the fabric of the work: the fate reserved for the figure of Jean Marais/ Orphée is not wholly untouched by the existential and emotional circumstances which gave rise to the film in the form of Cocteau's parting from Marais and the beginning of his relationship with Edouard Dermit/ Cégeste. Ultimately no poetic tool or vehicle can act as a definitive key. In Orphic "science" the magic of mirrors, which Cocteau used more than anyone else, is doubtless not enough. Told to "reflect more" in *Le Sang d'un poète* and *Orphée*, in *Le Testament* mirrors are accused by Cégeste of "reflecting too much", of "pretentiously inverting images" and "thinking themselves profound".

Cinematic orphism / births of the Phoenix / Cocteau at last himself in his work

Et le poète enfin dévoré par son oeuvre
Dormait devant le loup qui lui léchait les pieds
[And the poet at last devoured by his work
Slept before the wolf, who licked his feet]
Jean Cocteau, "Mésaventure d'Orphée", *Allégories* (1941)

Just as shifting the position of the body can alter and modify the course of the sleeper's dreams, so "chance accidents", "errors of calculation" can also influence the birth, form and

20 « La traversée des ruines », *L'Invention de la figure humaine*, Jacques Aumont (dir.), *Conférences du Collège d'Histoire de l'Art cinématographique, 1994-1995*, Paris, Cinémathèque française / Musée du cinéma, 1995, p. 30.

21 « Dans Orphée », *En marge de Clair-Obscur*, in *Œuvres poétiques complètes, op. cit.*, p. 929.

22 J. Cocteau, *Entretiens sur le cinématographe, op. cit.*, p. 86.

life of poems. The work is all the more alive for being the fruit of a distant alchemy, partially unrelated to the conscious calculations of art. The birth of a poem such as *L'Ange Heurtebise*, this "object of solitude" of which the "expulsion lasted seven days", is the perfect example of what Cocteau defines as a process of expiration, which he distinguishes categorically from superficial inspiration: "One should not", he states in the Foreword to *Orphée*, "say inspiration, but expiration". Expiration demands work on the self, difficult exploration, the conquest of one's night. Once born, the work appears incomprehensible, inimitable by its own author: "I remained stupefied", says Cocteau of the birth on 9 March 1925 (at 7pm) of the poem *L'Ange Heurtebise*. "I considered the figure it had adopted. To me it remained distant, aloof, totally indifferent to anything that was not itself. A monster of egotism, a block of invisibility."[23]

There are many accounts of such a process of "birth" of a poem by Cocteau, whether it be literary, graphic, pictorial or cinematic. These include the independence which the mouth drawn by the poet of *Le Sang d'un poète* asserts in relation to its creator. It refuses to be rubbed out, opens to speak, begs for air, dreams, snores and becomes a sore that clings to the skin. Another example is the great canvas representing *Blind Oedipus and his Daughters*, which figures in *Le Testament*, and which has a painful stylization representing a return to the expressionist intensity of the terrible drawings of *Opium*. In *Le Passé défini* Cocteau says of the genesis of this painting, in 1954, that in order to paint the tragedy's characters he endeavoured to "push to the extreme [...] the tragic and pathetic poses of the frogs of [my] childhood, dead in pools". The next day, 12 May, he went on, "That's the end of the day on *Oedipus*. I am completely exhausted. I hadn't noticed while I was working where I was becoming the painting, where I had left my body behind [....]" In October he again mentions the "visits" that he made during the months before his *Oedipus*: "Visits", he remembers, "to an enemy that will have to be defeated", an enemy that must be faced with a knife. "So much drama can only be painted with a knife in one's hand – and the very rare caress of the brush afterwards, on the raised scars."[24] In *Le Testament* the emblematic star is replaced in the prologue and epilogue by the knife, the role of which is to burst the soap bubble, that most Baroque figure of vanity and illusion. Perhaps the stubborn aspiration of poets towards immortality is one such illusion; in Cocteau's work aspirations of this kind always go hand in hand with "mortal *ennui*".

Cocteau preserves the enigmatic ambiguity of his strangely de-mythified Orpheus, "returned to his dirty water" at the end of his pseudo-apprenticeship, and, in so doing, completes the anti-elegiac, anti-visionary and anti-Romantic *déniaisement* of the primitive myth. It remains the case that the film very literally appropriates the myth of descent – into the Zone, where Orphée takes up residence, as in the abandoned shell of a hermit crab, in order to carry out the process and obscure rituals of poetic creation. This is the work of exploring oneself and one's doubles, the creatures by which one is obsessed, so that one can bring them back to life, transform them or fix and repudiate them in their anachronistic clinging to a time that is gone forever. The glazier of the Zone, making a last appearance in *Orphée*, falls into this last category. He is an emblematic but outmoded figure in Cocteau's mythology, who "stubbornly cries his cry in a place where windows no longer have any meaning".

For Cocteau is not Proust and shows no more indulgence towards the dead detritus of old myths than he does towards the now outdated forms of his own imaginary world. His descents into himself are intended not so much to recover a memory and use it as the basis of his work as to liberate the mythical, wild, impassioned source of his creative self. In *Orphée* this is represented through the love affair with the feminine double, the possibly maternal archetype incarnated by the Princess. It is the Princess's poetic, liberating power Cocteau emphasizes in his foreword rather than her funereal symbolism: "Her love for Orphée, and Orphée's love for her, represent the profound attraction of poets for all that is beyond the world in which they live, their striving to defeat the infirmity that amputates us from a great many instincts, which haunt us without our being able to give them a precise form or put them into action".

23 Notice in *Œuvres poétiques complètes, op. cit.*, p. 1681.

24 J. Cocteau, *Le Passé défini III*, 21 August 1954, Paris, Gallimard (*Nrf*), 1989, p. 218.

Clearer still, and returning to the allegorical approach which Cocteau always celebrated, in the epilogue to *Orphée* the visual representation of creative "work" takes the form of a unified block of humanity, a true power-house of poetic energy that draws the Princess, Cégeste and Heurtebise to the sleeping Orphée. "Heurtebise, suddenly, slips behind Orphée, closes his eyes and mouth with his hands. Cégeste runs in from the left and grabs Orphée's legs in both arms. They immobilize him." Through the poet's imprisonment, imagination, hypnotic concentration, willpower and mathematical calculation make it possible to go back in time and deliver the work. Orphée finds inspiration in the night of the Zone because he dives into it, allowing himself to be taken over and enchanted by the magnetic forces that the Princess gathers round her. She herself is a distant, imperious sister of the Sphinx[25] of *La Machine infernale*: "Work! Work! Heurtebise, I'm helping you! I'm working with you. Don't weaken. Count, calculate, strive as I strive myself. Go on, ripen him. You must! [....] Dive into yourself and leave yourself! Run! Run! Fly! Knock the obstacles out of the way!" It is on this work on the self, on this creative dynamism that the birth and life of *Orphée* the work depend, much more than on its medium, the ephemeral and too human Orphée, whose survival is moreover only a "mirage",[26] as Heurtebise reveals in the course of the *Testament*.

In Cocteau's work in general, and very visibly in his cinematography, the poetic vehicle he always asserted to be "looser" and freer than any other – dynamism and creativity work both through the descent into the self, the orphic exploitation of the deepest layers, the bringing to light of one's night and the creatures that this night impose upon one – and also by their removal, transformation, and disfigurement in the course of a work that is radically "open" and "unfinished", always evolving, always changing. The inner magma of images, myths, theatres of memory and the replaying of memories that goes on within them is drawn into an endless process of metamorphosis, to which Cocteau gave the mythological name of "phoenixology" – which he said he had borrowed from Dalí.[27] This is illustrated by the need for the actor to keep endlessly dying and being brought back to life, living "between fire and ashes",[28] "the need for the poet to go through successive deaths and to be reborn in a form that is closer to his person", the need for the work to reflect and contradict itself, to be erased and constantly to take new forms. The arcana of this metamorphic and resurrectional theme are expounded by Cégeste in *Le Testament*. Also in this film Cocteau, dressed in his vaguely Faustian garb of honorary Doctor of the University of Oxford – black robe and mortarboard – theatrically performs its ritual on a hibiscus flower, which is brought back to life by running the film backwards.

The cinema plays on space-time, which it constructs and deconstructs at will, speeds up, slows down, fixes or frees, erases or restores. As such it is the unpredictable, mythical "angel of light", the "petrifying source of thought [which] revives dead actions".[29] Cocteau's cinematographic obsession with music, speed and metamorphoses is always present. In *Le Testament* a photograph that has been burned, torn up and thrown into the sea enables Cégeste to be reborn, in a swirl of froth, by means of what the audience sees as an extraordinary, vigorous dive backwards, another form of going back in time obtained by running the film slowly in reverse. One of the major differences between still photography and the cinema is that the former fetishizes, embalms and kills the past while the other, in the phrase Cocteau repeated a thousand times, "kills death". Emblematic from this point of view is the still photograph, the "immobile speed", through which Eurydice seems, at one glance, to be seized by death, petrified by light, in the small rear-view mirror of the Rolls. Eyes wide, her face surrounded by rays and curving black lines, she is turned to stone.

In Cocteau's self-portraits in movement, in progress, nothing is fixed, nothing is simple beneath the apparent classicism of the writing. Similarly, in the prologue of *Orphée*, the drawing's light line traces and controls inner tension and torment through the "flat prison"[30] of ten portraits of Orphée. These are contradictory images. The first shows a profile looking

25 But the Sphinx "ties" , "unties", "hinders", "garrottes" and "straps" Oedipus forever, whereas the Princess frees Orphée and causes him to be reborn. See *La Machine infernale*, in *Romans, poésies, poésie critique, théâtre, cinéma, op. cit.,* p. 1164.

26 "His survival was a mirage. His divine head died and Eurydice was put back in Hell. As a great human voice said, 'Never spit into the wind'".

27 J. Cocteau, *Le Passé défini II*, novembre 1953, Paris, Gallimard, 1985, p. 318. But Apollinaire's entire oeuvre is placed in the same category.

28 « Orphée », Jean Marais, in *Poésie critique I*, 1950, Paris, Gallimard, 1959, p. 245.

29 *Le Testament d'Orphée, op. cit.*

30 This phrase is used by Cocteau about his portraits of 'Eugènes' in *La Fin du Potomak*.

down, the eye closed as though sewn shut, the lids barbed, the hair twisting and spattered with clots of nocturnal ink; the last is a simple transfiguration, a "glorious portrait" of which the calm profile, dominated by the lyre, is turned to heaven, its eye open. Between these two states we see eight deliberately discontinuous variations, revealing Orphée's versatility. He is seen with bowed head, as though caught in the act of diving, looking up, double, single, blind, with the pointed look of an arrow, wild, with taciturn pout or voracious mouth, his neck decorated with a double flower and then suddenly whole, the full face endowed with divine serenity.

Throughout his films, from one portrait – one self-portrait – to the next, Cocteau's life is more emblazoned than reflected or retold. His work is fundamentally "concave" – begging to be deciphered.[31] Its forms never close on themselves, but remain open, always soliciting the spectator's presence. As a complete contrast, we might think of the following description of Parmigianino's Mannerist masterpiece, the famous *Self-portrait in a convex mirror*:[32] "The hand placed as though to block access to the mirror, in which no reflection welcomes us, and with enigmatic symbols of half-visible writing, will never make contact with our hand. Closed in the circle of the mirror, the portrait head excludes us from this perfect world [...] from any possible exchange." On the contrary, Cocteau's cinematic self-portraits always have an open-ended dynamism which renders such exchange possible. This is the dynamism of enigmatic margins, of continuous progress through the image and through reality, whether in the form of a descent into the Zone (Cocteau replaces the archaic picturesque of the Inferno in the manner of Dante or even Gustave Doré with the motif of ruins which resonate with modern memories and the modern imagery of disaster) or of *Le Testament*'s walk through a horizontal landscape interrupted only by purely conventional spatial thresholds (a door, a sea shore, a road), without recourse to the esoteric symbolism of mirrors. This is a game at once casual and serious, a play of dialogue and allusions, in which Jean Cocteau at last openly incarnates himself, disappearing as he paints a hibiscus flower and, in so doing, paints himself (unless, armed with a cloth, he is at once drawing and erasing himself). He passes one last time through the moving landscape of places, times and works, identities and myths, masks and faces until his final incarnation, his final death, his final disappearance in the living form of a hibiscus flower borne away by the wind.

31 See the famous cartoon of *Le Sang d'un poète*: "Every poem is a coat of arms. It has to be decoded."

32 Mary Ann Caws, « Doigt qui recueille, œil qui ondoie », *Figures du baroque, colloque de Cerisy dirigé par Jean-Marie Benoist*, Paris, PUF, 1983, p. 137.

Francis Ramirez
Christian Rolot

'The draper farce': a phantom sequence of *La Belle et la Bête*

There is an episode of *La Belle et la Bête* that film-goers have never seen, despite the fact that Cocteau was very pleased with it. This is the sequence he calls, in his shooting diary, 'the draper farce'. Here is what he wrote about it on Saturday 10 November 1945 at 9pm: "I won't say, what fine work (I don't know whether it is or not), but what good work I've done since yesterday morning. Everything fell into an unexpected order all by itself. I didn't feel my eye or my tiredness. Actors, cameramen and effects people were all lifted on the same wing, which seemed to have sprung from my heart. It was the comic scene where Marais and Auclair imitate girls in the great hall, after shutting the draper in the cupboard."[1]

The following evening, around 10pm, came the trial, always dreaded, of projecting the rushes. Cocteau's level of satisfaction rose still further. He had felt sure he had worked well the day before, now he found himself in the presence of a small miracle. "It is direct writing that doesn't pass through any filter", he enthused. "I thought I was watching music by Mozart [....] Visually – until further notice – it's like the opening of *The Magic Flute*".[2]

Then, two and a half months later, on Tuesday 22 January 1946, Cocteau dubbed the sequence at the Saint-Maurice studios and the feared "notice" still had not come to spoil his pleasure. It was now the comedy of this scene in the manner of Molière or Goldoni that he found so exquisite.[3]

However, when the film was released at the end of October, the sequence had disappeared and the poet, though always quick to comment on his work, said no more about it. From enthusiasm to a complete cut, from exaltation to silence – what had happened? What shadow had bared its teeth? Why did Cocteau stop liking something he had found enchanting? It is this little enigma that the present enquiry seeks to illuminate. Until now, in the absence of the sequence itself, we had only written sources: the shooting script and diary. These were not enough to enable us to do anything other than follow the film-maker devotedly in his delectation. But a chance discovery made in November 2000 in Cocteau's house in Milly-la-forêt was to change the situation.

In Milly-la-forêt

"Dear Jeannot, let's be brave. Our house at Milly will console us for everything", wrote Jean Cocteau to Jean Marais in a letter of the summer of 1946.[4] Indeed the elegant property the poet had bought in this little village in the former department of Seine-et-Oise would become the safest refuge of his last years. The house saw a gradual accumulation of manuscripts, drawings, pictures and all kinds of relics, survivors of many removals, saved from loss and theft. As the years went by the house in Milly-la-forêt became Jean Cocteau's treasure trove or, in the words of the monster from *La Belle et la Bête* – his "Diana's lodge".[5]

After 1963 Edouard Dermit, the poet's sole heir, became the guardian of the temple. The years passed and over time inroads were made into Milly's enormous cargo. Sales, gifts, unreturned borrowings and discreetly unexplained disappearances nibbled away at the legacy. After Edouard's death,[6] the courtiers were replaced by mystery hunters. What is an artist's mystery? In reality very little to the uninitiated: a page full of crossings out, a draft of a poem,

1 J. Cocteau, *La Belle et la Bête. Journal d'un film*, Paris, Ed. J.-B. Janin, 1946, p. 157.

2 *Ibid.*, p. 159.

3 *IIbid.*, p. 223. "The work was easy, since the boys were imitating the girls, who then simply had to imitate boys [....] The voice of Nane [Germon] coming out of Michel [Auclair] was really very funny."

4 Not dated, in Jean Cocteau, *Lettres à Jean Marais*, Paris, Albin Michel, 1987, p. 213.

5 "'You see that lodge', says the Beast to Belle. 'They call it Diana's Lodge [....] Everything that I own I own by magic, but my real treasures are in that lodge. Its door opens with a golden key."

6 In 1995.

a drawing, a letter still sealed, producer's accounts, everything that might be termed the dung of creativity. When researchers are on a site what they love above all is paper. A tin of film excites them less; they can't read it with their eyes. They'll go back to it later, after this diary, this notebook, these sketches. And the opening of that round tin is always put off till next time.

One tin among many

At least a dozen such tins had slept in this way for years in Milly-la-forêt. Most belonged to Edouard Dermit and contained amateur films shot during holidays with Jean Cocteau and Francine Weisweiller in the 1950s.[7]

All by itself, forgotten on a bottom shelf, there was also a larger tin with a capacity of 300 metres and no label.[8] Over time the metal had gone brown and, no doubt from being jolted and banged, the tin had been sealed by its dents, like Cinderella hidden by her rags. It contained a reel of 35 mm film, about 140 metres long, or about four and a half minutes' worth, in excellent condition with not a trace of scratches or splices. The reel had an optical sound track and clear leader at beginning and end. Inside, on a scrap of paper, Cocteau had scribbled, *La Belle et la Bête*.

Examination of the first frames with the naked eye – Jean Marais, Michel Auclair and a third man in seventeenth-century costume, walking close to the wall of a house at night with their oversized shadows cast by moonlight – revealed that this was 'the draper farce'. The first important information provided by the exhumation was the absence of splices and the presence of optical sound, formally indicating that this was a fragment of a standard print, and that therefore the cut had been made very late, after the film was finished. After disappearing for fifty years this phantom farce, the existence of which was known only through written evidence, was turning back into cinema.[9]

When projected the film does not belie the feeling of jubilation with which Cocteau was filled when writing his diary – indeed quite the opposite. What it shows is something very sharp, very alive, and it was easy to understand why the film-maker, who still felt himself to be an amateur in 1945, had been so intoxicated by his own mastery of cinematographic writing. A long tracking shot and a long crane shot create the framework round which the sequence is constructed and, with linking shots, made it possible to edit a very smooth, fluid and lively sequence, quite unusual from a practitioner of jerks and discontinuity like Jean Cocteau. So to some extent his joy could be explained by the mastery of classical orchestration he has so clearly attained here. The shots no longer simply follow each other in a series, they no longer count only in themselves, but dissolve into an overall phrasing which seems to have come all at once.[10]

However, even to those who know the plot, the scene proves very surprising. To put it briefly, it contains something quite strong, incongruous, like the surprise of a word that should not be heard, caught from behind a door in all its crudity. For it is one thing to know that Jean Marais and Michel Auclair imitate Mila Parély and Nane Germon (in order to persuade a rich draper that he is loved for himself and not for his gold), and quite a different thing to see two boys you thought you knew well going into a drag number in the middle of the film with complete and natural ease. The instant transformation of Avenant and Ludovic into girls (they have just made the draper climb into a cupboard so that he will hear Félicie's fake confession with his own ears) is very amusing – Cocteau was right – but in a way that smacks slightly of heresy.

Jean Marais, whose fine stature suddenly looks awkward, becomes a tall, simpering girl, punctuating her expressions of fright with dramatic sweeps of her train. The imitation is so precise, so striking, that one has the feeling of watching not a man pretending to be a woman so much as a woman who is rather too effeminate. The voice of Mila Parély, which Cocteau

7 Doudou, as close friends called him, was, sadly, a mediocre cameraman. It is strange to observe that his films are indistinguishable from other home movies of the time. We see Cocteau saying hello to the camera, pulling faces and sticking out his outsized tongue.

8 Having found it, Pierre Caizergues immediately passed it on to us for identification.

9 'The draper farce' figures in the storyboard published in 1970 by Robert M. Hammond and reissued in 1990 (Belfond). The scholar had judged the missing sequence to be about ten minutes long (p. 174) and noted that some 16 mm prints distributed in the United States included a scene at the inn which depended on it directly and which the cut had rendered incomprehensible (p. 111). The sequence found in Milly-la-forêt is clearly different from what was planned in the script. We have established a precise shot breakdown (see appendix).

10 The shooting diary explains this speed in great detail. "I built a vertical track from the ground to the loggia. The camera moved up and down following them as they ran. After lunch [...] I took the track down and laid another so that when the camera got to the end, it could pivot and pan across the entire room. This moving machinery enabled me to have the boys move very quickly, shifting from their roles to the sisters' roles, tearing down a tapestry and using it as a framework, in fact perfectly preparing for the dub with Mila and Nane, who are going to dub their voices when they imitate them" (*La Belle et la Bête, Journal d'un film, op. cit.*, p. 157).

dubbed on to the image of the actor, is crucial to the success of the effect. Her "Well, yes … I do love him" from Marais's lips strains her own register, making it more acid and shrill. While a man is imitating a woman on the image track, on the sound track a woman is aping a woman. Michel Auclair, in the role of Adélaïde, is perhaps less of a real girl, less ambiguous than Jean Marais, but more classically amusing, with a big face like an angry cow, his clumsy curves manhandled by Avenant who, with a brusque shove, pushes him down on to a barrel at the foot of the stairs. Meanwhile, as we have said, the pair are running around, charging up and down the stairs, sliding down the banisters, falling, getting up again and changing voice with each shift in the scene, giving the illusion that the two actors have become four. Hidden in his cupboard the poor draper, convinced that Félicie is burning with love for him, tenderly melts until he can't wait to hand over the two bags of gold promised to the hoaxers.

Mme Leprince de Beaumont's tale, which in its main elements Cocteau scrupulously respected, does not include anything that connects with this farce. The first script for *La Belle et la Bête*, written in 1944 and very faithful to the original text, does not include this episode.[11] The sequence does not appear until the last version of 1945, in which Cocteau freed himself from his model and introduced many elements of his personal mythology, and it is obviously in this context that it acquires its full importance. Drag is in fact a recurring element in the poet's oeuvre.

So, despite its tone of buffoonery, 'the draper farce' belongs to the same paradigm as the elements of fantasy that 'Cocteau-ize' the final script. Statues that move and men-women are fundamentally part of the same process of appropriation.

Drag and doubles

Drag artists and their hermaphrodite cousins are fairly numerous, or at any rate highly noticeable, in Jean Cocteau's work as a whole. The text devoted to the American acrobat Barbette, who performed exercises on the trapeze at the Paris Casino dressed as a woman, is undoubtedly the most significant of those written by the poet on this matter. To identify the position Cocteau adopted when dealing with a subject so often besmirched with smut, we need only quote one crucial passage: "He swung to and fro on the audience, on death, on ridicule, on bad taste, on unseemliness and on scandal, without falling".[13] In this sentence everything is said and faced head-on, notably the almost obsessional risk of sneering. In fact from many angles the drag artist appears in Cocteau's work as one possible figure of the poet. Like the poet the drag artist limps between two worlds; like the poet he exposes himself to insult and, in his own right, casts about him the disturbance that invents a new kind of beauty. This is not the place to draw up an inventory of these uncertain creatures who, in poems, drawings, novels, essays and plays, are exposed to the onslaught of the censors. But it is impossible not to see that, from *Thomas l'imposteur* to the *Livre blanc*. from *Le Sang d'un poète* to *Le Requiem* by way of *Le Fantôme de Marseille*, the Avenant and Ludovic of 'the draper farce' have a multitude of brothers and sisters throughout Cocteau's oeuvre.

Moreover, we know that, in real life, Cocteau, who liked farce as long as it was "long and realistic", would amuse himself and others by mimicking many female figures. Anna de Noailles, Mme Muhfeld and Sarah Bernhardt were his favourite targets, but many other less well known personalities were subjected to what all describe as his extraordinary talent for creating colourful characters.[14] The musician Igor Markévitch recalls a kind of number Cocteau would perform with Christian Bérard, affectionately called "the bearded lady". "I remember", he says, "evenings and indeed whole nights at Jean's place with Bérard. They liked playing 'ladies'. They would meet on the beach, discuss their home life, their husbands and so on. This exchange of imitations became a kind of ping-pong of humour and I can't think of any better description of the French lower middle classes."[15]

11 The first script, which we have consulted at Milly-la-forêt in a manuscript version marked as belonging to Marcel Bertrou, was written for Gaumont (who turned it down in April 1945) and still mentions Marcel Pagnol as assistant director.

12 For this complex process of 'Coctalization', see our book: F. Ramirez, C. Rolot, *Jean Cocteau, l'œil architecte*, Paris, Éditions A.C.R., 2000, pp. 164–73.

13 This text, of which we have reproduced only an extract, was written by hand around a self-portrait of Jean Cocteau dated 1924. It shows the extent to which the author had adopted Barbette's moral acrobatics.

14 Jean Touzot gives a detailed description of this talent for mimicry in *Jean Cocteau, Le poète et ses doubles*, Paris, Bartillat, 2000, pp. 32–33.

'The draper farce' fits into a certain logic of Cocteau's oeuvre in another important aspect. This is the penchant for doubles, so evident across his different means of expression. For in Cocteau's work the motif, whether narrative, dramatic or graphic, is always liable to undergo a kind of parthenogenesis. It splits, divides and gives birth to another that is at once the same and different. In *Thomas l'imposteur* Guillaume becomes Thomas, while the king of *L'Aigle à deux têtes* is born again as Stanislas. Of course this strange and continual parturition takes all kinds of forms, from the lightest to the most terrible, as when, in certain drawings of pain, an axe slices through the figure to the soul.[16]

Thus in reality the sudden transformation of Avenant into Félicie and Ludovic into Adélaïde simply follows a logic of splitting that is present throughout Cocteau's oeuvre and particularly in *La Belle et la Bête*. For here, to consider only the character played by Jean Marais, the question of what might be termed his nest of identities clearly lies at the heart of what the film is about. In this film Marais appears in three guises, as Avenant, as the Beast and finally as Prince Charming. His avatar Félicie was thus simply embroidering and reinforcing his fundamental changeability.

We should add that for Cocteau the character of Jean Marais (or should we say the person?) seems to have been a privileged conductor of his obsession with doubles. A rapid glance at the roles Cocteau wrote or reworked for Marais is proof enough. *La Machine à écrire* [The typewriter],[17] *Ruy Blas*[18] and *L'Aigle à deux têtes*[19] are particularly explicit in this regard: in the first play the actor played twins, Pascal and Maxime; in the second he played two doubles, Ruy Blas and Don César de Bazan; meanwhile in the third, an "extraordinary resemblance", to quote the queen, links the murdered king to the young anarchist. Without going into greater detail, let us note that in general Cocteau treated this recurrent splitting in terms of a more or less obvious principle of opposition: a dark, lunar, malign, fantastical and unpredictable side contrasts with the sun of a glorious role. Here again the hero of the phantom sequence is no isolated figure.

Difficulties of integration

Can we find out where 'the draper farce' was situated in the first print of *La Belle et la Bête*? It is hard to give a simple answer to this simple question. Close study of the last storyboard annotated in Jean Cocteau's handwriting[20] shows that several successive solutions were considered.

Indications for the initial phase are typed. At this stage 'the draper farce', preceded by a short explanatory scene (Ludovic tries in vain to persuade Félicie to marry a rich draper who is in love with her) comes after the passage where the Beast is very upset to learn that a handsome young man by the name of Avenant has already asked for Belle's hand in marriage. The comic sequence is noticeably different, being broken down into more shots than the version that was eventually filmed. It is developed from page 66 to page 72 and includes twenty-five shots (221–45 inclusive). It is followed by a short concluding scene in one take, where Félicie, mad with rage, is seen throwing a wet sheet at the draper's face, then by a longer scene (shots 247–56) at the inn, where the deceived draper tries to recover his money and gets a punch in the face.

The second hypothesis is based on a pencilled note on page 63, which proposes a more rapid edit, cutting the explanatory scene with the two sisters. Cocteau then links the magnificent shot in which the Beast, devastated at discovering he has a rival, leaps away through the bushes, directly to the first nocturnal shot of the lost sequence. This transition was obviously a good idea for several reasons: it linked night to night, exterior to exterior, movement to movement, and above all, it placed a less dramatic moment (three men creeping along almost in silence) after a moment of intense emotion. Thus the major effect of the devastated monster was not spoiled by comic dialogue that would claim the audience's full

15 *Cahiers Jean Cocteau* (Gallimard), n° 7, 1978, p. 80.

16 See, for example, the striking third drawing of *Maison de santé*, the collection published by Éditions Briant-Robert in 1926, with a new edition published by Fata Morgana in Montpellier.

17 Begun in 1939, this play would be produced in the Théâtre des Arts in April 1941, then in the Comédie Française in March 1956.

18 Cocteau adapted Victor Hugo's famous play at La Roche-Posay during the summer of 1943. The film, for which Henri Calef became responsible, was directed by Pierre Billon in 1947.

19 The play was produced in Paris in November 1946, with Jean Marais and Edwige Feuillère in the leading roles. The film, shot during the winter of 1947–48, was released in September 1948.

20 The first page of this document, which we have consulted in Milly, bears the words, "Productions André Paulvé". It has 125 numbered pages and sets out a storyboard in 413 shots, as published by Robert Hammond. Its particular interest clearly lies in Cocteau's 26 additional handwritten notes. These notes, which unfortunately vary in readability, concern plans to move sequences (including our 'draper farce') from one place to another, changes to the dialogue and indications such as "redo" or "cut".

attention, but could go on vibrating for a few seconds longer during the first shot of the following sequence.

A third solution, very similar in aim, is suggested by further pencilled notes added nearer the beginning of the script, at shot 195. This is the equally memorable scene in which the Beast, panting, his shirt and face covered in blood, appears in Belle's bedroom and begs her to forgive him. The Beast growls and we sense danger: "Quick! Quick! Close your door. Your eyes are burning me." Belle steps back and the door bangs shut. The torch goes out by itself and we hear the growls and footsteps of the retreating Beast. This creates a kind of narrative fade to black after which the nocturnal beginning of the arrival of the two boys and the draper would also have fitted very well.

Does the rediscovery of the sequence enable us to know any more? Sadly no, since there are so many possible places where it could have been included. The only certain way to establish Cocteau's chosen version would be to find the standard print from which the reel found in Milly-la-forêt was taken. The cut could then be identified from the splicing, like a scar. Obviously such a discovery is highly unlikely.

From the sum of these remarks, doubtless too detailed for anyone who does not know the film by heart, we can conclude that, for the poet, at an early stage, 'the draper farce' became one of those problem sequences to be found in so many works. They are clearly important to the author (as proved by their planned insertion at points of high emotion), yet, curiously, it proves very difficult to find aa appropriate place for them.

A risky sequence

The final question obviously relates to the reasons why the sequence was cut. Why did Cocteau leave out this entire section which, everything tends to suggest, he had good reason to retain?[21] Here again, in the absence of any direct evidence, we are reduced to conjecture. However there are two possible hypotheses.

The first – impossible not to think of – relates to the image, and more broadly the career, of Jean Marais. However attracted Cocteau may have been to this scene, he must have realised that the young actor would be compromised by playing in drag. Of course the drag was to make the audience laugh; it was a comic drag act. However it was so perfectly done that both press and public, who could not fail to be aware of the relationship between Jean Marais and Jean Cocteau and who, furthermore, assimilated homosexuality to feminine behaviour, would almost certainly have spiced up their enjoyment with a few barbed comments. Certainly by then Cocteau and Marais were battle-hardened[22] and, at least after *Le Livre blanc*, Cocteau had publicly abandoned what Colette mockingly termed "Mr Punch's secret". Nevertheless, however long-used to name-calling, the poet may have been worried about the actor's image and also that of his film. In the advice which, throughout his life, Cocteau gave Jean Marais about his career, this issue never went away. Over and over and in different ways he would tell him, "You cannot destroy your mythology".[23] Moreover, by having Mila Parély's shrill voice coming out of the young actor's body, Cocteau was running the risk of attracting unwanted attention to the fact that his hero's own voice was lacking in substance. We know that, before attaining the tanned tone that maturity brought to his voice, Jean Marais worked at lowering it by means of cigarettes and cold air.

We should add that at that time Marcel Pagnol was a close friend of Cocteau's and had already, and very sensibly, strongly advised him not to give the Beast horns, for the reason that in France horns automatically signified that a man was a cuckold.[24] We can imagine, guessing the words the worldly-wise Provençal writer might have chosen, that similar advice might have been forthcoming in relation to the scene where Jean Marais and Michel Auclair pretend to be ladies.

21 We should emphasize the fact that Cocteau kept only the 'heart' of the farce at his house, in other words the section in which Jean Marais and Michel Auclair dress up as girls. The additional details are not in the rediscovered tin.

22 We should remember that, from the spring to the winter of 1941, *La Machine à écrire* and *Les Parents terribles* had met with several very insulting articles that appeared in *Je suis partout* in the names of François Vinneuil (Lucien Rebatet) and Alain Laubreaux. These pieces raised the question of lifestyle in the most explicit terms.

23 J. Cocteau, *Lettres à Jean Marais*, op. cit.', letter of January 1958, p. 427.

24 Jean Marais himself records this in his book *Histoires de ma vie*, published by Albin Michel in 1975. We should also note that the presence of Marcel Pagnol's companion Josette Day in *La Belle et la Bête* meant that he had a personal interest in the film's production and success.

In *Portraits-Souvenir* Cocteau recalls the memorable scandal of the evening at the Théâtre des Arts to which, in the company of the tragic actor de Max, he had gone dressed as Heliogabalus, "with red curls, a weighty tiara, a train embroidered with pearls and painted nails". The party, he remembered, turned out to be a nightmare for him, and Sarah Bernhardt shamed him for making such an exhibition of himself. "I choked back my tears. The caviar of my mascara was running everywhere and stinging me. De Max realized he'd made a gaffe. He led us away, uncurled our hair, removed our make-up and dropped us off at home."[25]

Surely Jean Cocteau was doing the same for his protégé by cutting 'the draper farce'. Just as de Max removed the young man's curls and make-up, so Cocteau removed 'the draper farce' from *La Belle et la Bête*, buried it in Milly-la-forêt and never mentioned it again.

To this explanation, rendered all the more probable by a series of letters (in 1955 Cocteau was still begging Jean Marais to abandon the idea of doing *Chéri* in America in order to avoid appearing as the "creepy young lead")[26], we can add another internal reason, certainly less novelistic and piquant, but perhaps ultimately more decisive. For, when seen over and over during the edit and in private screenings, it would have become apparent that this sequence, at first lyrically compared to the opening of *The Magic Flute*,[27] creates one of those sudden collapses in tension that are among the most unfortunate effects of digression, however delicious that may be in itself. A remark in the diary dated 13 November 1945 suggests this and may also apply to the sequence that concerns us here: "As soon as a film moves away from its main characters and foreign elements are brought in, the rhythm is broken and can only be re-established with unbelievable effort".[28]

It is our view that this was the decisive reason. Cocteau did not want to slow down the machinery of his tragic tale for anything. The secondary element of this entertaining farce risked producing exactly that effect. The reasons of art are less spectacular than those of the heart, but they are nonetheless imperative and, whatever may be said of him, Jean Cocteau was obsessed by the idea that involuntary faults might disfigure his work. "Not a single day goes by", he wrote in his diary of the summer of 1955, "When I do not notice some fault in one of my works – even in those that were checked countless times [....] I see them suddenly emerge from their holes, like lizards."

'The draper farce', of which the parodic voices were silenced for nearly sixty years, may have been one of these.

25 J. Cocteau, *Portraits-Souvenir*, Paris, Bernard Grasset, 1935, pp. 162–63.

26 *Id.*, *Lettres à Jean Marais, op. cit.*, p. 373.

27 It is interesting to note that Cocteau had already made reference to this opera in 1932, in relation to the Marx Brothers' *Animal Crackers*: "Harpo! The little rag-and-bone man from the moon, the little man from *The Magic Flute*." (*Essai de critique indirecte*, Paris, Bernard Grasset, 1932, pp. 168–69).

28 J. Cocteau, *La Belle et la Bête, Journal d'un film, op. cit.*, p. 162.

'The draper farce', a rediscovered sequence from La Belle et la Bête

total length: 4 min 1 sec

1 ESTABLISHING SHOT, EXTERIOR, NIGHT (39 secs)
Avenant, followed by the draper and Ludovic, walks by the wall of the house. Long shadows fall. The three men make their way on tiptoe to some steps. Avenant is first to go up the steps and into the house. Through the window, he then guides his companions in.

The action is followed by a tracking shot to the right.

Ambient sound - silence

AVENANT (to the draper): *Your shoes are creaking.*
LUDOVIC (to the draper): *I want you to hear what my sisters think of you, without their seeing you.*
AVENANT (to the draper): *Mind the step!*

1. Avenant, followed by the draper and Ludovic, walks by the wall of the house

2 FULL LENGTH SHOT, HOUSE INTERIOR (18 secs)
Avenant walks towards the camera, holding a candle. Behind him are the draper then Ludovic. All three advance in single file, very close together, preceded by the camera tracking out.
When they pass the camera it pans round and films them from behind. On their left the trio pass a fine staircase to the first floor. They go towards the far end of the room. Ludovic opens the large wooden door of a wall cupboard and asks the draper to hide inside.

AVENANT: *Don't make a sound as you come in!*
LUDOVIC (to the draper): *We've got time. The house will be empty until eleven.*

Parodic music emphasizing the characters' movements starts at the beginning of the shot and continues until the end of the sequence.

LUDOVIC: *Get inside!*

2. All three advance in single file, very close together

3 TIGHTLY FRAMED SHOT OF THE THREE FACES, SEEN FROM OUTSIDE THE CUPBOARD (5 secs)
After hesitating, the draper does as he is told. Avenant locks the door.

THE DRAPER: *In there?*
AVENANT: *In there.*

4 CLOSE-UP, AVENANT (5 secs)
Avenant is seen with the candle in his hand, his face three-quarters to the screen. He whispers to the draper through the door. Ludovic is on the far right of the screen, with his back three-quarters to the camera.

AVENANT: *Don't move. Listen. Nothing must make them guess you're here.*

5 CLOSE-UP, THE DRAPER INSIDE THE CUPBOARD (2 secs)
He is listening, tense and silent.

... All would be lost!

6 CLOSE-UP, AVENANT (2 secs)
Avenant, holding his candle, finds the situation amusing. He winks at Ludovic and pulls a hideous face as he laughs.

3. The Draper gets into the cupboard

6. Avenant finds the situation amusing

7a. Avenant et Ludovic approach the sisters' room

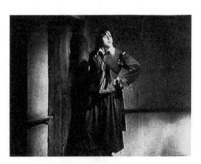

7b. Ludovic arrives at the door

7 WIDE SHOT, THE TWO BOYS (54 secs)
Avenant and Ludovic walk away from the cupboard towards the camera. Throwing off their hats they go up the stairs on the left, calling the two girls.
The camera follows them as they go upstairs.

Getting to the landing first, Ludovic moves towards the left, to the room his sisters are supposed to be in. He calls them.

Framed waist-up, he opens the door, closes it and, suddenly adopting a woman's pose, mimics Adélaïde's manner and voice.

Avenant joins him. In turn he mimics Félicie holding up her skirts and pulls a face to adopt her stiff, haughty expression.

Going back to the stairs, the 'two sisters' are unwilling to go down. The boys insist.

Avenant silently slides down the banisters to make the draper believe that Félicie and Adélaïde are still upstairs. At the same time Ludovic comes down in the normal way. The camera follows them, moving vertically down.

They run off screen right.

8 TIGHTLY FRAMED SHOT OF AVENANT AND LUDOVIC (22 secs)
Avenant and Ludovic come into shot and pull down the hanging. Avenant makes himself a train out of it and walks quickly as he holds forth. He is continually accompanied by the camera. He goes behind the staircase, comes to a large hearth, then returns to stand in front of the staircase, his hand on the banisters, tightly framed. Here, very solemnly and ridiculously, the drag Félicie confesses her love for the draper.
In the background we can see the cupboard doors.

9 CLOSE-UP, THE DRAPER INSIDE THE CUPBOARD (6 secs)
The draper is very moved when he hears the confession of the fake Félicie. A ray of light runs vertically down his face.

10 SHOT FROM THE WAIST UP, AVENANT AT THE FOOT OF THE STAIRS (11 secs)
Avenant, in the pose of a tragic actress, continues to make his declaration, his right hand clutching the banisters.

AVENANT: *Are you mad? You told him the house would be empty until eleven o'clock.*
LUDOVIC: *It doesn't matter. He doesn't understand what's going on.*
LUDOVIC: *Félicie!*
AVENANT: *Adélaïde!*
LUDOVIC: *Félicie!*
AVENANT (off): *Adélaïde!*

LUDOVIC (Adélaïde's voice): *What is it?*
AVENANT (off): *It's Ludovic and me. Come down.*

AVENANT (Félicie's voice): *We're coming down*
Goodness me, you're making us tired. What's going on?
LUDOVIC: *We had to talk to you without our father being in the house*
AVENANT (Félicie's voice): *Ludovic, I refuse to hear anything our father cannot hear. I'm going back up. Come on, Adélaïde.*
AVENANT: *Don't go. It's for the good of your father that I'm asking you to listen to Ludovic.*

LUDOVIC (off): *Your draper's love is drying up. You've got to decide, Félicie. You are too kind to let a man turn into the shadow of his former self.*
AVENANT: *Félicie, I know you have a noble soul and I've understood your secret. You love this man.*
AVENANT (Félicie's voice): *Well, yes... Well, yes... I do love him.*

And I'm forced to keep silent. Yes, I do love him, and I don't want

... let him know.

Ludovic, seen from behind, walks into shot from the front.
Both then walk away towards the background to be close to the cupboard in which the draper is hiding.

We are ruined Ludovic, he will think I'm marrying him for his money.
Ludovic (off): *Him?*
Avenant (Félicie's voice): *That's what he'll think, Ludovic…*

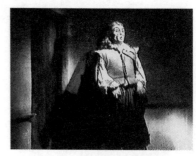

11 Close-up, the draper inside the cupboard (2 secs)
The draper, with a melting heart, raises his eyes to the ceiling and shakes his head with pity.

… and I shall die of shame.

7c. Avenant mimics Félicie holding up her skirts

12 Shot from the waist up, Avenant, Ludovic (26 secs)
The two boys quickly move away from the cupboard and go behind the staircase, followed by a tracking shot to the left.

Having walked round the staircase, Avenant and Ludovic, acting as if they are arguing, reappear in the foreground in front of the staircase. Avenant-Félicie is dragging the hanging along like a dress made of heavy fabric. Ludovic, in his man's voice, begs his sister not to sacrifice her love to her pride. He grabs her shoulders and shakes her as hard as he can. Avenant-Félicie becomes extremely agitated and violently pushes him away. Ludovic falls backwards and ends up on the ground next to a small barrel. At once he turns into Adélaïde. Avenant-Félicie, being an affectionate sister, crouches beside her.
But, humiliated and on the verge of tears, Ludovic-Adélaïde refuses all help to get up and, after very emphatically wiping her eyes with her train, starts back up the stairs, quickly followed by Avenant.

Avenant (Félicie's voice): *Do you think I could bear him to come upon me in a torn dress and with holes in my shoes?*
Ludovic: *But Félicie!*
Avenant (Félicie's voice): *Leave me alone!*
Ludovic: *Félicie!*
Avenant (Félicie's voice): *Ludovic, I've made my decision.*
Adélaïde is hurt! Adélaïde! My love! Adélaïde!
Ludovic (Adélaïde's voice): *Don't touch me! I can get up fine by myself. I've got enough strength to run and shut myself in my room and stop being present at such a scene. Goodbye!*
Avenant, shouting (Félicie's voice): *Adélaïde! My dear…*

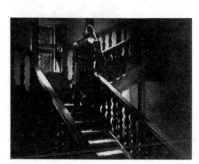

7d. Ludovic comes down the stairs in the normal way …

13 Close-up, the draper inside the cupboard (3 secs)
The draper's face as he hears the sound of running up the stairs.

Sound of running on the stairs.

14 Wide, high-angle shot down the stairs (15 secs)
The stairs seen from above, with part of the ground floor room. Avenant comes up, following Ludovic, who is already out of shot. The play of the argument continues. The two fake sisters go very noisily down the stairs.
Ludovic-Adélaïde goes towards a door, opens and closes it to give the illusion that they have left.

Avenant: *Don't run away!*
Ludovic: *My dear Félicie, I didn't want to hurt you. Listen…*
Ludovic: (Adélaïde's voice): *… No!*

A door closes.

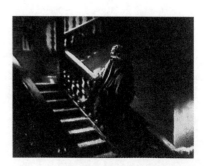

The two boys pause for a moment then open the cupboard door, which was slightly to the left.

7e. … at the same time, Avenant silently slides down the banisters

9. *The draper, deeply moved, in the depths of his cupboard*

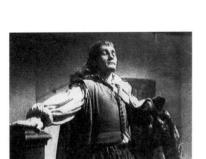

10. *Avenant, in the pose of a tragic actress, mimics Adélaïde's voice.*

15 TIGHTLY FRAMED SHOT, THE THREE SEEN FROM INSIDE THE CUPBOARD (12 secs)
Linking shot of the door opening.
The draper comes out of the cupboard.
The three men, with a conspiratorial air, quickly move away to the far end of the room. The draper is between the boys, each of whom has a hand on his shoulder. They walk out of shot to the right.

Fade to black.

16 WIDE SHOT, INTERIOR, THE INN, NIGHT (19 secs)
Two women are sitting in the foreground, darning cloth next to a man lying stretched out on a bench. In the background the door opens and the trio come in, Ludovic first. The three come down a few steps and cross the room, followed by a tracking shot sideways. They sit round a very rustic table. The draper, looking pleased with himself, brings two bags of gold out from his coat and gives them to Avenant and Ludovic.

[The reel kept by Cocteau ends here.]

AVENANT (to the draper): *Come quick, we can talk later.*
THE DRAPER (murmuring): *Ah...*
LUDOVIC: *We mustn't soften...*

AVENANT: *That's too much!*
LUDOVIC: *You're too kind to her!*
DRAPER: *She needs shoes, dresses...*
AVENANT: *Thank you ... Thank you!...*

'Coctalk' (*La Voix humaine*)

"Ways of giving weight to the invisible"[1]

La Villa Santo Sospir (1952) is Jean Cocteau's only documentary film, in which the film-maker is seen playing himself as artist, pedagogue and poet of the cinematograph. He appears as a slender, nimble figure, passing through gardens in a state of weightlessness, smoking cigarettes or emerging from the cabin of his yacht, a man full of imagination, gifted with multiple talents, whose body remains voiceless. Sometimes his lips move without emitting a sound, as in a silent film. In accordance with documentary tradition, the film is driven by a voiceover. This commentary offers not an expression of the subjectivity of an anonymous voice but, on the contrary, an impression of the timbre of the film-maker's voice, taken at a different time from that of the image, autobiographical and identified from the outset. Its pontificating, sometimes mocking tone helps draw back the dumb, blind red curtain and to bring these primitive images of an earlier time into the light. For with Cocteau the image is already there. The self-portrait is created, with a grateful acknowledgement to the cinema, by the voice of the graphic artist/ film-maker/ actor/ painter, now well-trained by its long relationship with the camera.

This is also Cocteau's only film in colour. Like a guilty man unmasked, he gives himself up to the justice inherent in cinema's lights and silence, and, on the border of a country still darkened by war, to representations of French geography – I refer to the single, disturbing shot of the shadow of the author's arm on the ground as he points out and names off-screen (but who knows, perhaps on-screen for once?) the towns all around. To all this, to these colours, the poet entrusts his skin, his paintings, his "tattooing" of the villa walls, a little of his material and bodily life, without saying a single word on screen. It is the portrait of an invisible, fluid voice that has been saved from the camera, defined by Cocteau's voiceover as "the most indiscreet eye in the world", just before he shows us his paintings on canvas, arranged and hidden behind wardrobe doors. The voice comes long after the image. It adopts the image, refines it, weighs and stamps it. Its elegance has weight. As Chris Marker profoundly noted, "Jean Cocteau's entire oeuvre is [...] an effort to attain weight, the most precise grasp of the world".[2]

"France has always killed its poets"[3]

Anyone who, because of films, has started to find his voice, whose burblings, speech and conversation have been born with visions of cinema and been authorized by its genius for transformation, as in the most conscious of waking dreams, owes a boundless debt of gratitude to Jean Cocteau. This demiurgical son, constantly tempted to tame, trap and embody his own Death, freely adopted the Muses as his mothers. Orpheus, the legendary Greek poet with whose character the film-maker identified, was the son of Calliope, supreme Muse of epic poetry and eloquence. Cocteau turned the cinematograph, with its crude ability to record reality as it moves and decomposes, into a source of inspiration.

In this territory that is darker and more shifting than ink, the writer/ graphic artist created a spoken language from the blackness of film combined with the unremembered whiteness between shots. Cocteau the film-maker invented the kind of voiceover which, with a

1 Chris Marker, « Le territoire le plus avancé de la démiurgie », *Esprit*, November 1950.

2 *Ibid.*

3 J. Cocteau, *Poésie critique*, Paris, Gallimard, 1960.

lack of discretion equal to that of the camera and noted at the time (*Les Parents terribles*, 1948) by André Bazin, addresses the audience and meets their expectations, like a voice on the telephone. Cocteau's voice produces an echo to be picked up the spy who seems to be watching the screen without authorization and following the person moving the camera. An unexpected dialogue is then established between the lapidary phrases spoken by the poet, whispered illegally from off-screen, through which "the most banal event always seems to have something indecent about it, like that of intimacy surprised",[4] and the words, exclamations, shivers and phrases uttered in the darkness of the cinema. Coming from the limbo of the off-screen space or from a time after that of the images, from the darkness of the wings or that of the cinema, these words are essentially clandestine, emanating from bodies in exile, separated from what their voices declare or whisper by the fact of being plunged in darkness, at once blind and imperceptible.

"Listening to the cinema talk"[5]

Jean Cocteau's films are always haunted by sound. To understand the truth of this one need only add to a viewing of the sumptuous *La Belle et la Bête* (1945) a reading of the daily events written by the writer-director on the sidelines of his shoot.[6] It is in the pages of his personal diary that the voiceover resides, absent for once from the film. This is the strictly inner voice of a film-maker who has terrible difficulty inhabiting his body. It is a quiet voice living in and through the film, blowing along its corridors like a draught, stifled in its mists, locked in the body of the Beast to be heard through the filter which distorts the voice of Jean Marais. This fascinating off-screen commentary on the direction and composition of a film plotted between August 1945 and April 1946 is also the diary of an unhealthy France, not yet in recovery, whose voice was exiled in London. Both actors and director divide their time between the crew and the doctors, the set and the hospital. You had to be ill to make this film.

Silence "backwards"

Location scouting in Touraine, the poet found the Beast's manor house and records the following amusing anecdote in his diary: "In one glance I recognized, down to the slightest detail, the set I had been afraid I would have to build. The man who lives there looks like the merchant in the tale and his son said to me, 'If you had come yesterday you would have heard your own voice. I was playing your records of poems to my father.'"[7] Jean Cocteau's "own voice", which remains resolutely off-screen until *Le Testament d'Orphée* (1960) resounds even in a place where he has not recorded it and announces his presence, or traces it in advance. Later, during the edit, this still novice film-maker discovers that films have a foreign, "almost Slavonic" language in their inner movement, which he calls "the backwards language". This enables him to watch his actors "living backwards" and, he adds, "I listen to them speaking this language which sounds like a real language because it has the same architecture as ours. [...] If I move the lever the other way they stammer, roar, hesitate, and then suddenly translate the words of the unknown language into French."[8]

In *Orphée* (1950) the radiophonic, off-screen voice of the vanished poet Cégeste (Edouard Dermit acting, Jean Cocteau for the voice) sends its messages from the shadows, the unoccupied zone. Orphée (Jean Marais), shut away in the black car of sinister memory, is a fan of these phrases, which resemble the coded announcements of Radio London (broadcasting to France during the war), repeated three times by the speaking ghost. These sentences lead him astray, like a path in the middle of the desert. One of them, anything but anodyne, states, "Silence goes faster backwards".

4 André Bazin, « Du théâtre transformé par la magie blanche et noire en pur cinéma », *L'Écran français*, 1948.

5 Subtitle taken from an article by Jean-Claude Biette: « Le film: en écoutant parler le cinéma », *L'Esprit de l'Europe*, Antoine Compagnon et Jacques Seebacher (dir.), vol. III: *Goûts et manières*, Paris, Flammarion, 1993.

6 J. Cocteau, *La Belle et la Bête, Journal d'un film* [1946], Monaco, Ed. du Rocher, 1958.

7 *Ibid.*, p. 21.

8 *Ibid.*, p. 233.

Cinema understands reversal. In Cocteau's films reversal and sound are closely linked. His concern with sound is as obsessional and evident as that of Jean-Luc Godard, who also invented a voice returned from the dead in his film *JLG/JLG. Autoportrait en décembre*. "Uncle Jean", as his New Wave nephew called him, devised camera movements to enable Mila Parély and Nane Germon, who played Belle's sisters, to dub Michel Auclair (the brother) and Jean Marais (Avenant), who were being filmed mimicking them, but off-screen. "The idea was", he wrote, "to put the girls' voices in the boys' mouths."[9]

Reversal makes it possible to create a new dialect, and also to reconstitute a flower, to stick back the petals that have fallen to the ground, to set it back on its stalk, in its shrub (*La Villa Santo Sospir*), to make death go forwards and life backwards and *vice versa*. The reconstitution of the flower is an image of the joint resurrection of body and voice – the link is made directly in *Le Testament d'Orphée*. The poet (Cocteau) finds Cégeste (Dermit) freshly returned from the black waters of the Mediterranean. The young poet sees the older man trampling a flower. "Aren't you ashamed?" he asks and, for the second time in his films, Cocteau films himself "backwards", busily reuniting petals and pistil and bringing the flower back to life. This image of ephemeral beauty given new life by a cinema that makes its compositions out of life and death reappears in *King Lear*, which Godard makes his own, as a "proof of love".

"Life is a long time dead"

So says the invisible voice before Orphée passes through the mirror, guided by the angel Heurtebise (François Périer). While Orphée and Heurtebise's interminable backwards walk retracing their steps to the mirror is filmed as a flashback with a following wind, it also inverts the position of the two characters. The erasure of their footsteps makes them lose their awareness of time, which is sucked into the moment – "Time moves quickly on screen if you cut it up" (*La Villa Santo Sospir*) – as in a power-cut. They plunge into a darkened space between dreams and no-man's-land. It is a serious, slow journey, a sequence shot between two frontiers that separate life from death.

> *J'ai mal d'être homme, comprenez-vous*
> *Si vous saviez d'ou je déplonge.*[10]
> [It hurts me to be a man, you understand
> If you knew where I'd dived up from.]

The disappearance of Sophie (Yvonne de Bray) at the end of *Les Parents terribles* also begins with a movement backwards. Looking at what is in front of her, being a spectator, exposes her to the unbearable. "It's unbelievable!" is the leitmotif of the play, uttered by tongue after tongue until it reaches the open mouth of Sophie the mother who, to paraphrase the author, cannot bring herself to understand what she does not believe. So she initiates her own disappearance by taking a few steps backwards, leaving the light-filled room containing everyone else. Her withdrawal is seen from a high angle. Cocteau often used this camera position when filming his plays (for example, the queen's carriage arriving at the castle in *L'Aigle à deux têtes*), which allows the audience to be voyeurs and to observe the closed space in which events are initiated. Sophie goes into the blackness on the other side of the door, then the blackness outside the frame and, seen from behind, goes to meet her death. The shot which shows her again shows her dying, and her fear before she disappears.

In *Le Testament d'Orphée*, when the poet finally succeeds in finding his way in a 'space-time' which has every appearance of being a time that will not pass, an unrepresentable eternity, Cocteau again shows a character going to face his death. This time the journey takes almost the entire length of the film and the film-maker's voice is present within his work for

9 *Ibid.*, p. 232.

10 J. Cocteau, « Tentative d'évasion », *Le Cap de Bonne-Espérance* [1919], edn Paris, Gallimard (*Poésie*), 1967, p. 60.

the first and last time, integrated by the actor/ film-maker/ poet in the same way as his costume and his period. He embodies his voice and takes the audience on an unforgettable journey through the ruins, a dangerous venture for this new, extremely mobile body, worried by possessing its own voice. His departure from space-time is magnificent: it is as though this gift of extra life were a gesture, an offering from his own death itself. His voice turns the figure to which it is attached into prey, a victim of synchronized sound, like the other actors. The complexity of this vision is simplified by the cinema. The shot in which the poet opens the doors of the portal that opens on to his own time, where the voice no longer comes after the image, is an inspiration. The opening of these doors is accomplished in a magnificent tracking shot that follows the actor from behind as he goes up to a porch with sliding doors like those of a hangar. He pushes hard on each side, without speaking, and eventually discovers, with us at last, without a gap, the dawn twilight of a deserted, abandoned landscape. It is an extraordinary sight in which our eyes take in a great expanse of air. The poet moves through the air in slow motion, like a wary cat. "Nothing travels for longer than the soul, and, if [the body] moves, the soul is slow to return to the body."[11] Like the soul, the voice is a component part of the perishable body. It has its own pace and space, unconnected to the body, which it takes time to join. When the poet crosses the threshold of 'space-time' and begins his walk, for a moment he is voiceless, perhaps soulless.

"There is a tragic, hallucinatory attempt on the part of everyone to identify with everyone", complained Marguerite Duras,[12] that other voice of French cinema. Whether they catch "the accidental synchronism" of music (*La Belle et la Bête*) or encourage silence (*La Villa Santo Sospir*), Cocteau's films have a power honed by the influence of childhood, both the cinema's silent childhood and the film-maker's own – in those days the two were inseparable. Cocteau acknowledges childhood as the source of everything for him. His was shared with his family and their leisured life, their receptiveness to the arts, and with the boys at his school, in their quest for victims and identification. One of these boys was Dargelos, whose snowball dealt the painful "blow from a marble fist" to a pale, fragile boy racked by love for him. The figure of Dargelos inspired and appears in *Le Sang d'un poète* (1930), followed, of course, by *Les Enfants terribles* (1950). This fine film, directed by Jean-Pierre Melville, was adapted and scripted by Cocteau, who also reads passages from his novel of 1929 in voiceover. The narration here is a lyrical exception: usually voiceover is used only for more succinct, less demonstrative utterances.

Cocteau's cinema is influenced and enhanced by this blessed, silent, attentive time, in which access to fantasy, play and the ability to "live a retold life", combined with the immodest innocence of "speaking aloud as we sleep",[13] do not yet offend anyone and are not yet subject to the judgements that must be faced by the adult and the poet. His films are more about voices and hands than looking and listening. Human beings, and particularly actors and poets, tend to make movements and say words. Throughout his life Cocteau identified only with the poet, always presented as such. From his first film, *Le Sang d'un poète*, to his last, *Le Testament d'Orphée*, he played this character, gradually emerging from the off-screen space. He inhabits his films; they are his castles. His existence within them is clandestine or ghostly, but he shoots each one through with arrow-like traces of his own life, deep, living wafts of his own breath, his rhythm, his line, his thought. According to Cocteau the poet is an archaeologist who "changes night into light"; he is not inspired, he expires. Expiration comes at the end of respiration, the moment when the breath can be heard; it is also death. "Writing on film as with ink", he wrote to his mother during the summer of 1930, "is something else, I can tell you, more serious, stranger."[14]

Film is a skin; it is a riskier, more open surface to appropriate and mark than the page, which is always *in camera*, even when published, or than the smoothed surface of the walls of houses and chapels decorated by Cocteau. Cinema screenings of films allow the film-maker,

11 Id., *La Difficulté d'être. Du gouvernement de l'âme* [1947], Monaco, Ed. du Rocher, 1957, p. 163. The disjointed rhythm of the soul, the slowness of its journey, described by Cocteau, is cited by one of his assiduous readers, Jean-Luc Godard, acting this time – in Anne-Marie Miéville's film, *Nous sommes tous encore ici: Dialogues*, Paris, Atelier Alpha bleue, 1997.

12 Marguerite Duras, *Le Monde extérieur*, Paris, P.O.L., 1993, p. 190.

13 In *La Villa Santo Sospir*.

14 Pierre Chanel, *Album Cocteau*, Paris, Tchou, 1970.

as Chris Marker has written, to "make other people dream them". 'Space-time' is an ideal partner for such an "assault on modesty", a scandal perpetrated by the poet who "publicly confides his secrets".[15] The cinema fosters 'vice' – an invitation to travel, but also and equally voyeurism and the exhibitionistic display of personal matters – which then becomes public, exorcizing private life, which by contrast can only be virtuous. Cocteau's cinema records a reality enclosed in a parallel universe, kept secret from our own, the "world of the screen" (Chris Marker again); one does not leave this world, imagined as a body, unless it be to return in a different state (or spirit). Until *La Villa Santo Sospir* Cocteau was breathing *in utero* in his films, transforming the off-screen space into an echo chamber or a sound box – his presence is detectable in the film's sound or construction, as attested by the recording of his own heart in *Le Sang d'un poète*. This is the first element of Cocteau to be heard on screen and, like his writing and his voiceovers, it is a quiet sound.

In an interview with *Le Monde* of 25 July 1959 the film-maker explained, "I exploit the realism of places, people, movements, words, music, to provide a mould for the abstraction of thought – and, I would say, to build a castle, without which it's hard to imagine a ghost. If the castle itself were a ghost, the ghost would lose its power to appear there and terrify us." The characters and actors are beloved ghosts echographed in an enclosed place or space by a vigilant camera. Castles and apartments are all stages of a theatre of which the doors are mirrors and *vice versa*. Cocteau's actors do not form a small world governed by social, physical or sexual hierarchies, nor a troupe, nor an appropriate cast; they are a choir of voices astounded to find themselves here, now.

The painful possibility of rebirth merged with the grace of the actor's performance is one last sigh offered by cinema. According to Cocteau, to return unchanged from repeated death is the test of the poet. This exhausting effort of reappearance is both a pendant to his vocation of "invisibility" and his exorcism. In continually dying, one grows used to living and returning to invisibility. Cocteau's films are preoccupied with writing, with the writing hand; they display eloquence in movement and gesture, in the actors' bodies, in the arm that points, throws, draws, in a gait, in the way a head turns, swinging into profile, its movements invented and paced by cinema. In these films people walk with their arms as much as their legs, backwards, on tracks, the body disconnected from the head; the constant attention and emotion on their faces gains as precise a significance as that of speech. In their return to life, to their home country, the dead reveal their renewed disappearance, on and off-screen, to those who live from day to day in continuity. Looking at life from the viewpoint of the dead, they address the impostors, those who adopt the approach of the living. When the poet pierced by Minerva's lance expires and exhales the words "How dreadful!" before falling to the ground, he is referring not to the pain of dying so much as to that of having seen what life has shown him, having seen "what man thought he saw" (Arthur Rimbaud). The images follow one another. In Cocteau's work this feeling is accentuated by the image's capacity to communicate, to open doors from one space to the next. The on-screen space of the film is like those huge ballrooms built for dances in stately homes, typically taking the form of a series of linked rooms with removable partitions that can be folded away depending on how many people are on the floor and how the space looks overall; they can be closed up in an accordion of doors, with or without glass or mirrors, with inhabitants – dancers, tapestries, audiences, ungraspable phantoms, music – as fleeting as the floors hired for a ball, or for the shooting of a film.

"An attempt to transmute word into deeds"
According to Cocteau *Le Testament d'Orphée* is "a syntax of images instead of a story accompanied by words". Cocteau's hands and voice linked together are vital functions of his cinema. The hands may be invisible or scarcely visible, gloved or naked, fleeting as the star with

15 Chris Marker, *op.cit.*

which he decorates his signature; they are a movement tracing words or lines, proposing and presenting. The voice makes the silence resound, it dictates the sound's reworking of the images, operates, listens and spies, performing its task by articulating the expiration of the poet-film-maker. In his notes on *La Villa Santo Sospir* Cocteau gives the following description of the house of his hostess Francine Weisweiller: "The silence of these walls was terrible and indeed they cried out their silence at the top of their voices [....] I wondered if it mightn't be possible to teach them to talk, or, to use a word a wall could understand, to murmur. To paint these walls was to replace one din with another."[16]

Cocteau's hands are the invisible hands of a choirmaster, indicating the music to the voices. They work in signs and the proliferation of signs, rather than representation. The way the shots are edited is an ordering of the narrative and nothing more. A narrative is a story told by someone who realises they are doing so and succeeding, translated into signs. "Translated from what? From that dead language, of that dead country where my friends died."[17]

Jean Cocteau's images show perceptible, observable phenomena, evidence proving the existence of a continual exchange between life and death. They suggest the truth of what is happening, of the things that can be seen in them and are not spoken of. The human voice is suspect and kept off, in the belly, in the wings, in the street. Events happen in these images without necessarily being understood. In Cocteau's work the cinema is a machine for reinventing movement, for making mirrors reflect, for reviving what is already alive. It is a silent mechanism, splitting "as though in relation to different attributions, the dual state of speech, raw and immediate on this side, essential on the other";[18] and dividing life from its reflection, leaving the usufruct to the audience, along with the freedom to believe in the reality of thought.

16 P. Chanel, *Album Cocteau, op. cit.*

17 J. Cocteau, *Le Discours du grand sommeil (1916-1918)* [1922], which begins with this question: edn Paris, Gallimard (*Poésie*), 1967, p. 150.

18 Stéphane Mallarmé, « Crise de vers », *Variations sur un sujet*, in *Œuvres complètes*, Paris, Gallimard (*Bibliothèque de la Pléiade*), edn 1989, p. 368.

Family jewels
The influence of Jean Cocteau
on experimental cinema

The films of Jean Cocteau, and particularly *Le Sang d'un poète*, exerted a profound and decisive influence over the American independent cinema of the 1940s, then still in its infancy. In *Le Sang d'un poète* Cocteau expresses his own particular vision as a poet. He creates a space for himself outside the cinema of entertainment, pursuing and reshaping a path that proved fruitful for all those who, like himself, regarded cinema as a new medium rather than just an industrial product. His subjective vision was to inspire young film-makers in their quest for personal expression, enabling them to develop a cinema of the first person. *Orphée* would later play the same decisive role for the next generation of American film-makers in the 1950s.

The ability to stand aside from a dominant current with which one felt no affinity, and to create a transgressive cinema which, recognizing difference and the existence of homosexuality, placed homosexual desire at the heart of the work, was, and perhaps still remains, part of the heritage left by the film-maker poet.

From the outset the first film by Cocteau that has been left to us,[1] *Le Sang d'un poète*, disputed the validity of surrealist aesthetics, although it was later assimilated to the cinematic corpus of the surrealist movement. When equal attention is paid both to the film itself and to its maker's statements, it appears above all as a piece all own on its own, similar in rhythm to the tranquillity of daydreams. It "imitates the mechanisms of the dream".

In *Le Sang d'un poète*, an attempt "to film poetry the way the Williamson brothers film the bottom of the sea",[2] Cocteau ventured into territories that he would exploit more fully some twenty years later. He was followed in his explorations by the young film-makers of the second American avant-garde, which began in the 1940s, chiefly on the West Coast of the USA. Cocteau was not seeking to make poetry with cinema, he wanted his film to be a vehicle for poetry, the basis from which poetry would emerge.[3] It is in this sense that he distanced himself from the strategies deployed by the surrealists and from their provocative images, the role of which was to liberate obscure unconscious forces as they manifested themselves in dreams. Cocteau on the other hand highlights the shifting quality of dreams; he gives primacy to the waking state in which each image evokes another, where they come together and respond to each other according to his desire. Poetry then becomes a visual medium and the questions connected to it are seen in terms of the relationship between the protagonist and the Muses, which takes the form of a coil of narcissistic questioning. The poet asserts himself through narcissism, which he sees as intimately linked to his poetic function, and which also enables him to show homosexual desire more or less directly. Masquerade, play and death act as variations on the theme of homosexuality, and provide a guiding thread throughout the film. We find them in the scene of the poet's suicide, the snowball-fight scene and the scene of the card game in the presence of a masked Harlequin, when the ebony angel is dying in the snow before a high-society audience.

Cocteau's film is imbued with a state of drowsiness, something also found in some American films of the early 1940s, including those of Kenneth Anger, James Broughton, Maya Deren, Curtis Harrington, Gregory Markopoulos and Sidney Peterson. Although in these film-makers' early works manifestations of the self are accompanied by violence and aggression

1 His film *Jean Cocteau fait du cinema*, whose title draws on those of Charlie Chaplin, was never edited and seems to have been lost. See on this J. Cocteau, *Entretiens autour du cinématographe* [1951], Paris, Pierre Belfond, 1973, p. 28 (reprinted Paris, Ramsay (*Poche cinéma*), 1986, as *Entretiens sur le cinématographe*).

2 The Williamson brothers made an adaptation of *Twenty Thousand Leagues Under the Sea* by Jules Verne in 1916, presented in Paris in 1918. Speech delivered by Jean Cocteau in January 1932 at the Théâtre du Vieux-Colombier: see J. Cocteau, *The Blood of a Poet, a film by Jean Cocteau*, trans by Lily Pons, London, Bodley Press, Hugo Editions, 1949, p. 47

3 Stan Brakhage made identical statements about poetry: "When I began my third film (*Desist Film*), I had no money. I wasn't yet sure of being a film-maker. Like Jean Cocteau, I was a poet who also made films. That's how I thought of myself: I was the Cocteau of Denver" (Stan Brakhage, *Brakhage Scrapbook, Collected Writings, 1964–1980*, edited by Robert A. Haller, New Paltz, Documentext, 1982, p. 113).

– we need only think of the sadomasochistic scene in Kenneth Anger's *Fireworks* – these are combined with a certain somnulence on the part of the protagonists. In reality the self is not yet fully constituted, its lack of definition causes images to float, if not actually to be suspended. Its assertion, often experienced through a series of tests, conditions the very particular atmosphere of each of the films. It leads to the development of different themes. In Gregory Markopoulos's trilogy, *Du Sang, de la volupté et la mort*, the theme of wandering is expressed in shots of trees, architectural details and flowers which, rather than advancing the narrative, are suggestive of states of beings and act as cuts, as interruptions in the flow. Wandering can also involve the stretching of time, as in Maya Deren's *Meshes of the Afternoon*. In this film similar scenes are repeated, multiplying points of view and deferring any development of the action in favour of variation. For example, the scene where Maya Deren, flower in hand, runs after a figure masked by a mirror, is repeated with subtle variations made possible by a series of shots acting as cuts. The lost flower becomes the key to a narrative of the gradual loss of identity.

The constitution of the self is also expressed through camera angles and framing, such as the low-angle shots in the scene of the beating in *Fireworks*, and also through groups of images showing us what the protagonists see. These are shown to us in the same way that the reality they see is shown to us, but we do not always know which reality or which protagonist is involved. In Markopoulos's *Psyche* it is hard to know through which character's eyes we are really seeing the scene of the gift of the rose. We constantly move from one side of the mirror to the other. In *Fragment of Seeking* by Curtis Harrington, the points of view are reversed as looks are exchanged between a young man and the woman he is preparing to kiss. The interminable pursuits of *Meshes of the Afternoon*, in which repetitions of the same action follow one on the other, their resolution perpetually deferred, maintain a state of uncertainty. The same is true in *The Dead Ones* by Markopoulos and Maya Deren's *Ritual in Transfigured Time*. The last scene of *Fragment of Seeking* produces the same effect of indeterminacy, giving us to understand that the woman being pursued was perhaps merely a narcissistic vision, a projection of the protagonist as a female character. The pursuit of the same through the other is represented in the manner of a mosaic of irregularly-sized pieces, and enables an effective exploration of the difficulty of facing one's own image, one's own reflection.

The gap between objective representation and the subjective image we have of ourselves turns the mirror into a privileged tool. The scene in *Orphée* in which Jean Marais embraces his own image in a mirror is exemplary in this regard. Following Cocteau, the mirror and its reflection inscribe an instability within representation. In *The Uncomfortable Man* Theodore Huff develops the theme of the mirror using an image projected on a face. The mirror does not reflect a fixed, stable image; it suggests a state of gas, liquid, or at any rate effervescence, which reveals the derelict state of the entire person, his lack of fulfilment. The discrepancy between the character and his reflection has nothing negative about it; it expresses an intermediate state, a state of being-between in which everything becomes possible. This state is characteristic of poets, of adolescents, of all those who cannot or will not become fixed in a role or state, but slip from one to the next. The evocation of homosexual desire in the films of Anger, Harrington and Markopoulos and of depersonalisation in those of Deren all portray intermediate states as suggestive of a difficulty of being in the world, which may be both uncomfortable and a great impulse to look beyond appearances.

With *Le Sang d'un poète* Cocteau launched, in the words of A.L. Rees, ''a genre in avant-garde cinema, the psychodrama, in which the central character undergoes a ritualized series of tests leading either to death or to transfiguration''.[4] He enabled a generation of film-makers to construct first-person, subjective narratives which portray psychic states and rites of passage. Disappearance is conveyed by means of a negative image in *Le Sang d'un poète* and in *Ritual in Transfigured Time* by Maya Deren. In leaving usual narrative forms behind the

4 A.L. Rees, *A History of Experimental Film and Video: From canonical avant-garde to contemporary British practice*, London, British Film Institute, 1999.

representations of these states and rites use forms which break up the narrative, making way for labyrinthine twists and turns and an accumulation of false trails, gaps, reprises, repeats and reflections. This explains the importance of the mirror, in which the subject confronts both his image and his otherness. This figure of the mirror links the subject to the look, establishing narcissistic fascination and moving away from any production of an image. In the mirror one can plunge into one's own image; it opens the way to the inner world. On passing through it one finds oneself at the heart of all that one does not dare experience, within the depths of the unconscious rather than held on the surface of the reflection.

Having fulfilled its role as the narrative's catalyst and provider the mirror may disappear, as in Jean Genet's *Un chant d'amour*, when the prisoner caresses himself, fantasizing that he is loved, unaware that he is being looked at. The narcissistic contemplation characteristic of Cocteau, Harrington, Markopoulos and even Michael Brynntrup is replaced by the gaze of the goaler, who can only express his erotic impulses through voyeurism and can only fulfil them through violence. The interplay of gazes here manifests a sadomasochistic component of homosexual desire, which we also find both in Kenneth Anger's *Fireworks* and *Scorpio Rising*[5] and in *Dead Youth* by Donald Richie, *The Illiac Passion* by Gregory Markopoulos or *Pink Narcissus* by James Bidgood. In the work of these film-makers the full development of the sadomasochistic tendency is revealed in highly lyrical and raw or very violent scenes, such as the sequence of the rape with mustard in *Scorpio Rising*. Here masculine embraces are a long way from the more conventional modesty of Cocteau's films[6]: the American film-makers share Jean Genet's pleasure in showing sexualized bodies. Where in Cocteau's work nudity was accidental, in Genet's it moves towards pornography and in Bidgood's it takes on the attributes of a kitsch that satisfies the protagonist's narcissistic fantasies. Here we move from homophilia, which merges with the pleasure of aesthetic contemplation, to an assertion of homosexuality which expresses itself in bodily pleasure. The recognition of pleasure and its representation on screen has caused Cocteau's star gradually to lose its brilliance for most gay film-makers from the 1970s to the present, with a few rare exceptions (such as Michael Bryntrupp).

Sexuality, long forbidden, finally asserts itself, becoming a driving force in cinematography. It is a mark of belonging to a group generally excluded from any representation in film and reflects the recognition of a different desire. In order to portray desire and naked male bodies film-makers are obliged to find forms that allow them to express such a difference. While Cocteau's work touches on sexuality, and sometimes evokes its narcissistic component, it is rarely explicit. Nevertheless it often leads to death, and here we see a parallel between *Orphée* and *Scorpio Rising*. Both films inhabit the realm of death, but the second asserts it even more violently.

The poet makes his way in a domain where the object of desire is not really fixed, but shifts, as it does in infantile polymorphism. The vagaries of desire and the poet's wanderings reappear in the American psychodramas of the late 1950s and 1960s, where we see the emergence of the figure of the carefree, directionless young man, perfectly embodied by Taylor Mead in *The Flower Thief* and *The Queen of Sheba Meets the Atom Man* by Ron Rice. The hero's physical wanderings go hand in hand with sexual availability. His apparently naive, childlike aspect and false innocence provoke forbidden desires; his nonchalant going-with-the-flow suggests the world of childhood which, as a metaphor for artistic creation, imbues almost all Cocteau's films, from *Le Sang d'un poète* to *Orphée* to *La Belle et la Bête*.

Cocteau's influence on the American film-makers can again be felt in his approach to the realm of childhood. Some of the American films give primacy to a childlike, not to say puerile, viewpoint, without establishing any kind of distance. These include Sidney Peterson's *Petrified Dog* or James Broughton's *Mother's Day* (in this film the adults play the roles of children in order to dive into memories of a time gone by). Others, such as Joseph Cornell and Stan Brakhage, recreate a fairy-tale way of seeing in some of their films.[7] Moving away from a stereotypical childlike vision, they try to rediscover a naive perception, of the kind a child

5 In this respect we can only regret the disappearance of the film of Jean Cocteau's ballet *Le Jeune homme et la mort*, with Jean Babilée and Nathalie Philippart in the title roles, planned by Kenneth Anger and shot in 1951 in 16 mm black and white instead of 35 mm colour.

6 "Half the critics regard *Le Sang d'un poète* as an erotic film and the other as an ice-cold, abstract work, from which all humanism is absent": *Entretiens sur le cinématographe, op. cit.,* p. 43. Whatever Cocteau, who saw his film as an erotic work, may have said about it, in our view his cinema was not the place where he worked hardest to manifest homosexual eroticism.

7 This fairy-tale aspect is also apparent in Kenneth Anger's *Rabbit's Moon*, in which two young children bring Pierrot a mirror. The presence of the mirror suggests narcissism and orphism.

might have on exploring the world before language, a world not yet informed by consciousness, a purely sensual world; they try to revisit the world of childhood and its traumas (*Le Sang d'un poète* and *Murder Psalms* are exemplary in this respect).

Childhood, reflections and indecision – everything in Cocteau's films that is ill-defined, unfinished and leaves the way open to the imagination has provided inspiration for his successors. However these film-makers transform his extraordinary material, giving it substance and violence. Where the aesthete's eye ran over scarcely revealed male bodies, his successors assert the sensuality and sexuality of nudity; adolescents wandering carefree give way to rebels and brutes. In Jean Genet's work as in Kenneth Anger's, the ill-defined is replaced by violence. Later generations would first draw strength from this force and then return to their famous predecessor. However, when they adopted him as a point of reference, it was for his lifestyle rather than as an artist. More than the film-maker, more than the poet, it was the dandy who was to set his stamp on the generation that included Andy Warhol, Gregory Markopoulos and Michael Brynntrup.

When Jean Cocteau was president of a cine-club: Objectif 49 and the Festival of *Film maudit*

It is quite a rare thing in a festival for a film-maker to present two new feature-length works. Jean Cocteau did precisely this at Venice in August 1948.

L'Aigle à deux têtes was screened in official competition and *Les Parents terribles* out of competition.

In addition the Italian selection included Roberto Rossellini's *Amore*, a film in two parts, one of which was *La Voix humaine*, based on a play by Cocteau, with Anna Magnani.

L'Aigle à deux têtes did not go down very well in Venice. However *Les Parents terribles* did: the young French critics were most enthusiastic. André Bazin wrote, "*Les Parents terribles* represents a revolution in direction and radically reworks the construction of sequences".

Every evening after the last screening we would gather at the bar of the Hotel Excelsior with Bazin, Jacques Doniol-Valcroze and a few others to talk over the day's films. Jean Cocteau liked to join us; sometimes Orson Welles came too.

We young critics attached great importance to the construction of a film, to what we termed its "writing" [*écriture*], shot sizes and camera movements. Cocteau also preferred the term "cinematograph" to that of "cinema" because the first contained the notion of writing.

His films bore this out – first *La Belle et la Bête*, in which the many special effects required diabolically precise shot breakdowns and editing, then *Les Parents terribles*, which involved the camera prowling round the characters and spying on them as through a keyhole.

In our nightly conversations at the Excelsior, we would talk with Cocteau about the position of French cinema in 1948, corseted as it was by administrative and trade union regulations. It lacked an avant-garde – perhaps we should create one.

The many cine-clubs in existence at the time all looked back to the past. They showed screen classics.

Why not set up a cine-club of a different kind, an avant-garde cine-club?

This was the start of the adventure of "Objectif 49". From start to finish its heart and soul was Jacques Doniol-Valcroze. On his return to Paris at the end of the Venice festival he assembled a few cinephiles who would become the club's active members. These included Léonard Keigel, who was then beginning to make films, Jacques Bourgeois, who worked at *La Revue du Cinéma*, and Grisha Dabat, who was given the title of General Secretary and took charge of the cine-club's relationship with Cocteau.

Almost at once a great many of us came to swell the ranks of Objectif 49, including Bazin, Pierre Kast, Alexandre Astruc, Roger Thérond, Claude Mauriac, Jean-Pierre Vivet, Jean Tronquet and Jean George-Auriol, whose wonderful *Revue du Cinéma* was in the throes of going bust; the penultimate issue had just come out.

Jean Cocteau, Robert Bresson and Roger Leenhardt agreed to be the presidents. Cocteau was the most present of the three. Other film-makers supported the movement, including Jean Grémilllon, René Clément and Marcel Carné. Of course we also had the support of Henri

When Jean Cocteau was president of a cine-club

Langlois and the Cinémathèque Française. But the help of one man was crucial in enabling us to set up Objectif 49; that man was Léonard Keigel's stepfather, Leonid Keigel, a cinema proprietor who programmed several Paris screens. He offered to do screenings for us in one of the most prestigious first-run cinemas, the 'Broadway' at 34 Champs-Elysées.

We developed the habit of meeting next door to this cinema, at Le Madrigal café. We would launch film titles and try to obtain a print afterwards. All of us were agreed on the general line: the aim of Objectif 49 was to help get films released, particularly those that had not found a distributor, and to enable films that had not done well first time round to be presented to the public a second time. Lastly, we would preview films that reflected our own ideas, tastes and passions.

For the first Objectif 49 screening, in early December 1948 at the Studio des Champs-Élysées, we did not look far for our opening film. We selected Les Parents terribles by Jean Cocteau.

As I was writing articles on film stars at the time, I was asked to bring one along. I knew Arletty; we used to go to the cinema together every now and then, and she agreed to come with me. We shared a box with Marcel Carné. The evening was introduced by Bazin and Cocteau and was a great success. People were turned away. We carried on in the following weeks, presenting other films, notably, on 12 December at the Broadway, Tragic Hunt by De Santis and on 27 December, once more at the Studio des Champs-Élysées, Rossellini's Germany Year Zero.

A few days before, on 21 December, the weekly magazine L'Ecran français had published a piece by André Bazin entitled 'Exploration of cinema. Defence of the avant-garde'. This was the club's founding text. In it Bazin recalled avant-gardes of the past and analysed the way in which Objectif 49 would do things differently way. He also replied to Henri Jeanson, who had ironically referred to Objectif 49's regular visitor as a "precious roll of film".

In early 1949 the number of screenings increased, and were often in different places, including the Musée de l'Homme, the Maison de la Chimie and the Marceau-Chaillot theatre. Times and venues would vary. Each screening would be introduced by a member of Objectif 49.[1] Sometimes there were surprises, as when, after a screening of The Magnificent Ambersons, Orson Welles told us about the passages that had been cut from his film and those that were not his (it is well known that he had been prevented from editing the final version and that new scenes had been included).

Thanks to its novelty, Objectif 49 soon attracted a large audience. Alongside the most passionate cinephiles (including some who would be spearheading the Nouvelle Vague a few years later), there was also a contingent from Parisian high society, who seldom otherwise went to cine-clubs. Objectif 49 was a place to be seen.

We were soon attacked, and in the most bitter terms. Louis Daquin was the first, in an article published in L'Ecran français on 8 March 1949, entitled 'Words out of place'. Daquin called us "formalists supported by a few hundred snobs". For him it was the content rather than the form of a film that mattered. He wrote, "Instead of examining Orson Welles shot by shot, instead of looking at the way the actors come into shot in this or that film by Renoir, explain to your members why the rest of us come away from the production houses with our scripts under our arms ...". He ended his diatribe, "You are not worthy of the critical freedom and independence your elders struggled so hard to acquire".

Two days later, on 10 March 1949, at the Maison de la Pensée française, there was a debate on the theme of the avant-garde, organized by L'Ecran français. André Bazin and Georges Sadoul expounded their opposing arguments. Supporters of the respective camps were there and the heated discussion continued well into the night.

Two weeks later, on 29 March, again in L'Ecran français, André Bazin and Pierre Kast replied to Louis Daquin. They observed that Daquin was unable to accept the move from

1 From January to July 1949 over thirty films were shown. Some were re-releases, including Christmas in July by Preston Sturges, The Rake's Progress by Sidney Gilliat, Espoir by Malraux, Le 6 juin à l'aube by Grémillon, Terre sans pain by Buñuel, Lady from Shangaï by Welles, Dernières vacances by Roger Leenhardt, Les Anges du péché by Bresson, Extase by Gustav Machaty, Brute Force by Jules Dassin, They Were Expendable by John Ford, Les Portes de la nuit by Carné, Crossfire by Dmytryck, L'Enfance de Maxime Gorki by Donskoï, Lumière d'été by Grémillon, It Always Rains on Sunday by Robert Hamer, Macbeth by Welles, The Magnificent Ambersons by Welles, Sous le soleil de Rome by Castellani, etc. There were also preview screenings of previously unreleased films including La notte porta consiglio by Pagliero, The Human Comedy by Clarence Brown, Foreign Affair by Billy Wilder, Pattes blanches by Grémillon, Hail the Conquering Hero by Preston Sturges, Here Comes Mr Jordan by Alexander Hall, etc.

2 This reception was held at the St James, a basement club on the avenue Montaigne, which no longer exists. Among those present were Robert Bresson, René Clément, Yves Allégret, Simone Signoret, Franchot Tone, Ludmilla Tcherina, Andrée Clément, Madeleine Renaud, Jean-Louis Barrault, Daniel Gélin, etc.

3 Cocteau himself shot a film on 16 mm, Coriolan, with Josette Day and Jean Marais.

4 The Biarritz cine-club prepared for the event by programming in June three films regarded as maudits: After Dusk Comes the Night by Rune Hagberg, Les Dames du bois de Boulogne by Bresson and Le Sang d'un poète by Cocteau. These screenings were introduced by François-Régis Bastide.

5 The panel of judges consisted of Jean Cocteau, René Clément, Jean Grémillon, Raymond Queneau, Alexandre Astruc and Claude Mauriac. Robert Bresson, Henri Langlois and Orson Welles were scheduled to be at Biarritz but did not come. The director of the festival was Grisha Dabat, the press officer Mitsou Dabat. Lydie

Mahias, Doniol-Valcroze's future wife, arranged accommodation for the young cinephiles.

6 The screenings took place at the town Casino. The festival opened with *La notte porta consiglio* by Pagliero, followed by Ford's *The Long Voyage Home*, *Zéro de conduite* and *L'Atalante* by Jean Vigo (Vigo's producer Jean-Louis Nounez attended both screenings), *The Southerner* by Renoir, *Kermesse funèbre* by Eisenstein, *Time in the Sun* by Mary Seton, *1860* by Blasetti, *Shangaï Gesture* by Sternberg, *Our Town* by Sam Wood, *Lumière d'été* by Grémillon, *Address Unknown* by R. Mate et W.C. Menzies, *None but the Lonely Heart* by Clifford Odets, *Kühle Vampe* by Dudow, *Unter den Brücken* by Kaütner (I had proposed these two films, I hadn't seen them and wanted to!), *La Belle Ensorceleuse* by René Clair, *Terre sans pain* by Buñuel, *Ride the Pink Horse* by Robert Montgomery (this film had the biggest success with the public), *Les Dames du Bois de Boulogne* by Bresson, *Mourning Becomes Electra* by Dudley Nichols, *Forgotten Village* by John Steinbeck and Herbert Kline, *Ossessione* by Visconti. Nine of these films were being shown for the first time and did not yet have distribution in France. Short films in the festival included Kenneth Anger's *Fireworks* and films by McLaren, Fischinger, Jean Rouch and Maya Deren.

7 As well as intense activity of a cinephilic nature there were also high-society receptions held by the marquis d'Arcangues, the comte de Vallombeuse and the comtesse de Beaumont. A *"Nuit maudit"* provided an excuse for fancy-dress. The undisputed stars of these events were Cécile Sorel and Tilda Thamar.

8 Sometimes also in another cinema, La Pagode. The films screened up to April 1950 included *Ride the Pink Horse* by Robert Montgomery, *La Belle Ensorceleuse* by René Clair, *Au-delà des grilles* by René Clément, *Alexander Nevski* by Eisenstein, *The Long Voyage Home* by Ford, *Un homme marche dans la ville* by Pagliero, *Passport for Pimlico* by Henry Cornelius, *The Strange Love of Martha Ivers* by Lewis Milestone,

yesterday's impressionistic criticism to today's criticism based on ideas, the study of films and their construction. "Everything that is truly useful to cinema", predicted Bazin, "will one day benefit the audience, even if prophets sometimes cry in the wilderness." He and Pierre Kast stated that Objectif 49 owed nothing to anyone; its members cared as much about content as about form. They concluded, "Our modest but legitimate ambition is to explore everything in today's cinema that refuses to accept commercial constraints. Does this make us aesthetes?"

Thanks to Cocteau we had been able to create a cine-club that was different from the others. Why should we not have a festival that was different from the rest? Cocteau encouraged us to set one up. Why not a festival of *Film maudit* [Accursed film]?

Jean Tronquet contacted the town council of Biarritz, whose dream was to compete with Cannes and its newly emerging festival. The marquis d'Arcangues and M. Guy-Petit, member of the French Parliament and mayor of Biarritz, warmly welcomed the initiative.

At a reception in early May 1949, in a club on the Champs-Élysées, the Festival of *Film maudit* was announced.[2] Jean Cocteau was not present, as he was on a theatrical tour in Egypt. A piece he had written was distributed: "We shall select the films ourselves", stated Cocteau. "We shall be biased." This was a revolution, the first public manifestation of 'auteur' cinema. It should be remembered that in festivals at that time films were selected by officials from each country. The USSR let it be known that it would not participate, given that "the films cannot be chosen solely on artistic grounds".

Cocteau went on, "The Biarritz Festival is intended to highlight films which, owing to their length or indifference to censorship and demands of commerce, represent a *curse* equal to that suffered by the books of certain poets". The term *maudit* [accursed] frightened the distributors. The distributor of *La Règle du jeu* refused to send a print because it "could jeopardize the film's distribution". Another of the innovations introduced by Biarritz was that it encouraged a different way of making films through the use of 16 mm. Objectif 49 invited film-makers working in 16 mm to come and show their films.[3]

The Festival ran from 29 July to 5 August 1949.[4] In the booklet published for the occasion Cocteau recalled that the term *poètes maudits* [accursed poets] was Mallarmé's. He went on, "These *poètes maudits* escape analysis and the judges prefer to condemn them outright". He added, "A fine film is an accident, it trips up dogma. It is such *films maudits*, of which the Cinémathèque Française has a great store, that we intend to promote and present at our festival."[5]

Jean Cocteau was the most assiduous of film-goers. He was present at every screening. Afterwards he enjoyed discussions with the audience, as did René Clément and Jean Grémillon.[6] We would often all have dinner together, in groups around the tables. It was an atmosphere unlike that of other festivals. We would listen to Cocteau, who fascinated us. He would talk about Lubitsch, whose films had opened his eyes to the cinema through their construction and *écriture*, the way they showed or concealed events. "Thanks to Lubitsch", he used to say, "I understood that what was outside the shot was often more important than what you could see on screen."

The young people attending the festival were staying in a high school dormitory. They included Eric Rohmer (also known at that time as Maurice Scherer), Jean Douchet, François Truffaut, Charles Bitsch, Jean Boullet and Jacques Rivette. There were cinephiles from England, with Graham Greene at their head. There were critics from *Séquence* and *Sight and Sound*, including Allen Brien and the future director Lindsay Anderson.[7]

Cocteau fell in love with the film *Mourning Becomes Electra* by Dudley Nichols, based on a play by Eugene O'Neill, and the jury gave it the prize. They had hesitated over *La notte porta consiglio* by Pagliero, but Cocteau won the day by pointing out that a film like *Mourning Becomes Electra* was a rarity in the American output. Two prizes were awarded for acting. One

went to Katina Paxinou for *Morning Becomes Electra* and the other to Vittorio de Sica for *La notte porta consiglio*. The prize for 16 mm went to Jean Rouch for *La Circoncision*. Rouch was one of the great revelations of the festival of *Film maudit*.

After the festival Cocteau began preparing to shoot *Orphée*. In August he wrote the preface to André Bazin's book on Orson Welles, which would come out in 1950. At the same time he was monitoring Jean-Pierre Melville's shooting of *Les Enfants terribles*. As he was very busy with both *Orphée* and *Les Enfants terribles*, he gave less time to the cine-club.

Early in October 1949 Objectif 49 bgean screenings again.[8] In January 1950 André Bazin, Jacques Doniol-Valcroze, Jacques Bourgeois and Jean Douchet went to Austria to present films selected by Objectif 49.

But the year 1950 did not begin well. André Bazin fell seriously ill, with the illness that would take him from us eight years later. He who had been so busy and worked so tirelessly had to interrupt his activities. He was only able to return to them a year later by economizing his energies. On 2 April 1950, on a road near Chartres, Jean George-Auriol was hit by a car and killed outright. He was forty-three. These two events played a part in the end of Objectif 49. However, it had always been planned, and was Cocteau's idea, that our cine-club should not become a fixture. The role of an avant-garde is to launch ideas, to alert the public, to generate enthusiasm, but it should know how to withdraw and die away, like a wave making way for other waves.

The last event organized by Objectif 49 was the Second Biarritz Festival, entitled *Le Rendez-vous de Biarritz*, which took place between 11 and 18 September 1950. The French distributors regarded the festival as "too artistic" and boycotted it; no French films were shown. On the other hand there were Russian films[10] and new foreign directors present, including Antonioni with *Cronaca di un amore*, Mackendrick with *Whisky Galore*, and stars including Lucia Bose, Dennis Price, Phyllis Calvert, Odette Joyeux, Nicole Courcel and Jean Marais. The festival continued to innovate with a concert of film music, conducted by Roger Desormière, and a stage performance of the film Jean Grémillon had been unable to shoot, *Le Printemps de la liberté*.[11] Absent from the festival were Cocteau (his film *Orphée* was on release in Paris), Bazin (he was in a sanatorium), Bresson, Leenhardt and Astruc.

In an article entitled '*Bilan sur Biarritz*' [Report on Biarritz], published in *La Gazette du cinéma* in October 1950, Jacques Rivette gave a largely negative account of the festival, concluding, "Objective destroyed". Jacques Doniol-Valcroze responded in the following issue of *La Gazette*, defending Objectif 49 and all its actions. "We do not aspire to success", he bravely stated, "it is the adventure that interests us." He added that Objectif 49 had developed a formula "which deliberately distanced itself from the classic cine-club formula of the time. This formula has become commonplace and anti-festival festivals are also in vogue. We are not so naive as to believe that we were alone in introducing innovations and seeking to promote a new avant-garde" This crossing of swords by Rivette and Doniol-Valcroze marked the end of the adventure of Objectif 49, initiated by Cocteau.

A few months later, April 1951 saw the launch of *Les Cahiers du cinéma*, of which the first issue was dedicated to Jean George-Auriol. The editors-in-chief were Lo Duca, Doniol-Valcroze and Bazin; the managing director was Leonid Keigel, the distributor who had made it possible to launch Objectif 49.

As for me, thanks to this cine-club and the festival of *Film maudit*, I was able to get to know Jean Cocteau better. Throughout my life I've always enjoyed talking cinema; with Cocteau it was pure enchantment.

Out of the Past by Jacques Tourneur, *The Maltese Falcon* by John Huston, *Gilda* by Charles Vidor, *I See a Dark Stranger* by Launder and Gilliat, *The Heiress* by William Wyler (film présenté par Cocteau), *Duck Soup* by Leo Mc Carey, *At the Circus* by Edward Buzzell, *Hellzapoppin* by H.C. Potter, etc. There were also shorts by Alain Resnais, Georges Franju, Pierre Kast, Luciano Emmer, Jean Rouch, Charlie Chaplin, etc.

9 Two days later he was to have introduced Leo McCarey's *Duck Soup* and *Les Charmes de l'existence* by Pierre Kast and Jean Grémillon at Objectif 49.

10 As the year before, the director was Grisha Dabat. The festival's president was René Clément. There was no jury and no prizes were awarded. The features screened were *King's Row* by Sam Wood, *Brighton Rock* by John Boulting, *Major Barbara* by Gabriel Pascal, *The Thirty-Nine Steps* by Hitchcock, *Crossfire* by Dmytryck, *L'Enfance de Maxime Gorki* by Donskoï, *The Capture* by John Sturges, *They Live by Night* by Nicholas Ray, *Intruder in the Dust* by Clarence Brown, *Give us This Day* by Dmytryck, *The Spider and the Fly* by Robert Hamer, *Whisky Galore* by Alexander Mackendrick, *Tombolo* by Giorgio Ferroni, *Cronaca di un amore* by Michelangelo Antonioni, *Le Troisième Coup* by Igor Savtchenko and *Le Rossignol de l'empereur de Chine* by Jiri Trinka. Shorts included films by Gjon Mili, Luciano Emmer, René Clément, Jean Grémillon, Pierre Kast, Jean Aurel, Jacques Baratier, Leonard Keigel, Henri Bonnière et Alain Resnais. Six Russian shorts were selected.

11 The performers included Maurice Escande, Louise Conte and Arlette Thomas. The Biarritz performances were introduced by Denise Tual and her assistant Michel Drach, the future director.

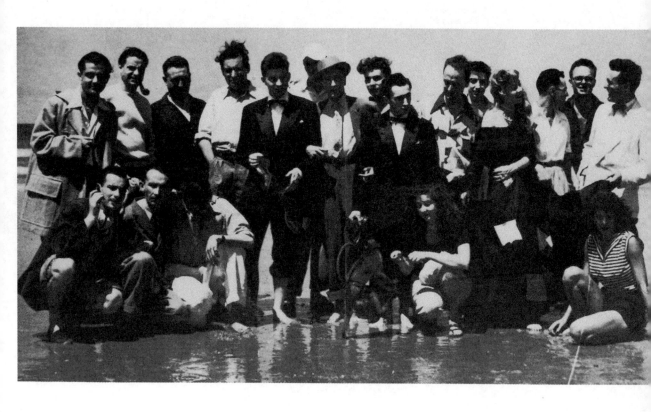

Festival of *Film maudit*, Biarritz, 29 July 1949
This photograph was Jean Cocteau's idea. On the first evening at Biarritz we had dinner with him
and some people complained that the local press were not interested in the festival of *Film maudit*.
"Let's go and paddle on the beach tomorrow morning at eleven", suggested Cocteau,
"And invite the photographers". He added, "If you can, wear a dinner jacket or evening dress".
Only three of the men had a dinner jacket, Doniol-Valcroze, Jacques Bourgeois and me,
while only one woman, France Roche, had an evening dress.
In the first row, from left to right, *Alexandre Astruc, André Bazin, Claude Mauriac,
Mitsou Dabat and Lydia Mahias*
Second row, standing: *Grisha Dabat, René Clément, Jean Grémillon, Raymond Queneau, Jacques Doniol-
Valcroze, Éric Rohmer, Jean Cocteau, Léonard Keigel, Jean Charles Tacchella, Jean Tronquet,
Roger Thérond, France Roche, Pierre Kast, Jean-Pierre Vivet and Jacques Bourgeois*

Jean Cocteau's dadaism

The name of Jean Cocteau is not one that immediately springs to mind in relation to the history of dadaism, but on the other hand it is not absent from that history, being linked to one of the movement's most sensational events. It is true, however, that in the history of Dada's contribution to modern and contemporary art, the 'split' between Tzara and the group of *Littérature* magazine on the "*Soirée du Coeur à barbe*" [Evening of the bearded heart] in July 1923 remains anecdotal.

That night, under the alarmed gaze of an informed audience and a few representatives from the international avant-garde, who have left us their accounts,[1] Tristan Tzara and his dadaist friends fell victim to brutal acts of assault and battery on the part of André Breton, Paul Eluard and others (who would later, from 1924, be called the "surrealists").

The conflict crystallized around the name of Cocteau, some of whose poems were recited at the event by the actor Marcel Herrand, among pieces by Tzara and Eluard. The members of *Littérature* had a poor opinion of Cocteau in every respect – he had been famous in the avant-garde for a decade or so – and could not bear to see Tzara refuse to ostracize him as they did.

The freedom of thought demonstrated by Tzara, Dada's founder, in the summer of 1923 was not new. In May 1921, he had paid mere lip service, with a ready tongue, as a witness in Breton's "trial" of Maurice Barrès, in which the writer faced "prosecution and judgement" by Dada. In November 1919, two months before Tzara arrived in Paris, Breton had written to him saying, "I'm finding *Littér.* very boring. I should like to be able to announce soon that it is merging with *DADA* and that there will be only one magazine, edited by you."[2] However, by one of those conjuring tricks that were Breton's secret, May 1921 saw the opening of a trial in the name of Dada, at which Breton himself presided, Tzara being no more than a witness.

Apparently wishing to give *Littérature*'s editor free rein – after all, his role in all circumstances was to foster things, to make them happen – Tzara allowed Breton to step out in front and take Dada over during the prosecution. However his unpindownable evidence, which met any attempt at Manicheanism with a bolt of caustic irony, exploded the entire trial and demonstrated, by ricochet, the validity of his own ethics. In Tzara's eyes the point was not to preside or to exert authority, still less perhaps to pass judgement, but instead, in all conscience, to develop the attitude most right at the time. There is no doubt that it was Tzara alone – sometimes, with a few friends, too much alone – who embodied the dadaist conscience. Against the rallying authority and presidential role which Breton regarded as incarnated in himself, Tzara advocated detachment and freedom of thought. Indeed this was so obviously the case that it was only by lashing out with sticks and fists, destroying sets and censoring the performance of *Coeur à gaz* [Gas heart], that the surrealists felt they had got the better of Tzara.

Back in the spring of 1921 friendship was still the order of the day. Less than a year later however, in February 1922, Tzara was again revealing his scepticism in relation to another of Breton's initiatives, a "Congress to determine directives and defend the Modern Spirit", whose eclectic committee included Léger, Ozenfant, Delaunay, Auric, Paulhan and Vitrac.[3] Tzara objected to the enterprise, stating, "The current stagnation, resulting from the merging

1 For example, those of the Dutch constructivist and dadaist sympathizer Theo van Doesburg (*De Stijl, Mécano*) and Jane Heap (*The Little Review*), to appear in French in Marc Dachy, *Archives du Mouvement Dada*.

2 André Breton, lettter to Tristan Tzara, 8 November 1919, *in* Michel Sanouillet, *Dada à Paris*, edn Paris, Flammarion, 1993, p. 471.

3 Aragon was also unconvinced. In 1972 he told me, "I was entirely hostile to this affair, which required us to develop relationships with people we had always fought against or for whom I quite simply had a general contempt": conversation with Aragon, published in « Dada Pansaers », *Plein Chant* (Bassac), n° 39–40, 1988, pp. 73–76.

of trends, the confusion of genres and the replacement of individuals by groups, is more dangerous than the reaction".[4]

This project, which disconcerted even Breton's close friends, definitively fell apart when Tzara won a huge majority during a big meeting at the Closerie des Lilas. Breton had made the mistake of putting members' signatures to a declaration issued by the "committee" without consulting them. He had also clumsily, perhaps unthinkingly, taken Tzara to task for his foreign origins, and questioned whether he was the authentic founder of Dada.

As a result, and despite their obvious mutual esteem, which neither ever denied, in Breton's eyes Tzara gradually evolved into the principal obstacle to his ambitions. The "*Soirée du Coeur à gaz*" was an opportunity to settle several quarrels, perhaps indeed with the aim of making Tzara face an unresolvable contradiction. The fact that it was Cocteau who became the pretext for what happened has implications extending beyond the anecdotal aspect of an event in which intellectual and aesthetic issues figure strongly. This was the first time that Breton and his friends adopted the strategy of a physical fight, to which Artaud would later also fall victim.

At the time of the "*Soirée du Coeur à gaz*", Tzara seems to have left the actor to select the pieces to be read. Despite an affectionate friendship which still recently bound him with Tzara, Eluard declared himself furious at seeing his name next to that of Cocteau. It would be very difficult to explain this reaction by artistic reasons alone. In *Vision in Motion*, an important book from 1946 documenting the period, Lazlo Moholy-Nagy, the artist and teacher at the Bauhaus, who was very sympathetic towards Dada, wrote, "Although the surrealists emphasized such a goal, the new form of communication was not accomplished by them, but more by the dadaists and simutaneously and even more by James Joyce. (This observation is not only valid in lierature. It is significant that the revolutionary impulses, and aims crystallized during the first quarter of the XXth century have been diluted everywhere into an often inconsequential aestheticism by the young generation.) [...] The dadaist poem shows more freshness than the surrealist literature. Dada is more 'poetic' and richer in its perceptive potency. In comparison to it an Eluard poem is rationalized fantasy, fireworks of images taken from the dictionary, not the eruption of life encompassing intellect and emotion. Except for his experiments in the simulation of psychotic writings, one is at a loss to see why Eluard is called surrealist. He is an amiable, melodious poet but rather conservative when measured by the dadaists' achievements of a multi-dimensional language." Point taken.[5]

Among the countless accounts of the event, that of Jean Cocteau is of particular interest. A few days later, on 1 August 1923, Cocteau wrote to Max Jacob, "You must have heard about the abominable fight at *Le Coeur à gaz*. I've never seen faces showing such stupid, narrow hatred. Those of Breton and Desnos were abject. It was about nothing but hatred. And that poor little J. Baron, just before he had his face rearranged by one of Breton's slaps, saying to me, 'Breton is too intelligent, intelligence is killing him' and so on, you know the story. Yes, Breton is a cretin."[6]

In this context, what happened on 6 July 1923 was a convergence of hostilities. But if Cocteau's fate within the *Littérature* group and later that of the surrealists would be a matter of quarrels, this was not his status within dadaism. A famous photograph shows the camaraderie that existed between Cocteau and Tzara at a time when Cocteau was providing the pretext for a confrontation that incontrovertibly proved there was no continuity between Dada and surrealism in Paris.[7]

Cocteau was the "apple of discord" between the dadas and the future surrealists. The term springs naturally to the pen; for, beyond any disagreement based on differences of aesthetic and ideological sensibility, it was in terms of sin that we must understand Breton's strong resistance to the simple possibility of group discussions of love and sexuality between men. This attitude is in itself surprising and raises certain questions. It put Breton in a dif-

4 Letter from Tzara to Breton, 3 February 1922, reproduced in Tristan Tzara, Œuvres complètes, I: *1912-1924*, texte établi par Henri Béhar, Paris, Flammarion, 1975, p. 590.

5 L. Moholy-Nagy, *Vision in Motion* [1947], edn New York, Paul Theobald & Co., 1961, pp. 341, 336. I have quoted the passages before, in my earlier works *Journal du Mouvement Dada* (Geneva, Skira, 1989) and *Dada & les dadaismes* (Paris, Gallimard, 1994).

6 Jean Cocteau, Max Jacob, *Correspondance 1917-1944*, éd. établie par Anne Kimball. Paris, Paris-Méditerranée / Ripon (Québec), Écrits des Hautes-Terres (*Cachet Volant*), 2000.

7 In Berlin with Hausmann, in Hanover with Schwitters, or in Tokyo with Murayama it was more a matter of continuity between Dada and constructivism. See Kurt Schwitters, *Merz*, éd. établie par Marc Dachy, trad. avec Corinne Graber, Paris, Champ libre/G. Lebovici, 1990, and Marc Dachy, *Dada au Japon*, Paris, P.U.F.(*perspectives critiques*), 2002.

ficult position in relation to several of his friends, not just those who were identified as "homo-sexuals" at the time, but also those who would be so later and almost certainly some whose sexual orientation is not known.[8]

I do not intend to slip into today's facile 'political correctness' by raising an issue which, when considered closely, has many strategic implications in relation to creativity. While Woman has a particular status in surrealism, as the object of idealization and systematic projection, several women were involved with dadaism as artists in their own right, includ-ing Sophie Taeuber-Arp and Hannah Höch, not to mention some remarkable intellectuals of the high level of Gabrielle Buffet-Picabia. This locates dadaism more in the tradition of the first avant-gardes, such as Russian suprematism. Tzara entrusted the great artist Sonia Delaunay with the sets for the *Coeur à gaz* event. In dadaism Woman is an artist and not a literary myth – as she is, for example, in *Nadja* – nor, like *The bride stripped bare by her bache-lors, even* by Marcel Duchamp, a receptacle for the projections of male artists.[9] In Aragon's account of the events we are discussing here, Iliazd's *zaoum* is regarded as a piece of Russian foolishness and Sonia Delaunay receives no consideration at all.[10]

Meanwhile the artistic importance of Tzara's play was definitively buried beneath the scandal that broke out when the attempt was made to stage it. In this light the effectiveness of the surrealist censorship of one of Tristan Tzara's major works has seldom been men-tioned.[11] However, all the events of the time should be interpreted in relation to the grad-ual suppression of Dada by surrealism, which the history of French literature as it is generally written confirms with every word. Do we even need to state that the battle joined that day has ever since been regarded as reflecting a potential for scandal attributed most generously, and with disturbing conventionality, to Dada? For though they are certainly part of the his-tory of Dada (surrealism simply did not yet exist at the time), the fact remains that these embarrassing incidents (in the course of which Breton was seen hitting Pierre de Massot, who was being held by two other pre-surrealists, and breaking his arm with his cane, while Eluard punched Tzara in the face) also reflect the rapid development of the surrealist com-mando technique. Strangely, the corollary was that the event was interpreted in reverse, with the resulting version being given credence by critics who were only too happy to be done with the demanding creativity of dadaism. In their eyes surrealism had come to bring order to the 'Dada adventure', which had run out of steam all by itself, collapsing into pointless scandals that ultimately wearied everyone. However this version forgets that, while the dadaists were certainly no strangers to the use of provocation – as long as it was leavened with a goodly dose of irony – they expressed it primarily through the creation of works that were "strong, straight, precise and forever uncomprehended" (Tzara, *Dada Manifesto*, 1918), for tactical reasons intrinsic to the rigour of the works themselves. The result was a single type of obligatorily polemical relationship between these works and an overwhelmingly con-servative public. But in the Dada record no dadaist was ever seen to adopt an approach of such dubiousness as that of the future surrealists' commando operation that night.

We should also consider these events from an artistic point of view. Without dwelling on the painful matter of the severe moral restriction inflicted by Breton and his friends,[12] we can observe that sexual differentiation acts to regressive effect in surrealism, while the mythification of Woman is by contrast strictly absent as a literary theme (love) from a dadaist diaspora quintessentially formed of differences of all kinds. Dada tends to fight on a higher level, struggling heroically in favour of abstraction and new art forms the intellec-tual importance of which far exceeds that of a literary theme (which, moreover, went on to cripple all surrealist painting).

For Breton's group love was a libertarian fight and, while the battle they fought in the society of their day must be credited with this fundamental quality, it nevertheless remains true that for Dada freedom lay above all in a rigorous struggle for the independence of the

8 We also know that it was for having called surrealism a "pederas-tic" activity in 1934 that Breton slapped Ilya Ehrenbourg, who had moreover become a supporter of the Stalinist regime. Breton was for-bidden to speak at the First International Congress of Writers for the Defence of Culture in June 1935. To crown it all, this incident seems to have played a part in the suicide of René Crevel, who had invested a great deal in the enter-prise and could not have failed to be very sensitive on this subject.

9 As today's 'Guerilla Girls' would put it, can a woman get into a museum otherwise than naked (canvas, sculpture, photograph)?

10 Aragon, *Projet d'histoire littéraire contemporaine* [1923], éd. Marc Dachy, Paris, Gallimard Mercure de france (*digraphe*), 1994.

11 Judgements on this play were hasty and artistically ill-informed. Tzara's own new edition of *Le Coeur à gaz*, published by Guy Levis-Mano in 1946, reflects the importance he accorded it.

12 Not to mention the painful case of René Crevel (see note 8).

visual and literary arts. We do no injustice to Breton by recalling that the entire avant-garde unanimously condemned him at a meeting at the Closerie des Lilas when, in the course of a disagreement, he clumsily alluded to the fact that Tzara had come from abroad. Within dadaism, which was international in its essence, everyone was a foreigner and Tzara, as his movement's moral leader, had better things to do than to cast a disapproving eye over Cocteau. On this level Tzara was the complete opposite of Breton, rallying and catalysing scattered energies in Zurich, Paris and Weimar, legitimizing them all, addressing an "authorization" to the Dada group in New York, welcoming Schwitters into Dada after he had been rejected by Huelsenbeck in Berlin, and many other actions.[13]

As a result the very name of Cocteau, and the difference in its treatment by Tzara and Breton, is highly revealing – as are other things – of the splits between Dada and surrealism.

Cocteau remains unique among all those involved in the dadaist avant-garde. A precocious poet, he had gained recognition at a very young age and was far from unknown on the Parisian scene. His real artistic experience is often perceptible behind his reactions, which were always nuanced by friendship. Cocteau and the dadaists, particularly Tzara and Aragon, became linked by ties of friendship and affection. Was Cocteau a dadaist? He himself said no, and he is absent from the famous list of presidents of the Dada movement drawn up by Tzara himself. This list appeared in February 1920 in the sixth issue of *Dada* magazine – four pages published on the occasion of the Morning of the Dada Movement, when Tristan Tzara had been exactly one month in Paris (the morning was held on 5 February, Tzara arrived very early in January 1920). Cocteau does not figure on this list, a close examination of which reveals once again the rigour underlying dadaist openness. While typographical approximations generally abound in the magazine, there are no spelling mistakes in the surnames on this list, which seems at first sight to cast its net wide, thereby asserting a generous openness in the dadaist spirit which borders on offhandedness. Artists both known and unknown are assimilated, with mere sympathizers in the dada constellation raised to the rank of President alongside founding members; however contributors to *Dada* magazine do not figure automatically.

In May 1919 Cocteau had given *Dada 4-5* "three easy pieces for little hands", published on a red background opposite Tzara's "note 14 on poetry". This issue dates from Dada's Zurich period and was typeset and printed by an anarchist printer, Julius Heuberger, whom the Dadas afterwards remembered with fondness. When the Swiss authorities put him in prison, the Dadas set about wreaking havoc by typographical means in his basement.

One can of course lose oneself in conjecture as to how Tzara established the nomenclature of Presidents, revealing possible contradictions which perhaps are not contradictions after all. The name Bloomfield (Blumenfeld) does not figure on the list, although he had joined Dada by sending Tzara a still-famous card from the "Chaplinist President". But Julius Evola is mentioned, even though in Rome this unconvincing "dadaist" had used the word Dada as the publisher's name on the cover of one of his works.

But, remembering that Tzara had only to leaf through all the issues of his magazine to find the names of all his contributors in alphabetical order, we can observe that he includes the names of all the authors from issue 4-5 except Jean Cocteau, Raymond Radiguet, Pierre Reverdy, Perez-Jorba, Paul Klee and, more surprisingly, Viking Eggeling. Tzara had already shown his admiration for Viking Eggeling – for example in "Zurich Chronicle" (published in *Dada Almanach* in Berlin in the autumn of 1920, a few months later) – whom he had met in Zurich. But Hans Richter has made clear, in *Dada XYZ* (1948), that "he [Viking Eggeling] joined our group but he was never a dadaist". In such a list, the absence of Cocteau's name enables us to make a few deductions. It was not necessarily his personal feelings towards the author or his work which mattered in Tzara's eyes, but the split Dada had created in the cultural system of the time. Radiguet and Reverdy were certainly not dadaists (in the case of Klee

13 When the entire surrealist group turned against Breton in the extraordinarily violent *Un Cadavre* [A corpse] (15 January 1930), Tzara refused to participate.

the question does not even arise). Many other creators, such as Picasso, do not figure on the list either, proving that, however surprising the annexations (Stravinsky) may appear, they nevertheless make sense. As often happens, the missing names say as much as, if not more than those that appear. Cocteau's case posed a question, which the list answered.

In correspondence with Cocteau, Tzara welcomed him to his magazine without regarding him as dada. Cocteau himself would declare that he was not a dadaist, although he was friends with Tzara and Picabia.

Cocteau's first letter to Tzara (then in Zurich until the end of the year) is dated 9 February 1919. "My dear Tristan Tzara, Thank you for your book in which the poetry takes shape all by itself in rock crystal. You give me great pleasure and I am following all Dada's efforts. Your Jean Cocteau. P.S. I have very few copies of *Le Cap de Bonne-Espérance*, but will send you one as soon as this becomes possible."[14]

This "book in which the poetry takes shape by itself in rock crystal" is probably not *La Première Aventure céleste de Mr. Antipyrine* [The first heavenly adventure of Mr. Antipyrine], which was published in Zurich in the "Dada Series" in 1916, but is more likely to have been the *Vingt-Cinq poèmes* [Twenty-five poems] published later in the same series in 1918 with ten wood engravings by Hans Arp.

When *Dada* no. 4-5 came out with his texts, Cocteau thanked Tzara on 1 June 1919 and drew his attention to a few errors: "My dear Tzara, Thank you for your album, in which I have found my little pieces. Sadly the suppression of the word "mint" [mint pastilles] takes away their main charm as "new fixed form", as does Ticla for Técla, since the last syllable of the first word rhymes with the last syllable of the final word. You see how fussy I am. Poulenc is currently setting these little pieces to music for song and orchestra: cornet, bass drum, triangle, accordeon, trombone. I should like to meet you and talk with you about these poems that touch me. Believe me to be your faithful Jean Cocteau."[15]

At the end of the same year, on 16 December 1919, when Tzara had just delivered a shattering reply to Jacques Rivière in *Littérature* magazine (*La Nouvelle Revue Française* had refused to publish his response), Cocteau wrote to him from 10 Rue d'Anjou, "My dear Tzara, I congratulate you on your answer to Rivière, perfect. Happy Christmas, Jean Cocteau."[16]

Tzara wrote back to him from Zurich, where he had time to receive one last letter from Cocteau. Twenty days later he was in Paris.

"10 Rue d'Anjou. Hello Tzara, your Christmas 'card' touches my heart. One doesn't like books. One doesn't like one's own books – that is why I didn't send *Le Cap*. I was hoping for a good adventurers' meeting.[17] I'm sure that we shall get along very well. I'm going to send you something for DADA, happy to be with you in any circumstance. Jean Cocteau, Paris, Christmas 1919."

Because Tristan Tzara was in Paris, there are no more letters to him from Cocteau until 30 December 1921, when Tzara was with Max Ernst in Cologne. "My dear Tzara, hello. I gave my poem Cocteau saluting Tzara to *Little Review*. I should like to see you. Please don't drink all the eau in Cologne. Wonderful card from Max Ernst. Thank you. Are there any others? hello Max Ernst, come back soon." Max Ernst, whose work had been exhibited in May 1921 at the Sans Pareil (exhibition organized by Breton at Tzara's instigation) had not been able to come to Paris, having been refused a visa by the French authorities. Cocteau decorated his letter with drawings – two crossed tibias, a death's head, a flower and a heart – which is something to be expected from him and was a practice he shared with Tzara, most of whose letters and dedications are covered in drawings.

To give a better idea of Cocteau's relations with the dadaists at that time it is tempting to quote other unpublished letters from Aragon to Jean Cocteau,[18] particularly since they shed light on the emotional climate of the group. The following letter from Aragon to Cocteau probably dates from 13 December 1919. "13. Thank you for *Le Cap*. But how can

14 Correspondance at the Bibliothèque littéraire Jacques-Doucet, Paris, Archives Tristan Tzara, cote TZR C 935.

15 *Ibid.*, TZR C 936.

16 *Ibid.*, TZR C 937.

17 The word Cocteau uses should be seen as an allusion to Tzara's *Lettre ouverte* [Open letter] to Jacques Rivière: "I do not write for a living and I have no literary ambitions. I should have become an adventurer of tremendous pace and delicate movements, had I the physical strength and nervous resistance to achieve one feat – that of not being bored" (*Littérature* 10, December 1919).

18 Correspondence preserved at the Harry Ransom Humanities Research Center (Carlton Lake), Austin, Texas, where I was able to consult it.

I talk about it with everything I'm hearing. I hate shady dealings. Jean Cocteau. I believed you in all simplicity. Wrongly it seems. They say you were poking fun. How can I be angry. Sadly all the same. Louis Aragon."

And from 22 December comes this: "*Vingt-Deux. Revenir / Paris si petit / Non / Le monde cage bleue et or / Je suis celui qui suis ailleurs / je déteste les arts / les artistes / les artisans / J'aime André Breton / qui ne m'aime pas / et il me faut d'autres décors / pour l'oublier le soir venu / qui sait Constantinople / LA.*"[19] [Twenty-two. Come back. / Paris so small / No / The world blue and gold cage / I am the one who am elsewhere / I hate the arts / artists / artisans / I love André Breton / who does not love me / and I need other settings / to forget this when evening comes / who knows Constantinople / L.A.]

These letters give a fair indication that Jean Cocteau played a part in the story of the friendships and passions that ran through the Dada group, the *Littérature* group and the friends they shared and who gravitated around them.

With perfectly consistency, Breton never published Cocteau in his *Littérature* magazine, but Breton does not represent Dada. The dadaists were less unswerving. As we have seen, Cocteau contributed to *Dada* magazine. Legend has it that Picabia left his pieces out of *391*, having promised to publish them; but on receiving a letter of protest from Cocteau, published them in his little magazine *Cannibale* in April 1920. In a few lines of explanation, he states that he had wanted absolutely to publish them but had had to abandon the idea at the last minute for lack of space. What is noticeable in Cocteau's letter, beyond the complaint of a man whose sense of friendship has been hurt, is the "confession" it contains: "What Tzara is doing often touches me very deeply. I can even say that, despite the fact that he is working at the opposite pole from me, Tzara is the only poet who touches me this way. Ribemont is pure, I am certain. But Dada, Dadaism cause me an intolerable sickness." The explanation he gives for this sickness is also of interest: first he states fairly baldly and bravely that "the session the other evening" seemed to him to be "appalling, sad, timid, far from all ambition" – this a reproach from a man who had worked with Picasso, Stravinsky and Diaghilev – but then puts on a slant consistent with the spirit of the times: "Tzara disorganizes. I find myself, me, a Parisian, faced with the first attempt at foreign propaganda that works". He nuances this judgement very usefully by emphasizing it: "It is your right, you have seen with what good humour I bore it and even that I did not hesitate to join in out of a disgust *for misunderstood patriotism*".

Cocteau may have been left out, but it cannot be said that he was not heard. At a time when the dadaists were being called Boches in the French post-war press, and Rachilde at Mercure de France was rejoicing at the death of Apollinaire, political nuances occasionally turned Cocteau into a real ally of the dadaists. Not only did Picabia take up the expression "Jean Cocteau the Parisian", from some of Cocteau's declarations in *391* but, in *Littérature* in September 1922, Breton turned the phrase against its author. "There are others, like M. Cocteau, whose names I should excuse myself from writing if it did not seem to me to be a matter of urgency to point out that they live off the corpses of the former [Breton had previously cited Valéry, Derain and Marinetti] and if their rantings did not ultimately cause us intolerable sickness. Anyone who has not read M. Cocteau's letter in *L'Intransigeant*, in which he undertakes to divulge his *poetic art*, will as yet be unaware of what can be produced on so delicate a matter by an author who possesses a genius for both nonsense and de-idealization."[20]

Breton's reference to Cocteau is not without importance. The piece in which it appears, entitled 'Clairement' [Clearly], is published on the first page of the fourth issue of the new series of *Littérature*. This was the issue with which, Soupault having disappeared from the magazine's masthead, and having got rid of Aragon, Breton became the sole editor. In his editorial Breton once more deployed his troops (September 1922).

19 *Ibid.*; one may note the emotional content of this letter, discovered thanks to an essay in progress on Tristan Tzara.

20 Breton uses the expression without quotation marks. Perhaps he does not want to seem simply not to remember Cocteau's words. I have not been able to find "*l'art poétique*" [poetic art] addressed to *L'Intransigeant* in Cocteau's complete poetic works.

The main target of his barrage was Tzara. Breton published the partial, truncated translation of a piece by the Berlin dadaist Richard Huelsenbeck which was intended to denigrate Tzara. This should be seen for what it is: Huelsenbeck had been in competition with Tzara from Dada's first moments in Zurich. The obscure meanders of human psychology meant that the most brilliant of the dadaists, unanimously acclaimed by his friends, nevertheless faced systematic and undiminished opposition – a kind of *reductio ad absurdum*. It was only on Tzara's death in late 1963 that Huelsenbeck laid down his arms and wrote a moving funerary tribute to his enemy-cum-friend of the earliest days of dadaism.[21]

In '*Clairement*', which is clearly a settling of accounts, the paragraph devoted to Cocteau proves, if proof were still necessary, that his presence in the dadaist arena was far from a matter of indifference.

However, Cocteau was not totally absent from *391* in 1920, nor from *La Pomme de pins* in 1922. In November 1920 we find two brief declarations from Cocteau (they were scattered through the dadaist magazines), at least one of which must have seemed to Picabia to have the merit of deepening the gulf between Cocteau and Breton, not to mention its thought-provoking charge: "Rimbaud went to Acre to get away from *Littérature*". It also shows that Cocteau was used as a tool reflecting differences of sensibility between the blocs formed by Tzara on the one hand, by Picabia on the other, and their common interlocutor, the *Littérature* group (Aragon, Breton, Soupault). Once again the Cocteau who played this role was sympathetic but unconvinced, in other words polemical.

Cocteau's last appearances in Picabia's publications sound two ambiguous notes. They come in the only issue of the magazine *La Pomme de pins* [The pine cone], published by Picabia from Saint-Raphaël to show that, despite all expectations, he was in favour of the Paris Congress. The first declaration states, "Jean Cocteau became Dada as he became a cubist, as he was the friend of Sacha Guitry, as he was the friend of Rostand, as he was a nationalist". The second, signed Francis Picabia, seems to be a protestation of sincerity on the latter's part. "My dear Cocteau, all that I had to say about you I have written. What they're telling you at the moment is pure lies, Tristan and dear Ribemont take note." Like Aragon's letters to Cocteau, this open letter from Picabia to Cocteau shows that Cocteau's time in dadaism was spent partly on the boards, partly in the wings and rarely with works in hand.

Music soothes the savage breast and the literary world was to benefit not from Cocteau's poetry, but from his jazz band, a few weeks after the non-publication of his poems in *391*. This was on the occasion of the private view of Picabia's work at Povolozky's gallery (La Cible, 12 Rue Bonaparte). But nothing in the relationship between Cocteau and Dada is ever simple; that evening, when Cocteau was a full participant in a dada event, Aragon was delivering a thorough critique of the jazz band and its success.[21]

21 See Marc Dachy, *Tristan Tzara dompteur des acrobates*, Paris, L'Echoppe, 1992, p. 23.

22 Aragon, *Projet d'histoire littéraire contemporaine*, op. cit., p. 109f.

Adieu Dada mon seul voyage

Jean Cocteau, le parisien.

Jean Cocteau and *Littérature* magazine (1919–23)

1 Hans Richter, *Dada, art et anti-art*, Brussels, La Connaissance, [1973], p. 116.

2 Jean Cocteau, letter to Irène Lagut (25 September 1920), *Lettres de L'Oiseleur*, éd. établie et annotée par M. Burrus, Monaco, Éd. du Rocher (*Alphée*), 1989, p. 175.

3 F. Picabia, « Francis Picabia », *L'Esprit Nouveau*, n° 9, juin 1921, p. 1059.

4 Nickname given to Cocteau.

5 Geneviève Latour cites Guillaume Apollinaire in *Les Extravagants du théâtre, De la Belle Époque à la drôle de guerre*, Paris, Bibliothèque historique de la Ville de Paris, 2000, p. 68.

6 Georges Ribemont-Dessaignes, *Déjà jadis ou Du mouvement Dada à l'espace abstrait* [1958], Paris, Union parisienne d'Édition (10/18), 1973, p. 111.

7 The retrospective performances by the Ballets Russes took place on 13 May 1912 and 18 May 1917 at the Théâtre du Châtelet.

8 Philippe Soupault, *Mémoires de l'oubli. 1914-1923*, vol. 1, Paris, Lachenal et Ritter, 1981, p. 89.

9 Letter from André Breton to Tristan Tzara (Tuesday 18 February 1919), quoted by Michel Sanouillet, *Dada à Paris*, Nice, Centre du xxᵉ siècle, 2000, p. 441.

10 During a morning devoted to Max Jacob (10 May 1919) Dermée had presented a paper in which he compared Jacob's verse to the creativity of the mentally ill. Breton later said he had "made [Dermée] pay dearly for this extraordinary clumsiness", in a letter to Tristan Tzara (12 June 1919), quoted by M. Sanouillet, *Dada à Paris*, *op. cit.*, p. 445.

Even today, Jean Cocteau's place within dadaism remains enigmatic. The ambiguity of his relationship with those responsible for *Littérature*, dadaism's organ of expression in France, seems to have been maintained intentionally. There is nothing surprising in that, it will be said, since ambiguity seems to have been the keystone of the Dada edifice.

More than any other relationship, that between Cocteau and André Breton provides a perfect illustration of the phenomenon described as follows by Hans Richter: "As a consequence of their obsession with opposing banality at all costs they viewed all human relations marked by a certain sensibility with a distrustful eye and resolutely stood on their neighbours' corns. Falling out and insolence became habits [....] Life was lived in trenches and no one bothered much whom they hit [...]."[1]

Cocteau maintained "elastic", contradictory ties with the dadaists; disputes and reconciliations were all part of the daily life of these "cannibals of Montparnasse and Montmartre".[2] But, as usual, Breton kept a jealous eye on his disciples, as Picabia has him say: "[...] I should have liked to have lived around Nero's circus, I find it impossible to live around a table of the Certà, the location of the dadaist conspiracies".[3]

Breton cannot be dissociated from the evolution of the Dada movement in France, whose leader he undeniably was. His avowed animosity in relation to the "frivolous prince"[4] also legitimizes the present analysis, which seeks to privilege Cocteau's relationship with the most emblematic figure of the Parisian manifestation of Dada, with whom he maintained the most ambivalent of connections.

Why did Breton open the doors of *Littérature* to Radiguet but shut them to Cocteau, if not out of Machiavellianism? This is not too strong a word to use, judging by the virtuosity of the manoeuvres deployed in either camp. It was war that Breton declared on Cocteau, rather than any literary quarrel. This hostility is part of the mystery of Cocteau's relationship with Dada and with surrealism because, irony of ironies, it was through his intervention that "sur-realism" was to be invented: "[...] In *Parade* there resulted a kind of sur-realism, which I regard as the starting point for a series of manifestations of this new spirit [....]"[5] While the word should not be understood here in the sense later attributed to it by the 'real' surrealists, it has nevertheless been uttered.

To return to dadaism, it must be agreed that the uninitiated do not necessarily distinguish what is dada from what is not. A dadaist would retort, "Not everyone who wants to be dada is dada". Moreover the movement's leaders interpreted Dada in extremely variable ways, engendering the well-known splits: "From the beginning, the spirit of the *Littérature* group was very different from both Tzara's group and Picabia's".[6]

Cocteau clearly had all the qualities of a perfect dadaist. This was the unpardonable crime for which Breton would make him pay throughout his life. Was Breton afraid of remaining in the shadow of the sparkling author of *Le Cap de Bonne-Esperance*? This is unlikely; he was never one to be outdone. So jealousy and rivalry alone cannot justify such a degree of acrimony. At least this is what we shall attempt to prove.

When Apollinaire died, Cocteau proclaimed himself his successor, which instantly drew the fire of the future dadas. The "ill-loved" shadow was still prowling the streets of Paris. As a

result the whole of the Parisian avant-garde claimed to be part of the New Spirit, each convinced the while that they were defending an individual aesthetic.

By this time Soupault was already the author of a small collection entitled *L'Aquarium*, published at his own expense in 1917. Aragon and Breton were studying medicine without much conviction. After publishing a few poems in *L'Anthologie de la jeune poésie*, Breton prepared to publish *Le Mont-de-piété* [The pawnshop]. All three had already been picked out by the magazines of Birot and Reverdy, to which they contributed.

Cocteau was a few years older and could claim more sustained and elevated experience. Between 1909 and 1912 he had published *La Lampe d'Aladin* (1909), *Le Prince frivole* [The frivolous prince] (1910) and *La Danse de Sophocle* (1912). It was not, however, until 1918 that his first real poetic work, *Le Cap de Bonne-Espérance*, came out. Where theatre was concerned, he had written the libretti for *Le Dieu bleu* and *Parade*.[7]

However the itineraries remained vague on both sides.

1919: the launch of *Littérature*

With Soupault's support – "All three of us had decided (remembering Apollinaire's warning, 'Don't trust Cocteau! He's a cheat') not to allow Cocteau to contribute to our magazine"[8] – the editor of *Littérature* at first rejected any involvement from Cocteau in his publication: "[...] There is not one omission: Dermée, Birot, Picabia, Cocteau, etc., that we have not thought about".[9] Breton was only partially true to his word. Despite the incident at the Rosenberg Gallery,[10] Dermée was published several times, as was Picabia of course, but not Birot or Cocteau.

It was probably at Aragon's request that Breton declared himself ready to reconsider his judgement of Cocteau. However, the growing sympathy between Aragon and the author of *Le Cap* soon tempered this fit of indulgence. Breton's distrust was all the more justified by the fact that the beginnings of this friendship mysteriously coincided with a coolness between himself and Aragon.

At this time Breton's hostility towards Cocteau had already ceased to be a secret for anyone. "There is one category of people I can't stand: those who, in memory of Jarry, I privately call 'pale boys'. Cocteau, Birot and Dermée fall into this category."[11]

"My feeling, entirely disinterested I swear, is that [Cocteau] is the most hateworthy creature of our time [...] and I assure you that hate is not my strong point."[12]

At first Tzara turned a deaf ear to these diatribes. Indeed he asked Cocteau to contribute to *Dada*, which was "intended as a magazine in which all the new trends are represented".[13] For his part, while loudly proclaiming his "esteem"[14] for Breton, Cocteau nevertheless acknowledged that, "With A[ndré] B[reton]: misunderstanding. It's sad. Me, I eat, I talk, I jump into the sea. A[ndré] B[reton] chews a pebble along the beach like Demosthenes. It's hard for us to get on."[15] His esteem was not shared at all. In addition to Breton's mockery Cocteau had to suffer that of Picabia and Aragon, who respectively nicknamed him "the Parmentier of jazz"[16] and "the poet-band".[17]

Though they did not spend time together, Breton and Cocteau bumped into each other now and then. This period of comparatively peaceful co-existence did not, however, prevent Cocteau from taking the accusations of the "three musketeers"[18] very seriously: "Am I that Monsieur Cocteau everyone is talking about, from *Littérature* to *Crapouillot* [...] as an uneducated grotesque, living off the dead, excluded from literature?"[19] These are criticisms he found all the harder to explain since he claimed to have shown them clandestine kindness.[20]

In February, no doubt informed of his presence in the coming issue of *Littérature*,[21] Cocteau got some of his confidence back and sent *Le Coq et l'Arlequin* to Breton. Spurred on by this first step, he was full of praise for "Maldoror":[22] "Aragon is an angel. As for Breton,

11 Letter from André Breton to Tristan Tzara (4 April 1919), ibid., p. 443.

12 Letter from André Breton to Tristan Tzara (Friday 26 December 1919), ibid., p. 454.

13 Letter from Tristan Tzara to Francis Picabia (4 February 1918), ibid., p. 474.

14 Letter from Jean Cocteau to Louis Aragon (Wednesday 8 January 1919), L. Aragon, *Papiers inédits. De Dada au surréalisme (1917-1931)*, éd. établie et annotée par L. Follet et E. Ruiz, Paris, Gallimard (*Les Cahiers de la NRF*), 2000, p. 256.

15 Letter from Jean Cocteau to Louis Aragon (Wednesday 28 January 1919), ibid., p. 254.

16 M. Sanouillet, *Dada à Paris*, op. cit., p. 36.

17 Louis Aragon, *Projet d'histoire littéraire contemporaine*, Paris, Gallimard (*Digraphe*), 1994, p. 111.

18 Nickname given at the time to the threesome of Breton, Aragon and Soupault.

19 Letter from Jean Cocteau to Georges Auric, in G. Auric/J. Cocteau, *Correspondance*, présentée par Pierre Caizergues, Université de Montpellier III, Centre d'Étude du XXe siècle, 1999, p. 90.

20 Letter from Jean Cocteau to Louis Aragon [a little after February 1919], L. Aragon, *Papiers inédits. De Dada au surréalisme*, op. cit., p. 264.

21 His name on the cover of issue 1 does indeed suggest this. According to Aragon, a piece by Cocteau, "Fragments of Socrates' preface", figured in the planned contents of the second issue of *Littérature*. See Aragon, *Projet d'histoire littéraire contemporaine*, op. cit., p. 45.

22 Another nickname given to Breton and his entourage, mentioned at regular intervals in the correspondence of Jean Cocteau and Max Jacob..

23 Letter from Jean Cocteau to Louis Aragon (21 February 1919),

L. Aragon, *Papiers inédits. De Dada au surréalisme, op. cit.*, p. 266.

24 This letter of Picabia's sets the tone for the quarrel, which remained unsettled a month after the incident: "Jean Cocteau not in our good books. Erik Satie says he's an idiot and all the rest say he's a brat", letter to Tristan Tzara (28 March 1919), in M. Sanouillet, *Dada à Paris, op. cit.*, p. 484.

25 See note 3. L. Aragon, *Papiers inédits. De Dada au surréalisme, op. cit.*, p. 286.

26 This was "*Les Mains de Jeanne-Marie*".

27 This was finally put off until January.

28 Jean Cocteau, « Carte blanche », *Paris-Midi*, 8 April 1919.

29 Let us recall that, at the time this play was being produced, Fraenkel had sent "*Restaurant de nuit*" to Birot in Cocteau's name. Read acrostically, the first letter of each line formed the words "*PAUVRES BIROTS*" [POOR BIROTS]. This poem was published in issue 18 of *SIC*, June 1917, p. 6. After this hoax Birot and Cocteau had to put up with plenty of witticisms.

30 Jean Cocteau, « Parade », *Comoedia*, 21 December 1920, p. 15.

31 *Ibid.*

32 Pierre Daix cites Simone Kahn, in P. Daix, *La Vie quotidienne des surréalistes: 1917-1932*, Paris, Hachette, 1993, p. 110.

33 He wrote to Aragon, "I will pass the message on to R[aymond] R[adiguet].": letter from Jean Cocteau to Louis Aragon (5 December 1919), L. Aragon, *Papiers inédits. De Dada au surréalisme, op. cit.*, p. 276.

34 Letter from Raymond Radiguet to André Breton (28 September 1919), kindly shown to me by Mme Marie-Christine Movilliat..

35 André Breton, letter to Tristan Tzara (8 November 1919), in M. Sanouillet, *Dada à Paris, op. cit.*, p. 452.

I don't like his character but he certainly has a fine soul and I think him gifted. Philippe Soupault is a young animal, grace and awkwardness themselves."[23] Confounding all expectations it was not Breton but Satie who used his veto,[24] though he was mentioned in the article in tones of high praise. Cocteau was obliged to withdraw his article.

This failure did not prevent him from publicizing the launch of the magazine: "*Carte blanche* was to have been the name of a new magazine that has just come out. Pierre Reverdy suggested it. Paul Valéry won the day with *Littérature* [...]; but without wanting the young people to go completely wild [...] we might have expected the gifted young people who are running *Littérature* to have found a slightly less dispiriting title."[25] Despite the unfortunate effects of this article on Breton's inner circle, Cocteau nevertheless continued to promote the magazine, which was preparing to publish a hitherto unknown piece by Rimbaud.[26] In April he announced Tzara's arrival in Paris[27] with these words: "It is important to welcome a literature as enjoyable as a cocktail to the mind".[28] Dada could have done without this kind of advertising, given that the quip of the moment was, "*Un cocktail, des Cocteau*" [singular: cocktail, plural: Cocteau].

Despite his repeated publicity, Cocteau still did not succeed in pleasing the dadaists. However, he was also guilty of ever more "clumsiness" – it is still a little early to speak of "provocation" – where they were concerned. "When we put on *Parade*,[29] dadaism was unknown. We had never heard of it. Now there is no doubt that the public see dada in our unmalicious horse."[30] The correctness of this view would not fail to annoy the *Littérature* team, particularly when Cocteau delivered the death-blow: "[...] I am not a dadaist. No doubt that is the best way to be one."[31] In a single sentence Cocteau demonstrated that he had assimilated the very essence of dadaism.

A similar reserve can be observed on Breton's part, at least if Simone Kahn is to be believed. When they met, after the usual introductions she admitted, "You know, I'm not a dadaist". "Nor am I", replied Breton with a smile.[32] Though strained, the relationship between Cocteau and Dada still remained cordial. Breton acted as an intermediary between Radiguet and Cocteau, who, for his part, adopted the role of mediator between Radiguet and Aragon.[33] However, the mood was morose. Late in the year Radiguet sent a warning to Breton – "I'm afraid *Littérature* will become a diplomatic magazine"[34] – who shared his fears: "I'm finding *Littér.* very boring", he wrote to Tzara. "I should like to be able to announce soon that it is merging with DADA and that there will be only one magazine edited by you."[35] In this atmosphere of weariness, the name of Dada was on everyone's lips. Cocteau, who declared himself to be "following all dada's efforts",[36] was not going to be left out. Through Picabia,[37] he sent a poem to Tzara, which was published in *Dada 4-5*,[38] alongside Soupault, Breton and Aragon. This demonstrates Tzara's interest in Cocteau and the eclecticism he was concerned to reflect in his magazine since, although Cocteau tried to adopt a dadaist 'style', the result remains perplexing.

1920: *Littérature* and *Le Coq*

The beginning of the year was a crucial time for French dadaism, since Tzara was at last in Paris. He was staying with the Picabias in the Rue Émile-Augier. Cocteau, who was a frequent visitor, was invited to take part in the first Friday of *Littérature*.[39] The ceasefire was short-lived. The production of Cocteau's *Le Boeuf sur le toit*,[40] greeted by Soupault as "a sad, wet blanket of a farce",[41] saw a return to hostilities. For his part Dermée published "*Auric-Satie à la noix de Cocteau*" [Auric-Satie with Cocteau-nut],[42] of which the last line was, "*On les surveille*" [We're watching them], giving an idea of events to come. Tired of this continued ostracism by *Littérature*, Cocteau decided to found his own magazine, of which the launch was officially announced in late March. "The first issue of *Cocorico*, a journal of 'pure war',

will be out on the 1st of April."[43] *Littérature* was not amused by this initiative. In May, during the Dada festival,[44] Soupault was seen popping a balloon bearing the initials JC. The 'rivalry' between the two magazines[45] provided a certain pretext for the definitive breaking-off of relations.

Le Coq, intended as an antidote to the internationalism of dada, offered a piece by Paul Morand in praise of the French spirit.[46] But the spirit Cocteau was trying to demonstrate ("Listen! The Cock has sung three times. We are going to repudiate our masters") was always very quickly tempered by ambiguous statements: "The individual values of dada oblige me to defend it against the boors and indeed to let myself be compromised."[47] In reality *Le Coq* was not as fierce as Cocteau implied: "Our main criticism of dada is that it is too timid. Why so little, once the rules have been broken? No dadaist dares to kill himself or kill a member of the audience. We watch *plays*, we listen to *pieces of music*." Only Radiguet among all its contributors[48] truly went on the offensive, the others confined themselves to defending different values from those of the dadaists, without however systematically criticizing them. Furthermore, instead of seeing it as an opponent, the wider public soon assimilated *Le Coq* to dadaism. Michel Sanouillet implies that the press even used the name Cocteau to refer to the leader of the dada movement.[49] Indeed Cocteau himself boasted of this: "That was how I came to represent dada in foreign eyes, when I was in fact the *bête noire* of the dadaists."[50]

Some have put forward the hypothesis that the situation became truly and irreversibly bitter when Picabia did not publish Cocteau's poems in *391*. The reality is quite different: tired of being messed about by the dadaists, Cocteau withdrew from the fight. "This time I'm facing a physical obligation to act (never against you, nor against Tzara, nor against others, friendship or the memory of friendship being a (sacred) thing, but against Dada [....] Give me back the three poems for *391* and, if I disgust you, never see me again."[51] Clearly that is in conflict with the version supplied by Tzara: "On several occasions Cocteau had offered Picabia poems for publication in *391*. Eventually, cornered, Picabia accepted three for one of the issues for spring 1920. A few days later Cocteau was asked to come and correct the proofs at Picabia's place. He did so and then, delighted to see himself published at last in *391*, took his two friends out to dinner at Prunier's. At the end of their lavish meal Picabia and Tzara went straight home and tore up the proofs. The three poems did not appear and Cocteau kept the whole story to himself."[52] There was certainly some misunderstanding since, furious at not finding these poems listed in the contents of *391*, Cocteau announced that he had broken with Dada.[53] However, he soon made up with Picabia, since his name figures on the guest list for the private view of Picabia's exhibition at the Sans Pareil[54] a fortnight or so later.[55] Moreover Cocteau continued to give public support to dadaism: "Dada is a stroll, cubism is a procession."[56] Yet in 1920 his weariness – he had admitted himself "sickened by surdadaism"[57] – was very real, as reflected in his barbed remark, "Rimbaud went to Acre to get away from *Littérature*".[58]

1921–1923: après-dada

In March 1921 *Littérature* published its famous "liquidation" table,[59] in which the eminent personalities of the art world were given marks from +25 to -25. Breton, need it be said, won the highest share of every vote, with an average of 16.85. Cocteau, who of course did not appear on the list, noted, "Max Jacob wrote and told me that the last issue of *Littérature* is as comical as can be: it's a sad thing to be reduced to giving marks as in school".[60]

The performance of Cocteau's *Les Mariés de la tour Eiffel*[61] provided the pretext for another dadaist disturbance. In June the programme at Hébertot's Galérie Montaigne was dangerously full. Tzara and Picabia had rented the gallery from the 6th to the 30th for their Salon

36 Unpublished letter from Jean Cocteau to Tristan Tzara (19 February 1919), coll. Tzara, quoted *ibid.*, p. 135.

37 On this subject see Francis Picabia's letter to Tristan Tzara (18 April 1919), *ibid.*, p. 486.

38 « *Trois pièces faciles pour petites mains* », Dada, n° 4-5, *L'Anthologie Dada*, 15 May 1919, p. 4.

39 This event took place on 23 January 1920 at the Cinéma Saint-Martin.

40 The performance took place at the Comédie des Champs-Élysées on 21 February 1920, directed by Jean Cocteau. The music was by Darius Milhaud, the sets and costumes by Raoul Dufy.

41 P. Soupault, « Comédie des Champs-Élysées: Le Bœuf sur le toit, par Darius Milhaud et les Fratellini », *Littérature*, n° 14, June 1920, p. 32.

42 Francis Picabia, Z, n° 1, March 1920, p. 7.

43 Letter from Jean Cocteau to princesse Soutzo ("Ides of March" 1920), J. Cocteau, *Lettres de l'Oiseleur*, p. 192.

44 This had taken place on 27 May at the Salle Gaveau.

45 *Le Coq* could not have been regarded as a serious rival since only four issues of the magazine ever appeared (May, June, July-August-September and November 1920).

46 *Le Coq*, n° 1, May 1920.

47 *Le Coq*, n° 4, November 1920.

48 Also taking part were Max Jacob, Lucien Daudet, Marie Laurencin, Jean Hugo, Blaise Cendrars, Roger de La Fresnaye and the Group of Six.

49 M. Sanouillet, *Dada à Paris*, *op. cit.* (note 5), p. 193.

50 J. Cocteau, « D'un ordre considéré comme une anarchie », Jean Cocteau, *Romans, poésies, poésie critique, théâtre, cinéma*, éd. présentée et annotée par B. Benech, Paris, L.G.F. (*La Pochothèque*), 1995, p. 525.

51 Letter from Jean Cocteau to Francis Picabia (29 March 1920), *Lettres de L'Oiseleur, op. cit.*, p. 206.

52 Tristan Tzara, « Entretien du 5 décembre 1963 », in M. Sanouillet, *Dada à Paris, op. cit.*, p. 192.

53 This letter to Picabia, intended to be confidential, was however officially published in the first issue of *Cannibale*, 25 April 1920, p. 10.

54 This was the exhibition of dada paintings and drawings by Francis Picabia, which had its private view on Friday 16 April 1920.

55 We should also note that his name follows that of Tzara, both figuring much higher on the guest list than "the dadas". This list appeared in the exhibition *Francis Picabia, Singulier idéal* at the Musée d'Art Moderne de la Ville de Paris (16 November 2002-16 March 2003). The following year, when Picabia exhibited his *Oeil cacodylate* at the Salon d'Automne, a drawing with a dedication from Cocteau is among the signatures, which also include those of Ribemont-Dessaignes and Tzara.

56 On the cover of *Proverbe*, n° 3, 1 April 1920.

57 J. Cocteau, letter to Albert and Juliette Gleizes (5 August 1920), *Lettres de l'Oiseleur, op. cit.*, p. 124.

58 On the cover of *391*, n° 14, November 1920.

59 *Littérature*, n° 18, March 1921, pp. 1-7.

60 Unpublished poem-drawing by Jean Cocteau, M. Sanouillet, *Dada à Paris, op. cit.*, p. 271, note 3. This was, however, the dadaists' intention: "The school system, which seems fairly ridiculous to us, has the advantage of presenting our point of view more simply", *Littérature*, n° 18, March 1921, p. 1.

61 The piece was performed by the Swedish Ballets on 18 June 1921 at the Théâtre des Champs-Élysées, directed by Rolf de Maré. The music was by the Group of Six, the masks and costumes by Irène Lagut.

Dada. In the context of this exhibition they had planned to stage two performances (on the 10th and 18th) of Tzara's *Le Coeur à gaz*.[62] A bruitist concert was also scheduled for the 17th, the day before *Les Mariés de la tour Eiffel*. That week, in which Tzara was followed by Marinetti and Cocteau, was therefore of particular interest to the wider public and it was precisely here that the problem lay. For this programme, which was intended as a mix, sowed confusion in people's minds. For the uninitiated, who could not tell the difference – an attitude which must ultimately be regarded as legitimate – between dadaism, futurism and "cocteauism", all three events came under the Dada aegis. That was enough to infuriate Tzara.

As was customary, the first night of *Le Coeur à gaz* soon degenerated. Tzara was annoyed and decided to organize a conference in the afternoon of the 18th to prepare the way for the second performance. On the 17th he and his cohorts let loose at the bruitist concert.[63] Hébertot flew into a blind rage, so that the next night, in reprisal, the doors of the Galérie Montaigne remained hermetically sealed on his orders. Tzara's conference did not take place. Once again it was Cocteau who bore the brunt of the dadaists' fury. Skilfully scattered throughout the theatre, they continually stood up and sat down shouting "Long live Dada" throughout the entire performance of *Les Mariés de la tour Eiffel*, so that the critics heard more of what was going on in the audience than on stage.

In February 1922 Cocteau signed the motion of censure in the affair of the Paris Congress. By openly defending Tzara,[64] he had now publicly adopted a more radical anti-Breton position. A few months later the publication of his *Vocabulaire* earned him this laconic assessment: "It's the best muck imaginable."[65] Never outdone, Breton raised the stakes, describing Cocteau as having a "genius for nonsense and de-idealization".[66] While at first finding this accusation "rather amusing",[67] a month later Cocteau was still pondering its real meaning.[68] He had, however, understood something else: "The only gift of this sterile mind is that of knowing, like certain insects paralysing their enemies, where to touch your friends to put the creative force within them to sleep."[69] He was referring to Breton. Given the circumstances he could hardly be expected to be impartial. He also attracted sarcasm from Benjamin Péret: "Jean Cocteau, angel droppings. Raymond Radiguet: a shovel for angel droppings."[70] These childish insults simply confirmed the view of Cocteau according to which the spirit of Dada had become "through the fault of a few schoolboys, as outdated, as boring as Jarry, Duparc, Sacha Guitry, Bruant, Madame Lara and Ibsen".[71]

It seems Breton made it a point of honour never to miss one of Cocteau's dress rehearsals. In December, in accordance with his sacrosanct custom, he and his comrades went to *Antigone*.[72] For once Cocteau dealt with this humorously when, in the middle of his speech[73] (he was playing the role of the chorus), he said, "Get out, Monsieur Breton. We shall continue when you have left the theatre." After many protestations the dadaists eventually left. In this period of crisis Picabia alone still seemed willing to give Cocteau support. "My dear Cocteau, all that I had to say about you I have written. What they're telling you at the moment is pure lies, Tristan and dear Ribemont take note."[74] But, if Breton is to be believed, the die was definitively cast: "We should do nothing to heal the wound represented by the work of Cocteau, Rivière, Morand, the recent books by Paul Valéry [....] Let it be known that I shall never have enough insults for those people."[75]

For his part Cocteau denounced the "dada suicide club", while stating that it was "the only one acceptable".[76] Perhaps the dadaists were also his target when he spoke of those "fanatical scribblers" who, "on the pretext of demoralization", planned to continue "Alfred Jarry's farces".[77] Cocteau, who said he detested "shady dealings",[78] was not, however, one of those who openly looked for a fight. It is more in his correspondence, in which, for example, Breton is described as a "cretin",[79] that his true feelings about Dada at that time have to be sought.

Cocteau was not initially scheduled to figure on the programme of the *Soirée du Coeur à Barbe* [Evening of the bearded heart],[80] but an altercation between Iliazd and Eluard – who

were part of the evening – forced the latter to withdraw, leaving a vacant slot. At Tzara's request Cocteau agreed to replace him. Rarely was an event so dangerous. Breton, Aragon and Eluard, beside themselves at seeing Cocteau's name on a Dada poster, made Tzara pay dearly for such provocation. The three of them unleashed real carnage. Cocteau was perfectly placed to witness this confrontation between dadaists: "I've never seen faces showing such stupid, narrow hatred. Those of Breton and Desnos were abject."[81] A fist-fight broke out. Breton broke Pierre de Massot's arm with a blow from his cane. The place was filled with panic and, in an ironic twist of fate, Tzara was forced to call the police. This event symbolically sounded the death knell of the Dada evenings.[82]

Adieu dada mon seul voyage Jean Cocteau le parisien
[Farewell dada my only voyage Jean Cocteau the Parisian][83]

Who could analyse such a situation better than Cocteau? "Now I know why we are so different and yet can still touch each other", he wrote to Picabia. "You are the extreme left, I am the *extreme right*."[84] This irresistible attraction was amplified by the relativity of the Dada spirit. "The conception the dadaists have of their own dadaism is highly variable."[85]

Another peculiar thing is that it was with Tzara, Ribemont-Dessaignes and Picabia – those whom Breton rightly acknowledged as "the only real 'dadas'"[86] – that Cocteau had the most courteous relations. However their "friendship", which seldom went beyond the bounds of sociability, remains doubtful. It did not prevent Tzara from denouncing "the time of old whores like Cocteau",[87] any more than it stopped Picabia's attacks.[88] The editor of *Littérature* made Cocteau his personal business. Indeed how could Cocteau have found grace in Breton's eyes once the latter had decreed that he was contradicting him? Breton's evident homophobia[89] is not enough in itself to justify his calculated rejection of Cocteau. The same goes for his so-called contempt for frivolity. Breton viewed Tzara's toying with high society with the same indulgence as that with which he tolerated Aragon's confirmed dandyism. Why were things different with Cocteau? Precisely because he was Cocteau.

Breton's intransigence proves that he clearly expected a lot of Cocteau. Cocteau knew this for, in 1918, Breton had come to the reading of *Le Cap de Bonne-Espérance*. Jean Hugo describes what followed: "When the reading was over and everyone was congratulating him enthusiastically, [Cocteau] went over to Breton, who was trying to avoid him. I was nearby. Cocteau expounded, implying, 'It's very good, isn't it? But this isn't what we should be doing any more, it's too sublime (he glanced in my direction), too Victor Hugo' [....] Breton remained silent with a face like ice. Cocteau turned pale and left him to slip away between the piano and the window."[90]

The master was disappointed by this possible disciple in whom he had undoubtedly invested some hope, without which he would not have come – Breton was not in the habit of making an effort for nothing – except, perhaps, with the intention of insulting Cocteau in public. His icy silence is thus highly significant. Another grievance was that Cocteau was a poet, worse still a great poet, who was ready to set Tzara's verse on a par with that of Anna de Noailles: "Poetry is electricity. They both transmit electricity to me. The shape of lamps and lampshades is another matter."[91] It is easy to imagine the disdainful expression with which Breton might have responded to these words.

However, there is too much venom in this relationship for one not to see it as passionate in nature. For what did these two men have against each other? Ultimately not much. Or rather, what they had were evasive but fundamental differences which, when they wrote, became often gratuitous accusations. This antipathy was all the more fearsome because it remained unexplained. Thus, having warned him not to trust Cocteau, Breton wrote to Tzara, "Once again [Cocteau] has done nothing to me."[92] There are some physical hatreds

62 This was a three-Act play whose cast included Soupault, Ribemont-Dessaignes, Fraenkel, Aragon, Péret and Tzara.

63 For more information on the events of that evening, see the account by G. Ribemont-Dessaignes, *Déjà jadis*, pp. 99–100.

64 Cocteau signed his name with the words "Tzara is my friend", M. Sanouillet, *Dada à Paris, op. cit.*, p. 335, note 1b.

65 Jacques Baron, « Les livres », *Littérature (nouvelle série)*, n° 4, 1 September 1922, p. 23.

66 André Breton, « Clairement », ibid., p. 2. He also accuses Cocteau of living "off the corpses of Valéry, Derain and Marinetti".

67 Letter from Jean Cocteau to Max Jacob (26 September 1922), Max-Jacob/Jean Cocteau, *Correspondance (1917-1944)*, texte établi et annoté par Anne Kimball, Paris, Paris-Méditerranée ; Ripon (Québec), Écrits des Hautes-Terres, 2000, p. 127.

68 See on this subject the letter from Jean Cocteau to Max Jacob (6 October 1922), *ibid.*, pp. 136–37.

69 Letter from Jean Cocteau to Max Jacob (2 October [1922]), *ibid.*, p. 132.

70 B. Péret, « À travers mes yeux », *Littérature (nouvelle série)*, n° 5, 1 October 1922, p. 13. See also in the same issue Roger Vitrac, « Retour d'ange, par Jean Cocteau », pp. 20–22.

71 Jean Cocteau, letter to Francis Picabia (29 March 1920), *Lettres de l'Oiseleur, op. cit.*, p. 206.

72 Indeed he described his intentions to Picabia, "We were talking about going to Cocteau's play this evening, but how should we go about it?": letter from André Breton to Francis Picabia (20 December 1922), in M. Sanouillet, *Dada à Paris, op. cit.*, p. 526.

73 *Antigone* was performed at the Théâtre de l'Atelier (20 December 1922) with sets by Picasso and costumes by Gabrielle Chanel. Music was by Arthur Honegger.

74 Francis Picabia, *La Pomme de Pins* (Saint-Raphaël), 15 February 1922. In this issue the same writer says, "The perfidious Tristan Tzara has left Paris for La Connerie des Lilas", and, "one day when Ribemont-Dessaignes was naked he put on a top hat to look like a locomotive, with pitiful results. Vauxcelles took him for a tube of hairs – not even that, dear Friends – he just looked a damn fool."

75 Interview with André Breton by Roger Vitrac, *Le Journal du peuple*, 7 April 1923.

76 Extract from « Un ordre considéré comme une anarchie », Jean Cocteau, *Romans, poésies, poésie critique, théâtre, cinéma, op. cit.*, p. 530.

77 *Ibid.*

78 Postscript to a letter from Jean Cocteau to Louis Aragon (8 January 1919), L. Aragon, *Papiers inédits. De Dada au surréalisme, op. cit*, p. 256.

79 Jean Cocteau, letter to Max Jacob (1 August 1923), Max Jacob/Jean Cocteau, *Correspondance, op. cit.*, p. 162.

80 This event was held at the Théâtre Michel (6–7 July 1923).

81 Jean Cocteau, letter to Max Jacob (1 August 1923), Max Jacob/Jean Cocteau, *Correspondance, op. cit.*, p. 162.

82 In 1924 Cocteau nevertheless interceded with the comte de Beaumont to enable Tzara to present *Mouchoir de nuages* [Handkerchief of clouds] as part of the *Soirées de Paris*. This play, directed by Marcel Herrand, with sets and costumes by Jeanne Lanvin, was staged at the same time as Cocteau's *Romeo et Juliette*. Jean Hugo noted, "Breton came to see *Mouchoir de nuages*, but as soon as the curtain came down he left the theatre, monocle to eye and cane in hand. He did not want to see Cocteau's play" (J. Hugo, *Le Regard de la mémoire*, Le Paradou, Actes Sud, 1983, p. 234). The support of Crevel, who published an article full of praise in *Les Nouvelles littéraires* (24 May 1924) did not stop Breton and Aragon from making a scandal at the third performance of this play by

– confined here to an almost fanatical obsession – that one must avoid rationalizing at all costs. So Breton described the "intolerable sickness"[93] caused in him by writers such as Cocteau who, for his part, acknowledged that dadaism caused him "intolerable sickness".[94] The problem was thus physical and manifestly contagious. However, while contempt may sometimes have come into it, they seem rarely to have been able to remain indifferent to each other. There is moreover no contempt that does not carry an element of admiration, any more than esteem is entirely foreign to hatred. It could be said that such hatred,[95] of which the constancy must be acknowledged, resembles an idyll denied.

One might object that dada did not stop with Breton. This was true everywhere in Europe, except Paris. Dada was a cenobite movement, today we would call it an international 'artists' collective'. Despite his many collaborations, Cocteau remained jealously individualistic. Incapable of accepting the dogmatisms of a school, he always remained on the fringes. "Because I cannot join any school, nor manufacture one myself, label-loving opinion sticks them all to my back."[96] Despite his enthusiasm for the avant-garde, Cocteau never entirely abandoned his doctrinal reserve in relation to it. In this way he respected a certain stylistic ambiguity of which he, sometimes grudgingly, made himself the mouthpiece.

These (very) young people probably all wanted the same thing at the same time. The only difference – if it really was a difference – was in their way of achieving it. Jean Cocteau may have been a dadaist without acknowledging it (and remaining unacknowledged). If so it was not for want of wanting to be one – out of snobbery, curiosity or affinity, it matters little – and doubtless he would have become one if Breton had not – involuntarily – set him back on the right track.

shouting, "Long live Picasso! Long live genius! Down with Satie!"

83 This statement figures in issue 15 of *391*, 10 July 1920, p. 3.

84 Jean Cocteau, letter to Francis Picabia, *Cannibale*, n° 1, 25 April 1920, p. 10.

85 Richard Huelsenbeck, *Introduction à L'Almanach Dada* (Charlottenburg), May 1920, p. 171; bilingual edn, translated by Sabine Wolf, annotated by Michel Giroud, Paris, Champ Libre, 1980.

86 André Breton, *Les Pas perdus* [1924], Paris, Gallimard (*L'Imaginaire*), 1970, p. 65.

87 Interview with Tristan Tzara, *Intégral* (3ᵉ année), April 1927.

88 As demonstrated by the following witticism: "We glimpsed Erik Satie, he was wearing a little sailor suit, instead of anchors the corners of the collar were embroidered with the portrait of Jean Cocteau", in *"Picabia dit dans 'Littérature'"*, *Littérature* 4, 1 September 1922, p. 18.

89 The following extract from a discussion on pederasty gives an idea of his attitude towards homosexuality:
BRETON — "I am utterly opposed to any further discussion on this sub-

ject. If it's going to turn into an advertisement for pederasty I shall abandon it at once."
ARAGON — "There's never been any question of advertising pederasty. The discussion is taking a reactionary turn here [...] I want to talk about all sexual habits."
BRETON — "Do you want me to abandon the discussion? I'm happy to act the obscurantist in a domain like this."
Archives du Surréalisme. 4: *Recherches sur la sexualité (Janvier 1928-août 1932)*, 2ᵉ séance (31 janvier 1928), éd. présentée et annotée par José Pierre, publiée sous l'égide d'*Actual*, Paris, Gallimard, 1990, p. 68. We should also note that this homophobia did not prevent Breton from publishing Max Jacob and Gide in *Littérature*, or from welcoming Crevel into the surrealist movement.

90 J. Hugo, *Le Regard de la mémoire*, *op. cit.*, p. 125.

91 J. Cocteau, « D'un ordre considéré comme une anarchie », *op. cit.*, p. 537.

92 Letter from André Breton to Tristan Tzara (Friday 26 December 1919), in M. Sanouillet, *Dada à Paris, op. cit.*, p. 453.

93 André Breton, « Clairement », *Littérature*, n° 4, 1 September 1922, p. 2.

94 Letter from Cocteau to Picabia (29 March 1920), *Lettres de l'Oiseleur, op. cit.*, p. 205.

95 Sadly this hostility outlived dada; Desnos was right when he said, "How can you believe that Breton and Cocteau have made it up, as Satie says? That day will be a hot one": letter to Francis Picabia (Friday [November 1924]), in M. Sanouillet, *Dada à Paris, op. cit.*, p. 551.

96 J. Cocteau, « D'un ordre considéré comme une anarchie », *op. cit.*, p. 527.

Additional references
Littérature (1ʳᵉ série), n° 1–20, March 1919 to August 1921 (réimpr. présentée par Philippe Soupault et Marguerite Bonnet, Paris, Jean-Michel Place, 1978); *Littérature* (nouvelle série) n° 1–13, 1 March 1922 to June 1924 (réimpr. présentée par Jacques Baron, Paris, Jean-Michel Place, 1978); André Breton, *Entretiens avec André Parinaud (1913-1952)*, Paris, Gallimard, 1952; Henri Behar, *Le Théâtre dada et surréaliste*, Paris, Gallimard, 1979; Henri Behar, Michel Carassou, *Dada, Histoire d'une subversion*, Paris, Fayard, 1990.

The "French French" music of Jean Cocteau

It was through the artful use of music that Jean Cocteau brought about his great metamorphosis, moving from the salons of the Right Bank to the artists' studios of the Left Bank and swapping his reputation as the "frivolous prince" for that of "evangelist of the avant-garde". It is also incontestably to Cocteau that we owe the great musical upheaval of the 1920s – or to him at least the affirmation of a new musical approach, stripped of all academic prejudice.

While noting his "intimately organic connection with music" (Henri Sauguet)[1] and his staggering capacity to imitate any virtuoso at the keyboard, "as long as it was in F major" (Georges Auric),[2] as well as his dazzling and shocking comments on the composers of all periods, to this day no one has been able to determine exactly what musical training Cocteau had. From *Portraits-Souvenir* we are able to glean accounts of evenings of chamber music at his grandfather's house – music which was not made "to be listened to, to please, but to be performed, measured, nodded to. A sport, an exercise like any other: fencing, canoeing, boxing" – and his "pell mell" discovery of Beethoven, Liszt, Berlioz and Wagner, in the "sarcophagus of painted wood, peopled by venerable mummies", as the small hall of the Conservatoire appeared to his boyish eyes. Opera was something he could only dream of as he secretly watched his mother being dressed for gala evenings. Her dressing was a perfectly ordered performance, "a prologue to the real performance for which all these elegant things have been devised".[3]

Cocteau had a natural vocation for the footlights – making his name as a poet when his poems were read by a few superstars at the Théâtre Fémina – and it was his encounter with the Ballets Russes that led him to link music indissolubly with the theatre. For him music does not seem ever to have been a solitary pleasure: the encounter between stage and audience and the misunderstandings that can result – the plot of his first "committed" ballet, *Parade* – remained a constant concern throughout his life.

It was in order to get his own "diversity" accepted by the élite of the Parisian high-society intellectuals, whose fiercest representative was, in Cocteau's eyes, his own mother, that he always set out to shock her the better to charm her. To this end he even, rather painfully, cultivated a certain taste for profanation (we know that one of his most characteristic images, blood on snow, was suggested to him by Paolo Uccello's polyptych *The Profanation of the Host*). It was no coincidence that the first of the three Greek myths which always, and with good reason, remained his main references – Antigone, Orpheus and Oedipus – focuses on a rebellion against the laws of a society from which, however, no one seeks to flee.

1 Henri Sauguet, « Jean Cocteau et la musique », *Cahiers Jean Cocteau* (Gallimard), n° 7, 1978, p. 83.

2 Georges Auric, « Témoignages » (entretien avec André Fraigneau), *ibid.*, p 71.

3 Jean Cocteau, *Portraits-Souvenir*, Paris, Bernard Grasset, 1935, pp. 23, 32 and 38–40.

Cocteau's very fertile association with the Muse Euterpe lasted about ten years and, as proof that he never lost sight of its effect on the public, was exactly delimited, at its beginning and end, by two 'open letters'. The first, published in *Le Mot* (the magazine Cocteau ran with Paul Iribe) on 27 February 1915, was entitled, "We should like to tell you something. Reply to young musicians"; the second, entitled *Lettre à Jacques Maritain*, was published in book form by Stock in June 1926.

The fact that the first open letter was written during the First World War is not without importance. Cocteau was then dividing his time between the ambulances of Misia Edwards

The "French French" music of Jean Cocteau

(the future Misia Sert), Comte Etienne de Beaumont's Aid to Wounded Soldiers, and the Maison de la Presse, founded by the General Secretary of the Ministry of Foreign Affairs, Philippe Berthelot, "for the propagation of French values". We should note in passing that, in addition to this influential personage, pleasingly described by Alberto Savinio as "Vercingetorix in a suit" and an "éminence grise",[4] a whole ballet of diplomats – Paul Morand, Paul Claudel, Alexis Léger, Jean Giraudoux, Henri Hoppenot, Marcel Mozkowski-Chaminade – were enlivening the dinners in town which Cocteau frequently attended, many of which were organized by his mother.

It would be hard to identify the "young musicians" to whom, on 27 February 1915, Cocteau addressed his *Reply*. What we do know is that these ghostly interlocutors, of whom he already felt a need, would take shape in the not too distant future, as though by some conjuring trick.

For the moment the only French composer that Cocteau had managed to meet was Edgard Varèse, his elder by six years. The allusion in the *Reply* to the mixed reception of "our young people" in Berlin – a city where Varèse had spent a long time – seems to confirm that he is indeed the musician in question. This is all the more likely since Cocteau was working with Varèse at the time on a project which *Le Mot* was not to announce until a month later, and even then in elliptical fashion. This was the production of *A Midsummer Night's Dream*, by "our ally" Shakespeare, at the Médrano circus, with real clowns in the cast. For this performance *Ein Sommernachtstraum* by the "German" Mendelssohn, which traditionally accompanied the play, would be replaced by "a pot-pourri of new French pieces" specially composed for the occasion by Satie, Ravel, Florent Schmitt, Varèse and Stravinsky (the latter, not being French, was included as an "ally").[5]

This event was intended to fight the enemy on the artistic front by outdoing a flamboyant performance of the *Dream* by Max Reinhardt in Berlin. The *Reply to Young Musicians* was part of its preparation; it also described the context with exceptional clairvoyance. In his first exercise as a music critic (an experiment with highly successful results), Cocteau employed the image-filled language, the "populist colour", which would henceforward be characteristic. He reminds us first of all that "in music it was the period of intertwined melodic threads, then came Débussy, decomposing, enervating, gently tearing the thread apart, then Ravel playing with the shreds of sound, and new cloth had to be made". He then turns the spotlight on the two rising stars of the day, the Russian Stravinsky and the "German-Austrian" Schoenberg. He describes the former's *Rite of Spring* as a "preamble to the war", whereas Schoenberg "calculates ... dislocates ... composes by machine ... adjusts the spectacles of an intellectual Herr Professor For fear of clichés he creates a new cliché. In order to be free, he imprisons himself in so many formulae! And condemns so many naive disciples to captivity!"

That these lines were written at the beginning of 1915, long before Schoenberg discovered the series of twelve notes which, in his own words, were to ensure "the musical domination of Germany for a hundred years" is food for thought.

However, the time had not yet come for the "new, French pieces" that Cocteau longed for. Despite "official patronage" which would have enabled him to say, "Here at last is our home-grown art!"[6] – the patronage of his "éminence grise"? – the Médrano *Dream* project was abandoned even before its promoter, Edgard Varèse, had left France for the USA. However the ideas on which it had been built were not lost to all, and particularly not to Cocteau; the Médrano clowns reappear in his *Le Boeuf sur le toit* in his "spectacle-concert" of 1920 and the pot-pourri principle can be found in the music for his *Les Mariés de la tour Eiffel* by the Group of Six. Oddly, the poet's use of this music was modelled on Mendelssohn's *Ein Sommernachtstraum*, with a "nuptial march" and a "funeral march", and a "dance of the dispatches" replacing Mendelssohn's "dance of the clowns".

4 Alberto Savinio, *Souvenirs*, Palermo, Sellerio, 1976, pp. 43–44 and 116–23.

5 « Allié », *Le Mot*, 27 March 1915. See also O. Volta, *Satie et la Danse*, Paris, Plume, 1992, p. 131–38.

6 Unpublished letter from Jean Cocteau to Albert Gleizes, no date [spring 1915], Paris, Centre Pompidou, Mnam-Cci, Bibliothèque Kandinsky.

It is well known that after the disappointment of the *Dream*, which followed a failed meeting with Stravinsky,[7] Cocteau eventually found his ideal partner in Erik Satie. He had first thought of "astounding Diaghilev" (and the little group he so cared about) with a ballet set to Satie's *Trois morceaux en forme de poire* [Three pear-shaped pieces], its three characters representing three forms of popular entertainment – music hall, the circus and the cinema serials then in fashion, but bowed to Satie's wish not to use his "old things". Instead they created an entirely new work together, using the three characters for a "parade" intended to attract passers-by to a performance which, confusing parade with performance, they would ultimately not go and see.[8]

What is striking is that, from his first communication, Cocteau revealed his intention to influence the music that the composer had been asked to write. He suggested "new ideas for the use of singing of which the line, freshness and warmth will be very moving above the noises of the orchestra"[9]. He also gave details of these noises, or rather of "work for sound-effects men" (a clear futurist influence), a "multicoloured Saint Polycarp" composed of gongs, ship's sirens (the *Titanic*), "aeroplane voices" and a Morse code transmitter. The "new ideas for the use of singing" consist of placing two boxes above and below the stage, whence would be heard a choirboy's high notes and the voice of a contralto, as in Gregorian liturgy.

We know that this arrangement evolved while *Parade* was developing. The dreamlike, poetic text, originally intended for the two voices, was replaced along the way by advertising slogans shouted by actors with megaphones and combined with the orchestral instruments, before all of it disappeared. Even the few singing exercises intended to accompany the movements of an acrobat in the sky, for which Satie had written a little melody, were taken out. These onomatopoeias were influenced by *Le Chant des voyelles comme invocation aux dieux planétaires* [The song of the vowels as in invocation to the planetary gods],[10] put together by Satie's old friend Edmond Bailly, the founder of the Bookshop for Independent Art. They reappeared in *Le Cap de Bonne-Espérance*, which Cocteau was writing at the same time.

Meanwhile the "foreground of drums and scenic noises", for which Cocteau wanted Satie's score to be a mere "musical background" against which the sounds would stand out,[11] was reduced to the clicking of four typewriters, the squeaks of a lottery wheel and the screams of two sirens (factory and ship). These were to be heard between stretches of silence, which the composer opportunely included so that the noise would not disturb his composition.

Despite all this, Cocteau felt able to assert that he had "dictated the score to Satie note by note".[12] The latter slyly responded by not even telling him about the substantial changes he made two years later at Diaghilev's request, of which Cocteau, when he came to discuss the reprise of *Parade* in his journal publications, thus always remained unaware.

Just as Cocteau had secretly hoped, the ballet – performed at the Châtelet on 18 May 1917 – caused a great scandal. At that time, as Thomas Mann amusingly recalled in his *Doktor Faustus*, "In Paris, where the world's pulse beats, the path to glory is through scandal [....] A proper première must take place in such a way that during the evening most of the audience stands up several times shouting, "Outrage! Impudence! Ignominious buffoonery!", while five or six of those in the know [...] exclaim from their box, "How right! What wit! Divine! Superb! Bravo! Bravo!" [...] For all this no such evening has been halted before the end. Not even the most indignant would want this, since it is their pleasure to grow even more indignant instead [....] As for the small number of those in the know, in the eyes of all they retain a strange and inestimable prestige."[13]

After *Parade*, in contrast to the fiercely hostile Paris society and critics, a few young musicians (Georges Auric, Louis Durey and Arthur Honegger, later joined by Germaine Tailleferre, Francis Poulenc and Darius Milhaud) paid homage to Erik Satie. In this they were encouraged by the poet Blaise Cendrars, who, while open to the hopes of a new generation, was

7 Francis Steegmuller, *Cocteau (A Biography)*, French edn, trans. Marcelle Jossua, Paris, Buchet-Chastel, 1973, p. 73–84.

8 See my introduction to the revised edition of the orchestral score of *Parade*, Paris, Salabert, 2000, pp. I–XVII.

9 Erik Satie, *Correspondance presque complète*, présentée par O. Volta, Paris, Fayard / IMEC, 2000, pp. 240–41, n° CCCXXXVI [1 May 1916].

10 For *Le Chant des Voyelles* d'Edmond Bailly (1907), see the reprint, Nice, Bélisane,1976.

11 J. Cocteau, *Parade*, 1916; original manuscript of the plot written for Diaghilev, private collection. For a partial reproduction see O. Volta, *Satie et la Danse*, op. cit., p. 69.

12 Letter from Jean Cocteau to Léonide Massine, no date [spring 1915], quoted in Frederick Brown, *An Impersonation of Angels: A Biography of Jean Cocteau*, New York, Viking Press, 1968, p. 154.

13 Thomas Mann, *Doktor Faustus*, Berlin, Fischer, 1950.

not cut out to be a leader.[14] With these young musicians – already on the right path carved out by Satie, but far more malleable than Satie himself – Cocteau finally found what he was looking for. At this turning point of the century, when Orpheus could be imagined only with a procession of poets and painters (Jean Moréas and the symbolists, Marinetti and the futurists, Apollinaire and the cubists), he observed that, apart from the isolated case of the futurist *L'Art des bruits*,[15] the domain of music had been neglected. Later he baldly stated, "There was an open space. We occupied it."[16] He explained himself with the same frank lucidity to his mother, who criticized him for a lack of focus. "Don't think that I've taken up with the musicians out of a spirit of sacrifice. My position with them greatly enhances my status as a poet. And that is extremely important to me. It gives me a power to act that one never finds in one's own field (example: Nietzsche and Wagner)."[17]

Blaise Cendrars had at that very moment just taken over a new publishing house, La Sirène, which was ready for anything. It provided Cocteau with the ideal place to publish the manifesto he was intending to launch. This took the form of a "tract-book", *Le Coq et l'Arlequin* [Cockerel and Harlequin], in which the Cockerel with his pure voice, in other words "French French music" (here we are!), is contrasted with the music of Harlequin, coloured with foreign influences. In order to produce this "home-grown art", "everyday" music "with a human beat", "to which you walk", which would be lived in "like a house", Cocteau advises young musicians to turn their attention to cabaret where, despite the Anglo-American influence, "a certain tradition has been preserved which, though vulgar, still has a pedigree". It is almost certainly there, he states, that they will be able to "rediscover the thread lost in the Germano-Slavonic labyrinth".[18]

Written in 1918 ("on two notes, like the fire engine's call")[19], this bible's publication was supposed to coincide with a concrete manifestation in the form of a *Séance Music-Hall*. This was to be presented by young graduates of the Conservatoire – or at any rate classically trained musicians – to an audience more usually to be seen at the '*grand concerts*'. By offering such people an evening of "cyclists, jugglers, whistlers" and other "whimsical gymnasts",[20] Cocteau was no doubt relying on the willingness of the more refined to slum it. In the end, after a series of hitches, the *Séance Music-Hall* never took place. However, the concept reappears in the *Premier Spectacle-Concert donné en février 1920 par Jean Cocteau* [First concert-show given in February 1920 by Jean Cocteau] at the Comédie des Champs-Élysées, with the poet's name figuring in full in purest Alcazar style. The "*spectacle-concert*" included a fox-trot by Georges Auric accompanied by a *Danse d'acrobates* while *Le Boeuf sur le toit* [The ox on the roof], the farce by Cocteau and Milhaud, was performed by clowns. Although, to their great frustration,[21] the clowns' art of grimaces, which was their principal means of expression, was concealed by large cardboard heads painted by Raoul Dufy, for Cocteau their presence on the stage was more than just a pleasing way of recycling the Médrano *Midsummer Night's Dream* project: it was also a nostalgic throwback to his own childhood. For most of the clowns and acrobats had been recruited in a bar opposite the Théâtre des Champs Élysées owned by the Englishman and former clown Geo Foottit, the "toreador of laughter" who, around 1900, had plunged the future author of *Portraits-Souvenir* into the atmosphere of a "devil's nursery".[22]

It was at any rate for the *Séance Music-Hall* in 1918 that Cocteau first took on the combined role of impresario and conductor. His controlling attitude earned him the ironic nickname of "General Clapier" among his protégés. In his correspondence of the time we read, "My dear Auric [...] I'm asking you, please, to make the song and two dances modern. I have an idea for staging them"; "My dear Poulenc [...] the melody should not be as good as Chabrier. You must make it good, but ugly, with quick crochets at the end"; "My dear Louis [Durey], here is your task for *La Séance de Music-Hall*. I'm giving each man his task without telling him the other's. The result should be a surprise (an atmosphere of surprise, necessary to my plan)."[23] While working away trying to encourage composition ("I had young com-

14 G. Auric, *Quand j'étais là*, Paris, Grasset, 1979, p. 132–33; O. Volta, « Une relation peu explorée: Blaise Cendrars et Erik Satie », *Cahiers Blaise Cendrars* (Boudry-Neuchâtel, La Baconnière), n° 3, 1989, pp. 87–108, at pp. 93–94.

15 The manifesto *L'Art des Bruits* by Luigi Russolo was distributed in 1913.

16 J. Cocteau, *La Difficulté d'être* [1946], Monaco, Éd. du Rocher, 1983, p. 44.

17 Unpublished letter from Jean Cocteau to his mother, 17 July 1920, shown to us by Louis Évrard with the kind permission of Pierre Chanel.

18 J. Cocteau, « Notes autour de la musique », *Le Coq et l'Arlequin*, Paris, Éd. de La Sirène, 1918 [1919], Collection des Tracts n° 1, pp. 29, 31–33. (NB « Dans le labyrinthe germano-slave » has been suppressed in subsequent editions).

19 J. Cocteau, *Lettre à Jacques Maritain*, Paris, Librairie Stock, Delamain et Boutelleau, 1926, p. 57.

20 See the facsimile copy of the programme for this event (original manuscript, not signed, by Jean Cocteau, preserved at the BNF, département de la Musique, dossier Erik Satie) in O. Volta, « Auric / Poulenc / Milhaud, l'École du Music-Hall selon Cocteau », *Centenaire Georges Auric-Francis Poulenc*, textes réunis par Josiane Mas, Université de Montpellier III, Centre d'Étude du xxᵉ siècle, 2001, p. 79.

21 Albert Fratellini, *Nous, les Fratellini*, Paris, Grasset, 1955, pp. 191–93, 227.

22 J. Cocteau, *Portraits-Souvenir*, *op. cit.*, pp. 70–71. See also O. Volta, « Auric / Poulenc / Milhaud... », *op. cit.*, pp. 70–71.

posers", he would remember one day, "but I lacked works")[24], Cocteau never stopped weaving his canvas, writing 'Carte blanche', a regular column in Paris-Midi which ran for several months and was supposed to keep readers abreast of the new values, going to present the "new musicians" himself at the Institut des Hautes Etudes in Brussels, and above all manoeuvring to get Henri Collet, who had just taken over writing the 'La Musique chez soi' section of Comoedia, to take an interest in the authors of an Album des Six. This had been especially put together with him in mind, going so far as to compare the young French composers to the mythical Russian Five who, in their day, had also set out to renew their country's music.[25] Although the Group of Six was first named in writing by Henri Collet, no one was fooled. "Because you have the sense of poetic magic", said André Maurois when he welcomed Cocteau to the Académie Française some decades later, "you knew that in naming a group one creates it".[26]

Although we have not the slightest information concerning either the conditions under which the new editor of Comoedia was hired or any possible intervention by an "éminence grise", it seems surprising that Henri Collet, who had not known Cocteau at all beforehand and had himself been known until then only as a musicologist specializing in Iberian music and as a composer of "Castillian music",[27] should have transformed himself overnight into a promoter of the purest "French French music".

Be that as it may, the effect of his article, followed closely by the Premier Spectacle-Concert de Jean Cocteau, exceeded all expectations. Almost before the six hitherto unknown young musicians had produced any work, publishers and concert organizers were fighting over it – and not only in France. All regarded them as a godsend, at a time when the Great War had cut down so many young people. To give their innovative spirit even more prominence, their friend Jean Wiéner organized "salad concerts" which included all kinds of pieces, from Bach to realist chanson. Meanwhile Caryathis, the "beautiful eccentric" (who had not yet become the formidable Elise Jouhandeau), commissioned them to compose the music she needed to produce her first, splash-making dance recital.

Without in any way losing his grip – quite the opposite – Cocteau established the headquarters of the Six in a cocktail bar, Le Gaya ("singular cocktail, plural Cocteaus", sneered the journalists). The following year it moved to the Le Boeuf sur le toit cabaret, which became the emblem of the Roaring Twenties, indefinitely perpetuating the title of the farce Cocteau had created with Milhaud. At the "Saturday dinners" – which were held once a week and expanded the circle to include a constellation of painters and poets – the Group of Six was given a newspaper, of course called Le Coq ("Le Coq says Cocteau twice")[28] and a Parisian jazz band was set up. (The Saturday [samedi] diners were called Samédistes, which was shortened to SAM, which in French can also be the acronym for a société d'admiration mutuelle or mutual admiration society.) The jazz band, whose drummer was Cocteau himself, played for some time in places as varied as the popular Olympia Music Hall and a gallery in St-Germain-des-Prés for the private view of work by the dadaist painter Francis Picabia.

In the meantime, what with Satie's Rag-time, Poulenc's Rapsodie nègre, Milhaud's Brazilian samba and a few little songs by members of the Group of Six in the manner of Félix Maillol, himself influenced by Viennese operetta, the "French French music" seems rather to have lost its bearings. It must also be acknowledged that, once this happy period came to an end, the careers of each of the Six proved (some more than others) that all this productivity had delayed rather than fostered the assertion of their respective individualities. On the other hand it did ensure that they became well-known almost before they deserved it, thanks to the free-spiritedness advocated by Cocteau, which they embodied. Regarding them as having opened doors, Bartók assured them of his trust; Schoenberg himself invited them to Vienna, while Stravinsky, after reading Le Coq et l'Arlequin, went so far as to change his manner of composing.

Disciples and imitators also appeared here and there. In Bordeaux a group of Three was formed, not forgetting to beg Cocteau for support, while the Arceuil school was established

23 See Georges Auric / Jean Cocteau, Correspondance, présentée par Pierre Caizergues, Université de Montpellier III, Centre d'Étude du XXᵉ siècle, 1999, p. 62; Francis Poulenc, Correspondance, présentée par Myriam Chimènes, Paris, Fayard, 1994, pp. 71-72 ; O. Volta, « Auric / Poulenc / Milhaud... », op. cit., facsimile reproduction p. 82.

24 J. Cocteau, « Les Biches / Les Fâcheux », NRF, XIᵉ année, n° 126, 1 March 1924, p. 276.

25 Henri Collet, « Un livre de Rimsky et un livre de Cocteau. Les Cinq Russes, les Six Français et Erik Satie », Comoedia, n° 2587, 16 January 1920, « La musique chez soi », p. 3. On 24 September 1919, Cocteau confided to Georges Auric that he had "manoeuvred" to get "le docteur Collet" to ask his advice. See G. Auric / J. Cocteau, Correspondance, op. cit., p. 62.

26 See Réponse de M. André Maurois au discours prononcé par M. Jean Cocteau, lors de sa réception à l'Académie française, le 20 octobre 1955, Paris, Firmin-Didot, 1955, p. 40.

27 See the article « Henri Collet » in Marc Honegger (ed.), Dictionnaire de la Musique, Paris, Bordas, 1979, I, p. 227.

28 J. Cocteau, Le Coq et l'Arlequin, op. cit., p. 6.

shortly afterwards in Paris, this time under the aegis of Satie. Among the Americans in Paris, George Antheil – also supported by a poet (Ezra Pound) – claimed to be part of the movement by composing sonatas for aeroplane engines or beginning a piano recital only after ostentatiously placing a revolver on his instrument.

The last collective work by the Group of Six was *Les Mariés de la tour Eiffel* (18 June 1921), though the music was in fact written by only five of the group's composers. In order to avoid upsetting Stravinsky, composer of *Les Noces* [The wedding], Cocteau had had to abandon the original title of this "spoken pantomime", *La Noce massacrée* [The wedding party massacre], which highlighted the massacre of a wedding party (in the style of a fairground shooting gallery) by the couple's son. This son, described as "crowned with laurels", should perhaps be regarded as an autobiographical allusion, since Cocteau was born at the same time as the Eiffel Tower and may have felt an oedipal guilt at having shared his mother's life until an advanced age, following his father's violent death in his childhood.

In May 1924 the Ballets Russes simultaneously performed Francis Poulenc's *Les Biches*, Georges Auric's *Les Fâcheux* and Darius Milhaud's *Train bleu* with a book written by Cocteau. This was the supreme consecration of Cocteau's "tract-book", *Le Coq et l'Arlequin*.[29]

However, for some time Cocteau's involvement with Raymond Radiguet had been gradually drawing him back towards writing (novels, essays, plays), leaving all ideas of musical struggle in the background. The death of his young friend, followed by that of Satie, and his discovery – rediscovery? – first of opium and then of religion eventually put a definitive end to this "long period during which, with a group of musicians and under the patronage of Erik Satie", he had "freed French music from its spell".[30] As mentioned above, he announced both this and his "conversion" *urbi et orbi* in another open letter, addressed to Jacques Maritain. As an epilogue to *Le Coq et l'Arlequin*, "born of the weariness of my ears", this letter to Maritain came "from a weariness in my soul".[31]

On the tenth anniversary of the founding of the Group of Six Cocteau distanced himself even further. "They wanted to make me a spokesman", he unexpectedly complained on this occasion. "They wanted to read a manifesto, when, without wasting a moment, I was starting on the most thankless of tasks, since it obliged me to go against my own tastes and deprive myself, for the foreseeable future, of an atmosphere of grandeur without which I cannot live."[32] As for the Group of Six, "it has never been an aesthetic group", he stated. "It was a group of friends: *of friends*, the difference is enormous [...] and the true pure, intact beauty, the hidden beauty of the group known as the Group of Six remains a manifestation of the heart much more than of the intellect."[33]

After this Cocteau had several further opportunities to collaborate with composers, including Stravinsky, Markévitch and Kurt Weil, as well as Honegger, Auric, Poulenc and Milhaud. However, his interventions in the domain of sound remained confined to exercises of "accidental synchronization", with which he had experimented in his ballets and films. These included contrasting very slow movements with very fast rhythms (as he had already done in *Le Boeuf sur le toit*), rehearsing the dancers to jazz but playing a recording of Bach's *Passacaglia* when their dance was performed in public, or reversing the position of pieces composed by Georges Auric for one or other sequence in his films in order to counteract the conventional feelings they might have inspired.

"French French music" was never again mentioned. As for Philippe Berthelot, who had almost certainly discreetly supported this project at the time when he was running his propaganda department, even the fugitive image that Cocteau the film-maker had thought to leave of him has disappeared. In an early version of *Le Sang d'un poète* it was possible to see this "éminence grise", still walled in his diplomatic silence, in the theatre box where a few

29 J. Cocteau, « Musique sans nègres », *L'Intransigeant*, 23 May 1924.

30 J. Cocteau, *Lettre à Jacques Maritain, op. cit.*, p. 20.

31 *Ibid.*

32 O. Volta, « Auric / Poulenc / Milhaud... », *op. cit.*, p. 85, facsimile copy of some extracts from the manuscript of this conference, dated 11 December 1929 and preserved at the BNF, département de la Musique, coll. André Meyer.

33 *Ibid.*

of the author's illustrious friends were applauding the suicide of the poet in the snow. After the scandal caused by the first private screening – a rather unpleasant scandal for once – Cocteau shot this sequence again, replacing his illustrious friends with extras.

MAÏA NÖEL
CHIROLOGUE
60, Rue de Seine · PARIS (6ᵉ)
Pour rendez-vous, téléphonez :
ODÉON 10.86

Analyse Chirologique de
Monsieur Jean Cocteau

La main, tres harmonieuse, a la paume etroite,
aux doigts agiles tres longs et fuseles, denote un ca-
ractere versatile, tout en contraste, a la fois nerveux
et indolent, audacieux et timide, actif et reveur, replie
et aimant la vie mondaine, genereux et egoiste. Personna-
lite magnetique, mobile, changeante, eprise de nouveaute
dans tous les domaines. Vie interieure intense. Sens
aigu des ambiances susceptible de determiner des reac-
tions qui apparaissent comme des caprices. Tactilite
cerebrale tres vive. Aptitudes mediumniques. Nature
impressionnable parce que terriblement receptive, sen-
sitive et intuitive, d'ou la possibilite d'etats depres-
sifs momentanes. Crainte de la couleur. Gout contradic-
toire de l'existence at home et du voyage.

La pouce exceptionnellement long, mince et
bien detache de la paume, l'aspect des diverses lignes
et, notamment la Mentale au trace accentue et traver-
sant obliquement la paume dans presque toute sa largeur,
reflete l'intellectualite dans le sens le plus eleve et
le plus vaste, l'imagination feconde, la bonne memoire.

Nature profondement artiste, doublee d'une energie
creatrice prodigieuse, sujette a des interruptions
avec reprise immediate dans une autre activite.
Forte attraction pour la musique, le theatre, la
poesie. Genie de la mise en scene. Esprit vif, cu-
rieux, enthousiaste qui gardera toujours sa frai-
cheur juvenile. Sens de la maternite sous la forme
d'enfantement d'oeuvres tres differentes, toujours
bien inspirees et bien construites.

La forme tres longue, etroite et legerement
bombee des ongles (qui rappelle celle feminine), ex-
prime le tact, la delicatesse, le charme, le gout de
l'harmonie, l'emotivite, l'extreme sensibilite et
l'intense besoin de comprehension et d'affectivite.

Paris, le 18-3-1952.

Palmistry reading of Jean
Cocteau's hand by Maïa Noël

Jean Cocteau's hands

"My hands, my poor hands that are older, more famous than I am. Sometimes a photographer says to me, 'It's not you I want to photograph, it's your hands.'" So wrote Cocteau in his diary towards the end of his life.[1]

The truth of these words is easy to verify, so numerous are the photographs in which the poet's hands are displayed, exposed, emphasized in one way or another, or provide a focus in half-length or full-length portraits of Cocteau. Sometimes they themselves constitute the whole portrait.

Photographic portraits

The half-length portraits include, among many others, the admirable photograph by André Papillon in which the poet is hiding behind his right hand. The hand itself is immense, isolated in the foreground, a ring on its third finger and the eternal cigarette pinched between index and middle finger. Then there is the photograph by George Platt Lynes, in which the hands are posed one on the other to create a strange and wonderful foreground. We must also mention the very famous photograph by Gisèle Freund, in which Cocteau's serious face is framed by a glove-maker's sign and his own hand.

Cocteau's hands again play a major role in the full-length portraits. This can be seen in the photograph by Serge Lido, which shows Cocteau and Colette sitting side by side in the gardens of the Palais-Royal, or the even more famous portrait of the poet by Dora Maar.[2]

Nothing seems left to chance in the pose and arrangement of these slender, endless hands. They are often prolonged by a cigarette and generally naked, but are sometimes

1 Jean Cocteau, *Le Passé défini* [1954], Paris, Gallimard, 1989, p. 183.

2 See illustration p. 209.

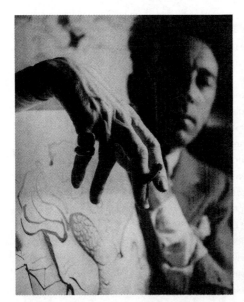

André Papillon
Portrait de Cocteau, about 1939

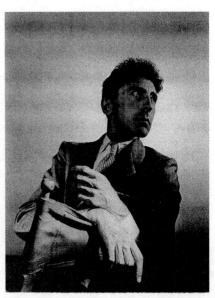

George Platt Lynes *Portrait of Cocteau in his study*, 1939

adorned with the famous rings that Cocteau had designed for Cartier,[3] or clothed in gloves of a refined elegance, worn for emphasis rather than concealment. There is every reason to suppose that Cocteau himself was rather proud of his hands, of which he wrote in *La Difficulté d'être* that people "admire them because they are long and very expressive".[4] This description endows them with two qualities, the one physical, undeniable and immediately verifiable, the other of a different order which requires further exploration.

For what exactly is expressed by these poet's hands, constantly displayed in various flattering poses? Perhaps it is the creator's feverish impatience, as in the countless photographs that show them working – drawing or painting, writing, making pottery – or his profound desire for calm, for inner peace, as in the equally numerous photographs in which they are at rest, placed one on the other, crossed as in prayer or next to a candle which illuminates the darkness.[5] This latter case can be seen as the translation into an image, in the fullest sense of the term, of a poetics of which the endlessly stated ambition is to bring the poet's night into full light.

So Cocteau's hands are tied workers in the service of his oeuvre; he also seems to entrust them with conveying what is undoubtedly the message dearest to his heart, that people should stop staring at him. Such is the meaning we would give to the famous photograph by Germaine Krull, in which the hand hides the face.[6] This is a real profession of aesthetic faith, a pathetic plea in favour of an oeuvre too often sidelined by the personality of its author. On seeing these photographs, Cocteau at once wrote to the photographer in an open letter[7] that confirms our analysis. Here is a significant extract: "I had difficulty in identifying these long, nervous things. Then I saw that these beasts, these dead plants, were coming out of a sleeve, from a suit of mine, and I understood how much they are more like me than a face." These two images, animal and vegetal, can be compared to the series of drawings *Mandragores et mains chevalines* [Mandrakes and horse hands], exhibited by Cocteau in 1937 at the Galérie des Quatre-Chemins, in which he identifies roots or horse-like forms with hands that act as self-portraits.

Hand shapes and lines on the palm
Usually we see only the backs of these hands, with the veins standing out very noticeably. Then, with advancing age, wrinkles and dark patches appear, causing Cocteau to observe, "My ageing hands. My mottled hands. I recognize them. They are those of my grandfather[8] and my grandmother."[9]

Of the lines on his palm, which he carefully observes, he notes in 1954: "The lines on my hand (I must copy them) are just a battle of contradictory lines intersecting furiously".[10] This phenomenon can be verified on the lithographic print of his right hand, dated 1962,[11] but also on a much earlier print of the same hand which appears in the book by Edmond Bénisti (*La Main de l'écrivain* [The writer's hand], Stock, 1939). However, this book, which Cocteau kept in his library, describes and explores only the shape and placing of the fingers, without providing any real revelations, at least as far as Cocteau is concerned.

According to the chiromancers it is of course the lines that are particularly useful for divination, so it is not surprising that the poet, knowing himself to be something of a seer, should have taken a repeated interest in them. When, in 1911 at Cap-Martin, the medium Ernesta Stern looked at the lines on his palm and said, "So many enemies! So many enemies! So many struggles!" he gave credence to the prophecy.[12] Then, in the photograph taken by Serge Lido around 1938, Cocteau himself plays the clairvoyant with a crystal ball above three male hands.[13] Always drawn to paranormal phenomena, he was naturally attracted to the mystery of the lines in which every person's destiny is supposedly written. If, as he wrote in *Prière mutilée* [Mutilated prayer], he regretted having "lost the secret of lines on the palm", he nevertheless used them as the basis for a drawing of the ship that would enable him to escape

3 See illustration p. 115.

4 J. Cocteau, « De mon physique », *La Difficulté d'être* [1946], Paris, U.G.E., 1964, p. 24–25.

5 The series of photographs of Cocteau's hands by Raymond Voinquel is dated by Cocteau in his *Journal 1942–1945* (Paris, Gallimard, 1989, p. 77): "Wednesday 8 April [1942] [...] hand posing at Voinquel's."

6 See illustration p. 290.

7 J. Cocteau, « Lettre à Germaine Krull », *Le Courrier littéraire*, n° 15, April–June 1930.

8 Almost certainly his grandfather Lecomte, who bequeathed him his artistic tastes.

9 J. Cocteau, *Le Passé défini, op. cit.,* 24 July 1954, p. 183.

10 *Ibid.,* 29 October 1954, p. 273.

11 Illustrated by Pierre Chanel in his *Album Cocteau* (Paris, Veyrier / Tchou, 1979).

12 This anecdote is recorded by Cocteau in *Le Passé défini, op. cit.,* p. 274.

13 See illustration p. 118.

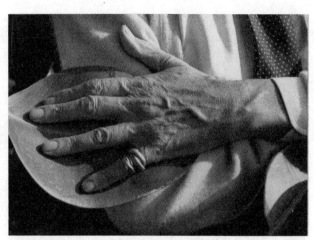

Florian *Cocteau's hand on a
rubber-plant leaf*

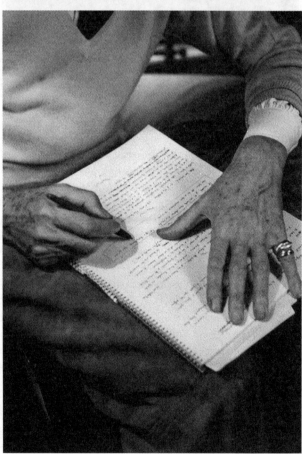

Anonymous *Cocteau writ-
ing his diary*, about 1955

his sick body. Two lines from *Prière mutilée* were to be translated into an image in the open-
ing drawing of *Maison de santé*:

14 J. Cocteau, *Œuvres poétiques com-
plètes*, Paris, Gallimard (*La Pléiade*),
1999, p. 506.

15 See illustration p. 319.

> *Entre les doigts de l'île ourdit l'araignée*
> *Un navire d'après les lignes de ma main*[14]
> [Between the island's fingers the spider weaves
> A ship after the lines on my palm][15]

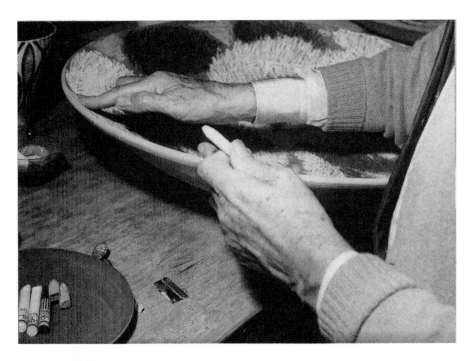

François-Christian Toussaint *Cocteau working on the dish 'Homage to Mistinguett'*, 1959

Though a poor reader of his own palm, when necessary Cocteau was quick to correct a mistaken reading by a professional chiromancer. Among the poet's papers I found the 'Chirological analysis of Monsieur Jean Cocteau' by Maïa Nöel, whose consulting room was at 60 Rue de Seine in Paris. This analysis was to be published in "a limited edition de luxe volume", *Telle main, tel demain*, which was almost certainly never produced. It was supposed to offer an "exceptional inventory of analyses of the palms of the most famous personalities in the arts, letters, sciences, sport and politics", including Alain Delon, Zizi Jeanmaire, Albert Schweitzer, El Greco, Georges Pompidou, Bernard Buffet, Roger Vadim and Jean-Claude Killy to name but a few. The interest of this analysis, dated 18 March 1962, lies less in what it says about Cocteau than in the corrections he himself made in the margin. He is visibly irritated that Mme Nöel should see from his palm that he liked "the life of high society". He notes, "I detest and avoid it everywhere and always", and suggests, "'likes human contact' would be more fair". Similarly, seeing himself described as "egotistical" leads him to comment, "'Solitary' would be fairer. I have always thought only of others." The implication is that, while he gives the clairvoyant some credit, he is not about to let her write whatever she likes![16]

Hands, everywhere

So it is no surprise that the motif of the hand makes countless appearances in Cocteau's work, manifesting itself in many different ways and on the widest range of media, including the Anchorenas's piano, the screen made for Hermès[17] and Harold's photomontage for the poster for *Orphée*.

Everywhere in fact, in his poetry, his films, his drawings, we find the recurrence of one of the obsessional motifs of a multiform oeuvre. It is there from the beginning, unlike the Orphic theme, which is absent from the poet's first three, repudiated books and appears only with *Le Cap de Bonne-Espérance*, which Cocteau saw as marking his true entry into poetry. Thus in *La Lampe d'Aladin*, his very first book, perhaps addressing the woman he loves, he sighs, "*La nuit vient estomper la veine à votre main*" [The night comes to blur the vein on your hand] (in "*Calme*")[18] and dreams of a close-up on his own dead hands, "*Je ne crisperai pas*

16 This palm-reading is reproduced entire as the frontispiece to this article.

17 See illustration p. 309.

18 J. Cocteau, *Œuvres poétiques complètes, op. cit.*, p. 1274.

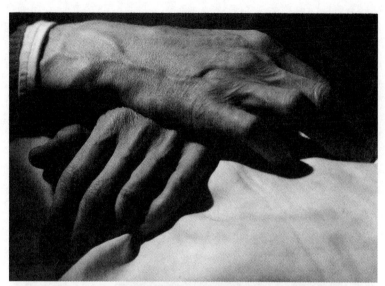

Raymond Voinquel
*Cocteau's hands one on top of
the other*, April 1942

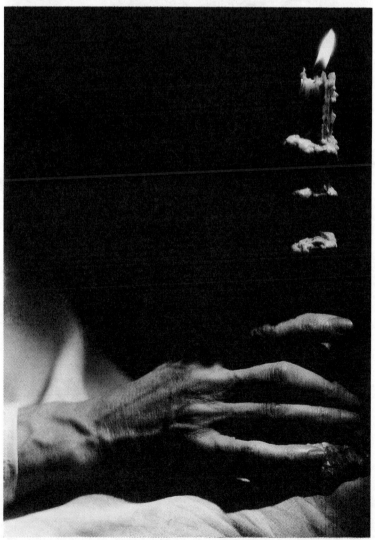

Raymond Voinquel
Cocteau's hands with a candle,
April 1942

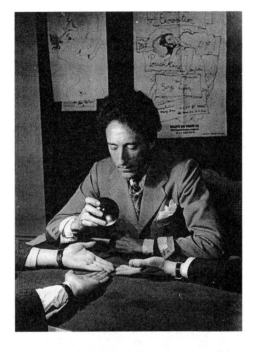

Serge Lido *Cocteau as a fortune-teller*, about 1938

mes doigts, mais tous les dix / Je les étendrai, blancs, sur la noirceur de l'herbe" [I shall not tense my fingers, but will stretch out/ All ten of them, white, on the blackness of the grass] (in *"Désir"*).[19] There is no need to cite all the images of hands scattered throughout his "poetry of poetry", but we cannot avoid including one of the most attractive poems in *Vocalises* from 1911, which reveals Cocteau's real, if modest and debatable, knowledge of palmistry:

> *"Les lignes de la main"*
> *Je sais lire dans la main*
> *Et Meriem a voulu*
> *Que dans la sienne je lise.*
> *Alors avec ma bouche*
> *J'ai suivi chaque ligne*
> *L'une après l'autre,*
> *De bout en bout.*
> *Il y avait la ligne de tête*
> *Assez petite,*
> *La ligne de coeur*
> *Longue, longue,*
> *La ligne de chance*
> *Fine et vague*
> *Mais la ligne de vie*
> *S'arrêtait tout à coup,*
> *Presque immédiatement.*
> *Alors j'ai feint de la suivre,*
> *J'ai glissé sur le poignet,*
> *Sur le bras,*
> *Sur le col,*
> *Jusqu'à la bouche;*
> *Et là, je lui ai fait oublier que je lisais dans sa main.*[20]

19 *Ibid.*, p. 1316.

20 *Ibid.*, p. 1457.

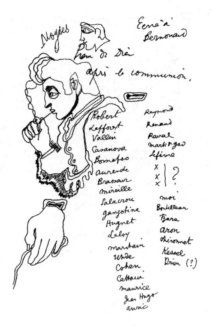

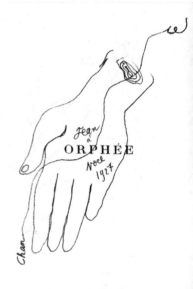

Jean Cocteau
Blood of a poet, with twelve
drawings by the author:
third in the sequence of
drawings
(*Le Sang d'un poète, avec douze
dessins de l'auteur,* Monaco,
Éd. du Rocher, 1957)

List of names and drawings
(Archives de Milly-la-forêt)

Drawing on his copy of
Orphée dedicated by
Jean Cocteau to Jean Catel
(private collection)

['The lines on a palm'
I know how to read palms
And Meriem wanted
Me to read hers.
So with my mouth
I followed every line
One by one,
From one end to the other.
The head line
Was rather small,
The heart line
Was long, long
The luck line
Was thin and vague,
But the life line
Suddenly stopped,
Almost at once.
So I pretended to follow it,
I slid on to her wrist,
On to her arm,
On to her shoulder
On to her neck,
To her mouth;
And there I made her forget that I was reading her palm.]

In Cocteau's films hands are more immediately visible and play a major role. These include the hand in *Le Sang d'un poète,* in which a mouth appears[21] or the famous candelabra hands of *La Belle et la Bête,* to mention only two well-known examples.

In the theatre the interplay of visible and invisible hands informs *Renaud et Armide,* but it is of course to the countless drawings featuring hands that we must now turn our attention.

21 This drawing illustrates the sequence: *Sa main* [His hand] (close up) in which the mouth is shown.

Jean Cocteau's hands

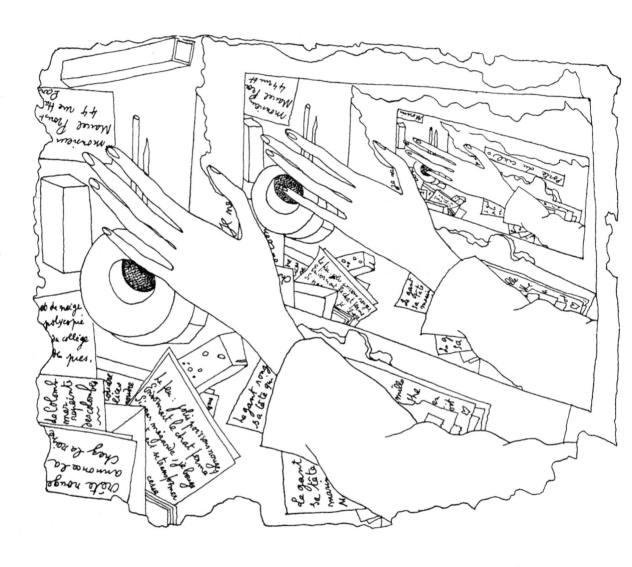

Hand designs

The motif of the hand seems to spring spontaneously from Cocteau's pen or pencil. We find it on a sheet of paper on which he has noted the names of friends for whom he must pray and it often enriches a dedication. Elsewhere it accompanies drawings of feet, as on the menu of the cabaret Le Boeuf sur le toit, which on the other side reveals a project for a film in which hands would play a major role. "Large hands. The brother's hands trying to open the sister's hand and take the knife – we see hands following characters who are going up steps".[22]

But in Cocteau's work the hand motif also reflects a concern to convey a particular message. This is shown by the hand, frequently reproduced, holding a pencil and a cigarette, as though to bind work and pleasure indivisibly together,[23] or the more mysterious hand resting on the poet's work table in the drawing entitled *Porte du ciel* [Heaven's Gate], which appears in Cocteau's first book of drawings.[24] What does it show? The same motif is reproduced three times in an image within an image implying repetition to infinity: a hand with long, tapering fingers – apparently the poet's hand – seems to be lightly touching an inkstand. Nearby lie two writing implements (pen? pencil?), a rubber, an envelope bearing the barely visible but identifiable address of Marcel Proust and paper on which can be made out the texts of three poems from *Vocabulaire*. Is the hand preparing to take up the pen, or has it just

Jean Cocteau
Heaven's gate
Dessins [Drawings],
Paris, Stock, 1924

22 See illustration p. 244.

22 See illustration p. 383.

24 J. Cocteau, *Dessins*, Paris, Stock, 1924.

laid it down? Then, in a space in the background, we make out the drawing's title, *Porte du ciel*. Suddenly a drawing that had appeared to be plunging into the depths of an endless mirror can be seen as opening on to redemption. The message is clear: the line of the drawing and that of the letters is linked to the exploration of time (Proust's presence is no coincidence) and inner space; it also leads the artist to heaven's gate. Does he pass through? Cocteau does not answer this question, simply suggesting an ambiguous reply. However, we should note that Orpheus' lyre has here taken the form of a hand in the process of writing or drawing.

Elsewhere Cocteau starts a drawing – it is clearly a portrait for which he has sketched two outlines – and, in a caption which seems to have come from the hand itself, comments on his inability to finish it: "It's over. I have been seized by the void. The line is dead. I must move on to other exercises." Cocteau's speaking hand now leads us to a discussion of the astounding transformations to which it is subjected by the artist.

Transformations of the hand

Cocteau gives several accounts of the mechanism of writing or drawing, speaking of an inner force which guides his hand, without the involvement of his will. He explains this clearly in the preface to the *25 dessins d'un dormeur* [25 drawings of a sleeping man]:[25] "To draw a line without trembling from the knowledge that it is in mortal danger at every point along its route, I have to fall into a kind of sleep, to allow the sources of my life to go down into my hand without reserve, so that this hand ultimately works alone, flies in a dream, moves with no concern for me."

Returning to this independence of the hand that is indispensable to creativity, he writes later, in *Le Passé défini*: "When I draw, I no longer exist, I no longer suffer, I'm no longer anxious, I am only this hand that draws lines", and again, "When I draw, I seem to empty myself of my wearinesses and my anxieties. My hand becomes a fairy and works on its own. It shows me what it brings to light from a self of which I know almost nothing."[26]

Without dwelling further on the magical hands of *La Belle et la Bête*, we shall now consider the profusion of drawings illustrating the phenomenon of an autonomous hand

25 Id., *25 dessins d'un dormeur*, Lausanne, H.-L. Mermod, 1928; edn Fontfroide-le-haut, Fata Morgana, 2002, présentation de Pierre Chanel.

26 This and the preceding quotation are taken from as yet unpublished pages of *Le Passé défini*, op. cit. (6 January and 17 April 1960).

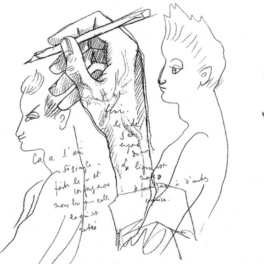

Jean Cocteau
Hand in the act of drawing
Unpublished drawing
(Archives de Milly-la forêt)

Unpublished drawing on headed notepaper of the Hotel Belles-Rives
(Archives de Milly-la forêt)

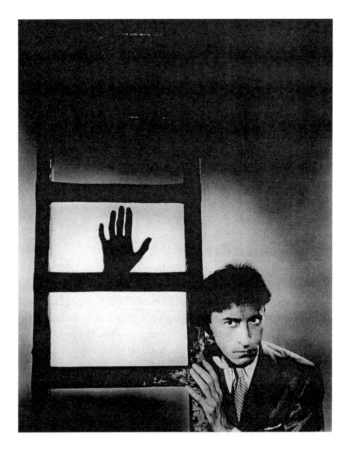

George Platt Lynes
Cocteau with a ladder, 1939

fulfilling all the body's functions by itself. We have already noted the mouth-hand; other vari-
ants include the face-hand, the galloping hand on which every finger has been transformed
into a horse ready for the race and the phallic hands on drawings of roots that have been
transformed into fantastical characters with penis-shaped fingers.[27] This phenomenon is also
depicted in photographic portraits of the poet, particularly, and undeniably, in the enigmatic
picture by George Platt Lynes, in which we see Cocteau leaning on a ladder, his left hand
resting on one of its sides, while his right can be seen between the rungs above, alone, as
though detached from his body. Significantly this right hand, the one that works all by itself,
is placed above his head. Meanwhile Philippe Halsmann photographed Cocteau with six
hands, each performing a different task, as though to emphasize the supernatural, almost
divine character of this bearer of exceptional hands.[28]

 Cocteau's work resembles Apollinaire's autumn, which is "full of severed hands".[29] But
Cocteau's are not Apollinaire's "hands of dear dead women",[30] they are alive and active.
They are his own hands. Cocteau plays with plaster and bronze casts of his hands, making
them come alive, as in the picture by an anonymous photographer in which his living hands
are posed on a cast of his hands, or the photograph by Pierre Jahan showing two hands,
one real, one plaster, emerging from the same sleeve, so that it is impossible to tell which is
which, or the photograph in which the same cast is placed next to the cast of Chopin's right
hand, given to Cocteau by his Polish friends.[31]

27 See illustration p. 309. These
drawings were included in the
exhibition of 26 February–
11 March 1937 at the Galerie des
Quatre-Chemins, Paris, on the theme
"Mandrakes and Horse Hands".

28 See illustration p. 173.

29 G. Apollinaire, « Rhénane
d'automne », *Alcools*, 1913.

30 *Ibid.*

31 During his visit to Warsaw in
1960.

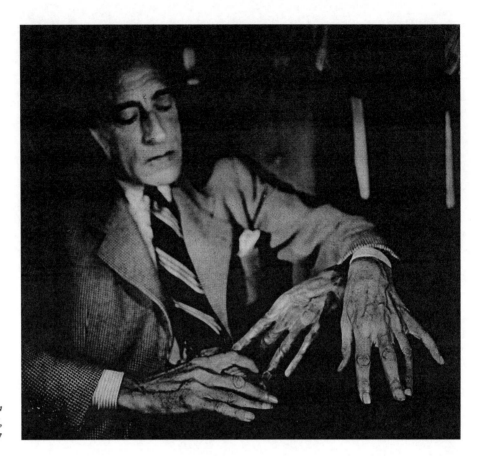

Pierre Jahan *Cocteau with a*
plaster cast of his left hand,
1947

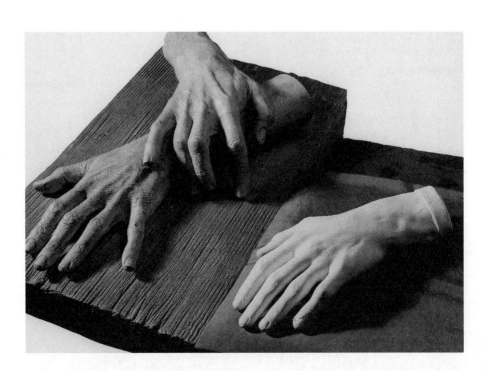

Ballerini, *Casts of Cocteau's*
hands and of Chopin's left
hand, about 1960

Cocteau knows how to disturb and fascinate us with the motif of the hand in all its playful, tragic, erotic, elegant, surprising and magical possibilities. It is present throughout his oeuvre and holds many undisclosed secrets. These hands have so often been exhibited, photographed, drawn and admired; do their movements and poses form a syntax? Are they expressions of a coded language that has yet to be deciphered? Impertinent questions!

Let us settle for looking at the poet's hands so as to forget his face and noting from their lines that they are the reflection of both a tormented life and a fertile existence entirely devoted to poetry in its most diverse forms.

Cocteau liked to quote Stendhal, who was, he said, "Quite right to write that the way a woman climbed into a carriage was inspired". We might also say that the way that Cocteau played with, used, or simply displayed his hands was inspired.

A conversation

Dominique Païni - When you met Cocteau, was it on the basis of an introduction, a chance meeting, or did you meet because he had noticed you?

Jean Babilée - When I met Cocteau, it was quite simple, after the war the first show we put on was at the Théâtre Sarah Bernhardt...

DP - When you say, "we"....

JB - I mean, after the war I came back to Paris. Everyone met up again after the Occupation and Irène Lidova got us all together and we put on a show at the theatre which is now the Théâtre de la Ville. Cocteau came to see us. After that the Ballets des Champs-Élysées was set up. That lasted four years, maybe five, and Cocteau used to come quite often. One day Boris Kochno said to me, "Tomorrow we're eating at Francis's place, Place de l'Alma, and Cocteau wants to talk to you." He said to me, "Listen, Nijinsky has at last done his *Spectre de la Rose* ["Spectre of the Rose"] – it's a *pas de deux* with sets – and I'm going to give you your Spectre de la Rose. And he wrote *Le Jeune Homme et la Mort* ["Death and the Young Man"], a *pas de deux* lasting a quarter of an hour with two very weighty sets. The second set, at the end of the ballet, was visible for no more than a minute and a half. There was a whole electrical mechanism with an Eiffel Tower, which formed the letters and chevron of Citroën. It was a wonderful vision of the roofs of Paris at that era.

DP - When he said, "I'm going to write *Le Jeune Homme et la Mort* for you", did he think of it in an abstract way and then design it at his desk or in his studio? Or did he write it, design it, imagine it through a direct and constant relationship with you? Did he come to you with a project?

JB - The first time I saw him he knew what it would be. He had already dreamed of doing it with Boris Kochno. They were ready to give me *La Jeune Homme et la Mort*. Perhaps he wrote it because he'd seen me dance.

DP - So he had imagined it beforehand.

JB - Of course, it wasn't something that came spontaneously. Besides, the piece he wrote for this ballet is of a beautiful concision. It's a real model, because you often read ballet libretti in which the descriptions go on and on. But this was so concise! It was so Cocteau, the way that piece was written.

DP - Did you know that Cocteau was a prominent personality in French culture?

JB - Of course I knew who Jean Cocteau was; I even knew some of his poems by heart. My greatest memories of Cocteau are those he told me afterwards and that he loved: happy moments in his life, for example the time when the Ballet Russes came to Paris. Those are things he kept inside and, suddenly, he'd start telling stories, to the point where he'd describe parties to me in detail. He'd be in this or that place and Diaghilev would come in He told me a lot of detailed stories and he was such a good talker that I felt as though I'd seen these things myself.

Michèle Bargues - Had he seen *The Rite of Spring*?

JB - He didn't talk to me about *The Rite of Spring*. He talked a lot about Nijinsky, the *Faun*, particularly extraordinary stories about things that happened at the Châtelet. Once he was in the wings with Diaghilev, before the curtain went up for *Le Dieu bleu* ["The Blue God"],

and they were watching Nijinsky who was centre stage, behind a door that was going to open (because they were in profile in relation to him). He was sitting cross-legged on the ground, fingers on his knees so as not to mess up his make-up. Diaghilev said, "Look at his wonderful concentration before going on-stage". At that moment Nijinsky carefully turned his head towards Diaghilev and said, "I want a Kodak". Diaghilev mimed tears. "No, no, darling, you know very well there's no more money". "I want a Kodak." "Yes, you'll get it." There, they're all stories like that. He used to tell loads of them.

DP - So he came and asked you to do *Le Jeune Homme et la Mort*. It seems as though he was the author of the whole thing.

JB - He was there at lots of important points, for example when Roland Petit, in a very beautiful series of movements, went on to something else, Cocteau would say, "You see, that movement is very beautiful, but you have to do it three times because the first time the audience sees it, the second time they notice it, the third time they recognize it." So, in *Le Jeune Homme et la Mort* you often have the same movement done three times in a row. In this ballet he wanted to try out what he called "accidental synchronization", in other words the music would be chosen at the last minute. Of course we had to have something in rehearsals to keep us going. In the early days our pianist, Nicholas Stein, a wonderful musician, started playing a kind of American jazz, *A Sentimental Journey*. For me there was such a gap between this music and the young man's tragic story that I couldn't move. Faced with my refusal, Stein began playing an invented score with no melody, well paced to fit the choreography we were developing as we went along. When everything was settled, he had a proper rhythmic score to accompany us. Then – we didn't know what kind of music there would be – when we got to the dress rehearsal usually it still wasn't settled. When I arrived on the set at the Théâtre des Champs-Élysées, I saw André Girard, the conductor, coming in with a score under his arm; he said to me, "I found Bach's Passacaglia in the end, it's the right length". I didn't know that piece of music. In the dress rehearsal I lay down on the bed, my feet against the wall, I lit a cigarette and then, with the curtain down, I heard the first notes of the Passacaglia and I began shivering all over. And everything went marvellously. I had a watch, because I had to know when I was going to "hang myself"... and that watch was used. At particular points I had precise things to do: Wham! and the music stopped. It was fabulous. Cocteau said to me, "Listen, they're never going to believe in this 'accidental synchronization'. From time to time we have to change the music." We would have done, but it was too expensive to rehearse the orchestra. So we stayed with the Passacaglia.

DP - That was one of his phrases, "accidental synchronization".

JB - Yes, as he was editing his films he'd noticed that, for example a piece of music by Bach seemed to have been composed to go with his images, the right rhythm and dramatic intensity. He decided to try out "accidental synchronization" with a choreography.

DP - I was thinking as I watched your role in *Le Jeune Homme et la Mort* that there were movements which didn't seem to be particularly integrated into choreography, or dance, as it was understood at the time.

JB - In *Le Jeune Homme et la Mort* there's not a single movement of any kind that isn't required by the story, by my relationship with the other dancer. Every gesture means something.

DP - The gestures are almost utilitarian in relation to the story being told.

JB - They are completely utilitarian, so much so that my father, who had always seen me in classical ballets, brilliant *pas de deux*, came into my dressing room and said two things: "It's extraordinary!" Then he said, "But, you're walking in this ballet, you aren't dancing, you're walking." I said, "Yes, I'm walking."

DP - In relation to what would become contemporary dance, thirty or forty years later, it was unbelievable.

JB - Cocteau called it a mimodrama.

MB - Had he seen Kurt Joss, German dance?

JB - Certainly, but the two are quite different. Roland Petit would begin a movement and I would finish it. It happened by osmosis.

DP - And your relationship with Roland Petit?

JB - It was all as easy as could be, as with all the things I like doing. We never had the slightest hitch, it all went wonderfully, we were happy to be working.

I should go back a bit: during the Occupation, I was in Cannes and I was dancing *Le Spectre de la Rose*. I got injured on stage and had to have an operation on my meniscus. At that time you spent twenty-one days in plaster. When they took the plaster off my leg was a very strange shape. I'd always worked in a swimming costume, with bare legs and slippers. When I started training again I said to myself, "Oh dear! That's no good. I've got to hide that leg". I went down the Rue d'Antibes and found a pair of dungarees. I bought it and it became my working costume. The war finished, I came back to Paris, the Ballets des Champs-Élysées was set up. Rehearsals began for *Le Jeune Homme*, I had my dungarees and one day, during the rehearsal I asked Cocteau, "What am I going to wear?" He said, "I see you in black trousers and a white shirt, then you take off your shirt and go on with a naked torso". I started to sulk, then I said to him, "But Jean, I feel so good in my dungarees, why don't I just keep them?" "Yes, you're right! As you are a painter, we'll put splashes of colour on them." That's where the dungarees came from – my accident.

DP - You would move very fast, you were a bit like an arrow, but one, it seems to me, that moved at Cocteau's speed.

JB - Ever since I was a little boy I've felt wonderfully in control of my body and I decided to use it; it gave me pleasure. When I had to portray an emotion, I knew what an emotion was and I gave myself over to it entirely. I've never gone in for play-acting. For me it was always an inner tension that makes you forget technique completely.

DP - Cocteau said the same thing about the cinema, that you had to forget about technique, and that's why, in some respects, he wasn't much liked by the cinema world, why he was never able to integrate himself into it fully. So how was *Le Jeune Homme et la Mort* seen in traditional dance circles? As something different? Untimely?

JB - Completely. It astounded people; daring to dance to Bach for a start! Although it was magnificent. Someone said, "It's as though God were looking down on human misery"; it was really beautiful. The first company to dance in London after the war was us, the Ballet des Champs-Élysées. We were at the Prince's Theatre. I performed *Le Jeune Homme et la Mort*. People were dumbfounded.

DP - The young generations of today will doubtless discover this ballet in the exhibition. What was it that dumbfounded people most about it, do you think?

JB - The whole thing.

DP - You don't think there was anything in particular?

JB - The set by Wakhevitch, the photographs by Brassaï, the music by Bach...

DP - I felt it was on the level of the choreography, the movement of the bodies, that it was most surprising; the things you were doing were so unconventional.

JB - I introduced some acrobatic movements into the choreography. They were familiar to me but were completely different from classical dance.

DP - Since Cocteau died in 1963, you often danced it while he was alive. Did he still pay it any attention?

JB - Yes, from time to time. There were drawings by Cocteau stuck on the sets and they used to get damaged regularly in transit. I would telephone him saying, "Jean, I need some drawings", and he would say, "Come over, I'll do you some drawings", and I'd go off with them.

DP - And when Cocteau departed this life, were there any changes?

JB - Roland Petit had staged it for Nureyev, Barichnikov, Makarova, and it wasn't *Le Jeune*

Homme et la Mort any more because it wasn't the same choreography or sets or costumes any more. Then Makarova didn't think her role had enough substance, so a whole movement of the music was doubled to lengthen the choreography. Whereas it started off as a mimodrama, Roland Petit turned it into a ballet with *pas de danse*. So Cocteau's *Le Jeune Homme et la Mort* lost its originality.

MB - The way you describe it, one senses the fusion between Cocteau and Babilée. You were possessed by the movement.

JB - Of course. Another dancer who could have done it was Barichnikov. He came to see me when I performed it again for Roland Petit in 1983 at the Châtelet, because he was making a film, *Soleil de nuit*, in which he danced a fragment of *Le Jeune Homme et la Mort*. Besides his extraordinary qualities as a dancer, Barichnikov caught the dramatic intensity of *Le Jeune Homme*, even if it wasn't the original choreography. Besides, I have a letter from Cocteau. He wrote, "This ballet belongs to both of us."

DP - There are some great actors who identified with their character – and you can't separate the two. You are *Le Jeune Homme* and no one can touch it any more.

JB - You know I've never liked to repeat a role created for someone else. It's been suggested to me and I've often refused. I did dance *Le Spectre*, but I never wanted to dance *Petrushka*. What I wanted was to have things created for me.

MP - That's a very contemporary idea in dance.

DP - I want to ask you some things about Cocteau's body. He himself was a tightrope walker, he practised all the arts. He used a clear line to draw. Did Cocteau have a skilful body?

JB - I would say what everyone says: he had strikingly beautiful hands, he had very fine wrists which he was happy to display. In my opinion he was very good-looking; his presence was enriching. It was a pleasure to meet him. I really liked him very much indeed. He had a fertile eye; he gave you talent when he looked at you.

DP - Did he move well?

JB - Yes, very well, with a great deal of ease and elegance.

MB - Did he never want to film *Le Jeune Homme et la Mort*?

JB - Often. He used to say to me, "We must film it."

But you haven't said anything about *L'Amour et son amour* [Love and his love]. That was a ballet I created.

DP - You went to see Cocteau with a different title, a different subject called *Psyché*, didn't you? That was one of your proposals, one of your creations, but what part did he play in it?

JB - I had never created a choreography for a *ballet d'ensemble*, only for *pas de deux*. One day I heard a piece of music by César Franck, *Eros et Psyché*. I fell in love with that music; I absolutely had to do something with it. I was at the Ballets des Champs-Élysées at the time. There were classes every morning, the studio was free in the afternoons. Quite unofficially, I arranged to meet six girls and two boys the following day at the studio. I asked the pianist, Nicholas Stein, to come too. And like that, on the quiet, I finished the ballet in a fortnight. Then I was called in to see Roger Eudes, who was the director of the Champs-Élysées theatre. "They tell me you've created a ballet." "Yes, I have!" He said to me, "Listen, in a month and a half there's a season in Paris. We'll perform it. What is it called?" "I don't know." "And the sets?" "I don't know." "Go home and think about it." When I got home I said to myself, "Who's going to get me out of this?" I thought of Jean, I telephoned him. "I've got a problem." He said to me, "Come and have lunch in Milly tomorrow." I went to Milly; he received me the way he used to receive people, showed me the garden then we sat down to lunch. He started by tossing the salad with his hands. He said, "What is your problem then?" "Well, I've just created a choreography." "That's not very serious; what next?" "The music is *Eros and Psyche* by César Franck, but I don't want any mythological references in the title." "Eros is love, Psyche is his love. Call it *Amour et son amour*." So I had the title. Then he said

to me, "For the sets it's very simple. Psyche is on earth and the gardens of Eros are heaven." And he drew me a geographical map representing a woman, with hair, blue eyes like lakes, the sea, the borders And there was a second set which represented the map of the night sky in blue with the constellations joined up with lines.

Thinking of that I have another memory. Once in Chicago I was doing a tour with the Ballet Theater and, as we got closer and closer to Chicago, all the dancers in the ballet were saying to me, "Oh dear! In Chicago the critics are ferocious, they tear you to pieces. You have to watch out in Chicago." I didn't know the place at all. We get to Chicago, I dance *L'Amour et son amour*, there's a moment on stage where I do a big variation. So I start this variation and I see a balloon coming down from the flies with a long string and a cardboard label, white, with the number seven written on it in black. The balloon starts coming down, down. Beforehand there'd been a party with children, they'd been sent balloons that they had to catch and they could win depending on the number. One balloon had got left out. Eventually it came within my grasp, I caught it and I did a jump into the wings to get rid of it. After the show we went for dinner and someone went to buy the newspapers, the way they always do over there. "*L'Amour et son amour* is absolutely marvellous! That Jean Cocteau has such sublime ideas! The figure seven, with all its symbolism, suddenly floating down from heaven!"

DP - But who let go of the balloon? Was it an accident?

JB - Let me tell you. Fifty balloons came down from the flies for the party and only one got left behind...

DP - Yes, it was before your ballet, during the day, and there was one left.

JB - There was one left, which came down during my variation.

DP - That's "accidental synchronization" too. And did you use the idea again after that?

JB - No.

DP - Because you could have incorporated it.

JB - No. When things happen once like that it's fine.

MB - The extraordinary thing is that they attributed it to Cocteau.

JB - And the critics were suddenly entirely won over. A dancer's life is very amusing; when you travel you have lots of adventures, a very nice life. I had a great time.

DP - That's obvious. Just talking about *Le Jeune Homme*, you feel an enthusiasm, a vitality, a power, a joy in accomplishment, which is absolutely unique. I was struck by that when I discovered it and it has remained mythical for me. And the black and white

JB - That's very good.

DP - Because, it seems, the sets were supposed to be dominated by black, white and grey.

JB - Yes, black and white, apart from the coloured paint stains on my faded blue dungarees, the young woman's canary yellow dress and Death's red scarf.

DP - Do you have any other memories?

JB - Yes. Once I was at his place and the telephone rang. He spoke for a moment and said to me, "That was Colette who just called me. She's asked me to go round to see her. Do you want to come with me?" I said yes, of course. We went fifty metres down the road and up to Colette's apartment in the Palais-Royal. I saw her straight profile in the window, there were glass paperweights on her desk, the room was magnificent. Jean said to her, "You know Jean Babilée?" She looked at me and said, with a strong Burgundian accent, "Oh, it's the boy who flies!"

DP - She said it all. It was so true that sometimes you seemed to have a rope attached to your back lifting you up. Sometimes you literally levitated.

JB - "Oh, it's the boy who flies!"

DP - Thank you, Jean. Anyway, we've come to the end of the tape. It's "accidental synchronization".

22 January 2003

Noël Simsolo

Jean Cocteau,
poet of the substantial

"Jean Cocteau has done nothing but search, in the novel, in the theatre, in drawing, in travel, through language and colour, in the snow-covered brass of pipe-cleaners or in the ink of light, for ways to give weight to the invisible, to set a trap for Death, an ink that betrays the presence of angels and shows us phantoms that suddenly turn into blue trees."

Chris Marker, *Esprit*, November 1950

Lyricism does not rule out abstraction. Curiosity about the realities of our world does not prevent us from immersing ourselves in the no-man's land of dreams. Throughout his life, Jean Cocteau had the cheek to voyage from one bank to the other of these apparently antagonistic principles. This enabled him to explore ancient continents, islands lost in the mist and new constellations; often he stayed in his room to pass in secret through mirrors and hunt down the invisible in order to give it shape, but he also went from one country to the next on a world tour with a schedule to mirror that of Jules Verne, or crossed the Atlantic by air while writing a *Letter to the Americans*. Whatever the nature of his raids, the main thing for him was never to return with a weight of exotic, picturesque or amusing tales to tell with all the loquacity of someone delivering a public lecture, spreading out a range of trinkets of dubious value before his audience. Indeed he would have been incapable of doing such a thing, since his sense of observation seldom led him to an interest in folklore, ancestral cults or table-turning.

In the course of his wanderings Cocteau went hunting for ghosts so that he could force them to appear at the twists and turns of the void. His hunting method involved taking the place of the game and provided him with abundant catches; for, once captured by the spectres, he would discover the reality of their mysteries and unresistingly allow them to take him over, obeying their slightest order and transcribing their games of living death into idioms on a human scale, but remaining a receptive sleepwalker until the transfusions of opacity ceased. Then he would escape their zones and return to his home port, where he would exhale the honey of this strange harvest using some vehicle linked to the many arts he practised simultaneously.

To expose oneself to the unknown in this way is the great privilege of poets. They are the only mediums of the invisible. Yet many of them waste their opportunity by chiselling away at the surface of the treasures in this arsenal, harvested by means of fake crests, superficial allegories and redundant metaphors. They confine the exercise of their art to incursions into a beyond that lies between day and night – a territory the wealth of which is not of a kind to be revealed in its entirety on the first visit – and cynically use it as an attractive business, putting themselves on display like vile charlatans.

The late nineteenth century suffered from such fake inventors, who drew on the reservoirs of enigmas with both hands. They dressed up their every sign in a symbol that would be seductive without being disturbing. How many followers of mystic occultism and saturnine fantasy copied out the ineptitudes listed in the *Book of the Dead*?

Cocteau was of a different mettle. He hid nothing of his dazzling experiences, left to one side the classifications established by the bogus magicians and wanted above all that every-

one should know exactly what he himself had caught, without trying to understand its source or meaning. To avoid being mixed up with those who betray the Muses, he worked on every word to save it from the worst.

And as the invisible elsewhere was not enough for him, he was also interested in the most obvious sights of his time, unearthing the treasures hidden on the other side of usage and putting them on display as things that were simply obvious but had been forgotten.

"It's only very great men who understand their own time: you've understood yours and created it at the same time' (Max Jacob, letter to Cocteau, 8 March 1926).

Persisting in preserving intact the child's readiness and sense of intoxication, Cocteau sought out totally new sensations in order to escape the weighty wisdom of human beings or the insipid docility of his disciples. He was not afraid to put himself in danger of death or ridicule. He was the best truant ever.

From escape here to vertigo there, he dared to touch the roof of the sky in Roland Garros's aeroplane, "negrified" his body in the hot sun of Provence, made up tales for wakeful sleep, gave life to puppets and the toys of fairground podiums so that he could arrange their wedding on the Eiffel Tower, and organized acts from the English circus into a provocative *Parade* with the help of Picasso and Satie.

Since he was not against imprudence, he took uncalculated risks, deserted his job as an ambulance driver to join the marines illicitly in the Great War, unfettered his nerves with the demons of opium and exposed himself in the front line to defend Jean Genet (and his accursed brothers in their dangerous revolt) at a time when occupied France was in the grip of Vichy morality.

Uncommonly perspicacious where the beauties of the modern world were concerned, he guessed that boxing was choreography, sensed that jazz sprang from music's very lifeblood, understood that bullfighting was derived from ancient theatre, proved that the plaintive Edith Piaf was a diva of *Kammerspiel*, insisted that the classical authors were modernists who had succeeded in passing through time, and opened as many Pandora's boxes as he could to free the monsters that were lounging inside and laughing at mortals.

With him human ways were confessed on the telephone wire, a lift threatened to slit the bellies of little girls then to sew them up again empty, statues came to life to direct light from candelabra, in blinding contrast to the coal-blackness of a beautiful medieval castle, and bedrooms of murder became the caravans of a junk-dealing sorcerer.

Nothing of his time escaped him. He unearthed forces produced by technological mutation, precious minerals for freeing the mind and many substances with spellbinding powers. The main thing was always to use everything that came to hand; he omitted no field of communication and delivered his booty to the greatest number, though he distrusted the dominant élites, preferring to speak to the mass with any means available. He took every opportunity to communicate his discoveries. Even mass journalism seemed to him to be conducive to the smuggling of poetry, but only with the cinematograph and its magic tricks did he charm the general public. *La Belle et la Bête*, *L'Aigle à deux têtes* and *Orphée* were truly successful only in local cinemas, no doubt because the image needed to be raw and not to be understood. For, above all, it showed things, and it is by presenting things in this way that one touches the essential in those who are watching them.

First in *La Fin du Potomak*, then in *Opium*, the drawings irresistibly devoured the text. Ballet and theatre shaped a unique method of direction, where hearing and sight become paths to the heart before the mind gets involved (or entangled). Ultimately the cinematograph proved the most successful vehicle. Instead of saying that a man passed through a mirror, he could show the man passing through the mirror. No one could fail to believe it.

Jean Cocteau, poet of the substantial

It would be wrong to think that a poet is of his time because he takes his own period as his subject. The poetry of contemporary life is of value only when a creator knows how to strike it with a thunderbolt, like Apollinaire with the war of 1914 or Louis Aragon describing the exodus of 1940 in *Les Lilas et les roses*. Cocteau know how to stop in time to be of his time, as the following lines from *L'Adieu aux fusiliers marins* [Farewell to the Marines] reveal:

> "*Il m'avait dit : 'Va Jean, l'époque*
> *est une bourse qu'on trouve.'*
> *il n'a pas dit : 'Ouvre la bourse*
> *et dépense le contenu.'*"
> [He had said to me, 'Off you go Jean, your time
> is a purse that you find'.
> He did not say, 'Open the purse
> And spend its contents'.]

"Jean Cocteau? He's a very great poet, linked to other poets through the fraternity of the front and to men through his heart. We still insist on that, because a deplorable misunderstanding seems to be becoming established where he's concerned – that the grace of his style should be the prey of the vilest thing in the world, the elite" (Jean Genet, *Empreintes* no 7–8, May/ June/ July 1950).

Little concerned with easy protection and ignoring the golden rules of good behaviour, Jean Cocteau transformed his wanderings into sovereign illuminations and created without cease, leaping stages of thought and laying waste to the flower-filled baskets of prettiness to hit the bull's eye by surprise, while respecting (through strength of moral will) an impeccable economy of means.

Wary of scholarly words and avant-garde recipes, he often allowed his instinct to dominate his reason, sometimes gave in to fascinating impulses and always chose to be a smuggler where others set themselves up as arrogant party leaders.

In other words the many cultural fields in which he worked at full tilt overflowed their confines with each of his experiments, instantly changing the rules as they did so by pushing back the limits imposed by academies and castes.

He was touched by everything: this deserter from a cosseted bourgeoisie laboured on royal highroads, forbidden paths and byways in order to sow them with doubt in a critical spirit guided by the beauties of disobedience, and to draw in them a thousand and one signs, tattooing inventions on territories that no longer had any frontiers other than the undefined spaces of poetry.

This obstinate insistence on making the Muses sweat by throwing them into the unknown of things foreign to their own domain was enough to annoy the mandarins of knowledge and the constructors of castrating dogmas. It also disorientated the schoolmasters, those thinkers content to impose wheezing commonplaces on the world and the vultures who prey on dead language. Such a quantity of intersecting tracks changed the status quo far too much. Leaping and pirouetting, Cocteau transformed the territory, rendering the building blocks of the old order and its hierarchies of values anachronistic. He compared things that were accepted as being absolutely incomparable, taking it upon himself to awaken the phantoms of Greek mythology only to illuminate them with the searingly unusual realism of a water-dowser, and even going so far as to decorate a chapel with drawings of pagan figures. He granted an intoxicating torrent of speech to the taciturn Sphinx of Thebes, created a monologue of cruel struggle with a handsome, indifferent man who breathed heavily on stage, dared to give Death the face of a woman suffering the pains of love and pushed paradox to the point of sublimity by infusing classicism with the new blood of conquering modernism.

It was no simple penchant for the art of contradiction that made him dance this way outside the norms, shooting hundreds of arrows all around the targets, which he thus rendered obsolete. The instinct of true poets strips them of all inclination for such sly calculations or the desire for immediate recognition by the inner circles of the state. On the contrary, he obliged them to find unbelievable beauty everywhere by losing themselves beyond the rhetoric of symbols and reassuring mimesis.

Jean Cocteau followed a line without knowing where it was going. He bathed in distractions until he could find poetry in the crumpled folds of outdated legends, the fogs of mucky reality or brutal scenes between terrible brothers, sisters, children, parents and lovers, with the delicious excuse of being "a lie that always tells the truth". This dangerous aphorism saw him stuck with an unfortunate label and raised a hare which seemed, to casual observers, to be stuck in one place, thereby fixing the attention of exegetes (friends or enemies) on a façade of appearance. He was then able to come back on the undertow as the poet of substances and to continue looking for the "truer than true" without the police of official culture having him watched, taking notes on his secret life or imprisoning him in their indictments.

> "Jean Cocteau everywhere. Everything interested him. He helped everything and everyone. Should we assume that this stripped his judgements of all value? I think not since, whether written or spoken, his slogans had such poetic precision that they were more than just a description; they constituted an anthropometric file on the work or artist that he had decided to support" (François Truffaut, Les Films de ma vie, 1975)

This poet in love with Oscar Wilde managed to reverse Dorian Gray's pact. He showed his portrait the better to hide his true face. The others thus smeared him with vice and called him a socialite (Jean Cocteau = Jean Cocktail); he allowed his double to be covered in the faded finery of a parasite so that he could work in secret in the mystery of his bedroom or the gardens of his true friends. When he did appear in the public squares, where art is judged according to the heights reached by its praises, it was never to look for prizes or to help himself to other people's glory, but to assist and support those he loved for their works and for their strength of character, the boxer Al Brown, the playwright Boris Vian and the film-maker François Truffaut, to name but a few.

We should note that, in leaving childhood, Jean Cocteau escaped by a whisker. His naiveté got him entangled in futile sophistication. His first poems decked out the fetid texts of the later symbolists with superfluities and artificial shimmer. They were easy and pretty enough for the Paris of the Belle Epoque to acclaim, flattering him before throwing him into the arena of the salons wearing the crown of the young prodigy and prince of poets.

Others might have spent the rest of their lives wallowing in all this. But the young Cocteau soon understood that sparkling skill was not true art and meetings with a few crucial people proved to him that he had to see and hear differently. Guillaume Apollinaire, Igor Stravinsky, Raymond Radiguet, Pablo Picasso and a few other mediums taught him to believe in the unknown.

He learned his lesson and became wary of radical manifestos, systematic scandal, seductive illuminations that hide the void by varnishing it with theories, and groups where each praises the other to the skies in order to claim the best part for themselves.

An occasional fellow traveller, accomplice where necessary, duettist when it was worth it, he took care never to belong to an artistic movement nor to train disciples in his own cult. This was not his role. He went this way and that, serving some, advising others, then set off on his own path, as a good adventurer in eclecticism should.

Isolation seemed to him to be preferable to reassuring relationships and he poached in private hunting grounds.

Not knowing where to place him in the cultural magma of the time, the judges and prigs sent him to the pillory. If he had belonged to some group or school, a terrorism of thought would have associated him lethally with weighty allies and his experiments would have seduced all in the name of an ideology of circumstance; but his friendships and alliances never followed the logic of the clan. They were based only on the works of those who were seeking to push art towards extraordinary, unexplored oceans.

So people were amazed to find him appreciating both Vivaldi and Satie, Raymond Radiguet and Blaise Cendrars, Nijinsky and Barbette, Jean-Paul Sartre and Leni Riefensthal, Luis Buñuel and Salvador Dalí, Pablo Picasso and Arno Breker, Paul Morand and Simenon, bringing them all into a family whose only unifying factor was himself.

Even among the surrealists, where he was hated, only Benjamin Péret, André Breton and their later, unconditional followers remained violently and most aggressively on the defensive in relation to him. All the others (and not the least among them Paul Eluard, Robert Desnos, Louis Aragon) eventually came to see his light without bearing him any ill will for his obstinate independence, his fidelity in dangerous liaisons and a certain blindness in politics, which was sometimes regrettable, but never threatened any form of devastating contagion and never seemed likely to lead him into shameful collaboration.

One only has to read his texts to see how much he hated censors and dictators. He who congratulated himself on being French when the Popular Front triumphed in what he called "a revolution without a drop of spilt blood", he who was beaten up by Pétain's militiamen for refusing to salute the French flag carried by the Nazis, he who gave his support to the Communist party during the crises under the Fourth Republic, he who rejected all forms of racism and freed only those monsters who were prisoners of a curse, was wary of any commitment that might seek to make him forget that one must always "know how far one can go too far".

For Cocteau's many penchants were in reality only one: he admired those who worked the substance of artistic practice as much as he did himself.

Here again, it was a matter of will-o'-the-wisps escaping from burning buildings and flooding his own mirror with lava.

Towards those he loved, his generosity became a vocation. His friendships are strewn with countless articles and prefaces. When he did not know how to begin to weave a preface, he would make his difficulty the subject of the introduction. This he did in the piece he wrote to open Thora Dardel's *Mon amant se marie* [My lover is getting married], published by M.-P. Trémois (1930). He turns it into a letter in which he explains that he has been prevented by illness from carrying out this service and, while talking about his ills, knits each sentence together to create a preface that ends:

> "You see, I'm talking and talking, I'm about to fall asleep, and I won't have written a line of our preface. Yet how can I refuse you anything? That would mean refusing Mme d'Orgel; for though Raymond Radiguet borrowed nothing from your life for the scenario of his masterpiece, he could not imagine the little countess in any shape other than yours. True the big voice of Mahaut and his wife deceived those naive types who seek keys to books, since your soft little voice is no more like that of the countess than our Nils is like the count. But all the same, Mme d'Orgel, we all know that it was you, a shadow of your fire, a ghost, a snow statue of you.
>
> So it was under Radiguet's star that I should have liked to answer you, to describe my surprise on discovering that you were writing such fresh, unsuitable, delightful things, to recall Alas, my sickness is returning with a vengeance, I'm crushed by the sun, my head is drooping; for you I have made an effort I should make for no one else and, before returning to the world of nightmares, let me kiss you and wish you good luck in the lovely real world where my health allows me ever less frequently to live."

In giving too much to some, one is obliged to displease others. The inquiries into his intentions turned into terrible inquisitions. As it was impossible to classify him according to a convenient nomenclature that would define him once and for all, they wanted to crucify him as a heretic or dress him up as a scarecrow.

It was asserted that he was stupid, frivolous and a glutton for facile glory. He was thought to put himself on display where others hypocritically jostled to show their faces. His thirst for discoveries was judged to be the odious trick of a conjuror trying to ensure that he would be endlessly talked about.

All this was just failure of taste and venomous sneering seeking to mummify him in superficiality. "A straw fire continually heaping on more straw", proclaimed François Mauriac with chagrin, not understanding that these constant braziers were ripening the seed and assisting the growth of many sublime, medicinal plants.

For if Cocteau got involved in everything, it was so that he could disentangle its essence, extracting it from the dross of fashion and asserting its eternal worth. He who declared, "Fashion goes out of fashion" never missed a single one; he was even ahead of them and gave them their soul with unstoppable precision.

Sometimes a ferryman, often a handler of stolen goods, he was a filter for new forms of expression, removing their deceptive masks and clearing them of any pointless embellishments. Except that this devil of a man collected the mud imprisoned in the filter so that he could work it like a diamond-cutter and turn it into yet more material on which to experiment with no form of protection.

> "It is undoubtedly with Jean Cocteau that the terms 'poet' and 'poetry' acquired their most precise definition. Gifted in every means of expression, he realised Nietzsche's dream of a 'dancer in battle', stretching above the world a blue sky far more terrible than the clouds and smoke of suspect sorcerers" (André Fraigneau, *Cocteau par lui-même*, 1957)

Whatever the field in which he imperilled his emotions, Jean Cocteau remained a dangerous poet, shaping as he chose the substance of the artistic practice he had dared to take up or comment on with oblique assaults.

His desire constantly to bring his night into the daylight obliged him to transform every medium (painting, sculpture, novels, music, drawing, cinema, theatre) into a revealing mirror. He did this as a craftsman does, like a baker kneading flour and throwing it so that it will be edible by other people. Never burning his wings on the oven's bursts of fiery anger, he was subjected to the distrust and hatred of those who were willing only to recognize the state of things rather than to understand the beauty arising from an unexpected metamorphosis. As a result his eternal attempts to find the truer than true led him to be long regarded as an impostor or a buffoon.

An entire element of his written work is based on the imperative need to reply to such unfair criticism, not out of some paranoid delirium or narcissistic megalomania, but as the only means of fighting against sneering obscurantism and stupid pedantry. Hiding nothing of his difficulty in being, giving up his professional secrets – recalling the hordes of the established order to the disorder of art was for him such a credo that his worst enemies eventually lost their footing. And, as he was present on every front, his notoriety grew and brought him other masks. This confused the judges so much that they wore themselves out with pointless attacks before understanding that to make a statue of this poet during his lifetime was the best way to make him fragile inside the isolation that served him as armour.

The result was that Jean Cocteau, too famous to be taken seriously, suddenly collapsed beneath official honours (Académie Française and homages), which caparisoned him in another image less appropriate for defying idiots.

A certain damage had been done.

Now the situation has changed. It is his work which, every day, is gaining ground on his myth. We are leaving behind the image of the talkative socialite to return at last to the substance of his works.

"Cocteau knew that poetry is what happens in the word 'table', in the word 'orchard', in the word 'snow' when they are put together in a particular way. It is what passes through and lights them up. Poetry makes language shine" (Luc Bérimont, *Magazine Littéraire*, March 1970)

But what is this work, in which the idea sought to exist through the form, actually made of?

It is not hard to identify its themes. Death and metamorphosis are omnipresent. The bedroom reigns as it does in the pyramids, its role being to facilitate communication with the kingdom of hell. Here the pupil Dargelos is the envoy of the Styx, Orpheus is already a blind man before his eyes are put out and the angel Heurtebise acts as a guide on every floor.

In this territory, there is no doubt: Jean Cocteau is an author.

From L'Ode à Picasso to La Crucifixion, from Antigone to Bacchus, from *Le Sang d'un poète* to *Le Testament d'Orphée*, the panoply sparkles and doubles reflect as they mirror each other. Recurrence and ethics nakedly assert themselves. But is this what counts and makes Jean Cocteau a crucial artist of the twentieth century? Is it these bestiaries, which borrow their figures and substance from mythology, Christianity and popular literature, that give the work its strength and originality?

In my opinion they represent only one too-visible drawing in a series decorating the invisible. For in Jean Cocteau's work it is the manner of dealing with the chosen substance that is by far the most important thing. As in painting or music, the motif (in every sense of the word) is only a point of departure with its references and excesses. As in jazz, it is just a theme on the basis of which everything comes together and falls apart.

Jean Cocteau's art sets out a theme in order to distort it through the manipulation of substance and make it breathe with other lives. Hence (in every case) the proliferation of breaks, collages, counterpoints, emptying out and superimposed hatching. There is nothing like something indistinctly shown to reveal something luminous and hidden. All this is done in order to materialize the invisible, to see the impossible, to catch the mysteries of the zone with a flash to create an illumination.

Sometimes a confession of these alchemical researches emerges, by ricochets and bevelled, as in this *Hommage à Kafka* in *Clair obscur*:

> "*Jusqu'à l'extrémité de sa nuit où ne flambe*
> *Aucune herbe (sur quelle herbe marcherait-il?)*
> *Imberbe roi des juifs il avance la jambe*
> *Gauche la droite offerte au supplice du gril*
>
> *Dans une odeur écoeurante de viande crue*
> *Seul valable l'instant du mot jadis écrit*
> *On peut voir proférer la parole enfin crue*
> *Ta bouche ouverte avec une forme de cri.*"

> [To the very end of his night where no grass
> Flames (on what grass would he walk?),
> Beardless king of the Jews he puts forward
> His left leg, the right to be roasted alive

> In a sickening odour of raw meat
> Alone worthy the moment of the word formerly written
> One can see your open mouth with a form of cry
> Proffer speech that at last is raw]

No question of signifying more through too much sense or masterly demonstration.

The drawings of *Opium*, the abundant profiles in posters, paintings and drawings, his indirect interrogations (or soliloquies) and theatre characters, the spacing of lines of free verse and alexandrines, the gossiping of Death and the incongruous descriptions of the battle of Fontenoy all express this mistrust of invasive meaning and appear as evidence in their very substance as objects in the process of making themselves. Their organization invokes the idea much more than the signs woven to represent the chosen subject. Moreover Cocteau's work speaks only of work and the discourse of the Sphinx in *La Machine infernale* can be taken as the perfect manifesto of his art. Tying threads together, untying them, retying them, knitting them into invisible links or using them as a net to catch ghosts and monsters, all this matters far more to him than the vulgar booty obtained on arrival. It is the assertion of a poet's morality. For those who see, read or listen, it is an invitation to follow the path of the text, to travel on a slice of mirror, to criticize one's certainties, to believe without seeking to understand, to be the blood of the poet.

Everything that Cocteau did is a proposition of stained glass pieces combining into infinity. His work calls for a naked look and a reading of the text of the enigma. The answer is not in the question. The answer is the question. Here masks are made of transparent glass. His gallery of ghosts is not in the domain of the fantastic. Reality springs everywhere within it; the reality of his time and of the myths of our civilization, of common dreams and reversals of fortune. All this is neither lies nor truths, it is only humanity.

And it is too human to paint its face in appearances of truth.

> So yes, contraband poetry, and so much more precious as a result, for it is true, the German Novalis tells us, that, if the world becomes a dream, the dream, in turn, becomes the world. And it is the humility and glory of Cocteau that he never either wanted or was able to separate the legend of Orpheus from his own, in other words, cinéma-vérité from the cinema of lies. If today this approach makes fools sneer, it is because it is not given to everyone to follow in the footsteps of such a powerful singer (Jean-Luc Godard, *Cahiers du cinéma*, February 1964)

The Cocteau myth still burns on with its two-faced medal (the socialite and the creator). From the photograph of the young enthusiast playing the drums at Le Boeuf sur le toit to that of the new member thanking his peers under the cupola of the Académie Française, there is more than enough to make you believe in it. How can we wash our eyes clear of so much iconography? In a time when everyone dreams of becoming famous, being on television or becoming an entry in some dictionary, many may find the case of Jean Cocteau surprising. For this was a man who was pained by being present and recognized everywhere.

But Cocteau knew that immortality can be acquired only through death, both that of the individual and his legend. To leave one's mark on the centuries, one must have left a deeper trace in one's own time than that of the star or the chimera. It requires more, different proof besides just one's life as an artist mentioned in encyclopaedias, schoolbooks and dictionaries.

The official status of genius leads to nothing more than becoming a statue to be shat on by pigeons. This is the trap of the Gorgon who turns life into stone. If the work is nothing much, the creator loses the match. For stone kills when it is hidden in a snowball.

Posterity becomes a name on a street or square and very few people still buy the books or read their pages. Worse still others come to steal the treasures from the mausoleum, copying out appearances and calling themselves heirs.

But Cocteau's work resists such simony. It is still very much here. It is consistent in its thousand fragments, unique in its multitude of practices, because in it words are like drawings, sentences resemble musical movements and characters put their lives on the line in a sincere journey from lies to reality and from the visible to the invisible.

It is foolish to try to demarcate this work, for to touch its secrets one must first dare to enter the zone where Cocteau dared to lose his footing, and then learn the lesson.

The true posterity of an oeuvre comes from the fact that it is absolutely impossible to imitate and that its influence can be felt where you would never expect it. The artists who have understood how Cocteau changed many things are those who, like him, question the substance of their art until it amazes them. They are pretty rare. There is Jean-Luc Godard in the cinema, Jean Echenoz in the novel (whether the writer likes it or not, *Lac* bears the mark of Cocteau's vampire), Robert Wilson in the theatre, Andy Warhol in painting, Frédéric Bézian in comic strips

All the rest is just a pointless game of closed rooms and distorting mirrors.

Moreover, in *Démarche d'un poète* [A poet's approach], published in Munich in 1953, Jean Cocteau gave advice that many of today's creators would do well to ponder:

"The role of the artist will thus be to create an organism with its own life drawn from his and not intended to surprise, please or displease, but to be active enough to excite secret meanings that react only to certain signs representing beauty to some, ugliness and deformity to others. All the rest will be merely picturesque or whimsy, two hateful creatures in the realm of artistic creation."

Think on!

A life assessed

Cocteau lost his most important battle, which was to be recognized as *the* French poet of the century after Apollinaire. The Surrealists won the day: books, catalogues and theses have relayed their version of the facts; over time the ostracism of Cocteau maintained by Breton was beginning to look like his destiny. Cocteau himself was horrified to see himself approaching death and posterity relegated to the rank of modernism's sad buffoon.

Apollinaire had called him the "king of poetry", Proust had praised his way of gathering the highest truths together "with a flamboyant symbol", Drieu and Morand had drawn on his character in their building of others; yet the 'mental' poetry of Char, the oddities of Michaux and the animal and vegetable portraits of Ponge were always preferred to his work. Rilke had paid him homage and Pound had translated him. On reading *Léone* Pound had cried "You have saved France!"[1] and later, from his cell in the Saint Elizabeth Hospital in Washington, he still regretted never having written an essay on the poet he regarded as the finest European writer of the century. Meanwhile, back in France, Cocteau was being treated as the class dunce.

Having long supported him as an editor, Chardonne made a more cruel assessment of his destiny: "He thought he was the Poet and wanted to invent everything", before adding, with his usual insight, "The great danger is to want to surpass oneself, one should remain below the line", finally concluding, "The most dangerous mistress is glory. She turns you into a puppet".[2] True, Cocteau's name was used to refer to a type of person, as had once been his dream, but not in the way he had hoped. At the end of a successful dinner a skilful host would be described as *a* 'real Cocteau'; the term was never used of a budding genius or a future da Vinci. 'He's doing a Cocteau', they would say of a man who liked to dress up like a peacock or appropriate other people's property. His reputation was that of a man who had visited every fairground on earth and had his photograph taken with his head in a "vast painted collar"[3] showing a liner or an aeroplane, but whom no one could ever recognize in real life, a man caught between ubiquity and inanity.

His influences were numerous but, like mountain rocks, the many layers of his consciousness had always filtered them, so that he retained only those elements that were indispensable to his growth. He had beaten every challenger in the featherweight category, but for over fifty years now France had produced no writers fit to take on the great form of the novel, unlike Thomas Mann, Robert Musil, Dos Passos or Faulkner. He had constantly leapt from branch to branch, but always in the same tree. Gide liked to mock him by saying that his favourite vegetable was the mange-tout [literally 'eats everything'], but this was perhaps the one thing they had in common. His oeuvre did not follow any fixed idea, but in imitating the proliferation that gives life to the world it did something much better.

He was of course recognized for having sometimes been the catalyst of his period and for having assisted at the birth of more than one genius, but he was tacitly criticized for not having provided a remake of *Les Enfants terribles* at regular intervals. Readers demand a strong personality, if not a defined aesthetic. Having neither the time nor the means to express themselves, and thus risking the sense that they are in some way incomplete, they demand a reassuring mirror. The author of *La Difficulté d'être* offered them a yet more shifting image: "We

1 Cited in a letter from Cocteau to Mary Hoek, 15 January 1950. See Francis Steegmuller, *Cocteau (a biography)*, Paris, Buchet-Chastel, 1973, p. 330.

2 Letter to Roger Nimier dated 1 September 1950, *Correspondance Jacques Chardonne-Roger Nimier, 1950-1962*, choix édité par Marc Dambre, Paris, Gallimard, 1984, p. 22.

3 Jean Cocteau, *Portraits-Souvenir*, éd. Pierre Georgel, Paris, Le Livre de poche (*Pluriel*), 1977, p. 42.

A life assessed

recognize ourselves as Cocteaus and we blush", noted Claude Mauriac in *Jean Cocteau ou la vérité du mensonge* [Jean Cocteau or the truth of the lie].

Ultimately his way of always being everywhere became wearisome, as did his image-gun style, like those jointed arms that let go of you as you loop the loop to catch you at the last moment just above the water, emptying the air out of your lungs. Did anyone even read him? With the exception of one or two titles he could not be sure. "My written oeuvre is a floating wreck",[4] he confided to his diary. Perhaps the public was afraid of suffering the slight disappointment noted, on his death, by Julien Green: "A little of the best of him went into his conversation and that best is ungraspable."[5]

In their constant criticism of his dispersal and transformism, the women who still held salons in Paris reduced his oeuvre to no more than a thin saga in which he was present in all the roles, from the narcissistic painter of *Le Sang d'un poète* to the jealous mother of *Les Parents terribles*, to the abandoned woman of *La Voix humaine*. Marie Laure de Noailles, Lise Deharme, Valentine Hugo and Elise Jouhandeau were all the quicker to condemn his inability to create life in literary terms because they knew him personally: they all wanted to marry me, he notes in his diary as an explanation of their abortionist tendencies.

The critic Jean-Jacques Gautier, who had not been kind to Cocteau, dedicated a book to him, signing himself, "The executioner with no hard feelings".[6] Even in London, in the offices of the BBC, an item naming the hundred glories of the century noted over his portrait, "Result of a snobbery that has not yet lost its power". Prince Rainier himself, having asked for an ode to celebrate his wedding to Hitchcock's star Grace Kelly, rejected Cocteau's *ancien régime* compliment, "almost certainly out of modesty", the poet hoped. And Rebatet, whose grace he had weakly sought at the Liberation, began once again to insult him in *La Parisienne*.[7] It sometimes seemed that opinion was unanimously ranged against him. Jean Touzot mentions "the rather fantastic dogma that is applied against him, which you would think was in the public interest, given the number of individuals and groups that have collaborated in it."[8] This had not weakened, despite the "thrashing with honours" he had received in the wake of his election to the Académie Française. At the time of Gide's *Si le grain ne meurt* [If It Die] and *Corydon*, Béraud used to quip, in a pun on the French word *vide*, meaning vacuum, that "Nature abhors a Gide". One might have added, "Culture abhors a Cocteau".

Of course he still had young writers on his side. After first lining up under the banner of Paul Morand, the 'Hussars' had also 'rediscovered' Cocteau, encouraged by André Fraigneau and Michel Déon, who sometimes came to see him with Coco Chanel.[9] The slightest favourable article was enough to give him fresh hope. On his return to Paris he left his door wide open, as in the good old days when he lived in the Rue d'Anjou, receiving very young writers and handing out advice; even absolute beginners were given the kind of encouragement received by the young writers of the great days gone by. Edmonde Charles-Roux, who had just been offered the post of editor at *Vogue*,[10] was told, "Go ahead, trains never pass by twice". Considering that he had no erotic motives, his availability grew to astounding proportions. In 1962 the man who, early in his career, had been encouraged by Théophile Gautier's son-in-law received a letter from Johnny Halliday thanking him for taking charge of his fan club.

Helped by his "delicacy [like that] of a needle", already noted by Max Jacob, he simultaneously perceived the unease he communicated, observing, "I know some people who avoid me out of a kind of fear of falling victim to a phenomenon of vampirism. They realise that I need their reality to make one for myself". He acceded to every desire of his young people, hoping to mask his inner void, which was already threatening them with sea-sickness. Fearing they might find out that he had received one of their rivals just as royally the day before, but also, as Truffaut saw so clearly,[11] systematically siding with those who took the risk of writing

4 *Id., Le Passé défini*, vol. 1, *1951–52*, edn 1983, p. 407.

5 *Id., Journal 1949-1966*, Paris, Plon, 1969, p. 13

6 *Id., Le Passé défini*, vol. 1, edn 1983, p. 93.

7 *Id., Le Passé défini*, vol. 2, 1953, edn 1985, p. 133 (June 1953).

8 Jean Touzot, *Jean Cocteau*, Lyon, La Manufacture, 1989, p. 11.

9 See Antoine Blondin, « L'Aigle à une tête », *Certificat d'étude*, Paris, Robert Laffont (*Bouquins*), 1991, pp. 795–802.

10 Conversation between E. Charles-Roux and the author, 22 April 1998.

11 François Truffaut, « Jean Cocteau, Le Testament d'Orphée », *Les Films de ma vie*, Paris, Flammarion (*Champs Contre-Champs*), 1975, p. 228.

– the most mediocre artist being worth more in his eyes than the best of spectators – he would promise them a preface for their forthcoming book, making them feel so good that they would leave him singing his praises. Suddenly rediscovered, Cocteau the forgotten once more became the heir to Ronsard and Apollinaire, the last virtuoso of a language so intimately linked to the soul of its speakers that, in some parts of the world, it had become the language of literature itself.

The world was once again treating Cocteau as it should. The genie that haunted his body but only irregularly visited his mind suddenly came back to life. The poet within him was sitting up, capable of waking him up in the middle of the night and forcing him to take up his pen, or of making him sleep through the day to go dream-walking over the rooftops. On the publication of *Clair-Obscur* Audiberti wrote to him,

> *Prince d'un bonté sans doctrine ni pompe,*
> *Riche de la minceur du figuier dans le fruit,*
> *Masqué par ton visage et voilé par ton bruit,*
> *Si la corde où tu marches, Jean, vient qu'elle rompe,*
> *Dieu l'arrange aussitôt, pour toi comme pour lui.*
> [Prince of a goodness without doctrine or pomp,
> Rich with the fig-tree's slenderness in fruit,
> Masked by your face and veiled by your noise,
> If the rope on which you walk, Jean, comes to break,
> God sorts it out at once, for you as for himself.]

This is just how he was.

Eventually, however, he grew sick of these waves of importuners. What was the point of expending so much energy to convince beginners of his exceptional nature, and what was the point of continuing to write poems for the critics to boo? He knew now that his desire to please almost always turned against him. "Cocteau was very brilliant when we last met", said T.S. Eliot to Stravinsky in 1951, "but he gave me the impression that he was rehearsing for a more important occasion."[13]

He went to sit down, exhausted, like the old general being got ready by his valet in Edgar Allen Poe's story, who collapses into dust as soon as his young visitor is gone.

Then he remembered that Proust often spoke of the journey that artists must undertake to realise themselves, to become truly themselves in the strict space of their creation, with, as their sole aid, "perishable man, like his contemporaries, full of failings, to which a real soul was chained and against whom it protested, from whom it sought to separate, to free itself through work".[14] This soul was killing Cocteau. His oeuvre itself was impatient to see him dead in order to exist. He had been its ringmaster, but always too clear-sighted, too sonorous and too imploring; he had given it too ostentatious an accompaniment of gestures and cymbals. It wanted to live its own life. It knew how many fine minds despised him, as theatre people despise circus performers, and ultimately convinced him, "One should be a living man and a posthumous artist".

A living poet was a contradiction in terms, almost an anachronism; like Verlaine at the end of his life, he spent much of the time floundering and staggering under the sarcasm. A true poet, or a good one at least, was a dead poet. Yes, soon everything would be in order.

Already afraid that his edifice would collapse, he eventually returned in a daze to Milly. The house was empty apart form Doudou, famously silent. The white irises, the green lawn and the ringing bell announcing the arrival of the postman all helped to reconcile him to himself. The knots in his nerves would gradually loosen as he opened his mail. The telephone

12 *Arts-Spectacles,* n° 493, 8–14 December 1954, quoted in *Le Passé défini,* vol. 3, edn 1983, p. 396.

13 Robert Craft, *Dialogues and a Diary,* Garden City, New York, Doubleday, 1962.

14 Marcel Proust, *Écrits sur l'art,* Paris, Garnier Flammarion, 1999, p. 303.

would begin to ring; a bit of repartee, a quick quip and he would be laughing with all the energy left to him by his slumbering sexuality. Looking at Doudou's latest painting he might say, in a flash of lucidity, "Never has anyone got quite so close to a daub", but at the same time he was filled with wonder at such proximity. Did not all of naive art spring from there? They would share a good cep omelette and a few glasses of Morgon, take a short walk in the garden and look at the flowers that had opened in his absence. But already the letters he had received – up to fifty a day – would be exerting their odious blackmail. Where would he find the strength to respond to such a mountain of post? And what could he say to the friend who, in an apparently favourable article, had again mentioned the borrowings scattered throughout his oeuvre?

As night fell the nightmare would return.

Nietzsche was greatly influenced by Schopenhauer and had taken his legendary injunction, "Become what you are", from Pindar; but Nietzsche could do as he pleased. Picasso had plundered Braque and Matisse, the futurists and all the classics since Velázquez, but Picasso could do as he pleased. Cocteau could do nothing.

"This is how it will be with you," Epictetus had written eighteen centuries earlier: "Today you are a wrestler, tomorrow you will be a gladiator, the day after tomorrow an orator, lastly a philosopher, without having ever fundamentally been anything. Like a monkey you copy everything you see. Today you like this, tomorrow that. You have set to work without thinking, you have not considered the matter from all sides."

These accusations were unfair, appalling, vile – so they had an effect on him. True, his scattered, multiform oeuvre was reminiscent of those "objects hard to pick up" Cocteau once recalled from a catalogue for weddings and banquets. But this was surely not reason enough for Igor Markevitch to enjoin him, while protesting his deep affection, at last to put "down on paper that masterpiece that you are yourself". As if he had not actually done so! When in fact he was being accused of having never spoken of anything but himself.

"A personality is simply a persistent error",[15] Radiguet had said. In that case the only guilty party was Cocteau himself. He had undermined his own reputation. Incapable of being, he had lost himself in doubles, shadows, reflection and ghosts. He was a man with his head cut off, dreaming of being top of the class and waking up bottom; a man so ridiculous, with his sharp nose "stuck on his face like the nose of an effigy",[16] as Jean Cau put it, that on many occasions Cocteau said he would refuse to shake his own hand if he met him in the street. That was how it was; he always ended up becoming what he was accused of being; he only had to read a hostile article to put himself in the journalist's place and accentuate the feature. As he had already admitted, in La Difficulté d'être, "I think I would hit the target more precisely, the blade would plunge in to the hilt and there would be nothing left for me to do but let my legs fold up, stick out my tongue and fall on my knees in the arena".[17]

[....]

The failed god

Summer always saw Cocteau walking in Villefranche. He knew every inch of the little port, from the Rue Obscure, where he met his double in Le Testament d'Orphée, to the shed where the fishermen kept their nets. When restored this building proved to be a wonderful Romanesque chapel of impressive purity, which he decided to paint and then to reconsecrate. Although the faith revived in him by Maritain had been extinguished, he remained convinced that all forms of belief were worthy of interest. As he still could not act as a Christian, he acted as an artist and, not without difficulty, succeeded in procuring the agreement of both the fishermen and the municipal authorities.

15 Raymond Radiguet, « Art Poétique », Œuvres complètes, Paris, Stock, 1993, p. 468.

16 In Jean Cau's fine portrait Cocteau in Croquis de Mémoires, Paris, Julliard, 1985, p. 51–58.

17 J. Cocteau, « De mon style », La Difficulté d'être, p. 22.

He had always derived a physical pleasure from building sets by hand and filming the transformation of a man into a wild beast, with accelerated growths of pubic hair, as at the end of *La Belle et la Bête*. Something that started as a pastime gradually took him over completely. Did he remember that the heroes of *L'Eternel Retour* [The eternal return] died and went up to heaven in a boatshed? Not only did he design the 'frescos' to cover the walls, he also remade the ceiling and apse and designed the altar, candelabra, door and the figure of Christ that dominates the whole. Carried away by his work he even spent days on unstable scaffolding, watched by fishermen and a few curious bystanders. Dressed in a simple workman's overall with a tight scarf that made the blood beat in his temples, he huddled in the egg of the present moment.

Work did far more to relieve his tiredness than sleep, which was disturbed by such terrible dreams that he would leave it exhausted – he slept no more than two or three hours on average. His hibernating body released a spectral double which was no longer subject to the effects of effort or thirst, like the bodies of mystics. He would forget all about the weather, the time and the waiting meal as he rediscovered, intact, the brilliant gift for drawing that he had manifested at the age of ten. The child was taking control of a man undermined by death. Soaking up the walls that he was covering with paintings, he became one with his chapel, combining his own substance with the colours, his taut yet blissful face camouflaged with plaster, like that of a happy child in a Provençal creche. On some days, seeing him so full of joy made you think of a foetus daubing the world with his placenta.

As he painted he would forget himself, becoming just a part of life. True, in his flesh he could feel the storm that had just ravaged the Dunkirk coastline, yet he remained as light, serene and ultimately "anonymous" as the seagull he could hear crying above the port or the boat drifting in front of the customs house near the Hotel Welcome. His wounded megalomania had become inverted into radiant modesty. Having lost his magnificence, the king of Paris and duke of the rue Anjou was nothing more than a little soldier of life, proud of being part of the great work, an empty being acting as a sensitive membrane to a full world, with no ambition other than to hear the world's noise, to translate the waves flowing through him from the sky into dots, lines and colours. He had become simply one atom among billions, painting at the heart of the cosmos as it bombarded the earth with photons.

After the opening of the chapel at Villefranche, he started work on the one in Milly, dedicated to St Blaise. Blaise had performed many miracles for the faithful – both human and animal – who came to see him, using the simples or medicinal herbs that he crushed in his mortar, like some Christian Orpheus prescribing marjoram and benzoin. The commissions poured in. Cocteau had earlier been asked to decorate the wedding room in the town hall at Menton, which he painted in a style combining the Greek canons with African scarification, reminiscences of Bakst and comic-strip graphics. Then came the chapel of the Virgin at the church of Notre-Dame-de-France in London and the theatre at Cap-d'Ail near Monte Carlo.

Soon others came to assist him. These simple, direct workmen showed him another side of humanity. Unlike Picasso, who always wanted more from himself, they sang as they painted, found satisfaction in the smallest realisation and exuded a love of work well done. Like the potters who fired his ceramics, the weavers who wove his tapestries or the technicians who supported him in the cinema, they were untouched by any authorial vanity and seemed to have a privileged access to happiness. For the first time Cocteau found real comfort in the daily presence of these strangers. Their capacity for being touched made him forget the bitterness of the geniuses whose lives he had shared, along with the jealous vigilance of the intellectuals, those functionaries of criticism, described by Proust as "bachelors of art".

Published by kind permission of Editions Gallimard, Paris, from Claude Arnaud, *Jean Cocteau*, 2003.

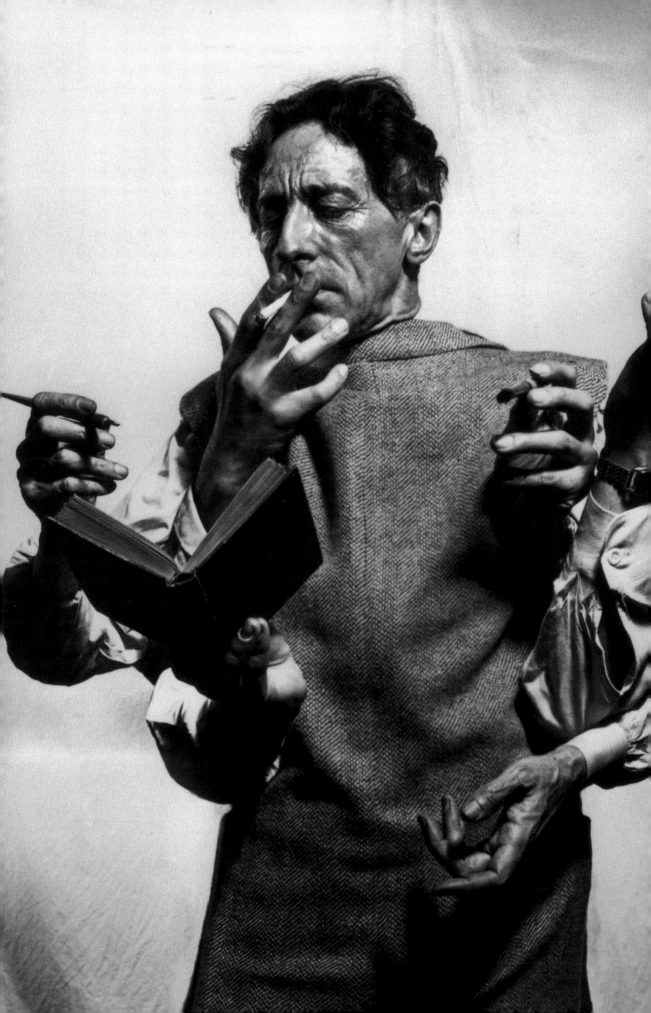

Poésies
Poetry

1 J. Cocteau, *La Difficulté d'être* [1946], in *Romans, poésies, poésie critique, théâtre, cinéma,* Paris, L.G.F. (*La Pochothèque*), 1995, p. 891.

2 Daniel Arasse, *Le Détail : Pour une histoire rapprochée de la peinture,* Paris, Flammarion, 1992.

One famous icon of modern art, immortalized by Man Ray, is a head made by Cocteau from pipe-cleaners. It is empty, fragile and luminescent; is it also immoral? Certainly it is made using tools which enable one to "lose one's head" efficiently, aids to the unleashing of oblivion through the opium pipe. Yet we are also undoubtedly entering the poet's head. For Cocteau never stopped using himself as material. *Le Sang d'un poète* [The blood of a poet], a model for the avant-garde, was intended as a "descent into oneself, a way of using the mechanism of dreams, of falling asleep, like a clumsy candle carried through the night of the human body, blown out now and then by a breath".[1]

Produced by Marie-Laure and Charles de Noailles, *Le Sang d'un poète* was to use cartoon animation in an undertaking both cinematic and graphic, which "shifted the lines", as Baudelaire put it. From its conception, this film expressed a fundamental fusion of movement and line, which the pipe-cleaner head, contemporary with Calder's wire sculptures, sums up in itself.

The thirty or so drawings in the series *Les Mystères de Jean l'oiseleur* [The mysteries of Jean the bird-catcher] reflect an earlier descent made by Cocteau into himself. Hiding away in the Hotel Welcome in Villefranche-sur-mer to mourn the loss of Raymond Radiguet, his companion in creation and feeling, Cocteau observed the metamorphoses of his own face in the mirror – yet to encounter the mechanized optical series of cinematography. The writing becomes part of the animation; the words comment on, amplify and distort the expressions of passion. It is the writing that enables the figures to move.

Cocteau was obsessed with "reproduction and reproducing oneself" before he began making films. The mystery of a man who loved the lightness of birds and angels is revealed in a book in which accidents of the production process are faked and the illusion of re-touched colours is created through printing. There was never a unique copy of this book. Cocteau amused himself by reproducing marks of originality, chance effects of improvisation. Playing with forgery, this is an object expressing sincere sadness. Cocteau uses his greatest capacity for invention when he exploits tensions between reality and forgery to undermine the solemnity of the creative act. Whatachieves is what the Italians of the Renaissance called *sprezzatura*, art that hides artistry, where meticulous application is concealed in favour of an apparent ease[2] and nonchalant elegance. This does not dispense the poet from working at his art, he simply does so without seeming to, as he sleeps: "the searcher sleeps". D. P.

1 Philippe Halsman
Jean Cocteau, 1949

Poésies

2 Man Ray, *Jean Cocteau,* 1926

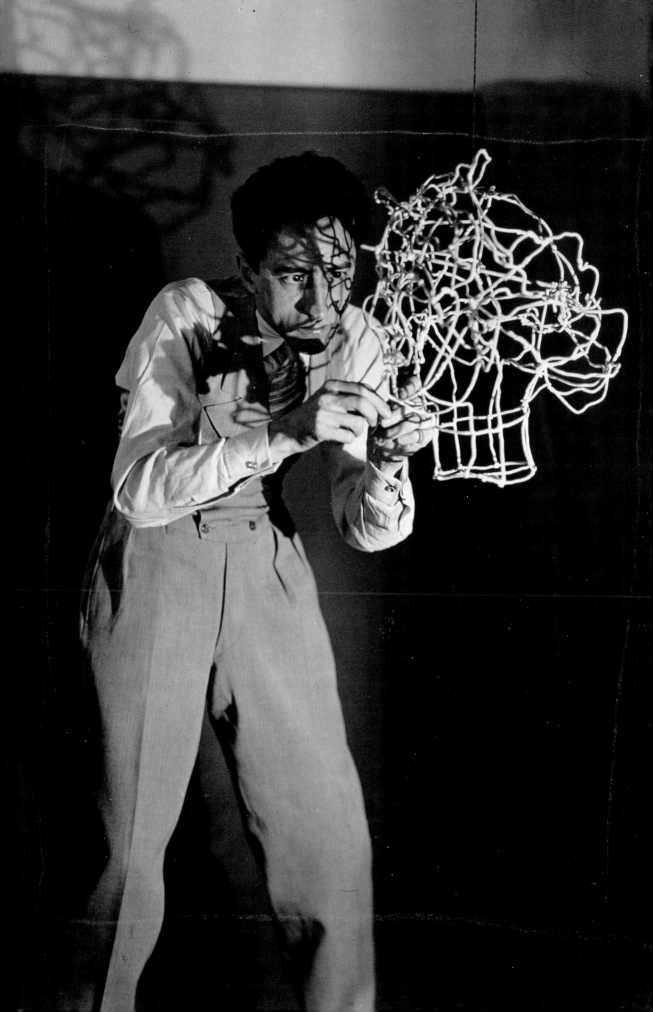

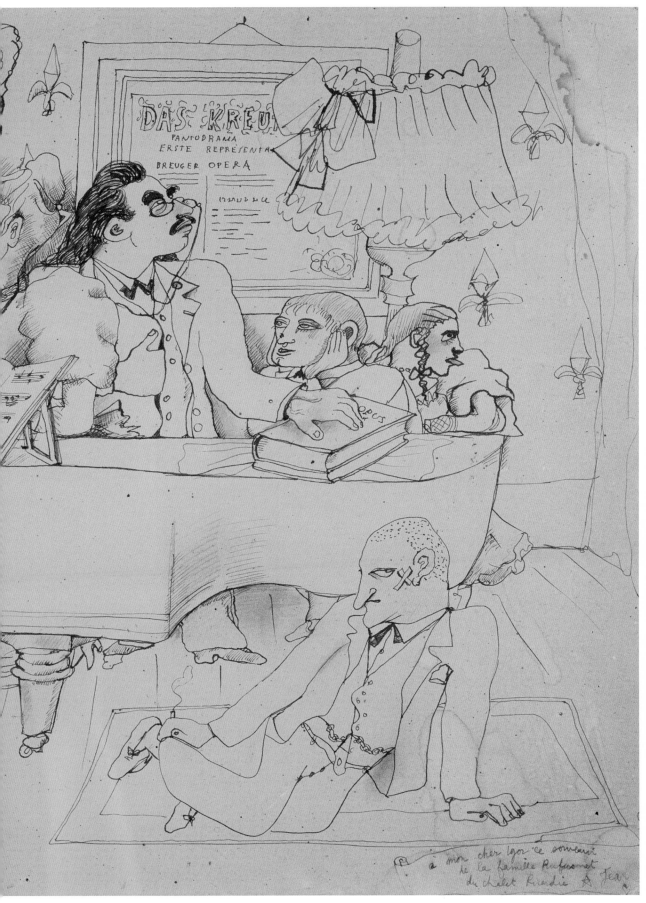

3 Jean Cocteau, *La Famille Rufus* [The Rufus family], 1934

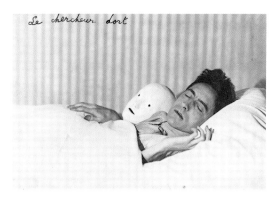

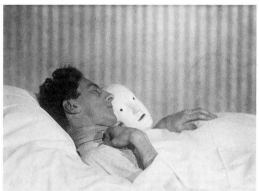

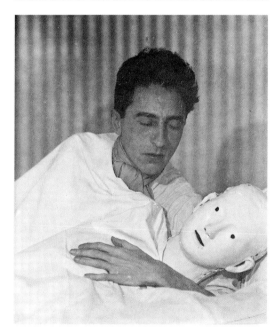

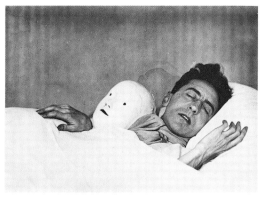

4 Berenice Abbott
Jean Cocteau and the mask
[from the prologue of
Antigone], about 1927

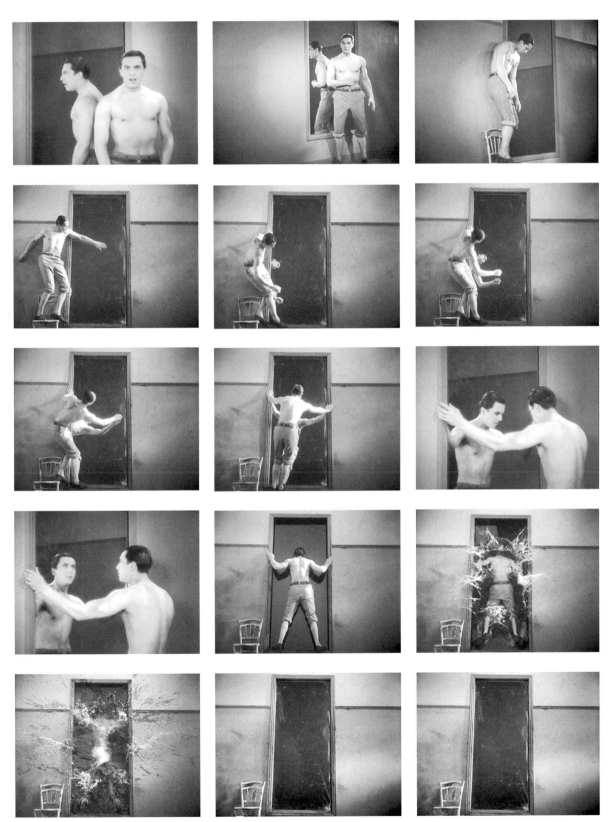

5 Jean Cocteau, *Le Sang d'un poète* [The blood of a poet], 1930 (mirror scene)

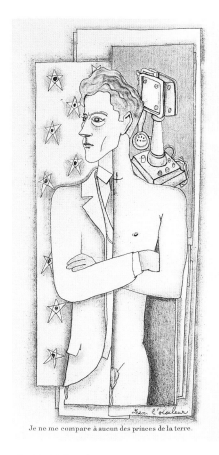

Je ne me compare à aucun des princes de la terre.

Chaque fois que le poète en coupe une, son cœur bat.

Revenons à l'arrivisme......

Le moindre joueur déplace plus de mystère qu'il n'apparaît.

6–9 Jean Cocteau, illustrations for *Le Secret professionnel* [Professional secrets], about 1925

L'inspiration

10 Jean Cocteau, *L'Inspiration* [Inspiration], undated

11–12 Jean Cocteau, original drawings (about 1924) for *Le Mystère de Jean l'oiseleur* [The mystery of Jean the bird-catcher], 1925

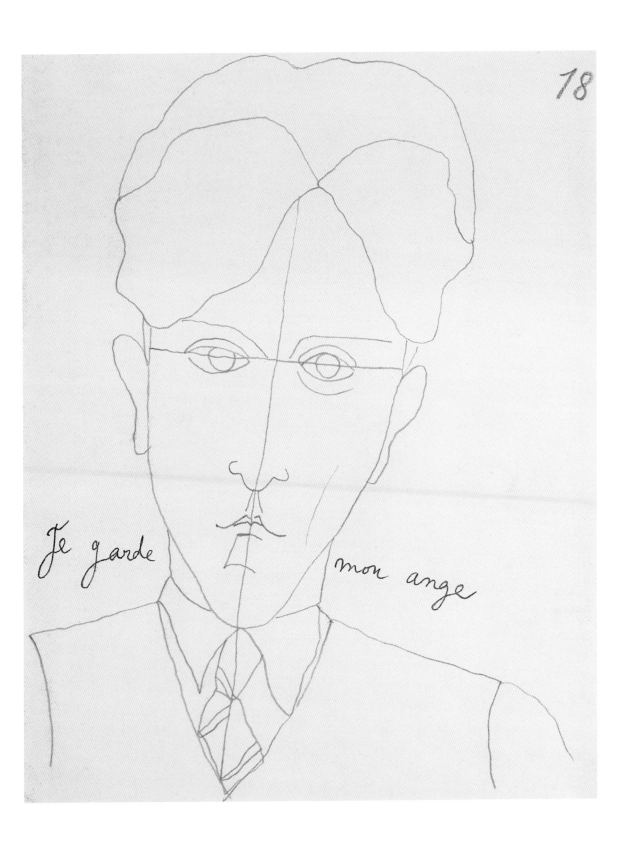

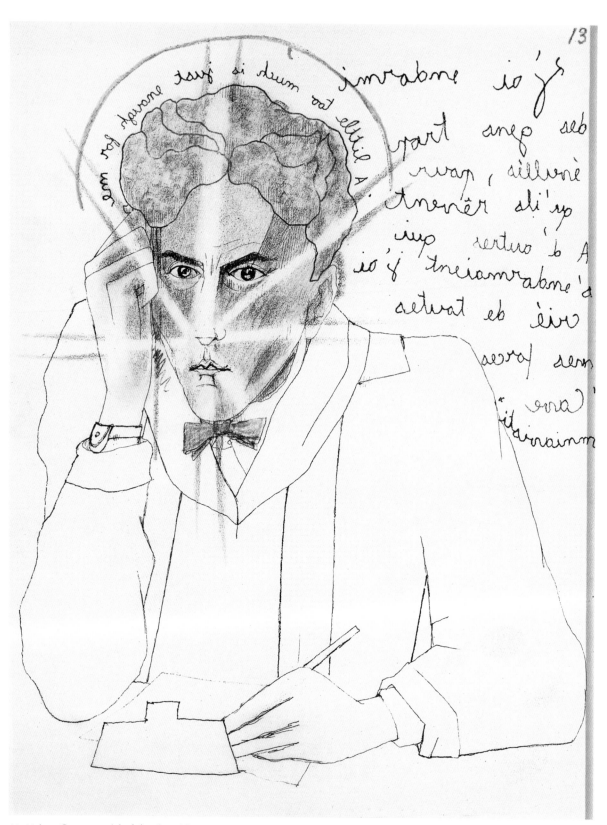

13–14 Jean Cocteau, original drawings (about 1924) for *Le Mystère de Jean l'oiseleur* [The mystery of Jean the bird-catcher], 1925

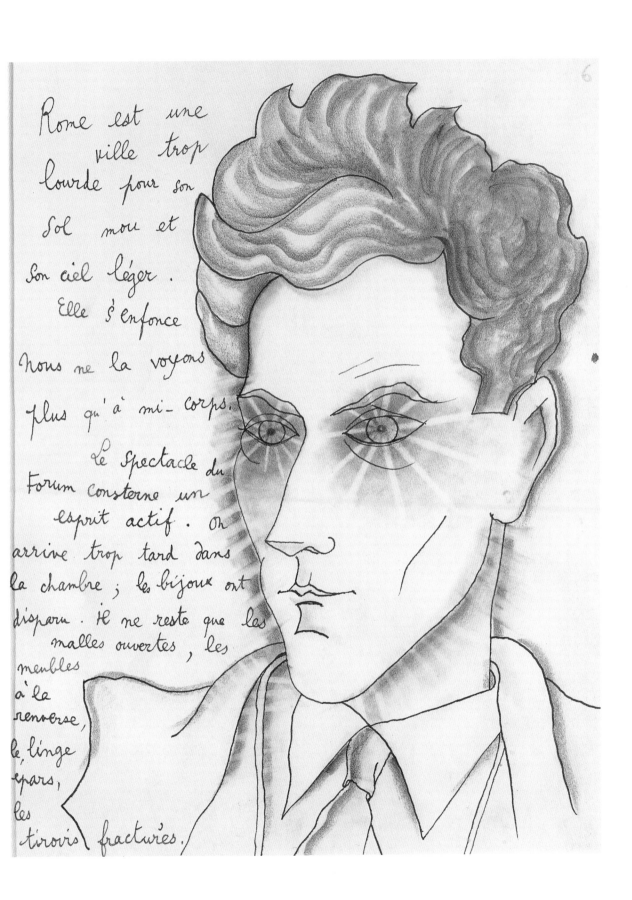

Rome est une
 ville trop
lourde pour son
sol mou et
son ciel léger.
 Elle s'enfonce

Nous ne la voyons

plus qu'à mi-corps.

 Le spectacle du
Forum consterne un
 esprit actif. On
arrive trop tard dans
la chambre ; les bijoux ont
disparu. il ne reste que les
 malles ouvertes, les
meubles
à la
renverse,
le linge
épars,
les
tiroirs fracturés.

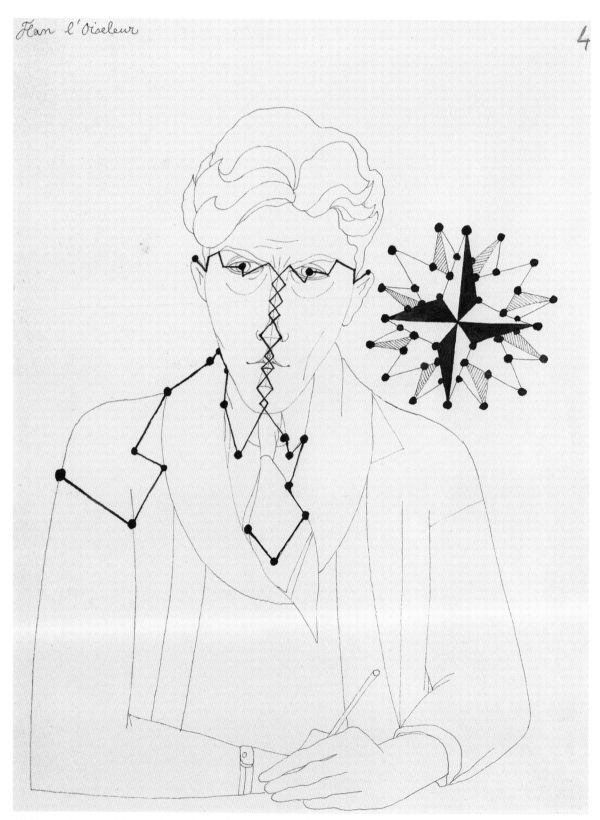

15–16 Jean Cocteau, original drawings (about 1924) for *Le Mystère de Jean l'oiseleur* [The mystery of Jean the bird-catcher], 1925

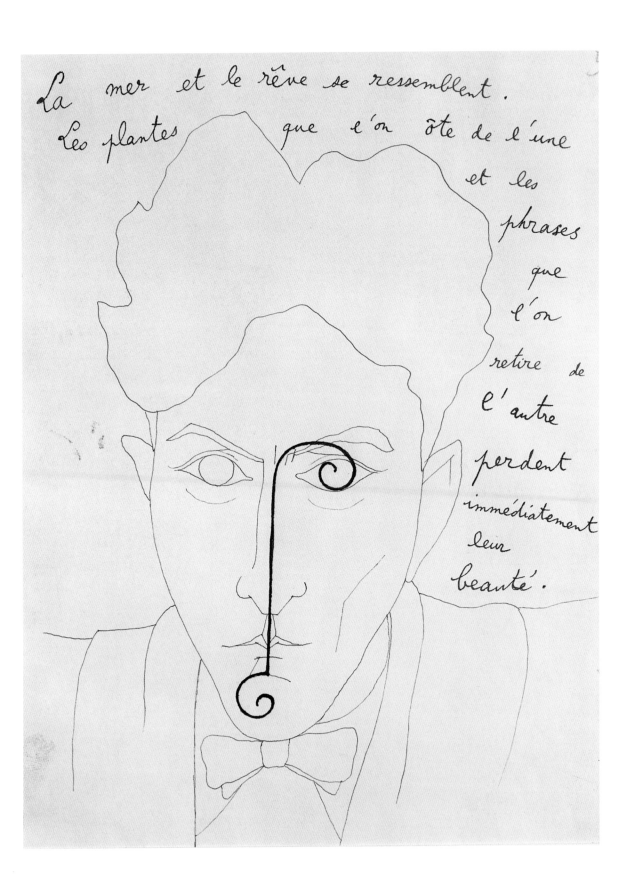

La mer et le rêve se ressemblent.
Les plantes que l'on ôte de l'une
et les
phrases
que
l'on
retire de
l'autre
perdent
immédiatement
leur
beauté.

17–18 Jean Cocteau, original drawings (about 1924) for *Le Mystère de Jean l'oiseleur* [The mystery of Jean the bird-catcher], 1925

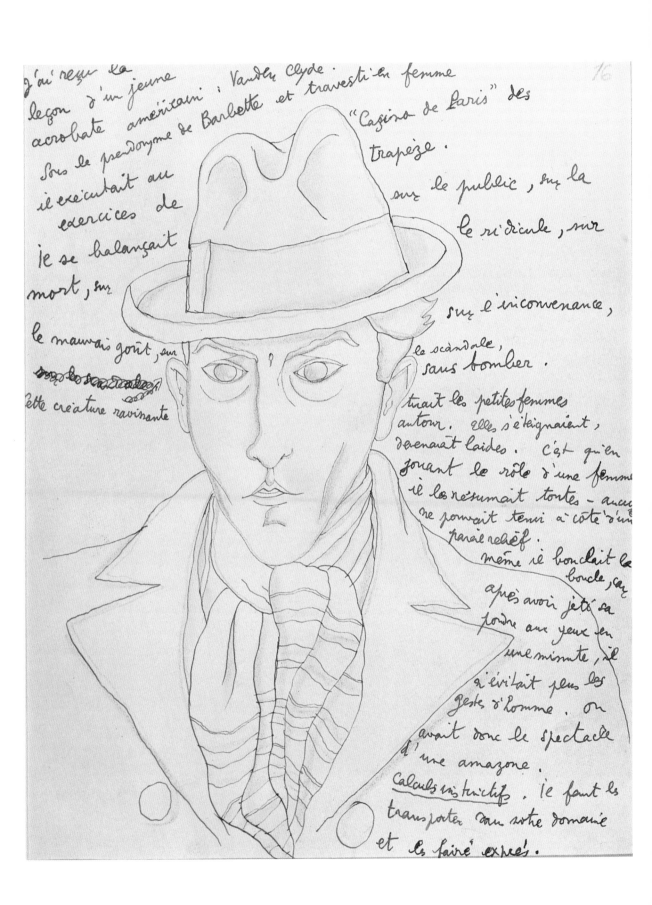

J'ai reçu la
leçon d'un jeune
acrobate américain : Vanden Clyde.
Sous le pseudonyme de Barbette et travesti en femme
il exécutait au "Casino de Paris" des
exercices de trapèze.
je se balançait
mort, sur sur le public, sur la
le ridicule, sur
le mauvais goût, sur sur l'inconvenance,
~~sur les scandales~~ le scandale,
cette créature ravissante sans bomber.

tirait les petites femmes
autour. elles s'éteignaient,
devenaient laides. c'est qu'en
jouant le rôle d'une femme
il les résumait toutes – aucune
ne pouvait tenir à côté d'un
pareil relief.
même il bouclait la
boucle, car
après avoir jeté sa
poudre aux yeux en
une minute, il
n'évitait plus les
gestes d'homme. on
avait donc le spectacle
d'une amazone.
Calculs instinctifs . il faut les
transporter dans notre domaine
et les faire exprès.

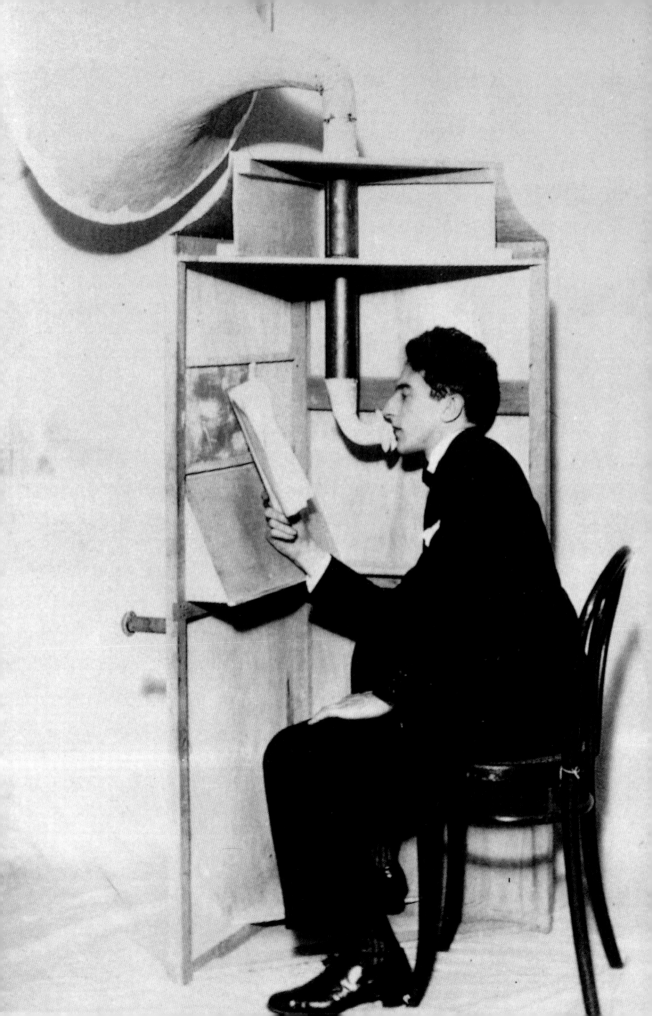

Parades
Parades

1 J. Cocteau, *Le Rappel à l'ordre* [Recall to order], in *Romans, poésies, poésie critique, théâtre, cinéma*, Paris, L.G.F. (*La Pochothèque*), 1995, p. 978.

2 J. Cocteau, *Opium* [1930], in *Romans, poésies, poésie critique, théâtre, cinéma, op. cit.*, p. 614.

In the 1910s and 1920s Cocteau was on parade. He would not be forgiven, later, for having put himself on display so often. Yet in those years, he was indispensable everywhere. He absorbed, reflected, documented, animated, stimulated, initiated.

From the shock of the Ballets Russes to the caricatural, cubo-futurist deconstruction of *Le Potomak*, Cocteau seems to have obeyed a single command, coming from both inside and outside: be modern. He was more modern than anyone, to the point of inverting the most widely recognized signs of modernism. Here lay his torment: he wanted to be seduced by modernist dogma, while retaining his free will; to be included in movements and groups, while pointing out their clichés (*Le Coq* [The Cockerel] is both close to Dada and anti-Dada); to be more modern than the modernists, until he irritated them so much that they rejected him; to hunt down the conformism of the anti-conformists: "Radiguet's arrival at the height of cubism and dadaism [...] taught us not to follow the trend and that only apparently conformist expectations could disorientate the aesthetes and become the true anarchy".[1] As always Cocteau turned his words into deeds, with "calls to order" and the foundation of his own group (the Six).

His passion for Picasso would stay with him for the rest of his life. He astonished Diaghilev, courted Apollinaire, criticized Stravinsky and defended Satie; he travelled to Italy with everyone; already a scrupulous memorialist, he photographed the heroes of Montparnasse. Like others (*Paris qui dort* [Paris asleep] by René Clair), he fell in love with the Eiffel Tower, producing *Les Mariés de la tour Eiffel* [The Eiffel Tower wedding party], after trying to put sound effects on the famous performance *Parade*, to which he made a large contribution.

Above all he drew more and more; he drew as he wrote, he wrote as he drew, he wrote and drew as he breathed.

His inventiveness was at its peak. The lively writing and exciting drawing translate thought in perpetual motion, something that would last throughout his life. "For me, writing is drawing, tying lines together in such a way that they turn into writing, or untying them in such a way that writing becomes drawing. I never stray from this. I write, I try to set precise limits on the outline of an idea, an action. All in all I identify phantoms, I find the outlines of the void, I draw."[2]

Cocteau's aviator friend Roland Garros offered him the opportunity to experience looping the loop, which Picabia had also enjoyed. This is reflected, like a "blind man's memory" (Jacques Derrida), in the contours in space and soaring spirals in the pages of *Le Cap de Bonne-Espérance* [The Cape of Good Hope]. **D. P.**

19 Isabey, Jean Cocteau at the megaphone in *Les Mariés de la tour Eiffel* [The Eiffel Tower wedding party],1921

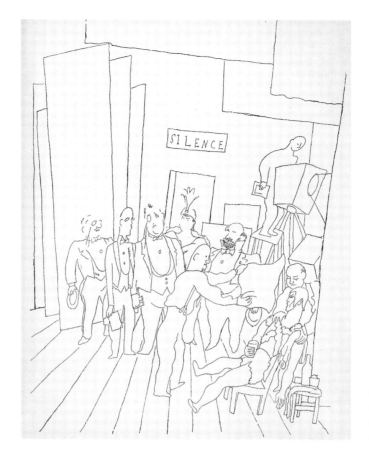

20 Jean Cocteau, *Dessins*
[Drawings], Paris, Stock,
1923: *Diaghilev, Misia Sert,
Nijinski à la première du Spectre
de la Rose* [Diaghilev, Misia
Sert, Nijinski at the première
of the *Spectre de la Rose*]

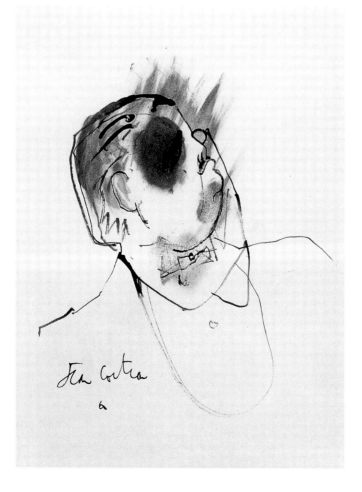

21 Jean Cocteau,
Diaghilev, undated

22 Jean Cocteau, *Nijinski in Le Spectre de la Rose,* 1911

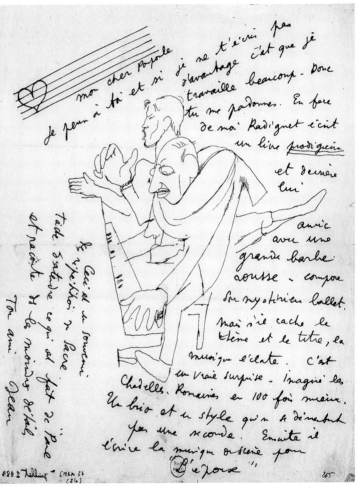

24 Jean Cocteau, Letter to Francis Poulenc with drawing
[Stravinsky and Nijinski rehearsing at the piano], 1912

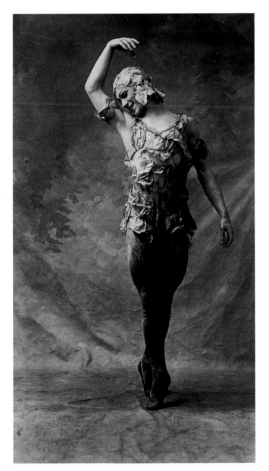

23 *Nijinski in Le Spectre de la Rose,* 1911

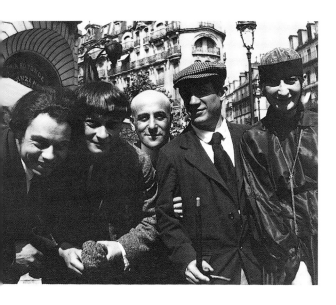

 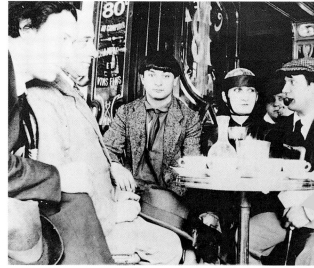

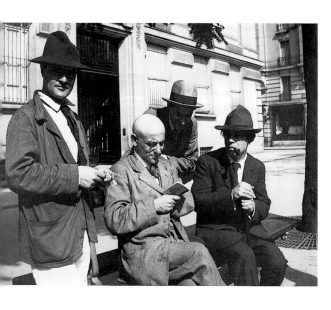 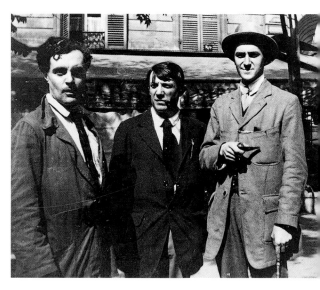

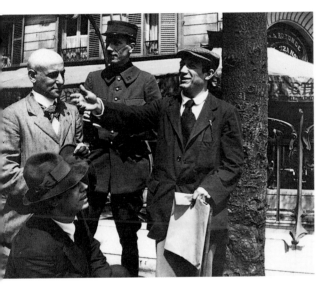

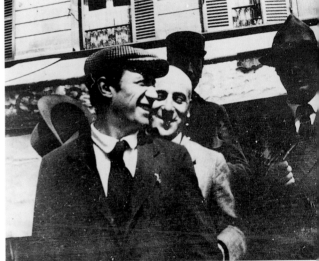

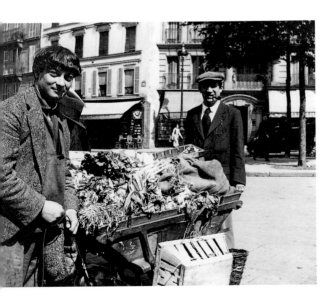

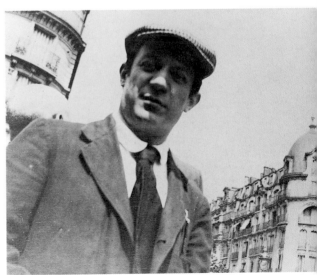

25-34 Jean Cocteau, *Montparnasse*, 12 August 1916

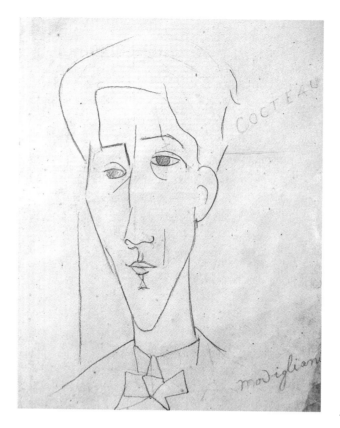

35 Amedeo Modigliani
Jean Cocteau, 1916

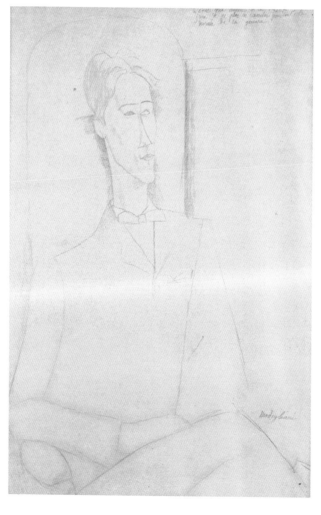

36 Amedeo Modigliani
Jean Cocteau, 1916

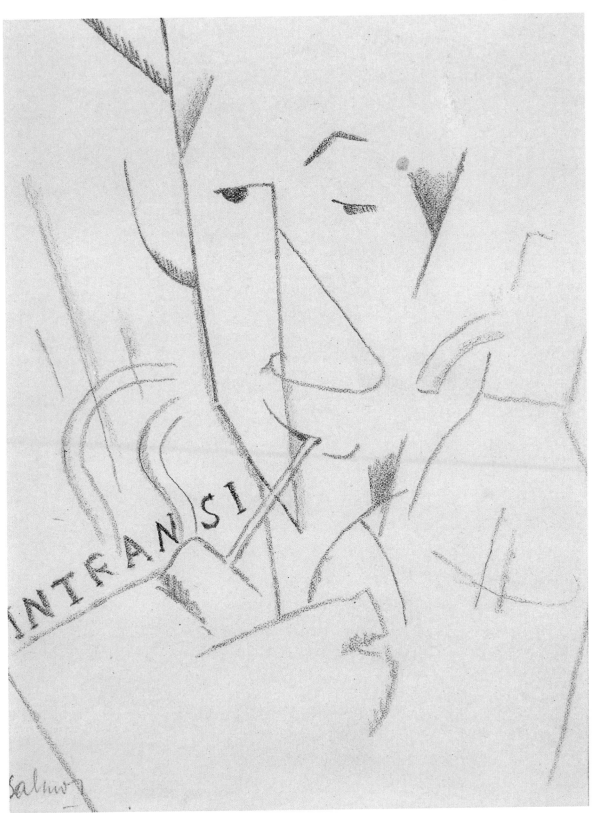

37 Jean Cocteau, *André Salmon,* about 1916

Jean Cocteau, *Sketchbooks,*
about 1917–1920

38 *Door, hinge, lock, key*

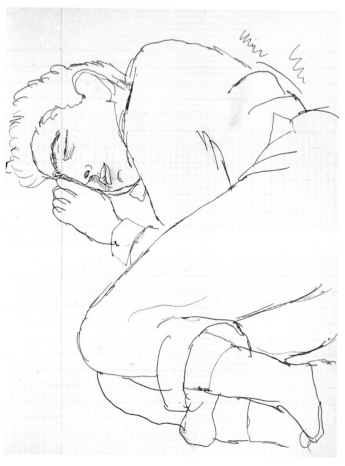

39 *Radiguet asleep*

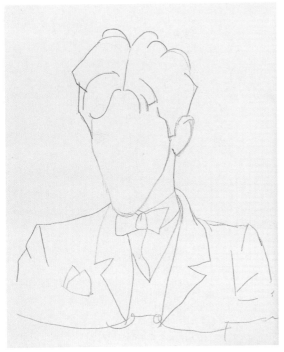

40 *Self-portrait without a face*

41 *Self-portrait*

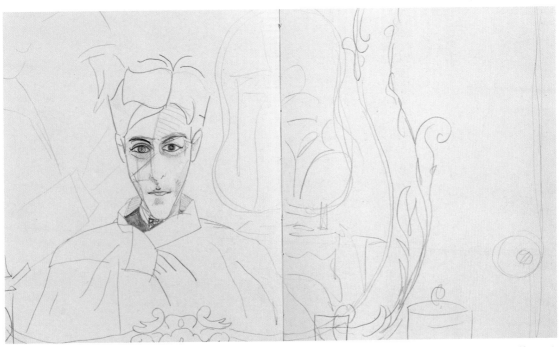

42 *Self-portrait*

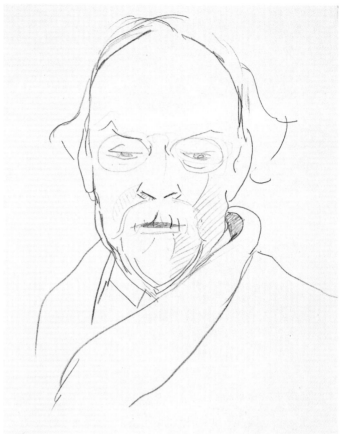

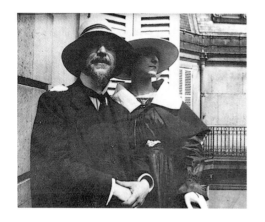

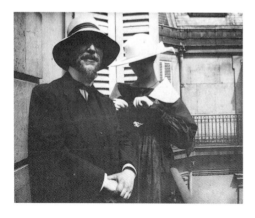

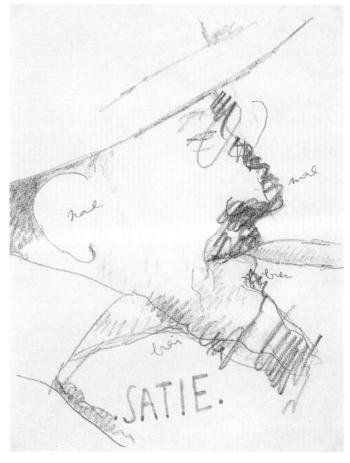

43 Jean Cocteau [?], *Valentine Gross (Hugo)
and Erik Satie on Cocteau's balcony, 10 rue d'Anjou,
Paris*, about 1916

44 Jean Cocteau, *Erik Satie*, about 1917

45 Jean Cocteau, *Erik Satie*, study for a portrait
about 1916

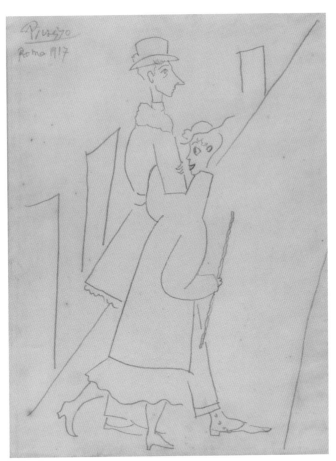

46 Pablo Picasso
Rome, 1917
[Cocteau with the dancer
Maria Chabelska], 1917

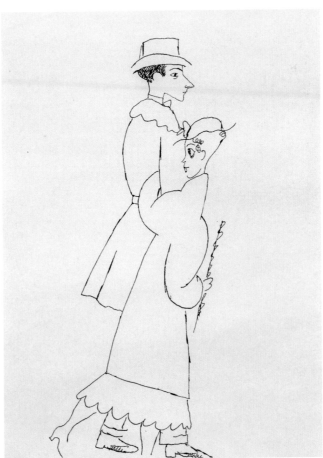

47 Jean Cocteau
*Self-portrait with the dancer
Maria Chabelska*, 1917

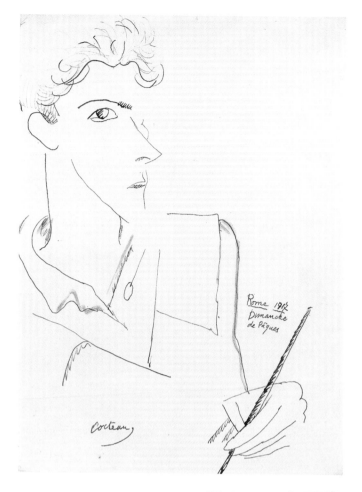

48 Jean Cocteau
Autoportrait, Rome [Self-
portrait, Rome], 1917

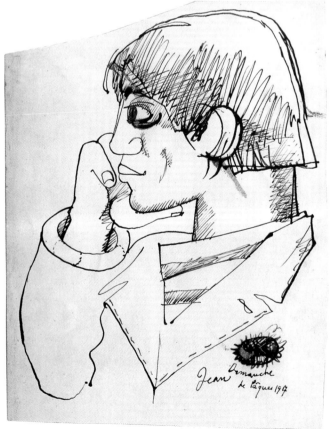

49 Jean Cocteau
Pablo Picasso, 1917

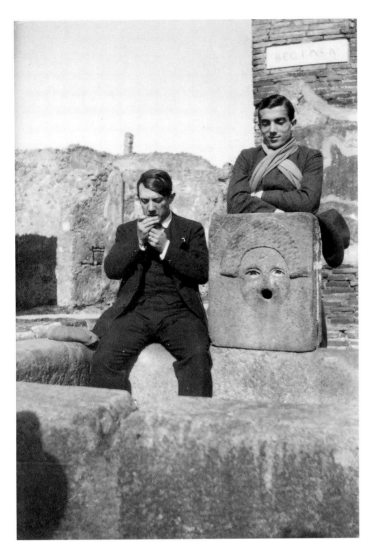

54–61 Jean Cocteau, *Naples*, spring–summer 1917

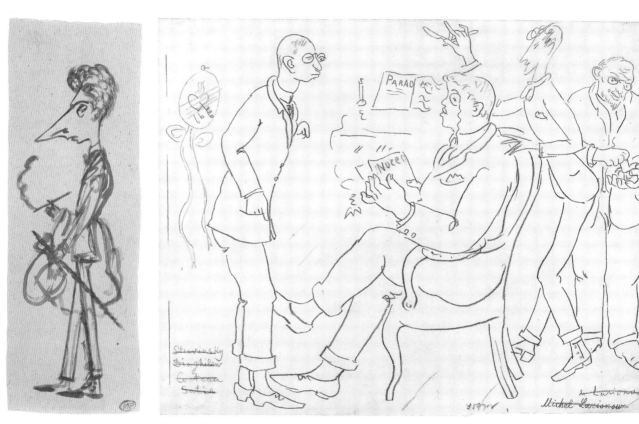

62 Pablo Picasso, *Caricature of Jean Cocteau*, 1917

63 Michel Larionov, *Stravinsky, Diaghilev, Cocteau et Satie*, 192

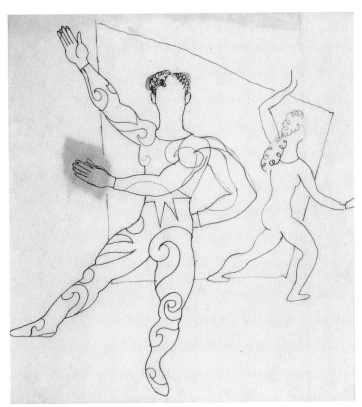

64 Jean Cocteau,
'*The acrobat*' *in Parade,* 1917

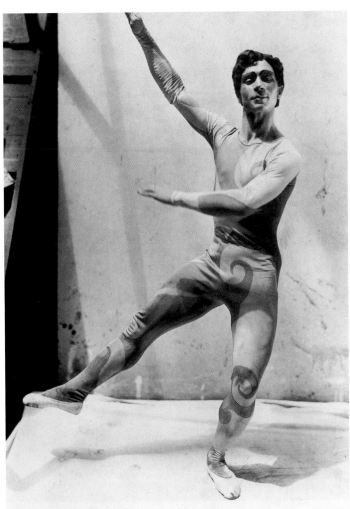

65 *Nicolaï Zverev,*
'*The acrobat*' *in Parade,* 1917

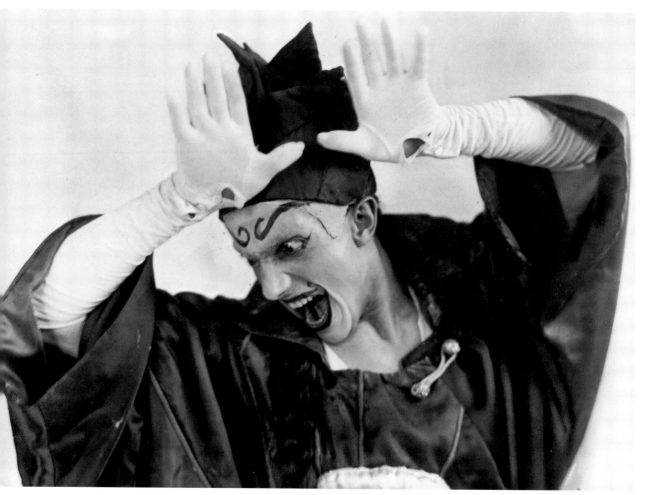

66 *Léonide Massine, 'The Chinese magician' in Parade*, 1917

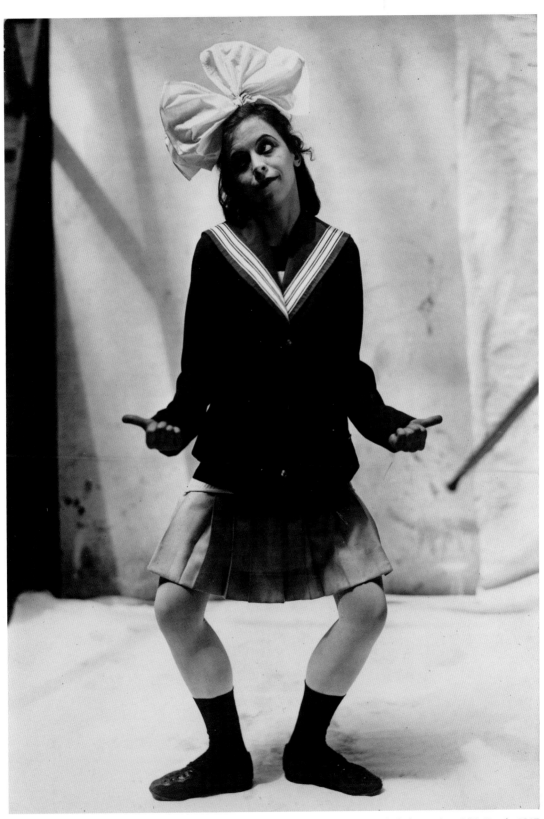

67 *Maria Chabelska, 'The little American girl' in Parade, 1917*

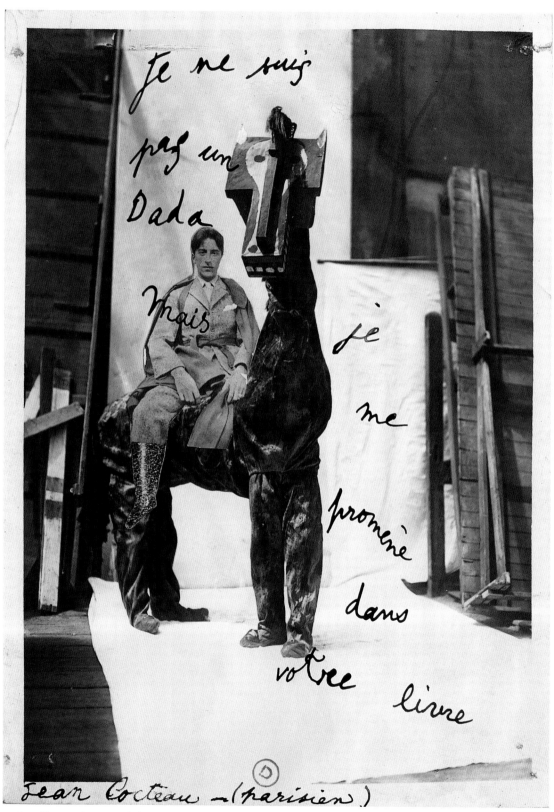

68 Jean Cocteau, Letter to Picabia and photomontage with the horse in *Parade*, undated

69 Jean Cocteau, *The Third Ode – Paris le soir* [Paris in the evening], 1914

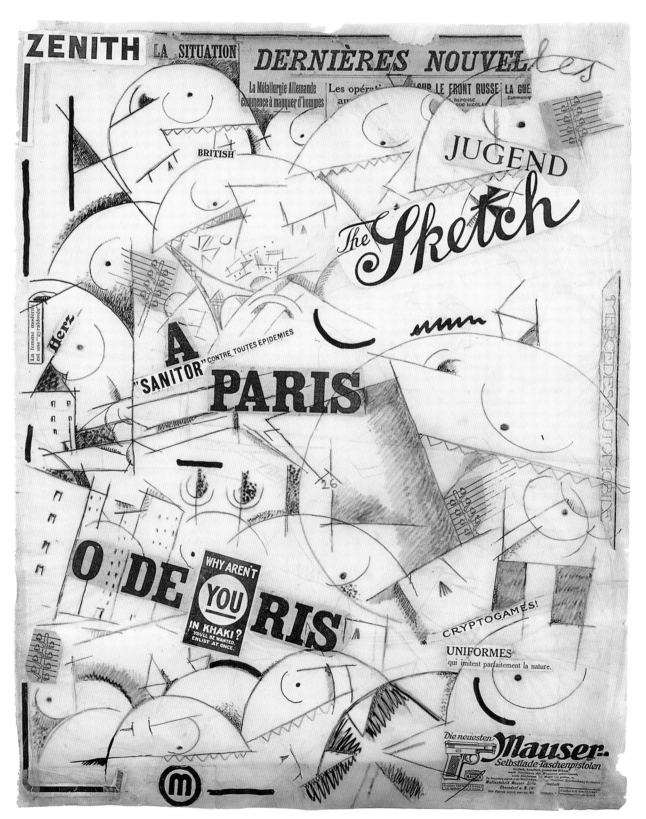

70 Jean Cocteau, *Les Eugènes de la guerre* [The 'Eugènes' of war], about 1913–14

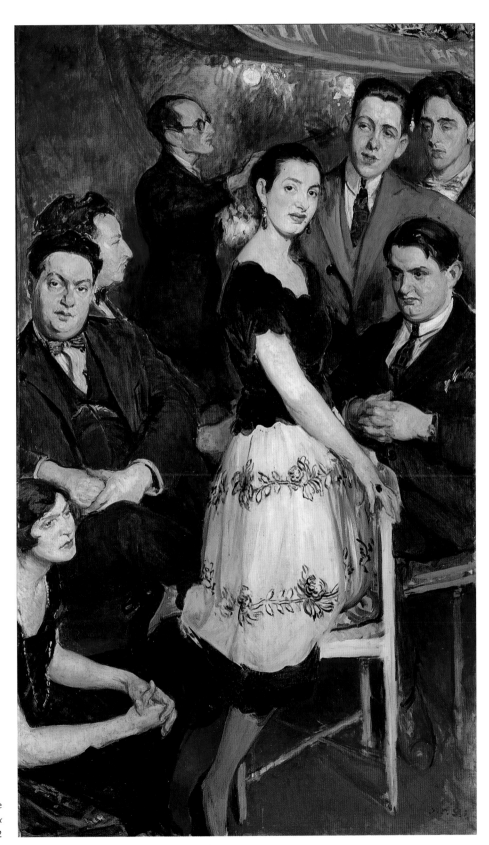

87 Jacques-Emile Blanche
Le Groupe des Six
[The Group of Six], 1922

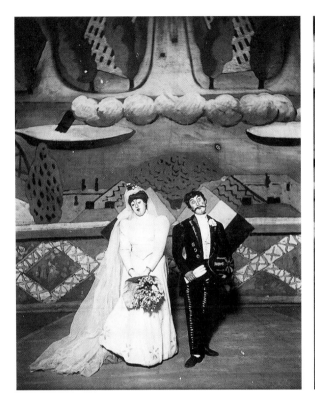

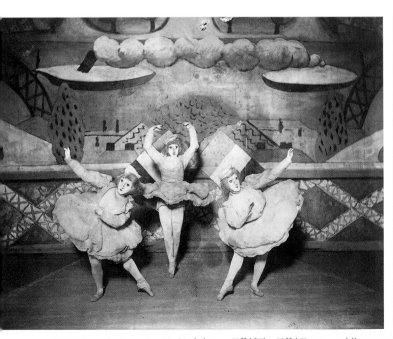

88–91 Jean Cocteau, *Les Mariés de la tour Eiffel* [The Eiffel Tower wedding party], 1921

29 mars 1920

Mon cher Francis

Vous savez ma franchise et les scrupules qui me harcèlent toujours. Vous savez aussi combien votre amitié m'est précieuse.

Personne n'écrit n'importe quoi. Ce que vous faites vous exprime, m'amuse, m'intéresse. Ce que fait Tzara me touche souvent profondément. Je peux même dire que Tzara malgré qu'il œuvre aux antipodes de moi est le seul poète qui me touche ainsi. Ribemont est pur j'en suis certain. Mais Dada, le Dadaïsme me cause un malaise intolérable. J'aimais qu'ils donnent de l'air dans la chambre cubiste — mais la séance de l'autre soir c'était atroce, triste, timide, loin de toute audace, de tout plaisir, de toute invention.

Picabia crée, désire créer un "drame", un "malheur", un "noir", un blasphème, une atmosphère de romantisme nouveau — Tzara désorganise. Je me trouve, moi, Parisien, en face de la première

tentative de propagande étrangère qui marche. C'est votre droit. Vous avez vu avec quelle bonne humeur je le supportais et même que je n'hésitais pas à m'y joindre par dégoût ou patriotisme mal entendu.

Cette fois je me trouve en face d'une obligation physique d'agir (jamais contre vous ni contre Tzara ni contre d'autres, l'amitié ou le souvenir de l'amitié m'étant chose sacrée) mais contre Dada, l'esprit Dada — devenu par la faute de quelques collègues aussi désuet, aussi ennuyeux que Jarry, Duparc, Sacha Guitry, Bruant, madame Lara ou Ibsen.

Rendez-moi les 3 poèmes pour 391 — et ne me copiez plus à cette lettre votre dégoût — moi je vous estime trop pour ne pas vous l'écrire et reste votre ami comme avant

Jean Cocteau

92 Jean Cocteau
Letter to Francis Picabia,
1920 (recto and verso)

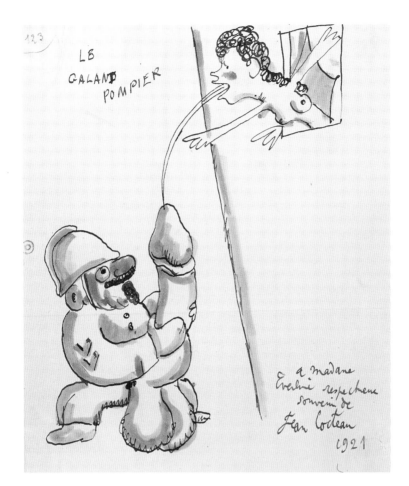

93 Jean Cocteau
Le galant pompier
[The gallant fireman], 1921

94 Jean Cocteau, *Dada globe*
[Dada globe], 1921

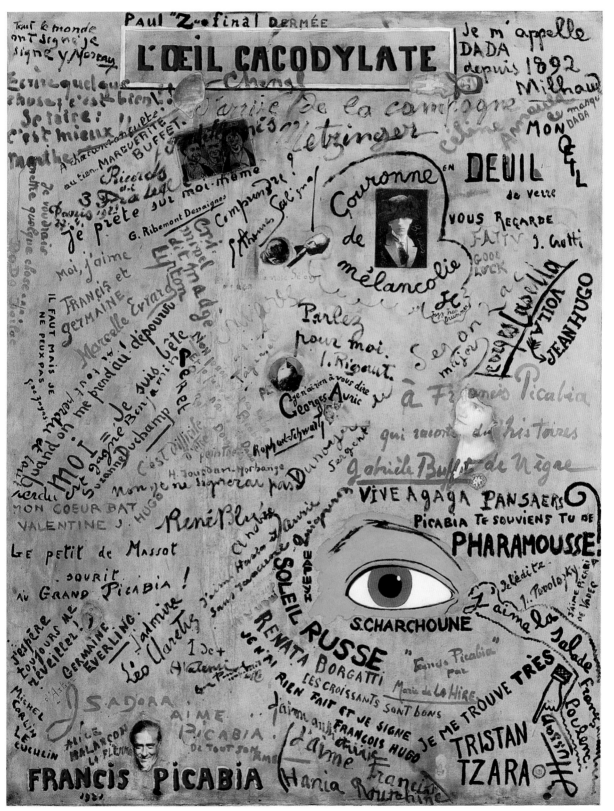

95 Francis Picabia, *L'Œil cacodylate* [The coprolatrous eye], 1921

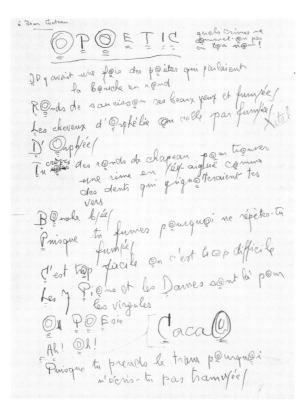
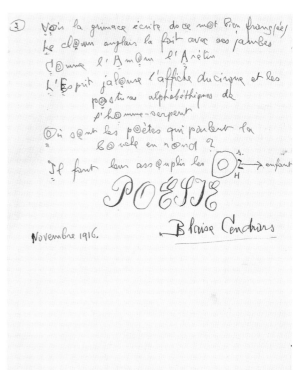

96 Blaise Cendrars, Letter to Jean Cocteau (*OPOETIC*), about 1920 (recto and verso)

97 *Blaise Cendrars,* undated

98 Man Ray, *Jean Cocteau and Tristan Tzara*, 1922

N° 1 MAI 1920 1 franc.

LE COQ

Paraît chaque mois.

le mystificateur, Alfred Jarry l'amer, Degas l'ironique,

Bon voyage Oscar Wilde le paradoxal, Richard

Bonjour, Paris !

Aimant *voir clair*, nous répugnons au mensonge du "sublime", à l'engourdissement fakirique des "temples qui furent".

Si Jean Cocteau a raison, si "toute affirmation profonde nécessite une négation profonde", les jeunes musiciens se doivent de beaucoup nier et, pour ma part, je crois que leur négation ne sera jamais trop violente.

Quand à l'*affirmation*, n'en doutez pas, elle aussi sera violente.

Il ne s'agit plus de discuter sur les faillites successives de trop d'esthétiques. Ayant grandi au milieu de la débâcle wagnérienne et commencé d'écrire parmi les ruines du debussysme, imiter Debussy ne me paraît plus aujourd'hui que la pire forme de la nécrophagie. Mais *Pelléas* n'en demeure pas moins le chef-d'œuvre par quoi commence le 20ᵉ siècle, s'achèvent Rossetti, Maeterlinck et les enchantements de la nuit.

Depuis nous avons eu le music-hail, les parades foraines et les orchestres américains. Comment oublier le Casino de Paris et ce petit cirque, Boulevard St-Jacques, ses trombones, ses tambours. Tout cela nous a réveillés. Mais, adieu New-York !...

Le petit orchestre des *Cocardes* de Françis Poulenc me ravit autant qu'une page de Rameau.

GEORGES AURIC.

Ravel refuse la Légion d'Honneur mais toute sa musique l'accepte.
ERIK SATIE.

Wagner le sublime, Jules Renard

N° 2　JUIN 1920　1 franc.

LE COQ

Paraît chaque mois.

JE RÉVEILLE

N° 3　JUILLET, AOUT, SEPTEMBRE　1 franc.
(ne compte que pour un numéro).

LE COQ
Parisien

Que vous offrir de neuf? Le poème futuriste et le calligramme ne distrayent plus un public parisien habitué de Luna-Park. D'ailleurs, la Ligue Anti-Moderne condamne ces formes pittoresques. Reste le Poème-surprise-à-lire-dans-une-glace. Il flatte la lectrice indiscrète et ne s'impose pas au lecteur malgré lui.

Achetez avec Le Coq un miroir de poche et lisez par exemple:

BUVARD

Gravez votre nom dans un arbre
Qui grandira jusqu'au nadir
Un arbre vaut mieux que le marbre
Car on y voit les noms grandir

●

On trouve dans nos magasins le plus grand choix de Poèmes-à-lire-dans-une-glace, pour toutes les circonstances de la vie.

LE COQ PARISIEN reparaîtra chaque mois à partir d'Octobre.

De son vivant on lui jette des pierres au poète. Après sa mort on ramasse la plus grosse pour lui faire un buste.

99–101　Jean Cocteau, *Le Coq* [The cock], magazine, 1920

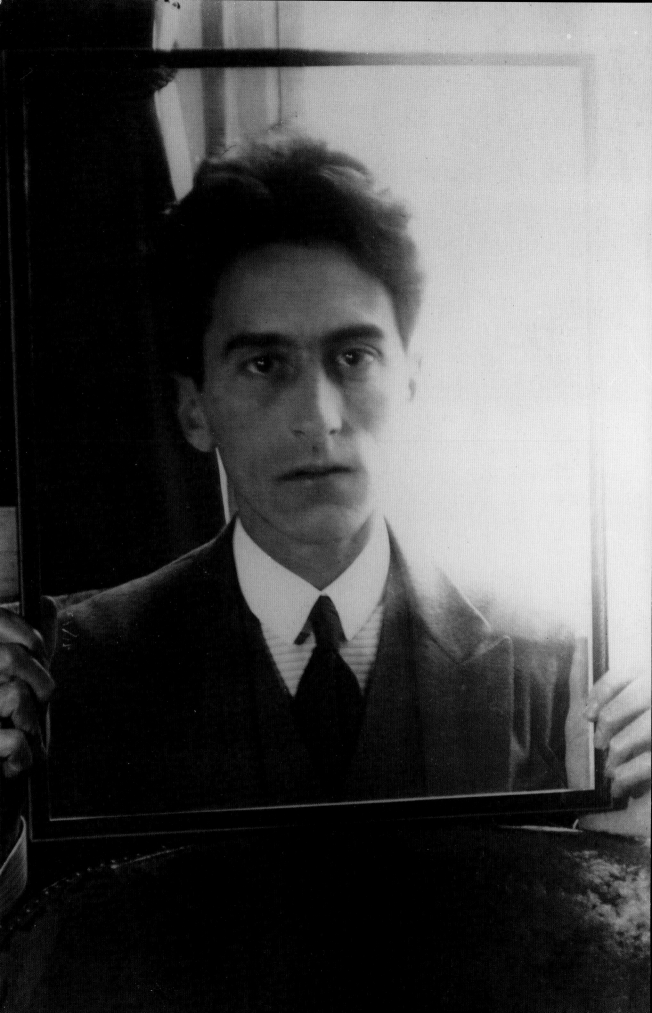

Coïncidences
Conjunctures

1 J. Cocteau, *Opéra*, in *Romans, poésies, poésie critique, théâtre, cinéma*, Paris, L.G.F. (*La Pochothèque*), 1995, pp. 348–49.

2 J. Cocteau, *La Difficulté d'être* [1946], *ibid.*, p. 873.

3 *Ibid.*, p. 923.

Portraits

Although not everyone liked him, Cocteau was a feature on the horizon for many of his contemporaries. His outline became more stable, engendering his persona. Or perhaps his persona reinforced the figure he cut. He did not love himself as much as people were already saying; he did not like "this badly planted hair and nervous system".[1] Radiguet's death simply accentuated his doubts and disgust over his appearance for, from an early age, he had never had any illusions about his face. "I've never had a handsome face. In me, youth took the place of beauty. My bone structure is good but the flesh is badly arranged on top. Besides the skeleton changes over time and degrades. My nose, which used to be straight, is developing a hook"[2]

Yet Cocteau is among the century's most frequently depicted personalities. Those who painted his portrait include Picasso, Kisling, Modigliani, Delaunay, La Fresnaye, Jacques-Émile Blanche, Dufy, Rivera and Picabia. Meanwhile Man Ray, Berenice Abbott, Germaine Krull, Gisèle Freund and Irving Penn all took turns to freeze still the movement of this Orpheus. Cocteau received his just deserts: he was seen everywhere, by everyone, and reproduced to the point of the invisibility that so attracted him.

The Cocteau look

Reproduced in so many reflections, his body 'disappeared'. That was a very good thing for someone so unsure of the way he looked. The style that clothes create for the body inflected the appearance, pose and profile of this unquiet Narcissus. Yet Cocteau's wardrobe does not help us fix a stable image. From the soft dressing-gown to the Academician's suit, the rolled-up sleeves to the fabric combinations, the poet was playing, although he seriously loved to decorate himself. Yet he mistrusted the dandy image, seeing it as "cold head and cold hand. I advise all ships to avoid such insolent icebergs".[3]

Rather than being its high-profile model, Cocteau preferred to turn fashion to his own use, to control it and lead it away from frivolity. He brought it into contact with variety theatre, circus acts, boxing, cabaret and music hall songs, all arts regarded as minor and which had the power to steer him clear of any overbearing seriousness.

Manager of Al Brown, drummer of Le Boeuf sur le toit, lyric writer for Marianne Oswald, admirer and director of the Fratellini clowns, habitué of nightspots of dubious repute, trainer who helped Coco Chanel make the move from the catwalk to the theatre (*Antigone*), Cocteau fired on all cylinders in his effort to ward off the chill of dandyism.

Wars

At the beginning of the First World War, Cocteau was involved in journalism, writing and drawing, with Paul Iribe. *Le Mot* [The word] is a masterpiece of decorative graphic design, somewhere between Art Nouveau and Art Deco. In it Cocteau "eats" German, adapting his 'Eugènes' from *Le Potomak* to the aesthetics of the pointed helmet. Though declared unfit

102 **Man Ray**
Jean Cocteau, 1922

for service, he went to Rheims as a civilian ambulance driver and there met up with Misia Sert, who had rounded up utilitarian vehicles that were not being used in Paris. Then he returned. Later he admitted, "I left the war when I realised, in Nieuport, that I was having fun. That disgusted me. I had forgotten hatred, danger, surprises, I had my head in the clouds. As soon as this realisation struck me, I set about trying to leave, taking advantage of being ill. I hid it, like a child playing."[4] This is a strange remark, somewhere between disgust and a certain cynicism, between a rejection of horror and rebellion against being deprived of what was to him the most important, crucial thing – poetry.

The horror of war reasserted itself for Cocteau in the searing writing and drawing of *Thomas l'imposteur* [Thomas the Impostor] (1923).

The question of political engagement clearly affects the way Cocteau is seen. In 1951 he said, "My form of engagement is to lose myself at the farthest, most uncomfortable point of myself [....] In our day a free man is seen as a coward when in fact he preserves no place where the blows can't reach him. He is stoned from all sides. That's the snow statue of *Le Sang d'un poète*."[5] In the same interview, having recalled his friendship with Aragon and Eluard, Cocteau added, "I'm accused of being light, whereas for me lightness consists in changing one's attitude according to circumstance. Moreover Giraudoux always used to say to me, "When they want to beat us up, they beat you up. You are the ideal lightning conductor to save us from being struck."

Cocteau's life in Paris during the years of the Occupation have left a negative mark on his image. The man who hailed the sculptor Arno Breker, who sought support from the occupiers in avoiding censorship, who tried, with Céline's help, to win over the theatre critic of *Je suis partout*,[6] is also the man who drew portraits of Eluard (including one on the back of a page of praises to Pétain!). The same man made every effort to get Max Jacob out of the camp at Drancy regularly dined with Lise Deharme, Picasso and Eluard,[7] and accepted an invitation from Otto Abetz in order to calm attacks on him in the collaborationist press. Beaten up by the militia, in 1940 he wrote a sharp piece against racism. The list of contradictory actions by a citizen who remained free of suspicion during the war is endless. However, his was the dangerous lightness of the lightning conductor – flexible, resistant to harsh winds, channelling the bad conscience of some others, whose Stalinist or Trotskyite fanaticism was not without its political consequences.

Deep down, Cocteau did not believe in anything. Art was his only refuge. But very early on he observed, "The left-wing press never supports left-wing art, or else it happens that the extreme left-wing press gets things wrong through an excess of zeal and confuses oddness with boldness. The connection between the best elements of the left has yet to be made. This is difficult, because politics evolves slowly, behind art. You could say that our best politicians have now reached their Symbolist phase (or perhaps their Romantic phase)."

His personal diary for the years 1942–45, and the large self-portrait in pencil dated 1940 in Perpignan, reflect a period which saw no reduction in the pain of the *grands écarts* – the splits, or separations, that he felt within himself. **D. P.**

4 J. Cocteau, *Opium, ibid.*, p. 619.

5 J. Cocteau, *Entretiens autour du cinématographe*, recueillis par André Fraigneau, Paris, André Bonne, 1951, p. 68.

6 See the dreadfully anti-semitic and racist letter addressed to Cocteau, which forced him to cease asking Céline for any favours. Before, during and after the war Cocteau was fervently and vehemently anti-racist.

7 Lise Deharme, *Les Années perdues*, Paris, Plon, 1961, p. 70 (brought to my attention by Jean Touzot).

103 Jacques-Emile Blanche
Jean Cocteau, about 1913

104 Jacques-Emile Blanche
*Jean Cocteau in the garden of
Offranville,* 1913

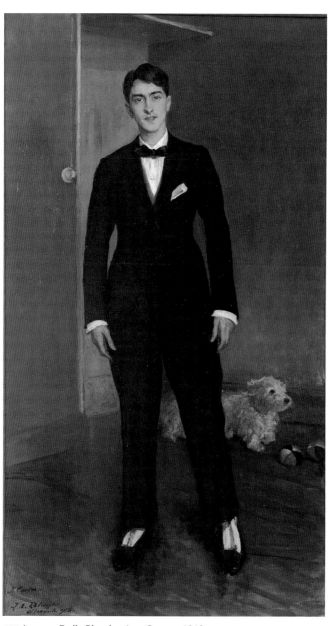

105 Jacques-Emile Blanche, *Jean Cocteau*, 1913

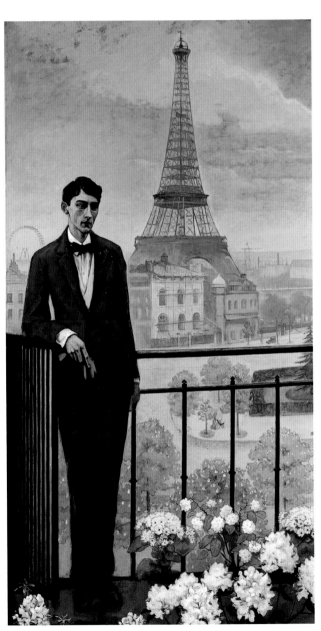

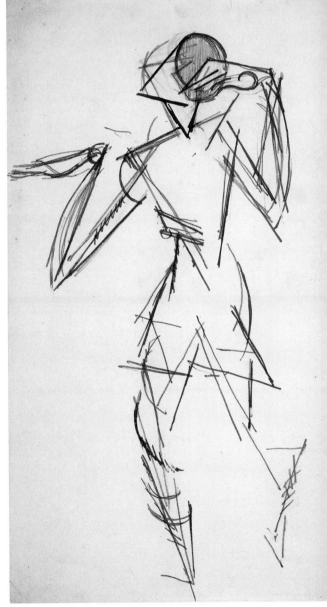

106 Romaine Brooks, *Jean Cocteau at the time of the Great Wheel*, 1912

107 Albert Gleizes, *Jean Cocteau*, about 1915–16

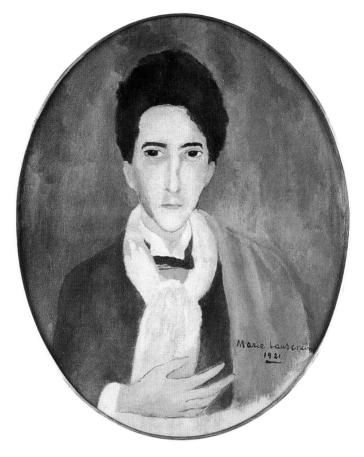

108 Marie Laurencin
Jean Cocteau, 1921

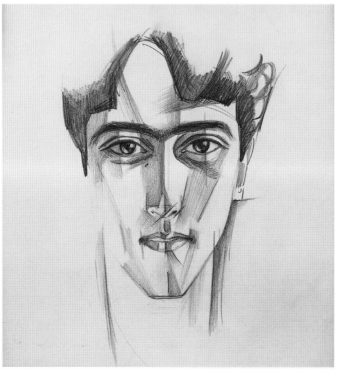

109 Paulet Thevenaz
Jean Cocteau, about 1913–14

110 Dora Maar
Jean Cocteau, undated

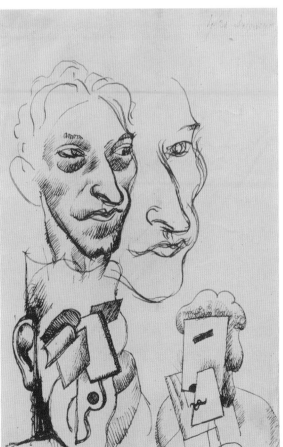

111 Roger de La Fresnaye
Studies of Jean Cocteau,
undated

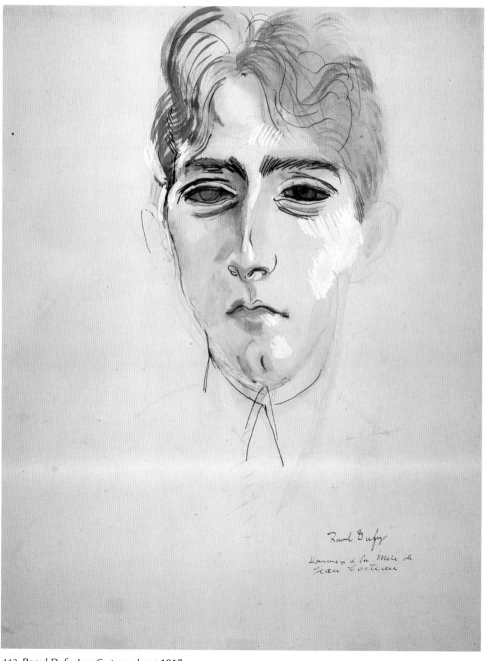

112 Raoul Dufy, *Jean Cocteau,* about 1917

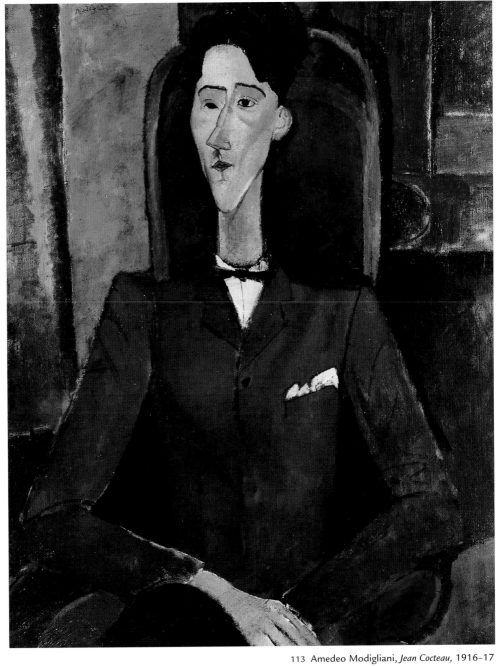

113 Amedeo Modigliani, *Jean Cocteau*, 1916–17

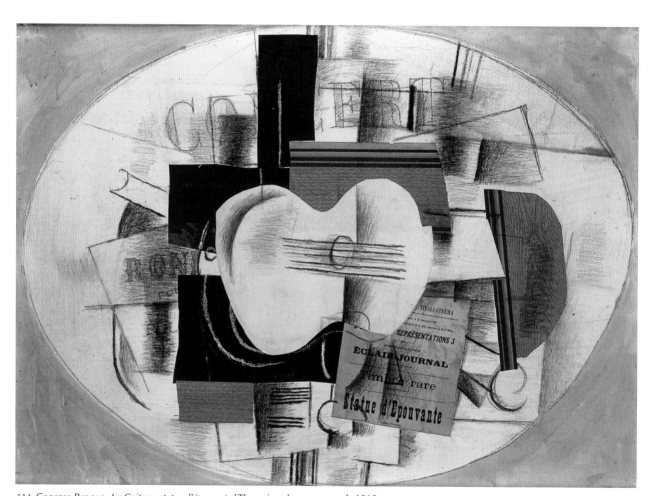

114 Georges Braque, *La Guitare, statue d'épouvante* [The guitar, horror statue], 1913

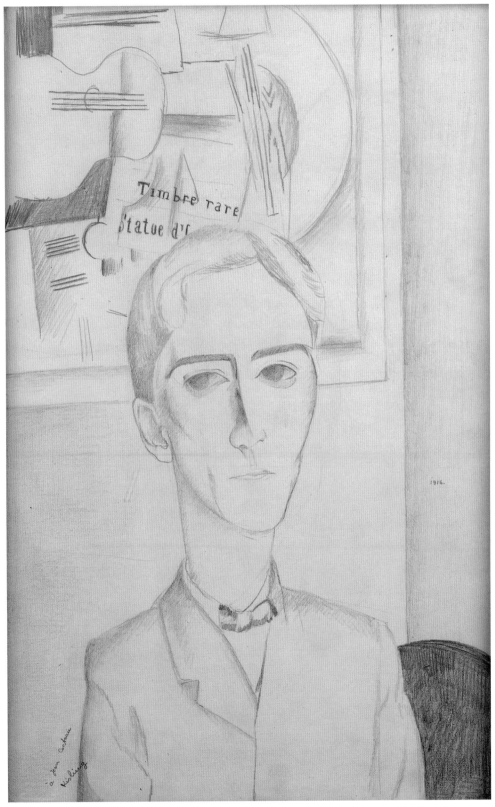

115 Moïse Kisling, *Jean Cocteau*, 1916

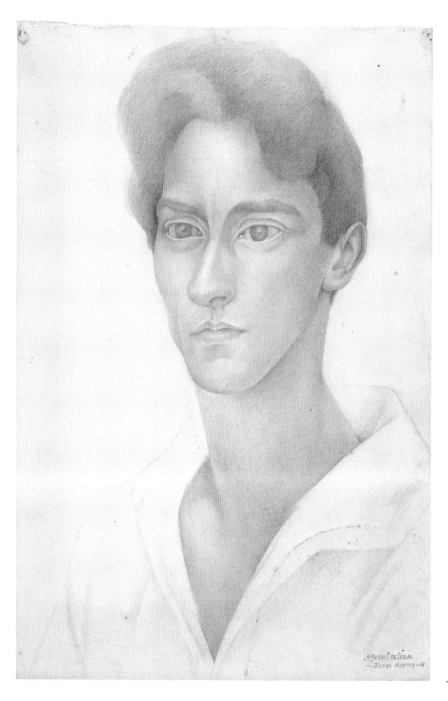

116 Diego Rivera
Jean Cocteau, 1918

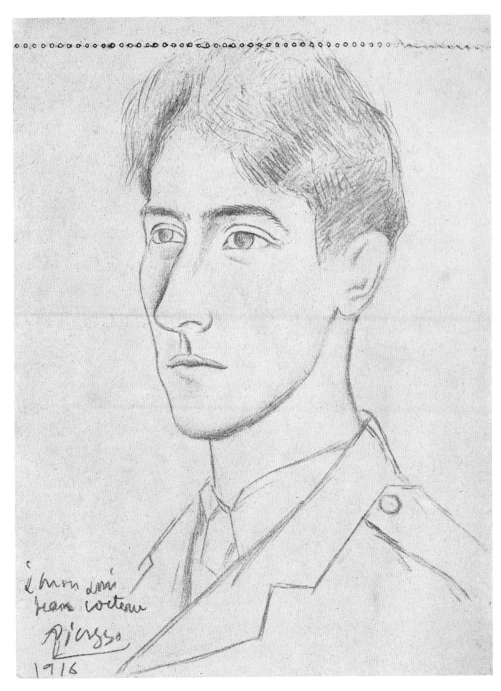

117 Pablo Picasso
Jean Cocteau
(in military uniform), 1916

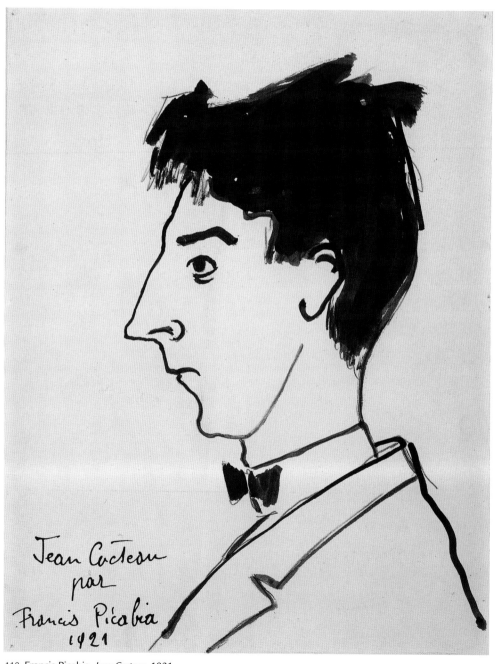

118 Francis Picabia, *Jean Cocteau*, 1921

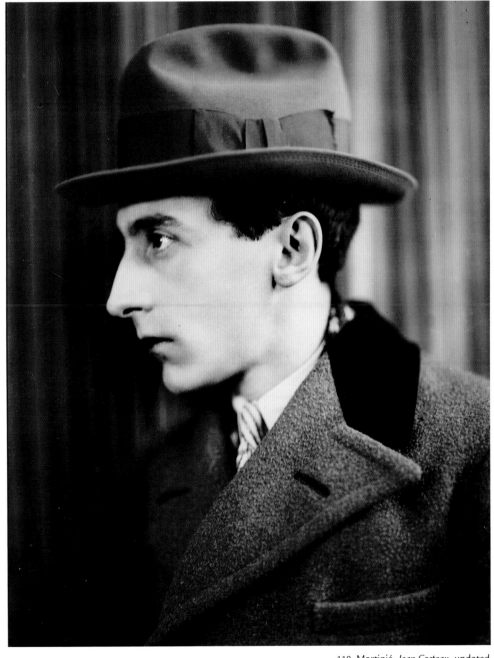

119 Martinié, *Jean Cocteau,* undated

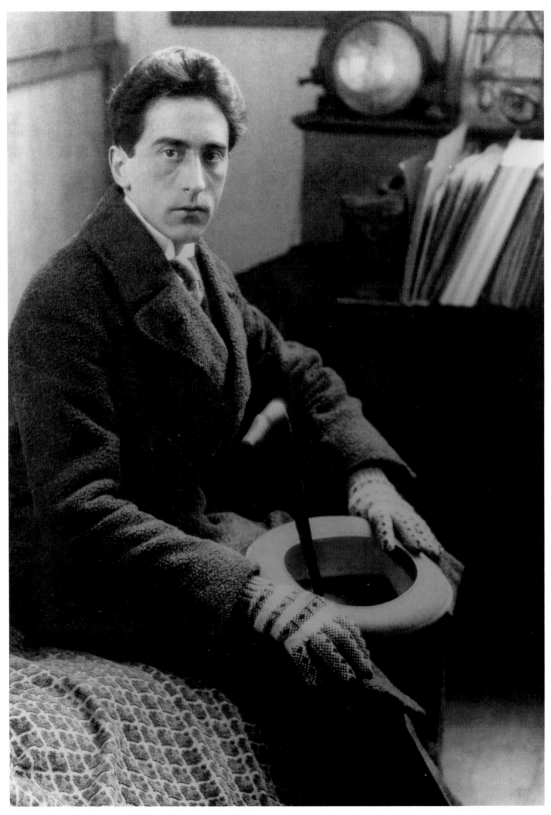

120 Man Ray, *Jean Cocteau* (with woollen gloves), 1924

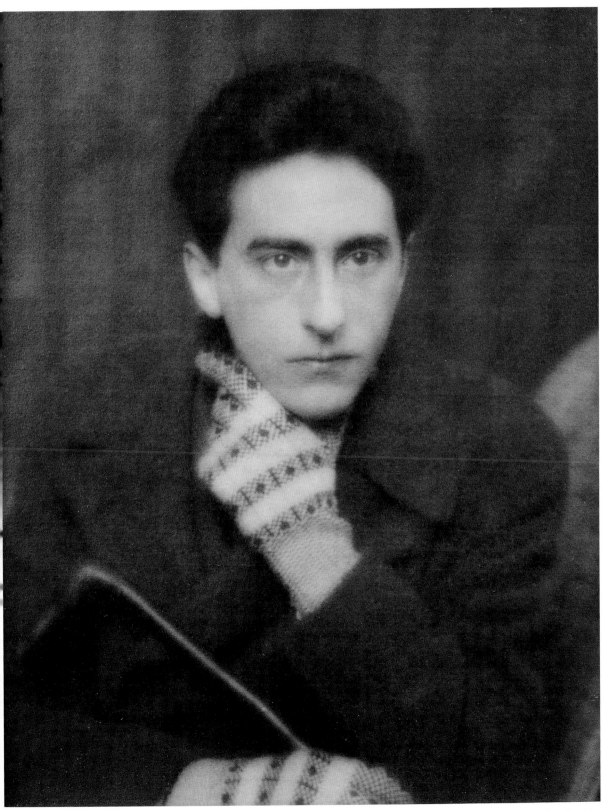

121 Man Ray, *Jean Cocteau* (with woollen gloves), 1924

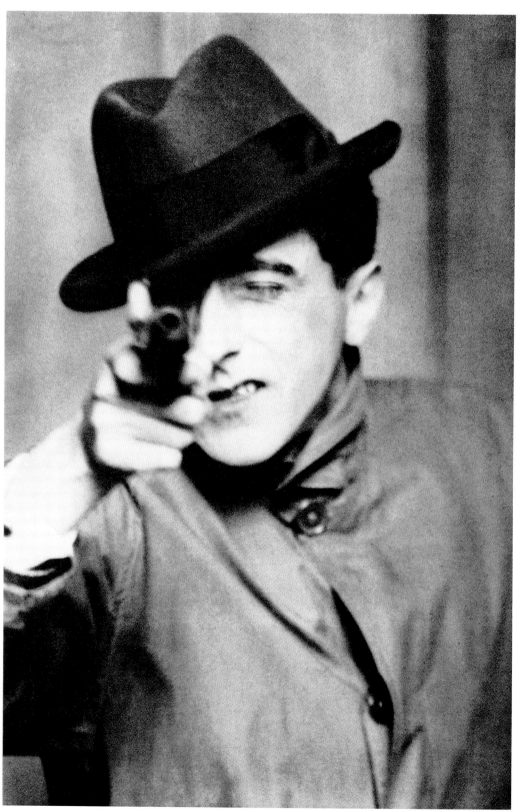

122 Berenice Abbott, *Cocteau with a revolver*, 1927

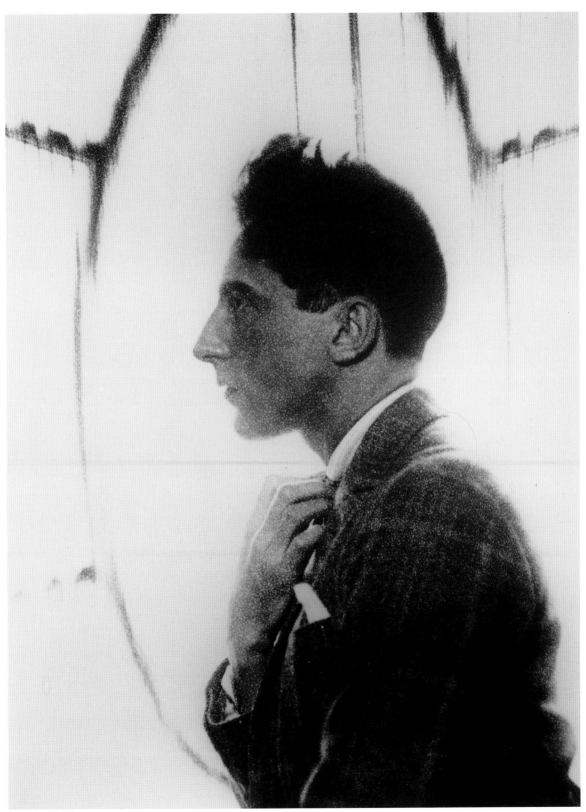

123 Man Ray, *Jean Cocteau*, 1922

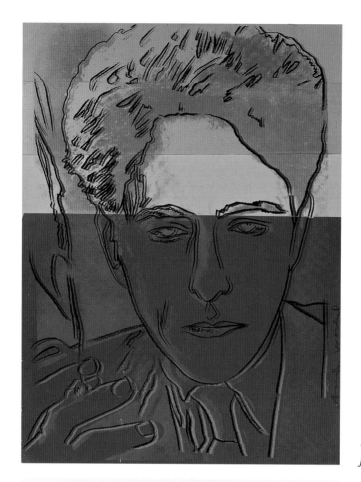

124 Andy Warhol
Jean Cocteau, about 1983

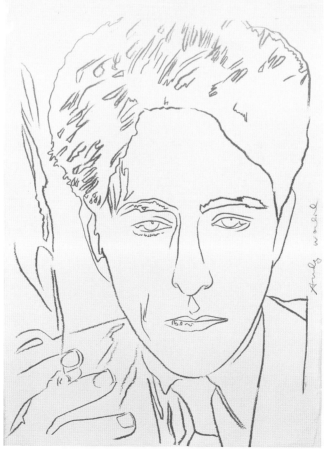

125 Andy Warhol
Jean Cocteau, about 1983

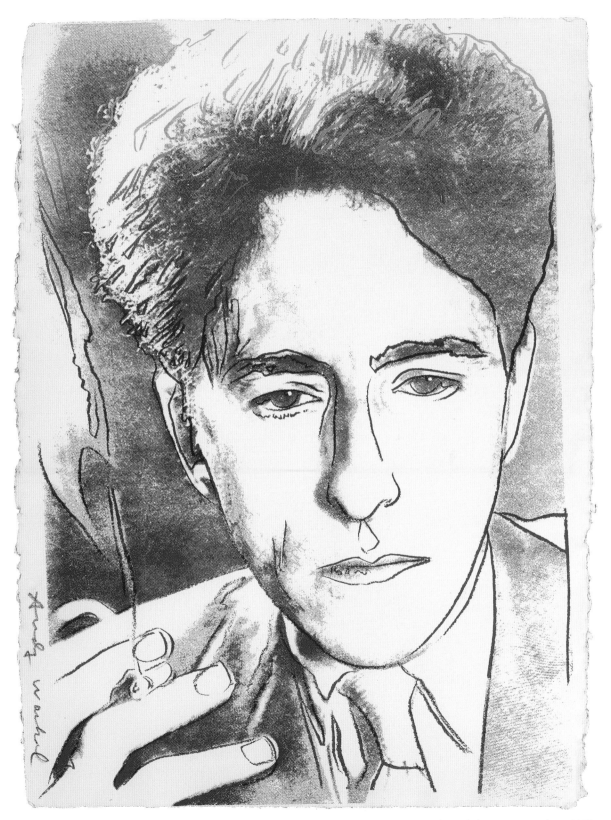

126 Andy Warhol, *Jean Cocteau,* about 1983

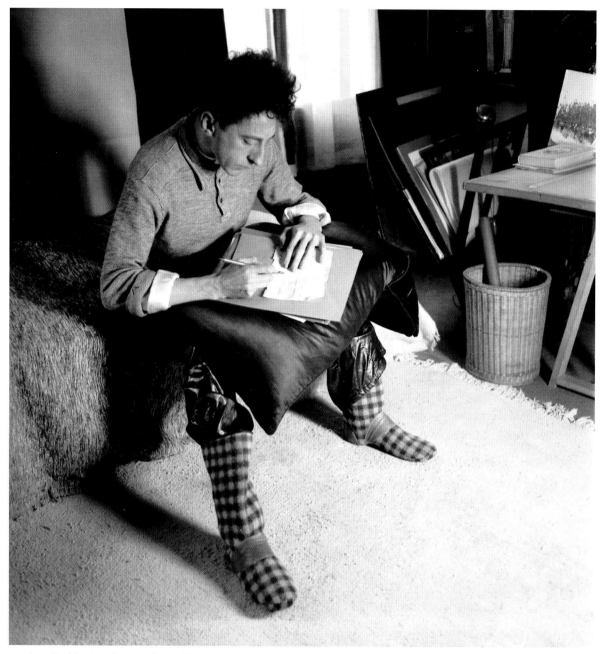

127 Jean Roubier, *Jean Cocteau*, about 1930

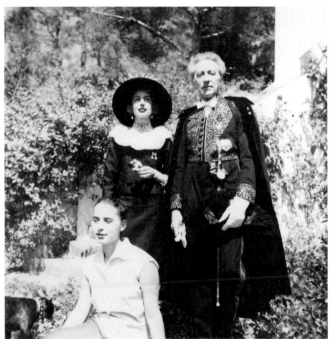

131–33 *Cocteau in the official dress of the Académie Française*, 1955

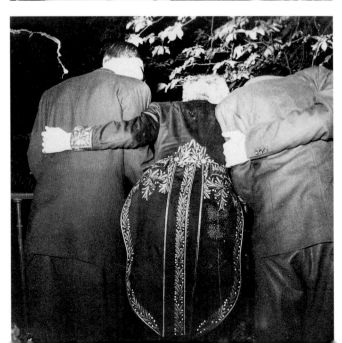

Pablo Picasso, *Designs for sword hilts,* **1955**

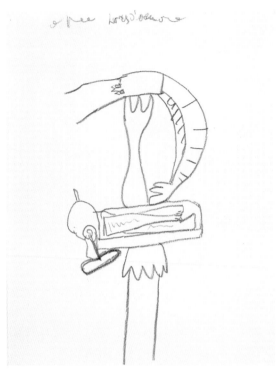

134 *Epée d'hors-d'œuvre* [Hors-d'oeuvre sword]

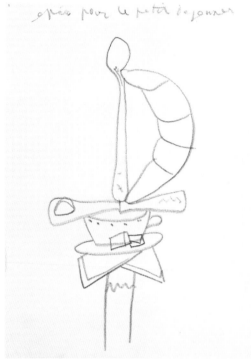

135 *Epée pour le petit-dejeuner* [Breakfast sword]

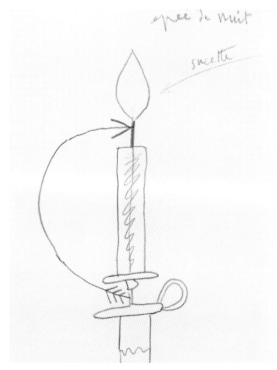

136 *Epée de nuit* [Night sword]

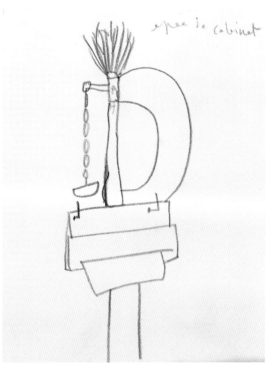

137 *Epée de cabinet* [Toilet sword]

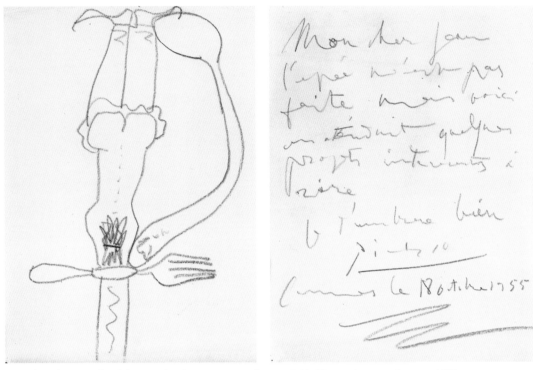

138 *Culotte du roi Dagobert* [King Dagobert's trousers sword] 139 Pablo Picasso, Letter to Cocteau, 1955

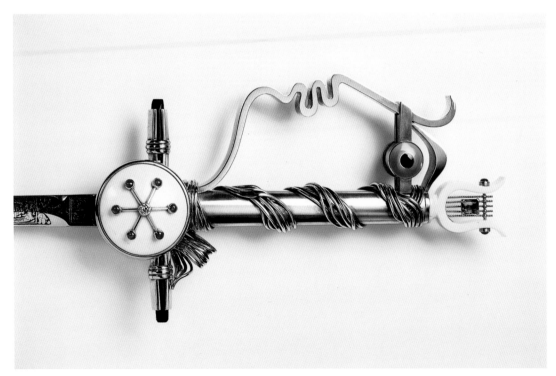

140 Cocteau's Académie Française sword, designed by himself, made by Cartier's, 1955
Hilt of gold, silver, emerald, rubies, diamond, ivory, enamel; blade of steel; Art de Cartier collection

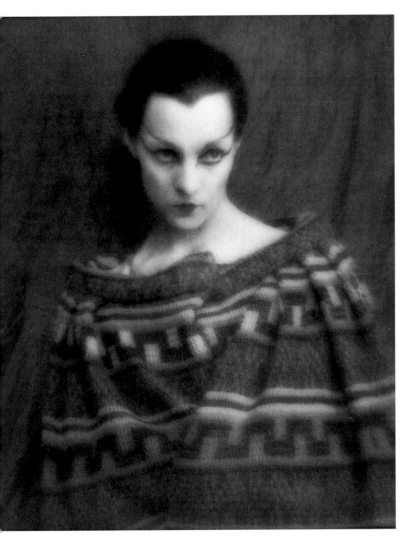

141 Man Ray, *Génica Athanasiou* (in *Antigone*), 1921

142 Jean Cocteau, *Elsa Schiaparelli,* about 1937

143 Jean Cocteau
Poiret s'éloigne, Chanel arrive
[Poiret makes off,
Chanel enters], 1928

144 Jean Cocteau
*Élégantes huées en attendant
une voiture* [Booed-at
fashionable women waiting
for a car], about 1925

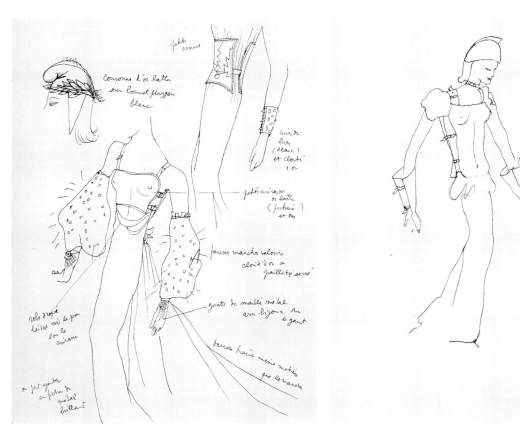

145–46 Jean Cocteau, *Fashion designs for Chanel*, 1933

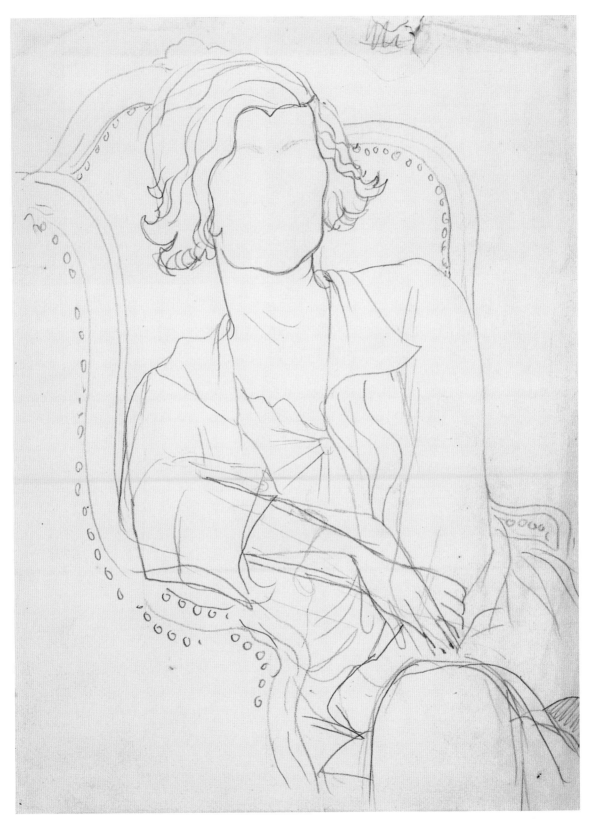

147 Jean Cocteau, *Coco Chanel,* about 1930

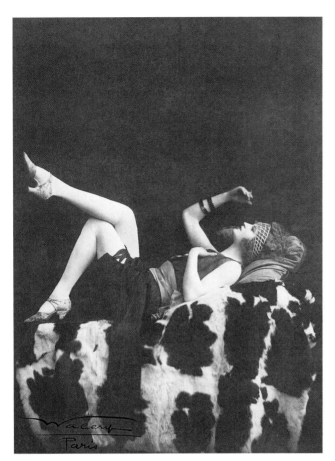

148 Walerin, *Barbette*, 1930

149 *Barbette*, undated

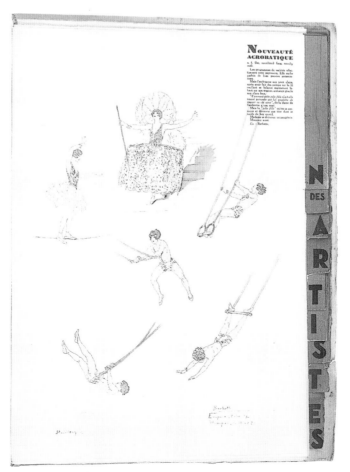

150 Programme for the
7th Gala of the Union
des Artistes, 1929
(page on Barbette)

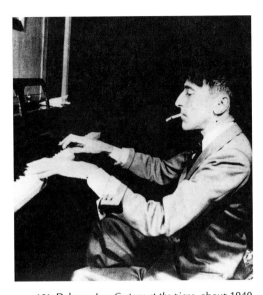

151 Dalmas, *Jean Cocteau at the piano,* about 1940

152 Jean Cocteau, *Edith Piaf in Le Bel Indifférent,* undated

153 Jean Cocteau, *Marianne Oswald,* undated

154 Jean Cocteau, *Charles Trenet,* undated

155 Jean Cocteau, *Django Reinhardt,* 1937

156 Jean Cocteau, *Al Brown,* 1938

157 *Al Brown fighting,* undated

158 Jean Cocteau
La Vierge au grand C.
[The Virgin with a big C],
1931, cover

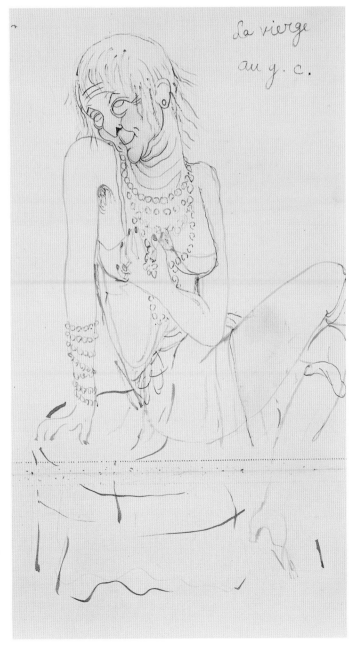

159 Jean Cocteau,
La Vierge au grand C. [The
Virgin with a big C], 1931,
frontispiece

Jean Cocteau, *La Vierge au grand C.* [The Virgin with a big C], 1931

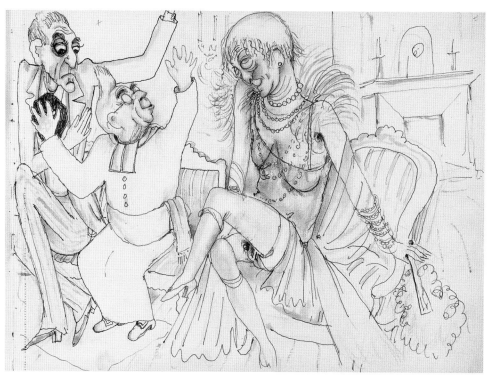

160 *Étienne de Beaumont, the abbé Mugnier and the Vierge*

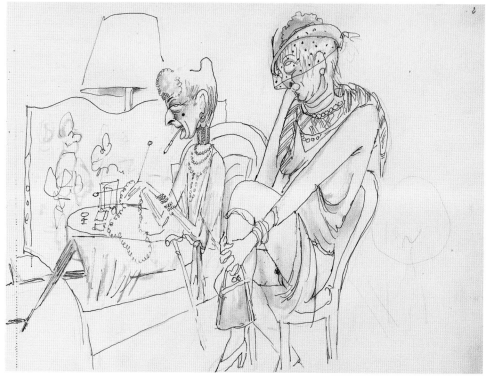

161 *Mme de Chévigné and the Vierge*

162 *Coco Chanel and the Vierge*

163 *Valentine Hugo and the Vierge*

Jean Cocteau, *La Vierge au grand C.* [The Virgin with a big C], 1931

164 *Jacques-Emile Blanche painting the Vierge*

165 *Coco Chanel, Misia Sert and the Vierge*

166 *Valentine Hugo holding a programme for L'Âge d'or, the Vierge*

167 *At Colombin's: the Vierge, Léon Daudet, Étienne de Beaumont*

Jean Cocteau, *La Vierge au grand* C. [The Virgin with a big C], 1931

168 *The Vierge and Anna de Noailles*

169 *Anna de Noailles, the Vierge (in the background), Étienne de Beaumont*

170 *Anna de Noailles,*
Marie Scheikévitch

171 *Marie Scheikévitch*
and Anna de Noailles

172 Jean Cocteau
Drawing on the menu of Le
Bœuf sur le toit, about 1923

173 Jean Cocteau
Design for publicity material
for *Le Bœuf sur le toit*
and *Le Grand Ecart*, 1927

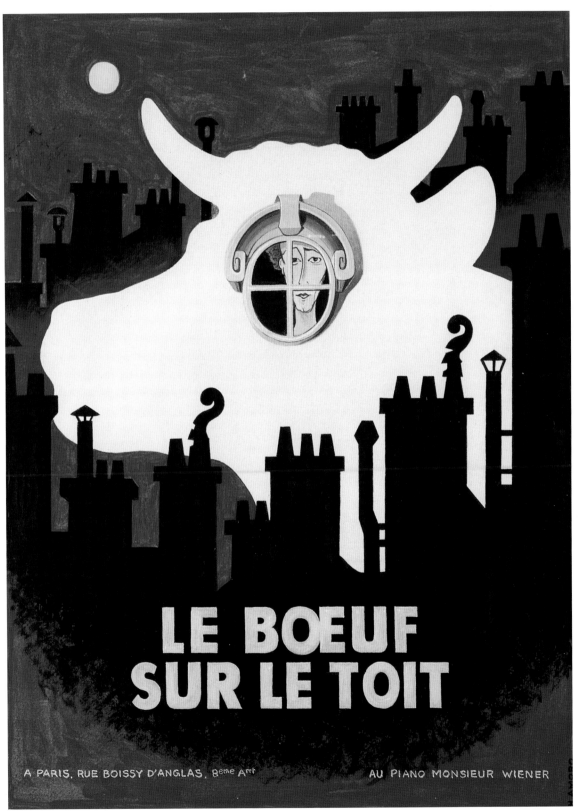

174 H. Amoro, *Le Bœuf sur le toit,* poster, undated

175–77 Jean Cocteau, « *Le mauvais lieu* » [The low dive], from *Dessins* [Drawings], Paris, Stock, 1923

178–82 Jean Cocteau, *Marins écossais* [Scottish sailors], 1916 (after the series *Danses antiques* [Dances of the past] by Valentine Hugo)

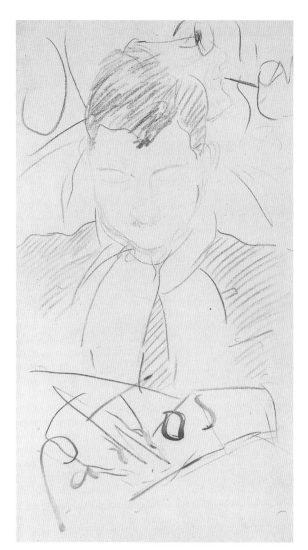

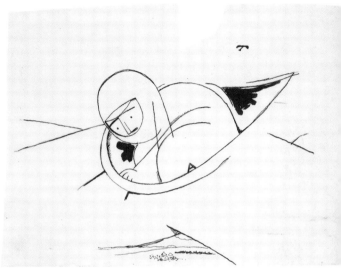

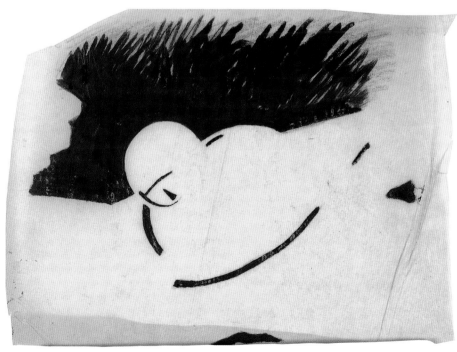

183–85 Jean Cocteau,
Sketches: *Roland Garros,*
1913–15

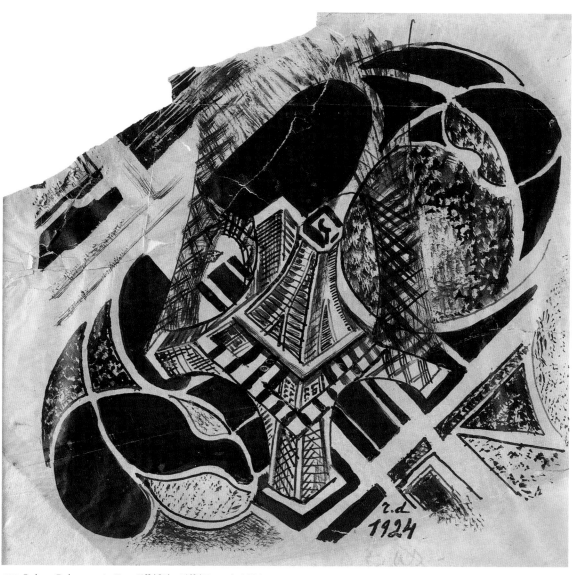

186 Robert Delaunay, *La Tour Eiffel* [The Eiffel Tower], 1924

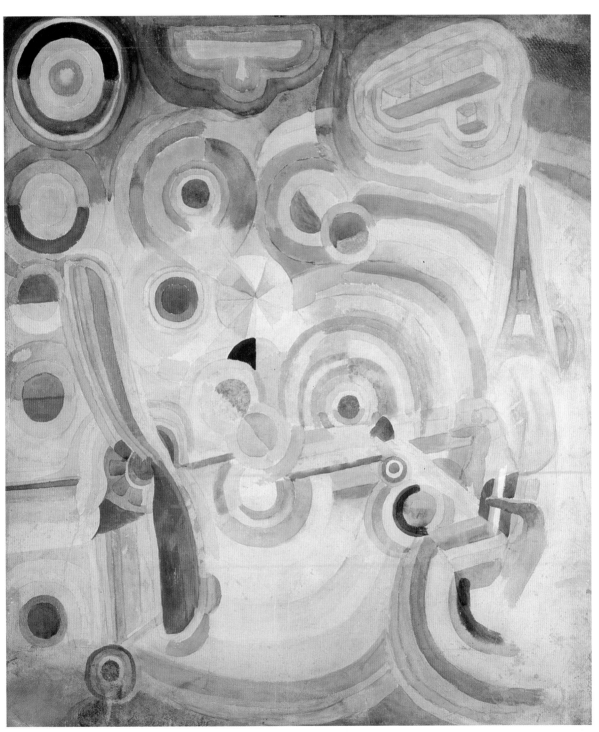

187 Robert Delaunay, *Hommage à Blériot* [Homage to Blériot], 1913–14

Jean Cocteau, Sketches for
Le Mot **[The word], 1915**

188 « *Atrocités XX
[Défensive]*» [Atrocities XX
(Defensive)], 1915

189 *En ces temps-là, ils
séjournaient dans la ville qu'on
appelle la vache multicolore*
[At that time, they were
staying in a town called the
piebald cow], 1915

190 *Soldat allemand
et sa monture* [German
soldier and his mount],
1915

le mot.

Nº 16 — 1ʳᵉ Année 10 Centimes Samedi 3 Avril 1915

un taube qui ne viendra
pas à Paris.

191 Jean Cocteau, Cover for *Le Mot* n° 16, signed *Jim*, 1915

192 Jean Cocteau, Illustration for *Le Mot,* signed *Jim,* 1914–15

ATROCITES (XVIII).

"L'homme doit être élevé pour la guerre et la femme pour le délassement du guerrier : tout le reste est folie." *(Zarathoustra.)*

193 Jean Cocteau, « *Atrocités XVIII* » [Atrocities XVIII], *Le Mot* n° 18, signed *Jim*, 1915

194 Jean Cocteau, Study for « *Atrocités XVIII* », 1915

195 Jean Cocteau,
« *Atrocités VIII* »,
Silhouettes to be reversed
out for *Le Mot* n° 16, 1915

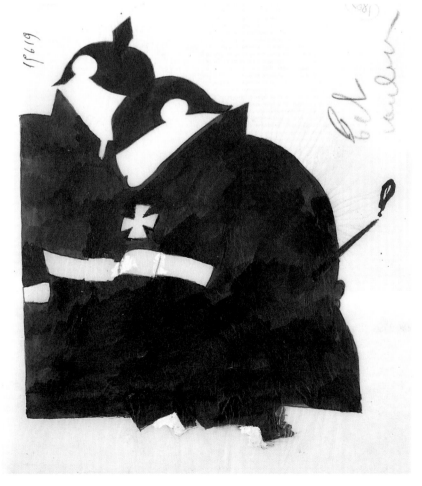

196 Jean Cocteau,
« *Atrocités I* », Sketch to be
reversed out for *Le Mot*
n° 14, 1915

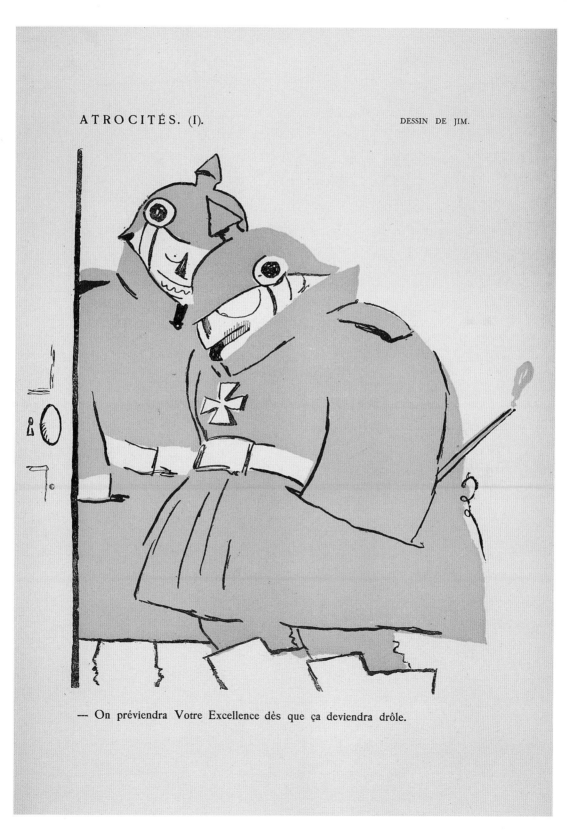

ATROCITÉS. (I).

DESSIN DE JIM.

— On préviendra Votre Excellence dès que ça deviendra drôle.

197 Jean Cocteau, « *Atrocités I* », *Le Mot* n° 14, signed *Jim,* 1915

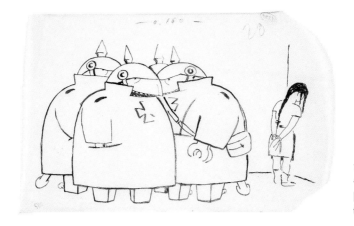

198 Jean Cocteau,
« *Conciliabule n° 2* »
[Confabulation no. 2], study
for *Le Mot* n° 15, 1915

199 Jean Cocteau,
« *Allons, sois chentil,
donne-moi la main* » [Come
on, be nice, give me your
hand], study for *Le Mot*
n° 16, 1915

200 Jean Cocteau,
« *Effractions et
déménagements* » [Breaking in
and making off], study for
Le Mot, 1915

201 Jean Cocteau,
« *La chevauchée fantastique* »
[The weird ride], unpublished
study for *Le Mot*, 1915

202 Jean Cocteau, Study for
« *La Croix de fer* » [The iron
cross], *Le Mot* n° 20, 1915

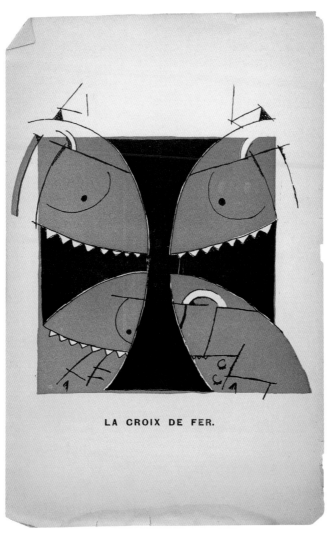

LA CROIX DE FER.

203 Jean Cocteau, « *La Croix
de fer* » [The iron cross],
Le Mot n° 20, 1915

204–06 Jean Cocteau,
« *Zeppelin* » [Airships],
sketches for *Le Mot*, 1915

207 Jean Cocteau,
« *Atrocités XIX* »,
« *Delikatessen : L'Allemagne
pense à débiter le Zeppelin en
tranches* » [Atrocities XIX,
Delikatessen: Germany
considers putting the airship
on sale in slices], study for
Le Mot, 1915

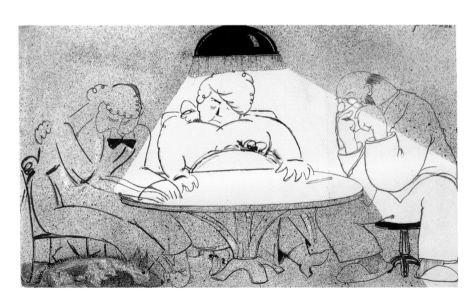

208 Jean Cocteau ,
« *Spiritisme* » [Spiritualism],
drawing for *Le Mot,* signed
Jim and *Paul Iribe*, 1915

pour diriger une hésitation native. Ces Jonas vivent et meurent avec lui.

» Vers l'âge adulte le Zeppelin éclate et sa peau molle tombe sur la terre.

» Le Zeppelin redoute les Zavions.

» Le Zavion est un oiseau à deux ou quatre ailes qui crache de l'huile de ricin et houspille le zeppelin.

Vers l'âge adulte le Zeppelin éclate.

» Lorsqu'un Zavion approche, le Zeppelin grogne, ondule et s'éloigne.

» Pour tout le reste, les mœurs des Zeppelins demeurent extrêmement secrètes.

» Athénée rapporte que Darius en possédait un troupeau. Il convient d'envisager cette assertion avec la plus extrême réserve.

» Ajoutons que le zeppelin est peu comestible. Cependant, on me signale que l'Allemagne songe à les réquisitionner pour

Le Zeppelin mange de six à douze hommes.

nourrir le peuple, l'opinion se choquant, paraît-il, de voir de si grosses bêtes ne servir à rien.

Professeur J. M. S.

209 Jean Cocteau,
« *Le Zeppelin* » [The airship],
Le Mot, 1915

Jean Cocteau, Letters to his
mother with drawings, 1916

210 *Digging in the ruins*, 1916

211 *Nieuport-les-bains*, 1916

un tube de fonte avec Major Juliand – aimable
et ne se consolant de ce poste qu'avec le volume
Vollard – Cézanne –
– Obus – balles – conserves –
Ce segment (Eclusettes) ennuyeux parceque détruit
par mer et torpillé – alors on galope à quatre
pattes en face des boches – cette course très
si ona fait penser aux cibles courantes des
baraques foraines – On est le lièvre – le biche –
l'arbre, le barque et etc.

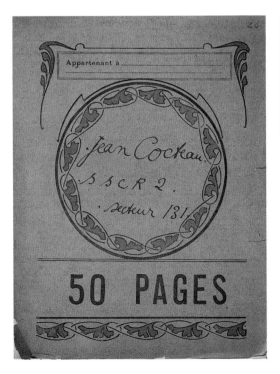

212 *Whistling bullets*, 1916

213–14 Covers of Cocteau's war notebooks, 1916

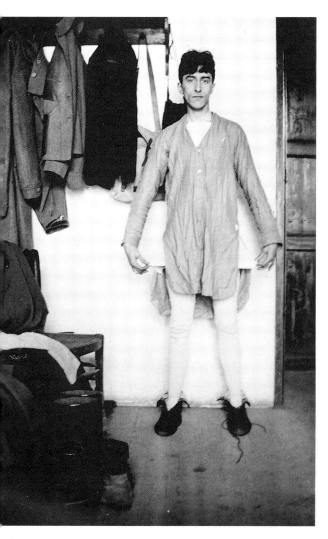

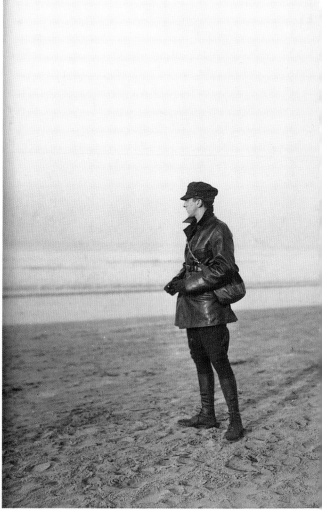

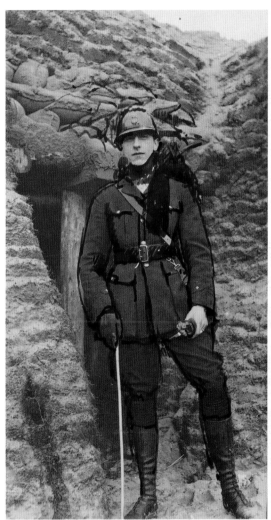

215–18 *Cocteau on the Belgian front*, about 1915–16

La patrouille

219–20 Jean Cocteau, Illustrations for *Thomas l'imposteur* [Thomas the impostor], redrawn for an edition of 1953

La mort

11

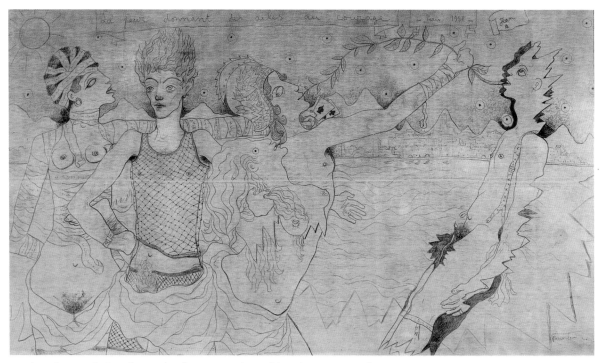

221 Jean Cocteau, *La Peur donnant des ailes au courage* [Fear giving wings to courage], 1938

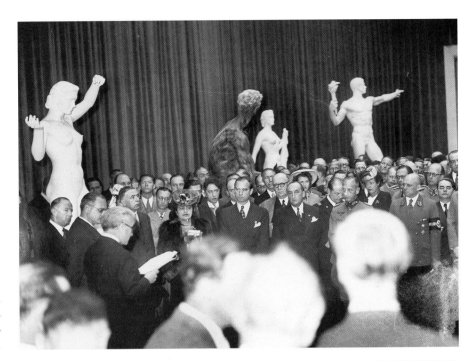

229 *Vernissage (private view) of the exhibtion of Arno Breker's sculpture at the Orangerie, Paris, with Serge Lifar and Jean Cocteau,* 1942

2. 7. 42

Mon cher Cocteau,

Freud, Kafka, Chaplin sont interdits, par les mêmes qui honorent Breker. On vous voyait parmi les interdits. Que vous avez eu tort de vous montrer soudain parmi les censeurs! Les meilleurs de ceux qui vous admirent et qui vous aiment en ont été péniblement surpris.

Redonnez-nous confiance. Rien ne doit nous séparer.

Votre

Paul Eluard

230 Paul Eluard, Letter to Cocteau, in reaction to his « *Salut à Breker* », 1942

231 Jean Cocteau, Portrait of Paul Eluard and draft of a letter (not sent) to maréchal Pétain, 1942 (recto and verso)

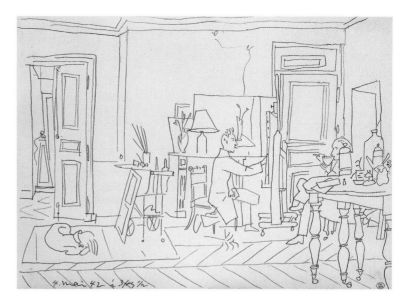

232 Pablo Picasso, *L'Atelier de Dora Maar* [Dora Maar's studio] (Cocteau drawing Paul Eluard), 1942

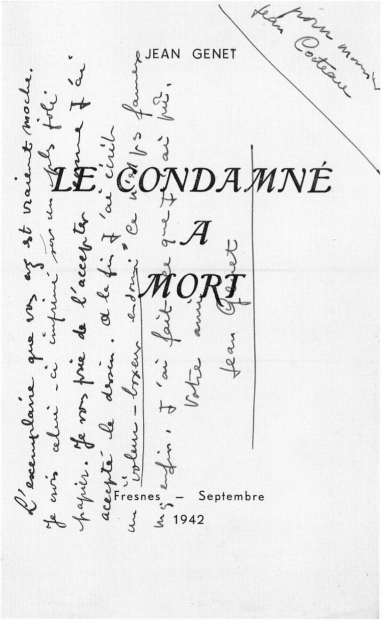

234 Jean Cocteau, *Jean Genet,* about 1943

233 Jean Genet, *Le Condamné à mort,* 1942, copy dedicated to Jean Cocteau

Coïncidences

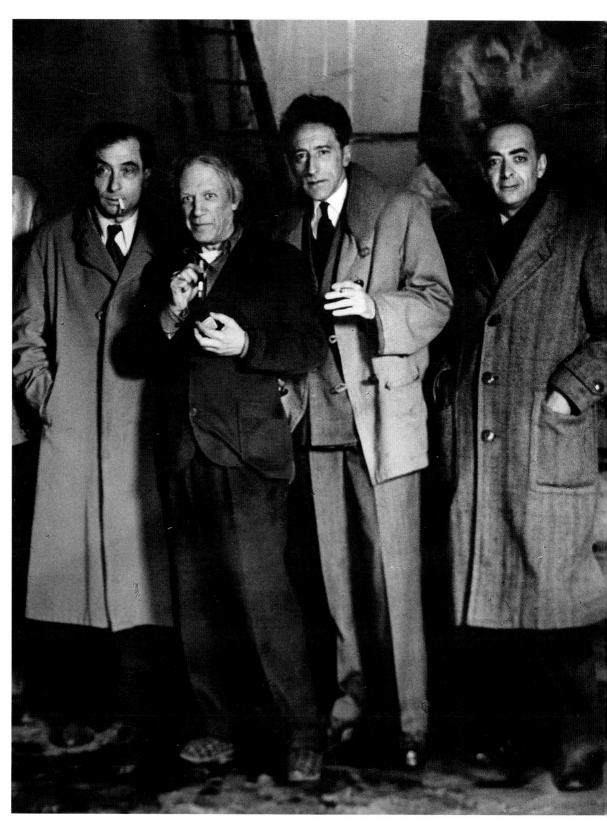

235 M. Saillet, *Reverdy, Picasso, Cocteau and Brassaï chez Picasso, quai des Grands-Augustins, Paris*, 1944

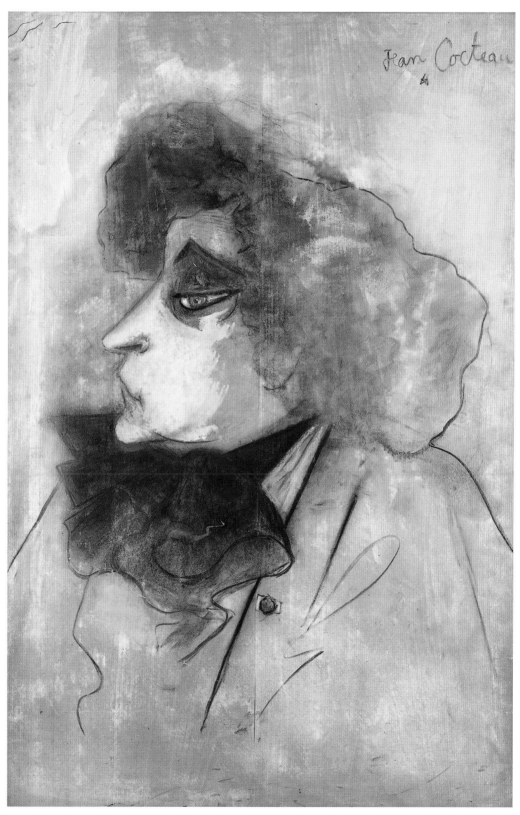

236 Jean Cocteau, *Colette*, 1944

ECRIVEZ
LISIBLEMENT

LONDRES
19

L'homme invisible
The invisible man

1 J. Cocteau, *Journal d'un inconnu* [1953], Paris, Grasset, 1983, p. 20.

2 *Ibid.*, p. 19.

3 *Ibid.*, p. 32.

4 *Ibid.*, pp. 37–38.

Cocteau was at once the least known and most famous of poets. His extreme visibility protected his invisibility.[1]

Caught in the gap between these two polarities, Cocteau maintained a continual self-questioning, placing himself in impossible dilemmas – being everywhere, observing everything and everyone and participating in everything, yet always masked, protecting the authenticity of his secrets and fantasies, going about in disguise.

Polarities meant torture: "I left Paris; they cultivate the Mexican method of torture there. The victim is covered in honey, after which the ants eat him."[2]

Polarities meant weakness and defeat: "I have often slipped on the slope of the visible and grabbed the rope it held out for me. I needed to be hard; I was weak. I thought I was beyond reach; I said to myself, 'My armour protects me' and I didn't repair its cracks. They became holes open to the enemy."[3]

Polarities raised theoretical and formal issues: "The enigma of the visible and the invisible retains its elegance as an enigma; it is impossible to solve it in a world where we are fascinated by what is happening now, which is without distance or hindsight."[4]

Cocteau is unique because in each case he incarnated the poles on either side of the gap. He both revealed and concealed, he was both ferocious and pleasant, visible and invisible. He was both unique and complex, not to say 'difficult'. He is one of the most fundamentally difficult artists of the twentieth century to understand, even though he appears very easy.

The torment of invisibility fed his graphic art, one of the finest aspects of his creativity. The series of self-portraits without a face develops in step with the evolution of tastes and fashion, moving from a precious cubism to Ingres-like silhouettes. The repetition of the same pose, pensive to the point of melancholia, may signify the impossibility of reconciliation.

Masks provide another way of effacing oneself. The different possibilities of his persona offered Cocteau new pretexts to play on words, images and objects. The masks of *Antigone* relate as much to fencing (the face mask) as to architectural antefixae (the pipe-cleaner features). But for Cocteau masks were above all the amphibious sign of his attraction to ancient poetry and theatre, which never translates into flat, erudite references. His borrowing from the ancients, primarily from Greece, was a mask that paradoxically allowed Cocteau greater subtlety: irony, humour, sarcasm, criticism, sadness, pain and indignation are all expressed and conveyed in an allusively Greek manner (Orpheus, Oedipus, Minerva ...).

So there is a degree of idealization, but it is undermined; the attitude is analogous to that of someone who is daydreaming but who knows what is going on. The Greek aspect of Cocteau's work always implies 'Know what I mean?'

Cocteau had little regard for psychoanalysis. Did it ultimately claim him as its own, unawares? If so, it was his other blind spot, after politics.

The disturbing, sexualized hands of the drawings known as "mandrakes" give visual expression to the sense of being torn between a fallen ideal, the sexuality of dreams and a slide into fantasy.

The erotic drawings do not reflect a simple, unequivocal obsession. Above and beyond the (unequal) division between heterosexual and homosexual inclinations, Cocteau was pursuing his quest for a pure, precise, "exact" and thus intensely suggestive line.

237 *Jean Cocteau,* photograph retouched by Cocteau, 1919

L'homme invisible

Lastly, in the theatre, Cocteau took the ultimate risk of creating dialogue in which one of the speakers is literally invisible, absent or indifferent, such as the silent, cruel person on the other end of the phone in *La Voix humaine* [The human voice] or the apathy of *Le Bel indifférent* [The uncaring beauty]. These pieces are nevertheless not monologues. They remain dialogues with the invisible. **D. P.**

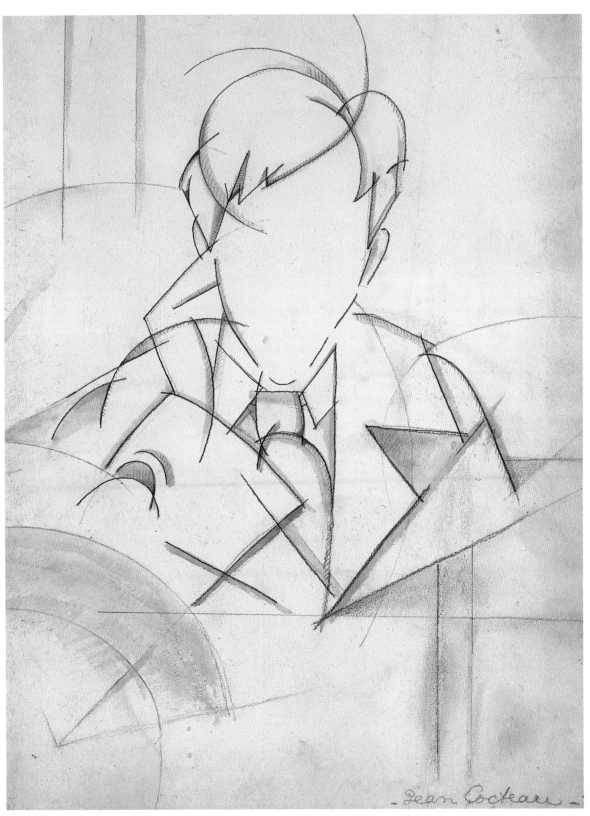

238 Jean Cocteau, *Self-portrait without a face (cubist)*, about 1910–13

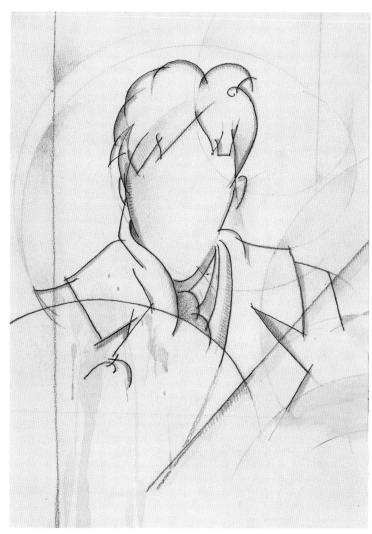

239 Jean Cocteau, *Self-portrait without a face (cubist),* about 1910–12

240 Jean Cocteau, *Quadruple self-portrait,* 1915–16

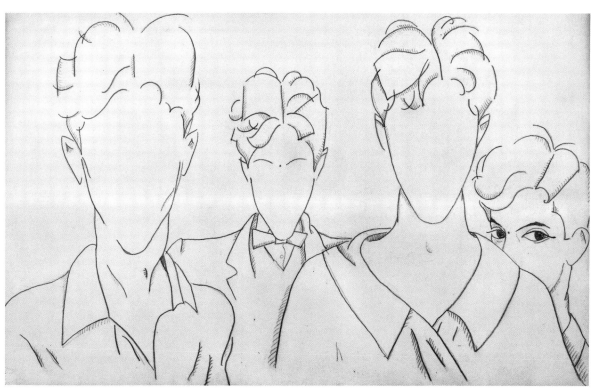

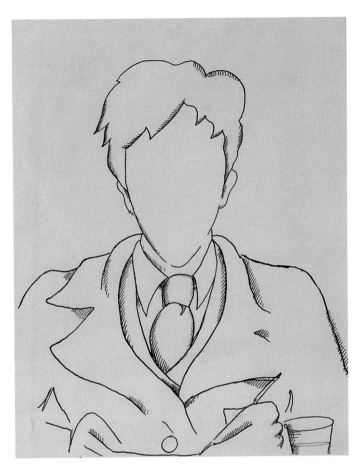

241 Jean Cocteau
*Self-portrait without a
face,* about 1910–13

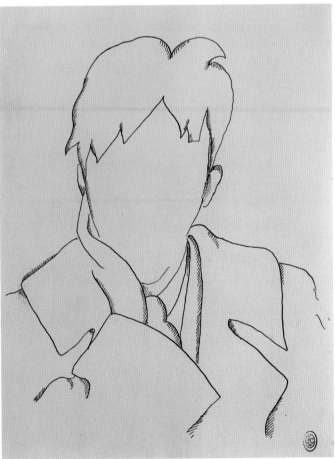

242 Jean Cocteau *Self-
portrait without a face,*
undated

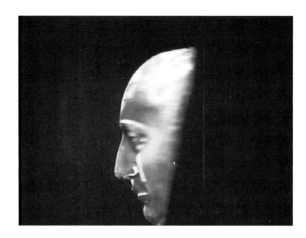

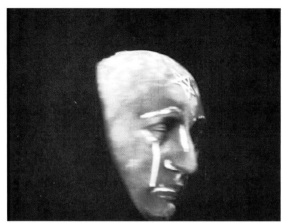

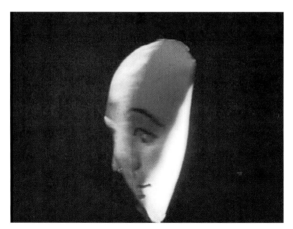

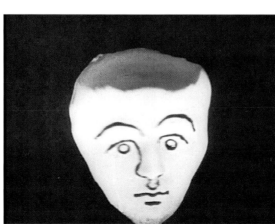

243 Jean Cocteau
Le Sang d'un poète [The blood of a poet], 1930, frame stills

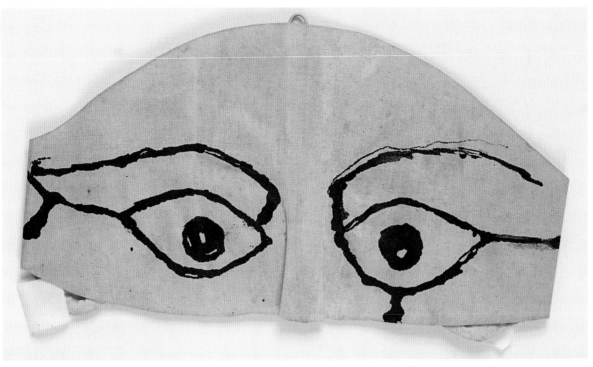

252 Jean Cocteau, Mask 'with ears' for a ball given by Etienne de Beaumont, undated

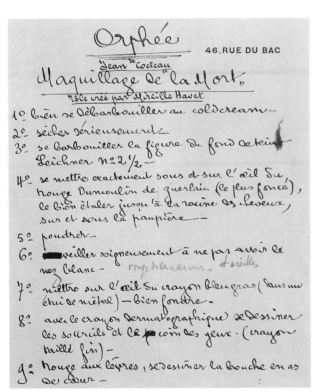

253 Indications for the make-up of Death (Mireille Havet)
in *Orphée*, about 1926

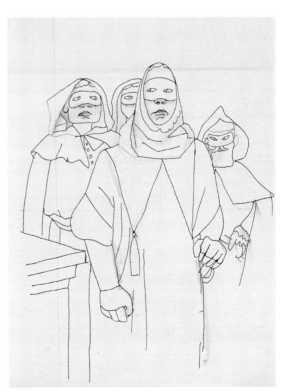

254 Jean Cocteau, *Men in masks*, undated

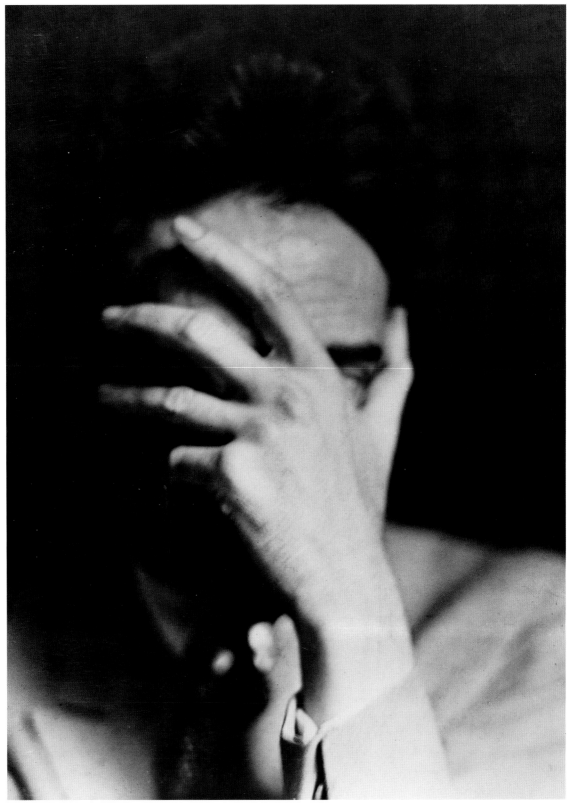

255 Germaine Krull, *Jean Cocteau* (face in hand), 1930

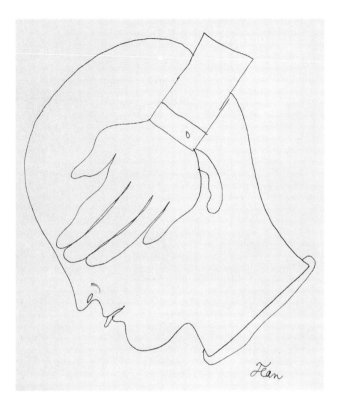

256 Jean Cocteau
Hand over eye, about 1923

257 Jean Cocteau
Orphée holding his head,
undated

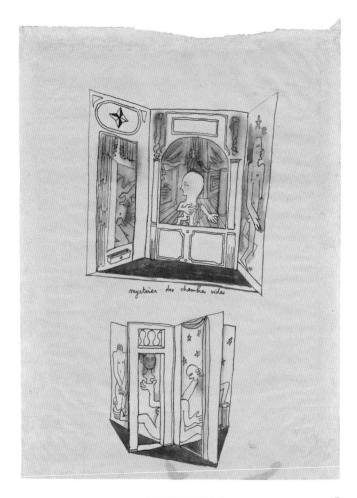

258 Jean Cocteau
*Mystères des chambres
vides* [Mysteries of
empty rooms], undated

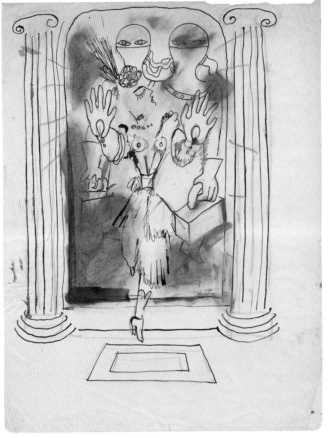

259 Jean Cocteau
*Orphée : La Mort et ses
deux assistants* [Death
and her two assistants,
from *Orphée* (Orpheus)],
undated

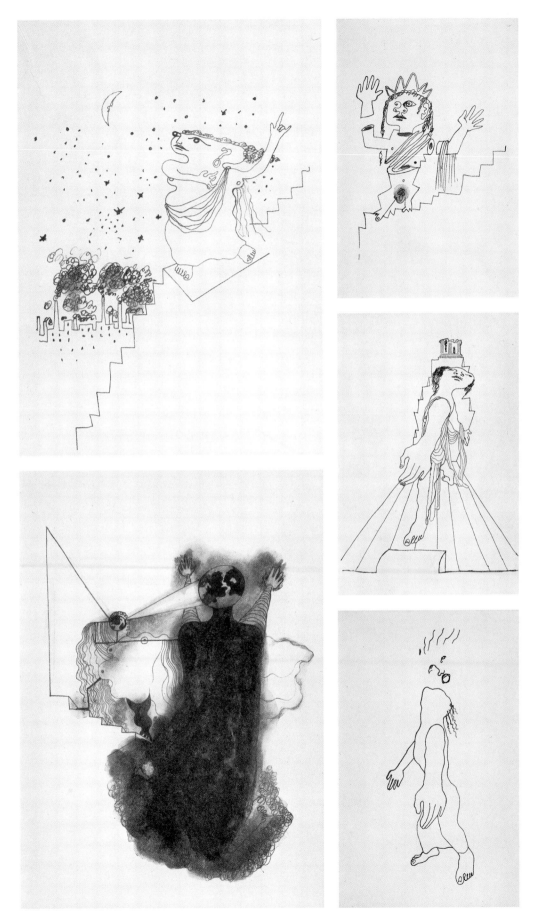

260 Jean Cocteau, Illustrations for *La Machine infernale* [The infernal machine], 1934

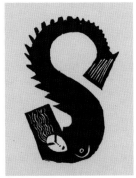

261 Jean Hugo (?)
Sirène avec ancre [Siren with anchor], undated

262 Jean Hugo, *Siren*, about 1918

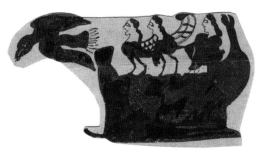

263 Anonymous, *Altered printed illustration of a bird in flight in front of a boat With three Harpies,* undated

264 Anonymous
Greek siren, undated

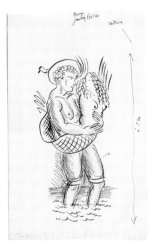

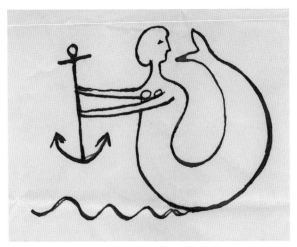

265 Raoul Dufy
Male figure with mermaid in his arms, about 1917

266 Pablo Picasso
Siren with anchor, undated

267 Jean Cocteau
Deux sirènes [Two sirens], undated

268 Jean Cocteau
Siren, undated

269 Jean Cocteau
Sirène avec rouleau
[Siren with scroll], undated

270 Jean Cocteau
Six sketches, undated

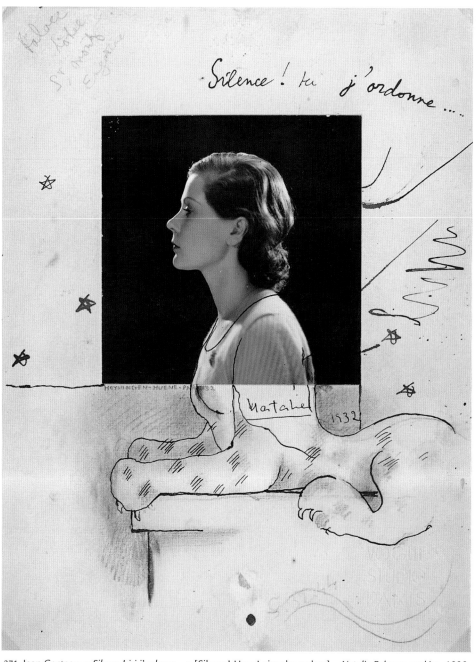

271 Jean Cocteau, « *Silence ! ici j'ordonne...* » [Silence! Here I give the orders] – *Natalie Paley as a sphinx*, 1932

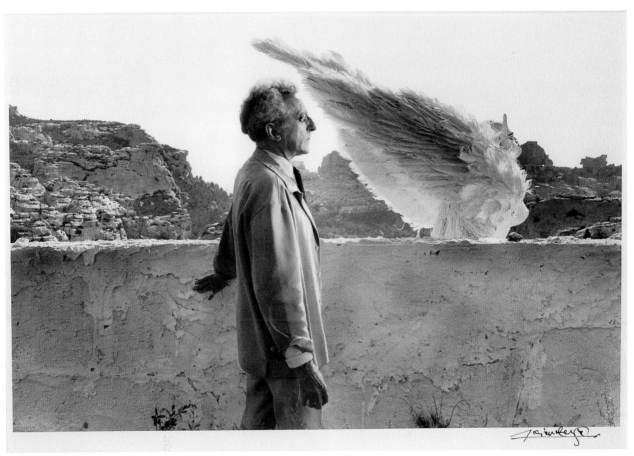

272 Lucien Clergue, *Cocteau before the sphinx*, from *Le Testament d'Orphée* [Orpheus' testament], 1959

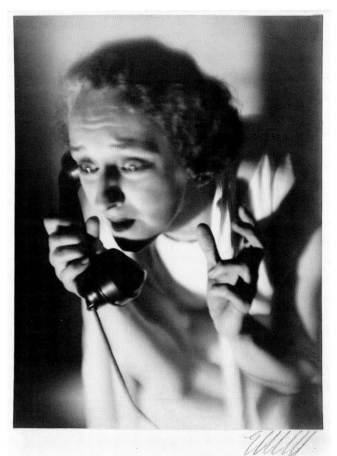

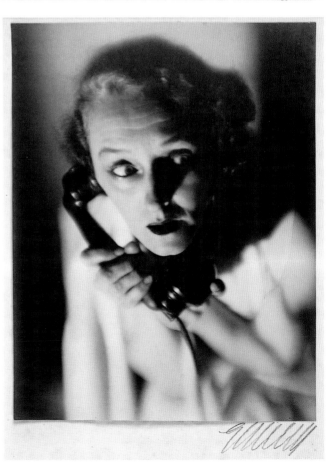

273–75 Germaine Krull, Berthe Bovy in the role of the single
protagonist of *La Voix humaine* [The human voice], 1930

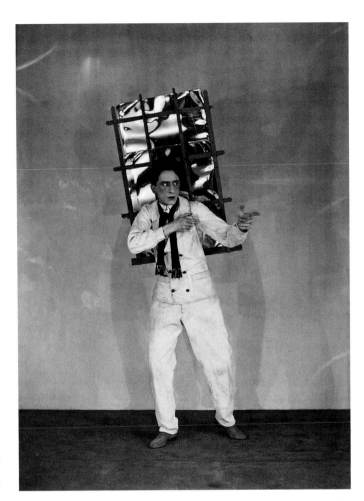

276 Jean Cocteau in the
role of the angel
Heurtebise, 1927

277 Man Ray
'Rayogramme' illustrating
Jean Cocteau's poem
L'Ange Heurtebise [The
angel Heurtebise], 1925

278 *The Annunciation*, photographic montage with Jean Cocteau and the comtesse de Beaumont, 1918

279–80 Jean Cocteau
Two drawings for
Maison de Santé [The
nursing home], Paris,
Briant-Robert, 1926

281–84 Jean Cocteau
Illustrations
for *Imaginary Letters*
by Mary Butts, 1928

Jean Cocteau
Drawings for *Jean l'oiseleur.
Ad Usum Delphini* [Jean the
bird-catcher (Delphinium
custom)], about 1925–26

285 « *Le Militaire et la
Balayeuse, ou la présentation
des " hommages "* »
[The serviceman and the
streetsweeper, or the
presentation of 'tributes']

286 « *Trio : deux femmes
et un homme* » [Trio: two
women and one man]

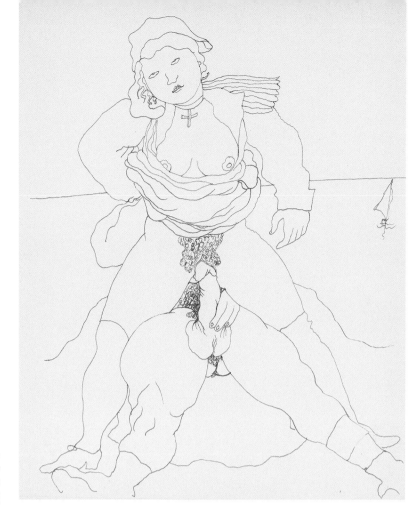

287 « *La Bretonne et le Marin.*
Scène du bord de mer »
[The Breton woman and the
sailor. A seaside scene]

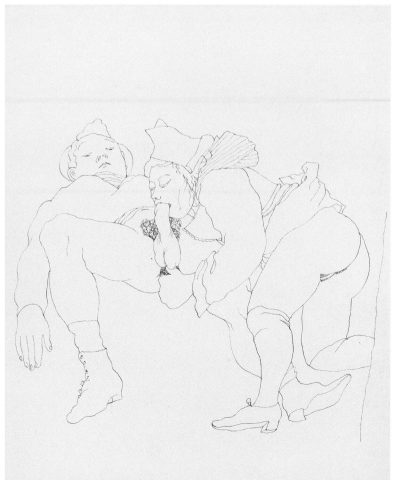

288 « *La Bretonne*
et le Marin »
[The Breton woman
and the sailor]

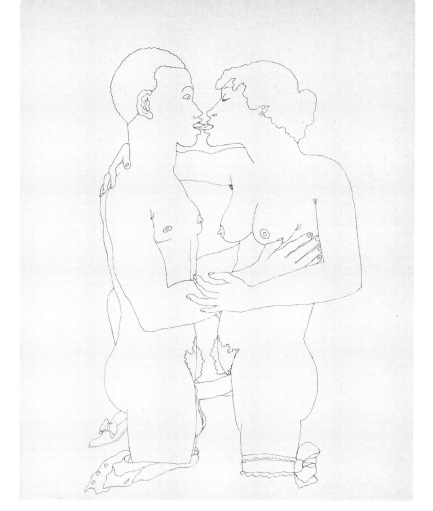

Jean Cocteau
Drawings for *Jean l'oiseleur.*
Ad Usum Delphini [Jean the
bird-catcher (Delphinium
custom)], about 1925–26

289 « *Duo : homme noir
et femme* » [Duo: black man
and woman]

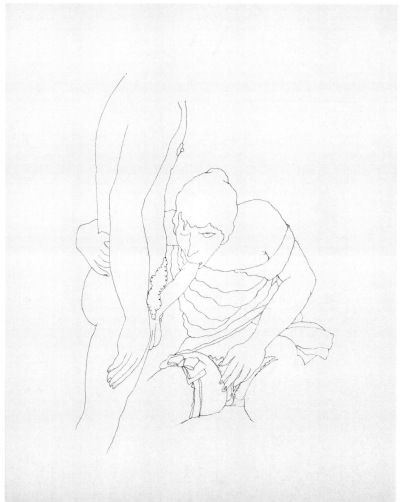

290 « *Duo : un homme,
une femme* » [Duo: one man,
one woman]

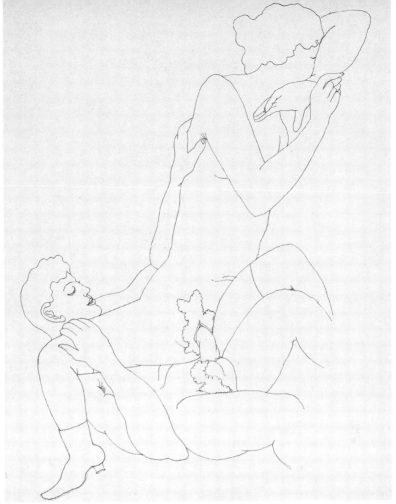

291 « *Duo. Pudeur.*
Un homme, une femme »
[Duo. Shame.
One man, one woman]

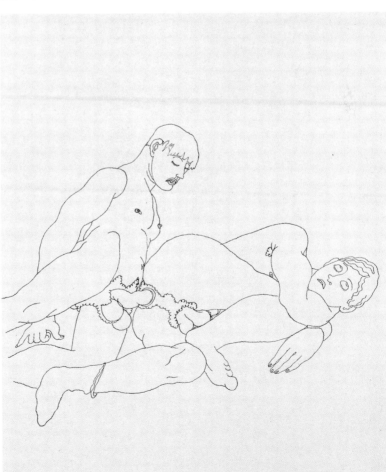

292 « *Duo. Deux hommes* »
[Duo. Two men]

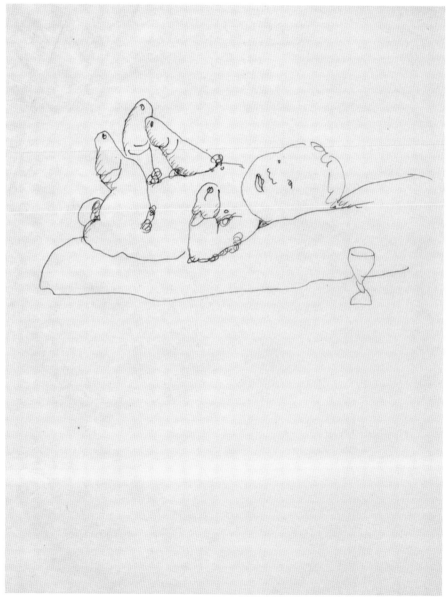

293 Jean Cocteau, *Bébé aux extrémités phalliques* [Baby with phallic extremities], undated

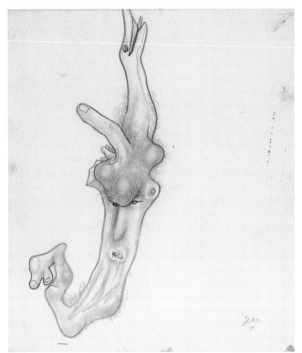
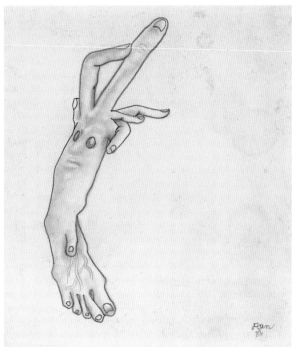

294–95 Jean Cocteau, *Mandragore et mains chevalines* [Mandrake and horse hands],1936

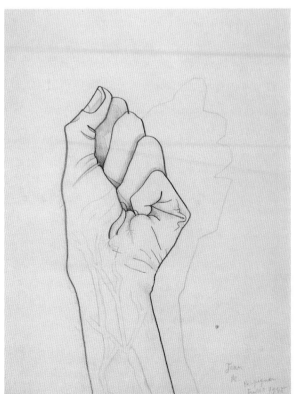
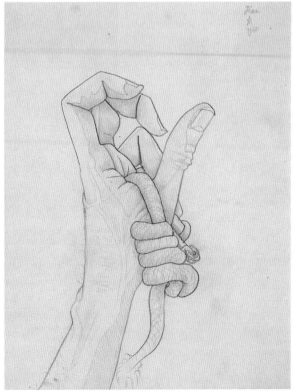

296–97 Jean Cocteau, *Hands – studies for a screen*, 1940

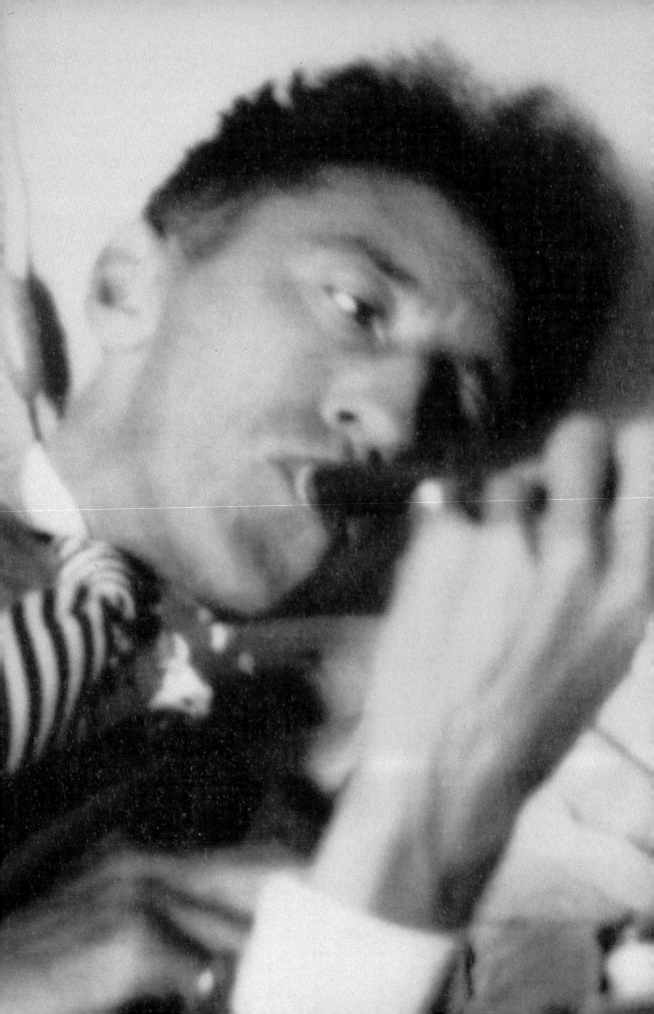

Cocteau s'évade
Escape

1 J. Cocteau, *Essai de critique indirecte : Le mythe laïc : Des beaux-arts considérés comme un assassinat*, Paris, Grasset, 1932, p. 130.

2 J. Cocteau, *Journal d'un inconnu* [1953], Paris, Grasset, 1983, p. 15.

3 J. Cocteau, *Discours du grand sommeil* [1919], in *Romans, poésies, poésie critique, théâtre, cinéma*, Paris, L.G.F. (*La Pochothèque*), 1995, p. 254.

4 J. Cocteau, « *Cocasseries tragiques du sommeil* », *Opéra*, in *Romans, poésies, poésie critique, théâtre, cinéma*, op. cit., p. 356.

5 J. Cocteau, *Opium, Journal d'une désintoxication* [1930], in *Romans, poésies, poésie critique, théâtre, cinéma*, op. cit., p. 575.

Cocteau tried everything as a means of escape, even painting, particularly that of Giorgio De Chirico: "For nights on end I ran my eye over those docks, that labyrinth of disturbing warehouses, where the size of a human being cannot be judged, where man finds no place."[1]

A prisoner of both himself and other people, Cocteau was not always optimistic about his period, despite the forced expressions required by a life in high society. For his was a time that had "invented the term escape, when the only way of escaping oneself is to let oneself be taken over".[2]

From an early age he found refuge in sleep. On the front in 1915 he wrote the *Discours du grand sommeil* [Discourse of the great sleep]. From the outset this reference to a kind of 'little death' is linked to mourning. For Cocteau sleep was a rehearsal for death. He wrote to his deceased friend Jean Le Roy, "I have great, sad news to give you: I am dead."[3]

But sleep unleashes the power of dreams. In *Opéra* [Opera] it generates visions of a surrealistic kind, before those of Buñuel or Dalí (it appeared almost five years before *L'Âge d'or*). "Look at our academician. What a superb academy! I see a stinking corpse covered in flies in the eighteenth-century manner".[4] Thirty years later Cocteau would be elected to the Académie Française, to which he invited the highly controversial Jean Genet.

Sleep is the model's ideal state. With original, cinematic power, Cocteau observed his friends and lovers. Friendship and love allowed him pleasurable escapades, escapes into literature or the seaside. The photographic 'reportage' of Le Piquey and Le Lavandou represents exceptional slices of happiness reconstituted by the vibrations of light on sun-drenched, naked bodies and the photographic plate. It was a period of intense creation, of major works, stimulated by the proximity of Raymond Radiguet: in 1922, *Le Secret professionnel* [Professional secrets], illustrated by Picasso; in 1923 *Le Grand Écart* [The splits], *Thomas l'imposteur* [Thomas the Impostor] and *Plain-Chant* [Plain chant]. Radiguet published *Le Diable au corps* [The devil in the flesh]. It was a time of escapes into emotional harmony and the satisfaction of artistic success.

But the friends and lovers disappeared one after the other. Then there were other wounds, caused by reviews, the public and particular élites (the surrealist group). Cocteau was lucid in his lament: "I flatter myself that I've got away. But I find I am back where I started." Yet he imagined pursuing angels and fleeing society, fashion and youth when all became too arrogant. *Le Testament d'Orphée* [Orpheus' testament] perhaps expresses a desire to come back to life in a better world in which time is reversed, landscapes can be contemplated with eyes closed and sailors are fraternal and sensual.

Then there was opium. Opium made it possible to live life as the "horizontal fall" visualized in *Le Sang d'un poète* [The blood of a poet] and *Orphée* [Orpheus] as acrobatic movements performed in the air, as well as in hell.

Cocteau's personal diary is a one of delirium; the long prose piece *Opium* is both a poem of pain and a description of the ecstatic sensuality imparted by smoking the drug. "In opium what leads the organism to death is euphoric in nature. The torture stems from moving in the wrong direction, back to life. The veins are alarmed by an entire spring, bearing ice and lava of fire."[5]

298 Cecil Beaton, *Cocteau*
(smoking opium), 1938

Opium replaces sleep. The cure that combats addiction takes away even the taste for sleep. Then "one must leave a trace of this journey, which memory forgets. One must, when it is impossible, write and draw, without responding to the novelistic invitations of pain, not take advantage of suffering as of music, have the pen-holder tied to one's foot when necessary, assist the doctors to whom laziness imparts no information."[6]

Together, text and drawings constitute one of Cocteau's major works. The wounds represented on the paper sometimes resemble those of Cocteau's great sorrowful contemporary, Antonin Artaud. The two poets met on the occasion of *Antigone*, with 'Momo"s great love, Genica Athanasiou, in the title role. But the cinema had already brought them together, almost certainly without their knowledge. "We knew that the most characteristic and salient powers of the cinema were always, or almost always, effects of chance, in other words a kind of mystery, inevitable in a way we were unable to.explain."[7]

"Above all the cinema has the power of an inoffensive, direct poison, a subcutaneous injection of morphine. This is why the film's subject cannot be inferior to its power of action – and must be fantastical in nature."[8] Is this Cocteau or Artaud?

Chance, mystery, the fantastic and drugs – or how high society's suicide victim meets high society's drug-addict. **D. P.**

6 *Ibid.*, p. 577.

7 Antonin Artaud, *Œuvres complètes*, vol. III, Paris, Gallimard, 1970.

8 *Ibid.*, p. 81.

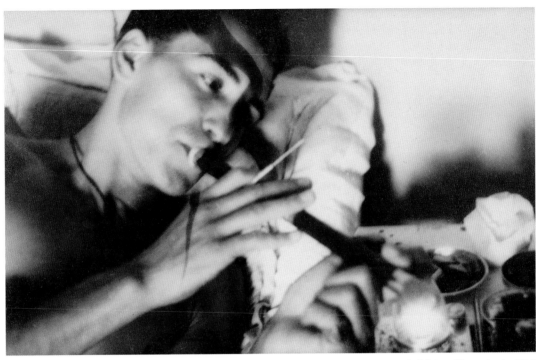

299 Cecil Beaton, *Marcel Khill* (smoking opium), 1938

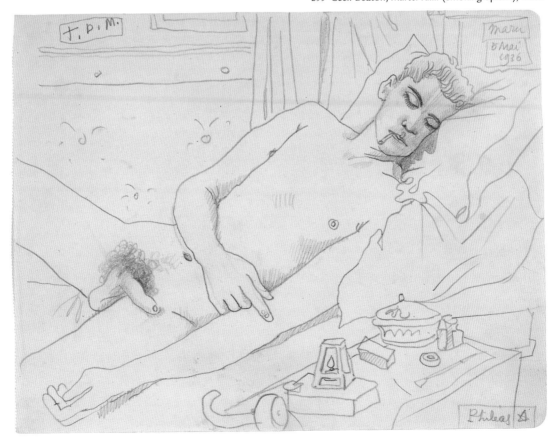

300 Jean Cocteau, *Marcel Khill smoking opium*, 1936

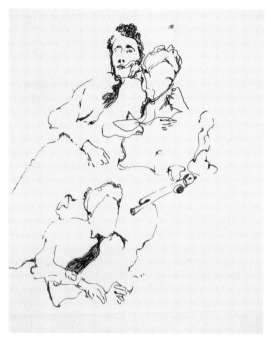

301 Jean Cocteau, *Rêverie d'opium* [Opium dream],1923

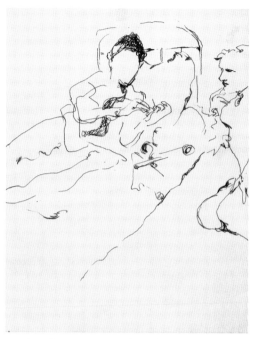

302 Jean Cocteau, *Le Poète fumant l'opium* [The poet smoking opium], about 1923

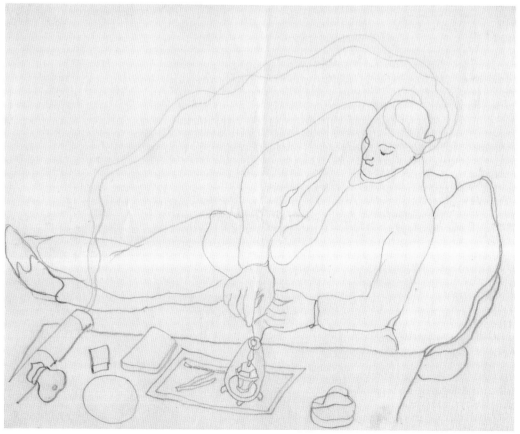

303 Jean Cocteau, *Fumeur d'opium* [Opium smoker], undated

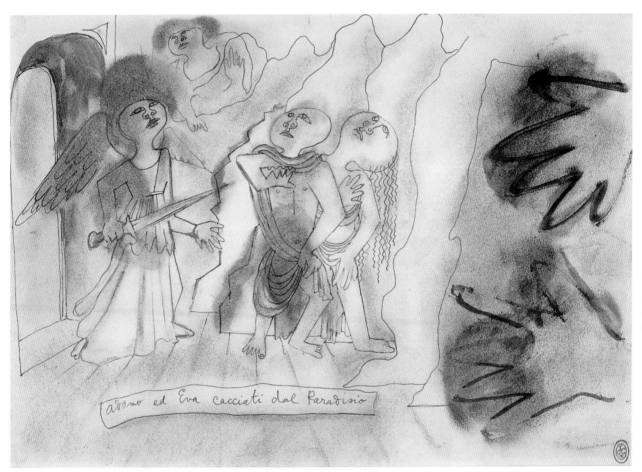

304 Jean Cocteau, *Adam et Ève chassés du Paradis* [Adam and Eve expelled from Paradise], undated

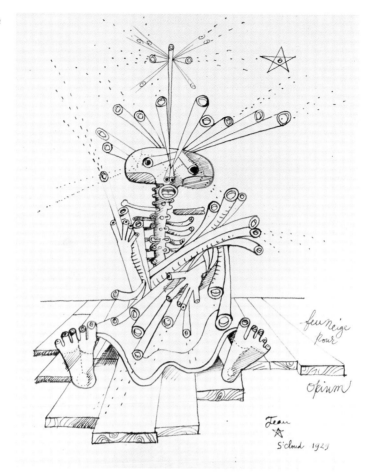

305 Jean Cocteau
« *Feuneige* » [Snow-fire],
drawing for *Opium*, 1929

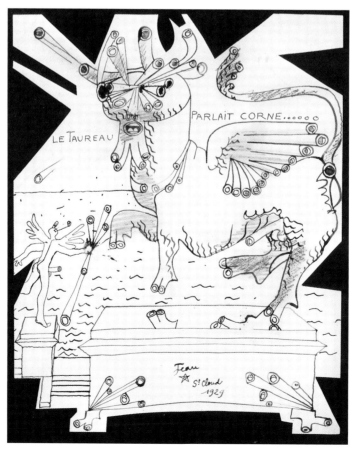

306 Jean Cocteau
Le Taureau parlait corne
[The bull talked horn]
1929

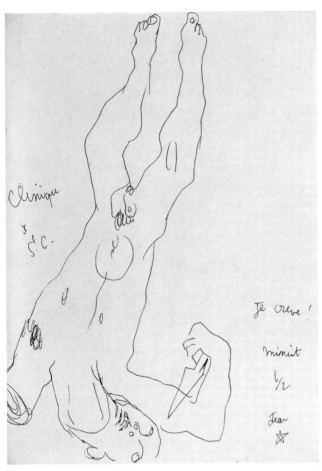

322 « *Je crève !* » [I'm bursting]

323 [Untitled]

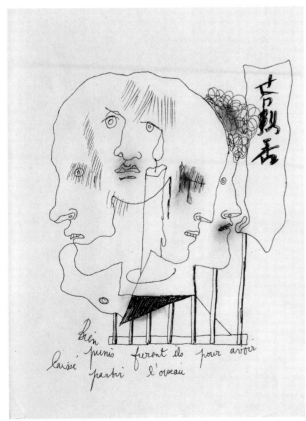

324 « *Bien punis furent-ils pour avoir laissé partir l'oiseau* »
[They were punished as they deserved for letting the bird go]

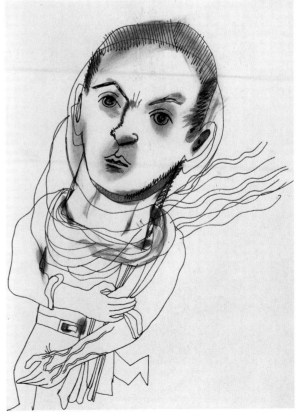

325 [Untitled]

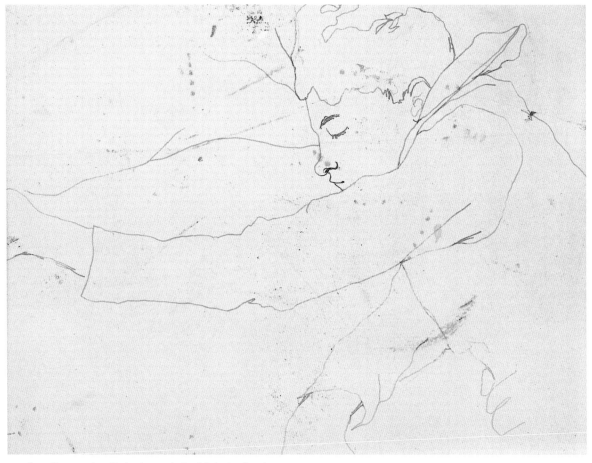

326 Jean Cocteau, *Jean Desbordes*, study for *25 dessins d'un dormeur*
[Twenty-five drawings of a sleeper], 1927

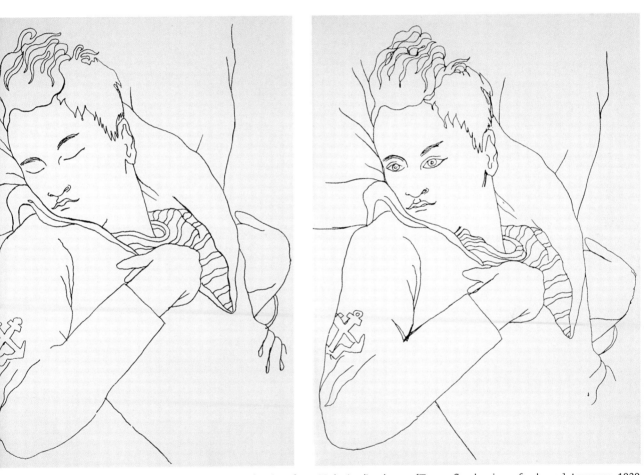

327-28 Jean Cocteau, Two drawings from *25 dessins d'un dormeur* [Twenty-five drawings of a sleeper], Lausanne, 1929

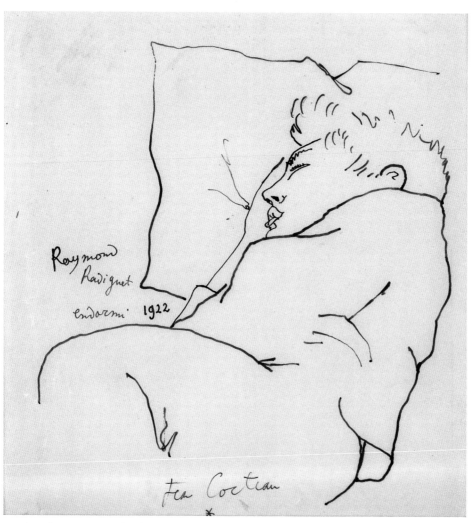

329 Jean Cocteau, *Raymond Radiguet endormi* [Raymond Radiguet asleep],
dated 1922 but reworked in the 1950s

330 Jean Cocteau, *Sommeil hollywoodien* [Sleep à la Hollywood], 1953

331 Jean Cocteau, Poster for the exhibition *Pouchkine 1837-1937* [Pushkin 1837–1937], 1937

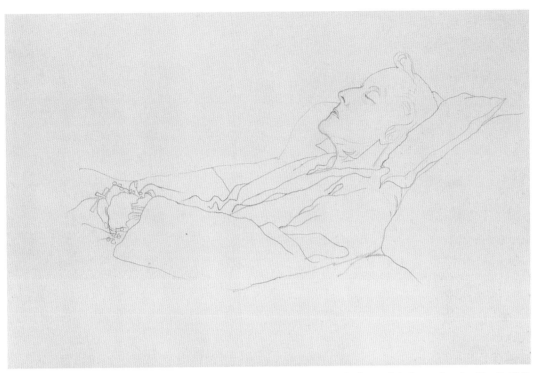

332 Jean Cocteau, *Portrait de sa mère sur son lit de mort* [Mother on her deathbed], 1943

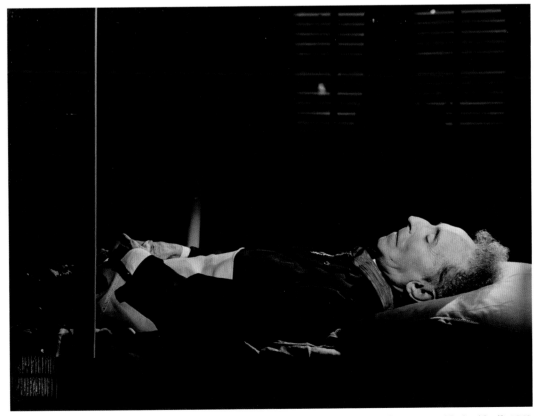

333 Raymond Voinquel, *Jean Cocteau sur son lit de mort* [Cocteau on his deathbed], 1963

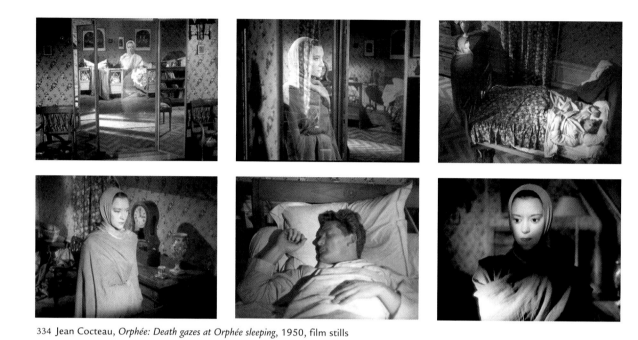

334 Jean Cocteau, *Orphée: Death gazes at Orphée sleeping*, 1950, film stills

335 Jean Cocteau, *La Belle et la Bête: The Beast gazes at Beauty asleep*, 1945, film still

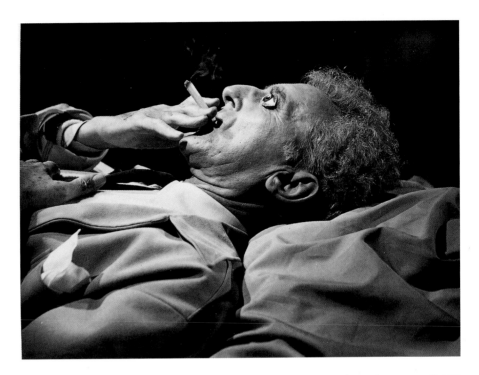

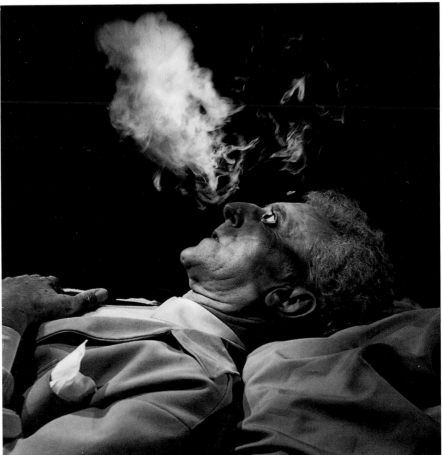

336 Lucien Clergue,
Le Testament d'Orphée:
The dead man smoking, 1960

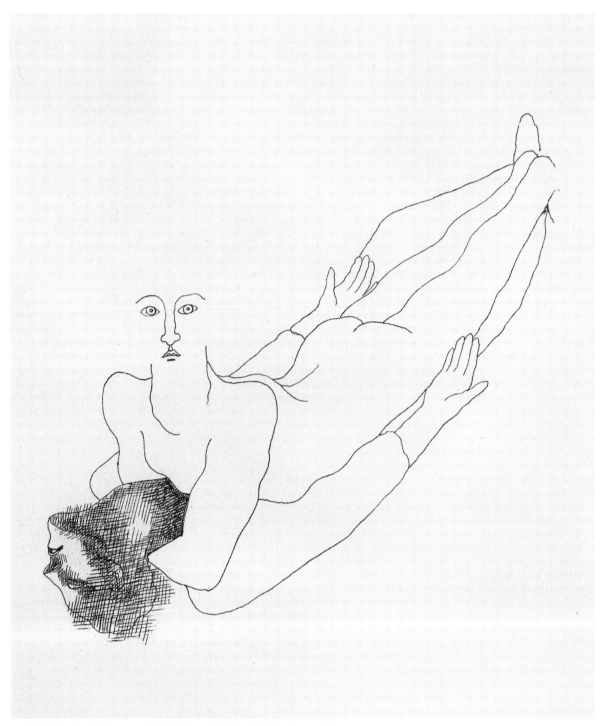

337 Jean Cocteau, « *La mort accomplit son œuvre* » [Death finishes her work],
illustration for *Le Grand Ecart* [The splits], 1926

338 Jean Cocteau, Postcard of Le Piquey
sent to his mother, 1918

339 *Cocteau working at Le Piquey*, 1923

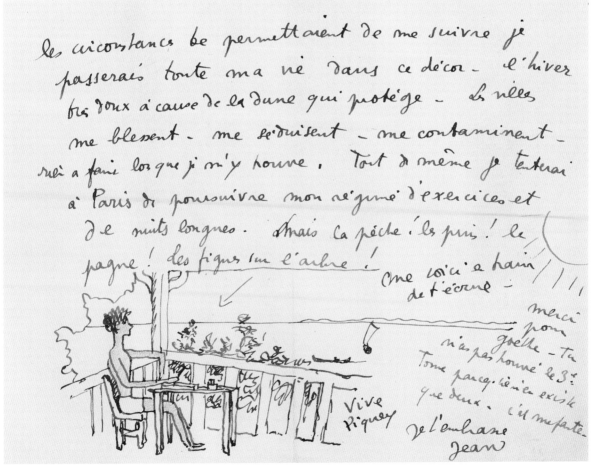

340 Jean Cocteau, Letter with drawing sent to his mother from Le Piquey, 1917

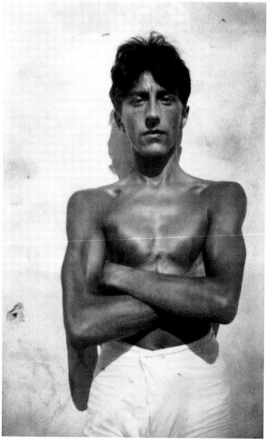

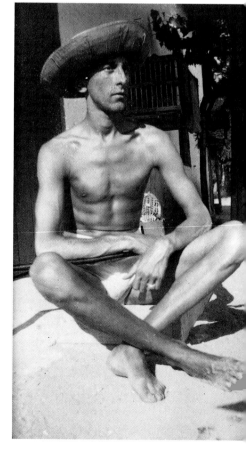

341–45 *Jean Cocteau at Le Piquey*, about 1917

349 *Raymond Radiguet,* about 1921

346 *Cocteau at Le Piquey,* about 1917

350 *Cocteau at Le Piquey,* about 1917

347 *Cocteau at Le Piquey,* about 1917

348 *Radiguet and Auric bathing, Auvergne,* 1921

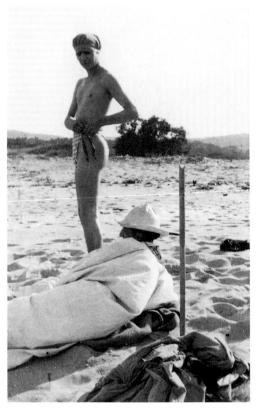

351 *Cocteau and Radiguet at Le Lavandou,* 1922

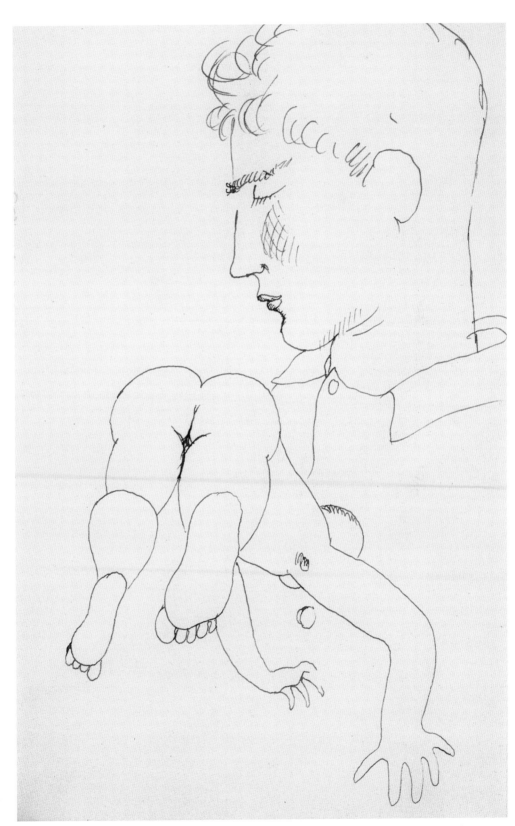

352 Jean Cocteau, *Radiguet et le Pantin* [Radiguet and the puppet], about 1920

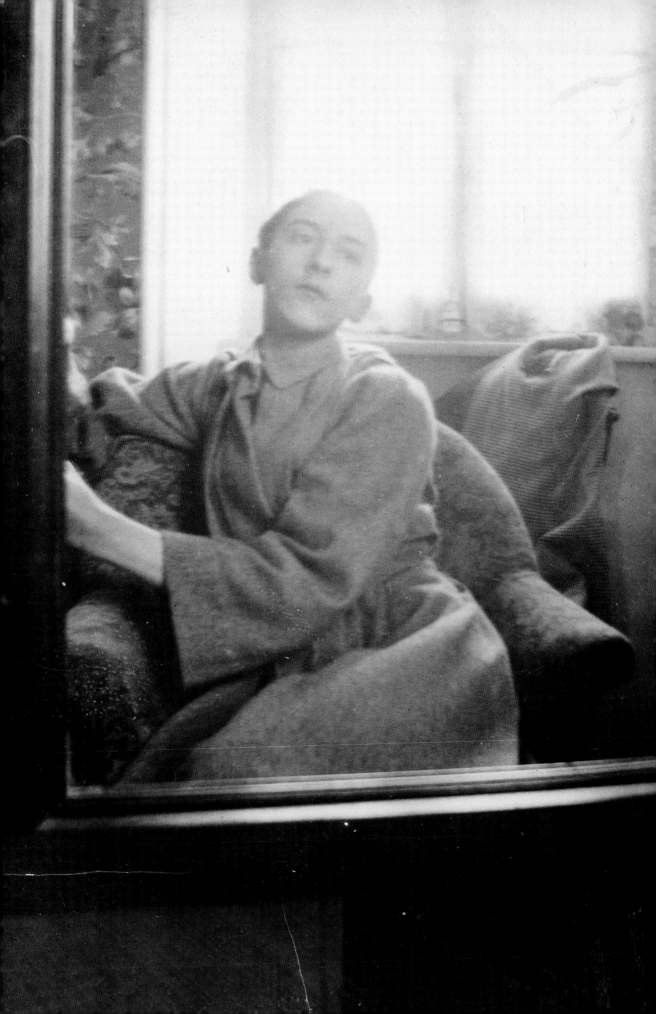

L'homme qui se retourne
Looking back

1 J. Cocteau, *La Difficulté d'être* [1946}, in *Romans, poésies, poésie critique, théâtre, cinéma*, Paris, L.G.F., (*La Pochothèque*), 1995, p. 911.

2 J. Cocteau, *Discours du grand sommeil* [1919], in *Romans, poésies, poésie critique, théâtre, cinéma, op. cit.*, p. 255.

3 J. Cocteau, « Carte blanche », *Le Rappel à l'ordre*, Paris, Stock, 1926, p. 142.

4 J. Cocteau, *La Difficulté d'être, op. cit.*, p. 911.

In 1913, in his magazine *Montjoie*, Apollinaire announced the dawning of the reign of Orpheus, with a modernist demand for the return of the supremacy of poetry over all other arts. This piece, at once project and prediction, was something Cocteau never forgot.

In 1925 he played with the myth of the poet who went to the underworld to find his beloved in a version written for the stage, commissioned by Louis Jouvet. The adaptation mimicked the effects of marital farce 'Greek style' and included additional characters such as the angel Heurtebise and the figure of Death in a bold combination of poetic narrative and dramatic art. Unlike the film version of the story, the play tends towards the decorative and is strewn with 'tragic' gags. The film does away with the talking horses and descends into a hermeticism almost like a detective story, into esoteric fantasty. The viewer is invited to understand Cocteau rather like Flaubert through Mme Bovary: 'Orphée is me'.

After *Le Sang d'un poète* [The blood of a poet], *Orphée* was another successful synthesis of all Cocteau's favourite themes – mirrors, the self-portrait of an unknown, realism as the condition of dream and above all the act of looking back, which itself could be a description of Cocteau's entire oeuvre. In the Greek legend, looking back caused Eurydice's death, but it constituted the underlying structure of Cocteau's thought, a paradoxical motor which turned looking back into something necessary for any process of development and exploration. More than merely making a constant call on his memory, Cocteau turned remembering into energy for writing. The act of writing itself could be renamed 're-remembering'; it led anamnesis towards fiction. It proposed a second Cocteau, his double, ideal in a variable way. He crossed his path, met his eye and sometimes revived him. He met him in the narrow streets of Villefranche-sur-mer in *Le Testament d'Orphée* [Orpheus' testament].

Looking back and remembering are also aids to living: "It even happens that if I give myself up to remembering, although this book advises me to rein it in, I completely forget my problem and I feel alive, not in the room where I'm working, but in the place and time I am describing."[1] This is perhaps another echo of Flaubert.

For the poet to look back was to travel in time, to believe in a "temporal perspective", as described by his contemporary the film-maker and theorist Jean Epstein.

Time is a phenomenon of perspective, but life is a folded surface. The poet looks back to distil life, to sum it up in a pure act, radically consecrating it to the essentials and stripping it of all clutter. "Life shows us only the small surface of a sheet that has been folded over a great many times. The most contrived, capricious acts and the most insane person alive are inscribed on this minute surface. Inside, mathematically, symmetry is set up. Only death can unfold the sheet and its patterning brings us fatal beauty, fatal lassitude."[2] In other words, for Cocteau the act of looking back was particularly identified with the act of inventing, or reinventing, his youth, of paradoxically drawing on the past to be able to go on understanding the young people all around him. "Young people have tasks other than dying."[3] In Cocteau youth became very thinly stretched;[4] until his last breath he pretended to control the death he knew so well.

Cocteau is probably one of those artists whose intellectual and social life could be reconstructed day by day. From *Le Grand Écart* [The splits] and the drawings which often

353 **Jean Cocteau**
Self-portrait in front of the mirror, fifteen years old,
about 1904

accompanied his novels and poems to *Portraits-Souvenir*, he never stopped retrospectively re-telling and re-organizing his life. Like Stendhal in *Henry Brulard*, Cocteau created a narrative parallel to his real life. The first sentence of *La Difficulté d'être* [The difficulty of being], "I am over fifty", is not dissimilar to almost the first of Brulard's thoughts: "Oh! In three months' time I shall be fifty Is that possible? Fifty! I shall be fifty years old."

In the name of this permanent report on himself and the past, Cocteau long maintained his taste for caricature, which he began practising at a very young age under the influence of Sem.

It was Cocteau's devotion to fairy-tales, combined with the memory of his early experience of the theatre, the cinema and the circus (*La Biche au bois* [The doe in the wood] at the Châtelet, the clowns Footit and Chocolat), which caused him to be associated with the now legendary film, *La Belle et la Bête* [Beauty and the Beast]. It is a film for adults with many different messages, implicitly escaping the erotic conventions the folktale tradition demanded, and providing an opportunity for bold effects. Cocteau wrote a diary during the film's shooting, a lesson in film-making from an amateur who was little appreciated by the professional world of post-war cinema.

Les Enfants terribles [The incorrigible children] remains an exceptional attempt to marry together the vitality, the nonchalance and the cruelty of youth, that state which has no real duration and is already gone before it can be enjoyed. Combining realism and the disturbing strangeness of a room overloaded with objects and emotions, edited with classical fluidity and acted with a certain degree of hysteria, *Les Enfants terribles* prefigures Jacques Rivette's *Céline and Julie Go Boating* (with an apartment where mirrors have worlds within them, magic and drugged sweets) and the surreal mental imprisonment and mysteries of Raoul Ruiz.

In the late 1950s many young intellectuals – including the future film-makers of the Nouvelle Vague – may be seen as the dying sparks of weary surrealism. They regarded Cocteau as the model of the film-maker–poet (ideally summed up in the expression *auteur*), who had successfully combined mystery and fantasy with a lucid mastery of cinematographic nuts and bolts. D. P.

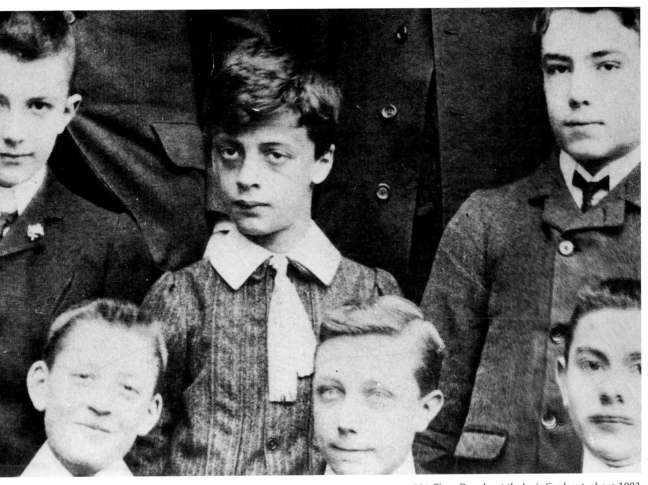

354 *Pierre Dargelos at the Lycée Condorcet*, about 1903

L'homme qui se retourne

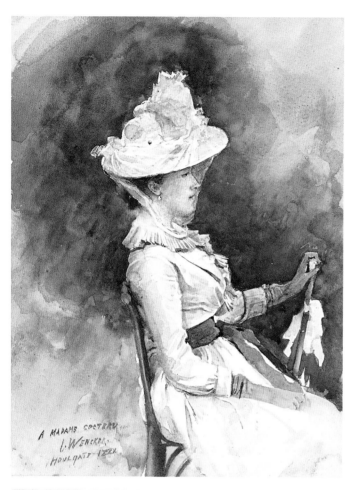

355 Joseph Wencker, *Eugénie Cocteau at Houlgate,* 1888

356 Georges Cocteau, *Eugénie Cocteau,* about 1888

364–65 Jean Cocteau
Edmond Rostand and *Maurice Rostand*, illustrations for *Portraits-Souvenir*, 1935

366 Jean Cocteau
Edouard de Max, about 1910

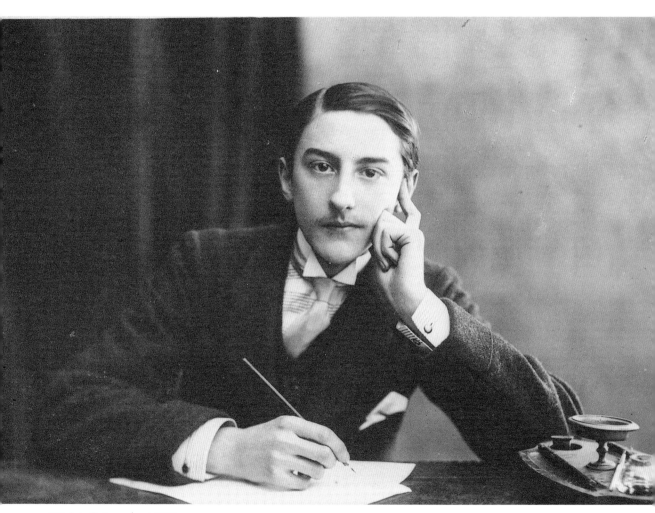

367 *Jean Cocteau*, about 1911

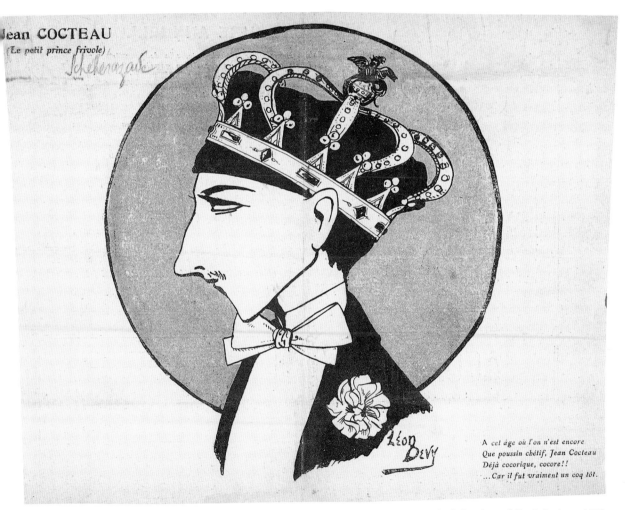

Jean COCTEAU
(Le petit prince frivole)

Schéhérazade

À cet âge où l'on n'est encore
Que poussin chétif, Jean Cocteau
Déjà cocorique, cocore!!
...Car il fut vraiment un coq tôt.

368 Léon Devy, *Jean Cocteau « Le petit prince frivole »* [The little prince of frivolity], about 1910

369 Jean Cocteau
Cover of workbook marked
« *avant Rome* » [before
Rome: before 1917)],
undated

370 Jean Cocteau
Workbook marked « *avant
Rome* » [before Rome:
before 1917)]: « *Titres
de mon volume* » [Titles of my
book], undated

371 Jean Cocteau, Workbook marked « *avant Rome* » [before Rome: before 1917): sketches, undated

372 Jean Cocteau, *Sarah Bernhardt,* undated

373–74 Jean Cocteau, *Mistinguett:*
caricatures, about 1910

375 Jean Cocteau
Marcel Proust, 1935

376 Jean Cocteau
Anna de Noailles,
about 1910–14

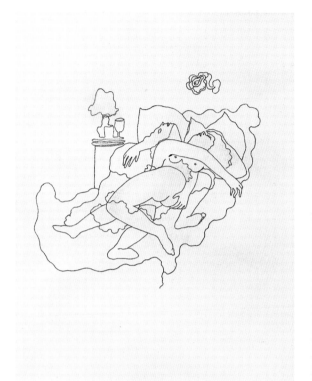

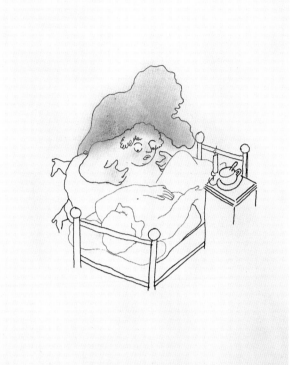

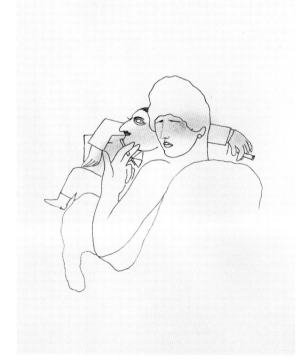

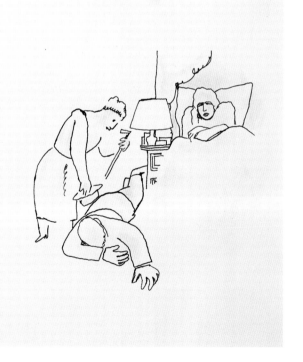

377–84 Jean Cocteau, Illustrations for *Le Grand Ecart* [The splits], 1926

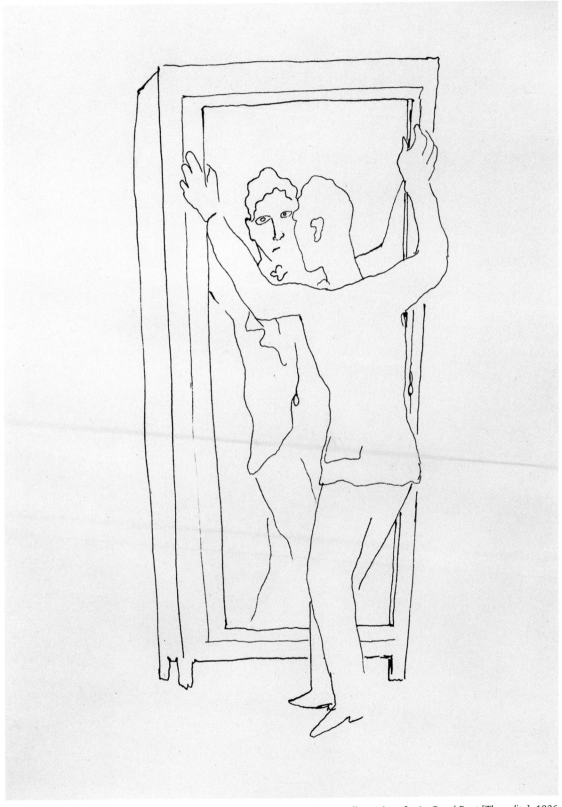

385–88 Jean Cocteau, Illustrations for *Le Grand Ecart* [The splits], 1926

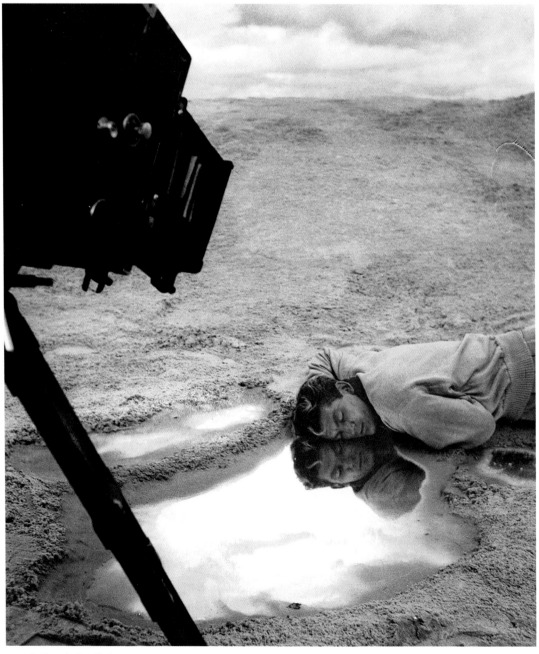

389 *Orphée*, during filming, 1950

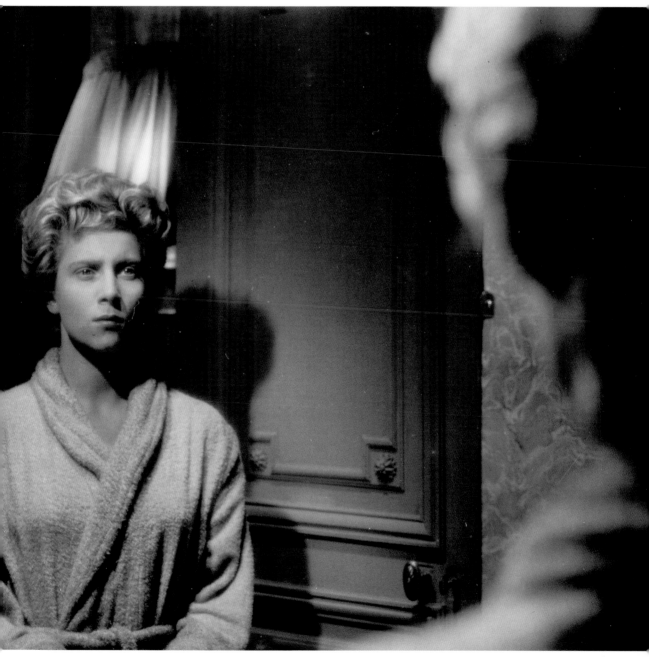

390 André Dino, *Les Enfants terribles*, during filming, 1949

391 André Dino, Cocteau
on the set of *Les Enfants
terribles*, 1949

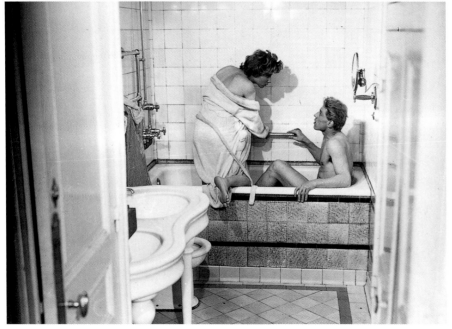

392 André Dino,
Les Enfants terribles:
on set, 1949

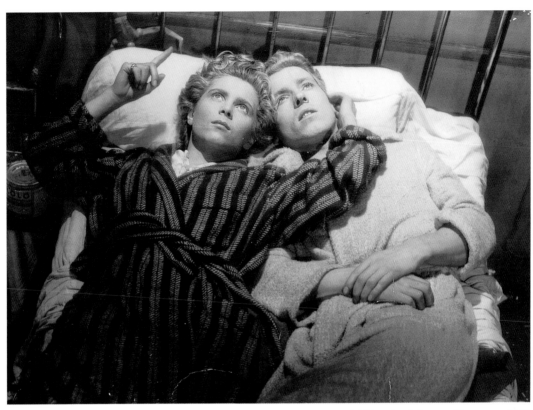

393 André Dino, *Les Enfants terribles*: on set, 1949

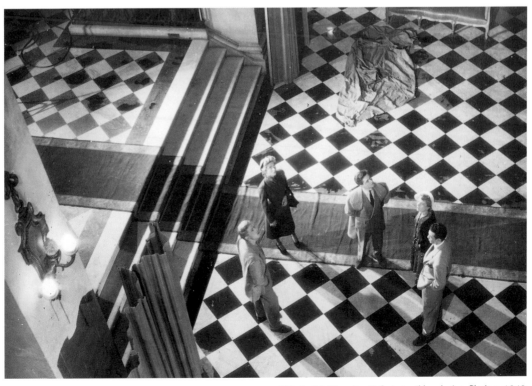

394 André Dino, *Les Enfants terribles*: during filming, 1949

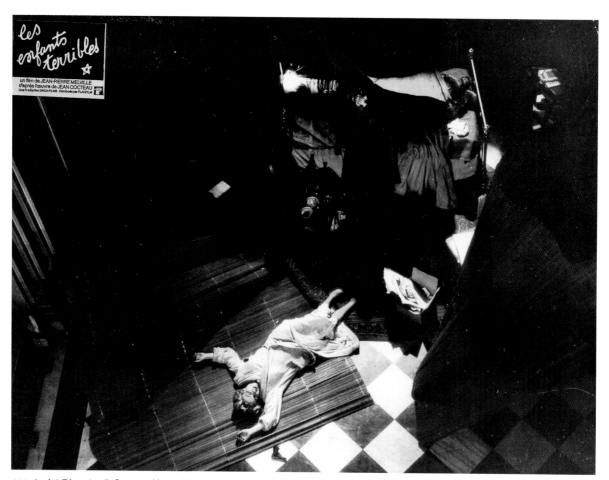

395 André Dino, *Les Enfants terribles*: publicity still, 1949

396 André Dino, *Les Enfants terribles*, « *Au ciel des tragédies* » [In the heaven of tragedies], 1949

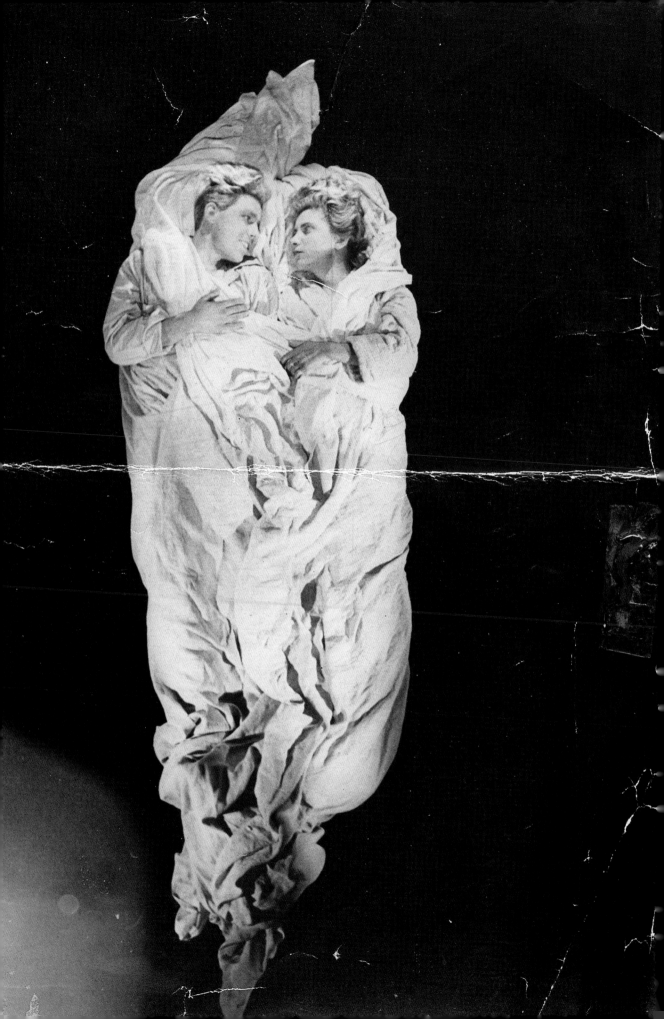

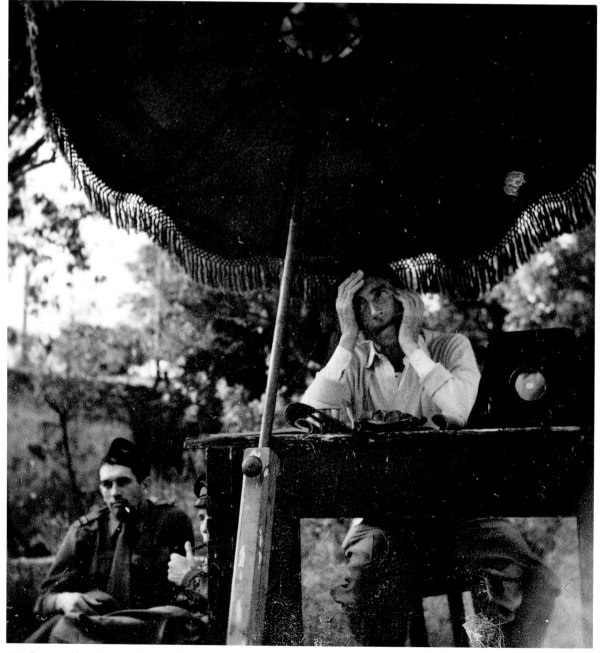

397 *Cocteau in thought,* during filming of *La Belle et la Bête* (?), about 1944

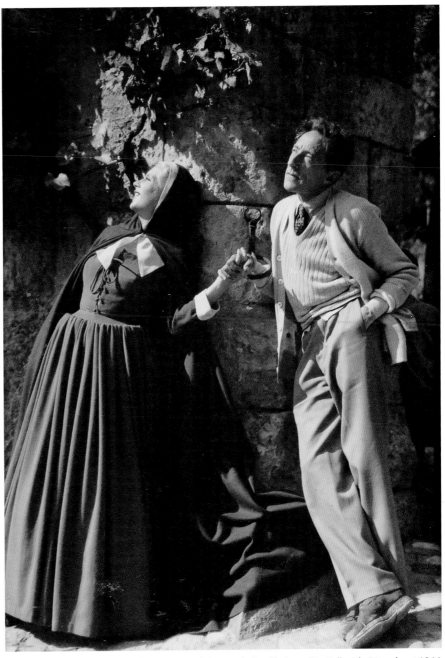

398 G.R. Aldo, *Cocteau and Beauty*, during filming of *La Belle et la Bête*, about 1944

399 Serge Lido, *Jean Marais making up*, during filming of *La Belle et la Bête*, 1944

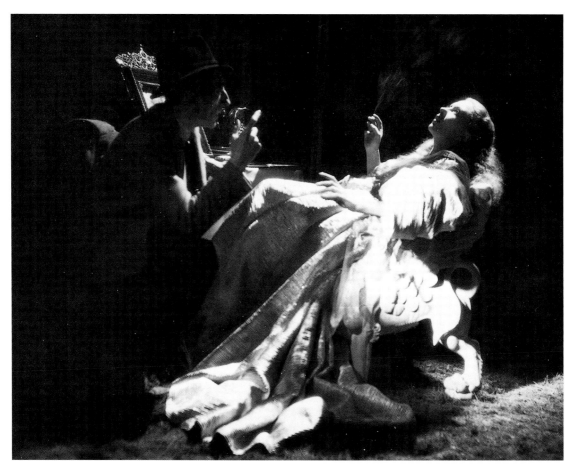

401 *Cocteau and Josette Day smoking during a pause*, during filming of *La Belle et la Bête*, about 1944

400 G.R. Aldo, « *La Bête au miroir* » [The Beast at the mirror],
publicity still for *La Belle et la Bête*, 1945

402 G.R. Aldo, *The Beast, Beauty and the lighting man,* during filming of *La Belle et la Bête*, 1944

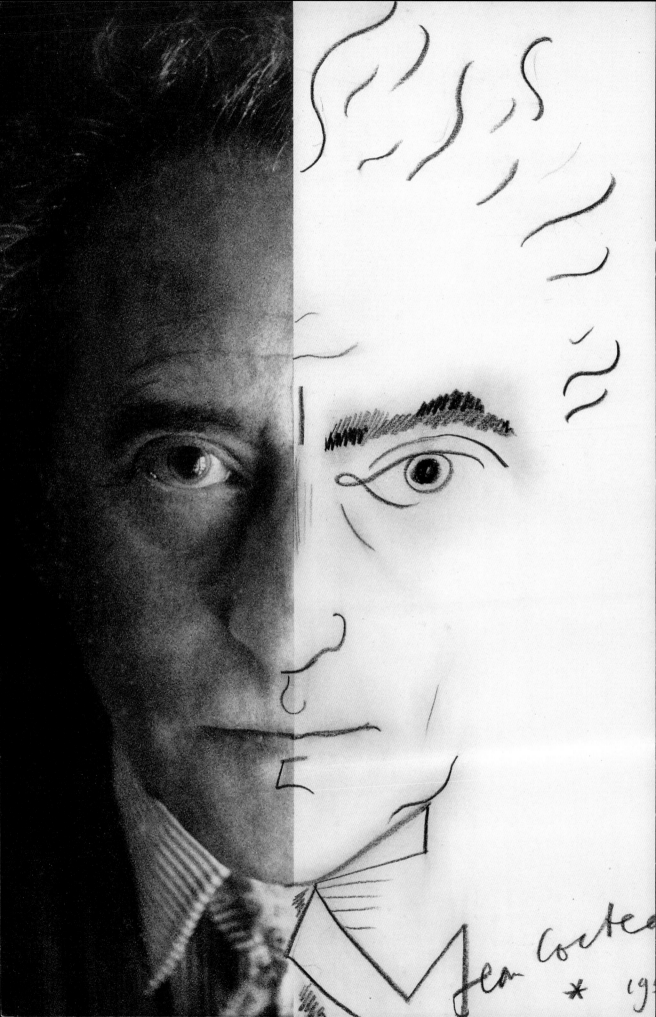

Jean Cocteau
* 19

Cocteaugraphies
Cocteaugraphics

1 J. Cocteau, *La Difficulté d'être* [1946}, in *Romans, poésies, poésie critique, théâtre, cinéma*, Paris, L.G.F., (*La Pochothèque*), 1995, p. 963.

Leaving aside his refusal to distinguish between the forms of writing and drawing, Cocteau is the only poet-novelist who so systematically illustrated his own texts. *Le Grand Ecart* [The splits], *Les Enfants terribles* [The incorrigible children], *Thomas l'imposteur* [Thomas the impostor], *Opium*, *Portraits-Souvenir*, *La Machine infernal* [The infernal machine] and *Le Potomak* are accompanied and enriched by series of drawings. It is as though Cocteau's classicism was also realised by starting with a fiction to be represented, a kind of eclogue.

Within his considerable output – he drew as he breathed, anything and everything – we can identify an approximate typology:

– A 'modern classicism', post-cubist then Ingresesque, perhaps under the influence of Picasso, reflected in a great many portraits and the self-portraits without a face. This type of classicism replaces an earlier, less distinguished variation influenced by Léon Bakst, Jacques-Émile Blanche and Jose Maria Sert.
– Self-portraits. The collection *Les Mystères de Jean l'oiseleur* [The mysteries of Jean the bird-catcher] is a masterpiece of this genre.
– Caricatures influenced by Sem in his youth, from the '*Eugènes*' to *Le Potomak* and the magazine *Le Mot*
– An expressionism defined by drugs: the drawings of *Opium* and *La Maison de santé* [The nursing home]
– An attempt at 'Greek metaphysics', reflected in, among others, the drawings for *La Machine infernale*, although these are disturbed by angry crossings-out.
– Erotic drawings: sailors with their flies undone, private parts of both sexes, phalluses contemplated by lovers, and so on.
– Mass production of pseudo-Greek profiles decorating countless ceramics, hangings and various frescos.

This list is not in any way intended to be exhaustive; however it does throw into relief an evident experimental energy. Colour was not Cocteau's chosen field. Everything about him, from his precise line to his existential thread to his wiry physique, comes back to the line that writes or draws. On the one hand Cocteau wrote and drew on everything; on the other, he wrote and drew in every field. He was interested in everything that could be written or drawn.

The scenography of *Oedipus Rex*, the choreography of *Le Jeune homme et la mort* [Death and the young man] or the animated calligraphy of his film credits create an image of Cocteau as a man merged with a line. "But a line is not a skeleton. It expresses a way of looking, a tone of voice, a way of moving, a way of walking, in fact everything that goes to make up a physical person. It reflects a motor force that has no nature or location on which philosophers can agree."[1]

We should also mention the slate walls on which Cocteau would scribble an urgent sketch or a telephone number, writing and drawing quickly, rubbing out, starting again, rubbing out again. Chalk is an ideal material for pentimenti, for Cocteau's graphic thought.

403 Jean Cocteau, Cover of the collection *Clair-Obscur* [Chiaroscuro], 1954

For Cocteau everything became graphic, from Babilée's body to Oedipus' masks to the costumes and sets designed by Jean Hugo for *Roméo et Juliette*. Similarly *Le Sang d'un poète* was originally conceived as a cartoon animation. Sacha Masour's velvety production stills reveal Cocteau's constant preoccupation with drawing his sets and characters (the hermaphrodite, the "geographical cow" and the angel with dragon-fly wings).

Cocteau readily used objects and found images to give volume to his line. His 'combined paintings', his object-poems which can properly be called visual poetry, sometimes resemble the work of Picabia, Picasso, Schwitters or Max Ernst. Cocteau is the man-line, the man-experiment.

Although he borrowed from his contemporaries, many of them also kept an eye on his inventions and adopted them themselves. "I'm staying with you", he warned. The Cocteau effect lasts throughout the oeuvre of Jean-Luc Godard; it was explicitly relaunched by David Hockney; it survives strangely and no doubt involuntarily in the work of conceptual artists such as Markus Raetz or in the fantasy of Mark Brusse, voluntarily in the work of the young Alice Anderson.

Cocteau is even more present among us because he is definitively invisible. **D. P.**

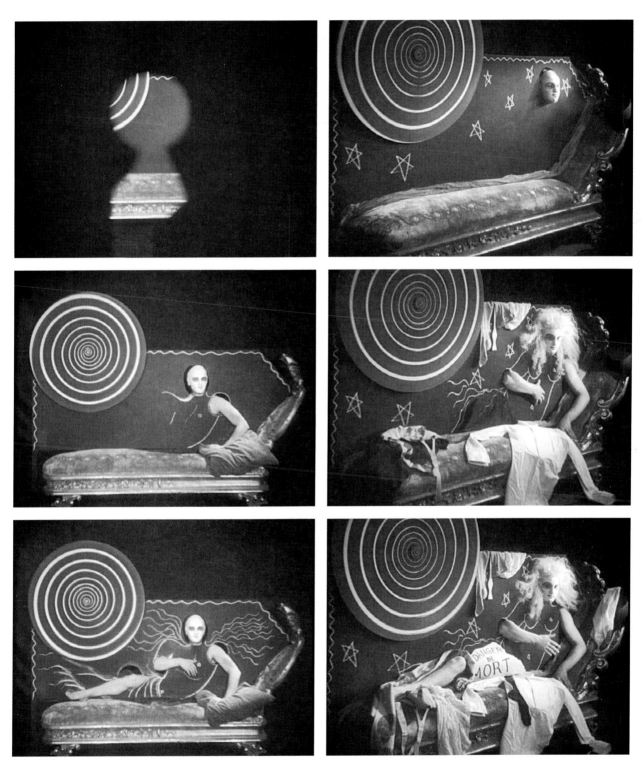

404 Jean Cocteau, *Le Sang d'un poète: The hermaphrodite scene*, frame stills, 1930

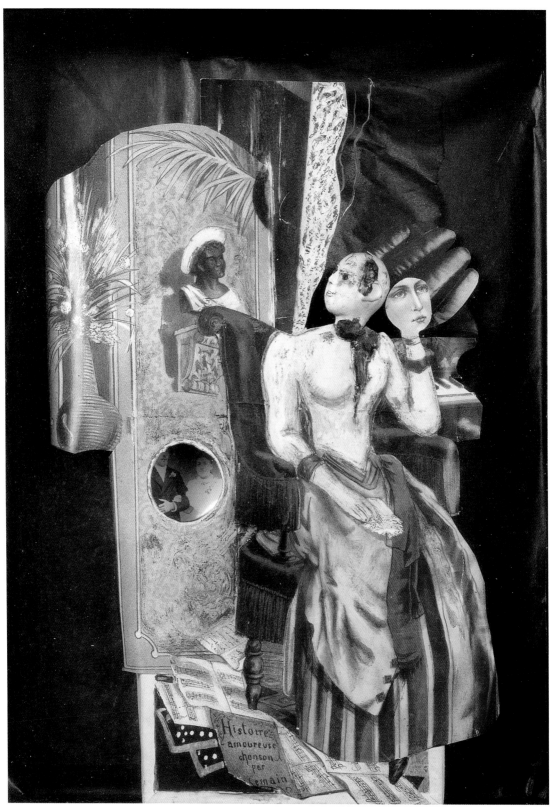

405 Jean Cocteau, *Sans title* [*Histoire amoureuse*] [Untitled (A story about love)], about 1926

406 Jean Cocteau, *Untitled*, about 1926

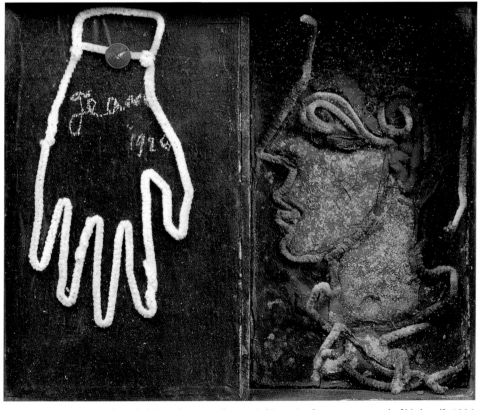

407 Jean Cocteau, *Portrait de jeune homme et de sa main* [Portrait of a young man and of his hand], 1926

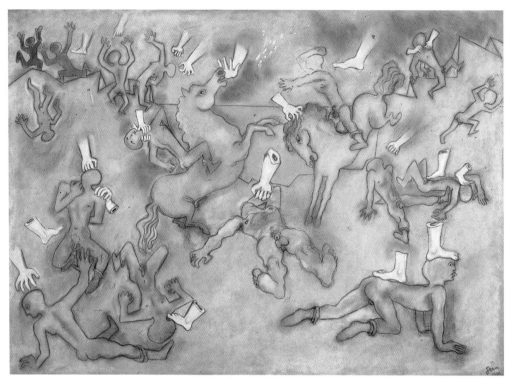

408 Jean Cocteau, *Plaster hands and feet attacking people at the seaside*, 1926

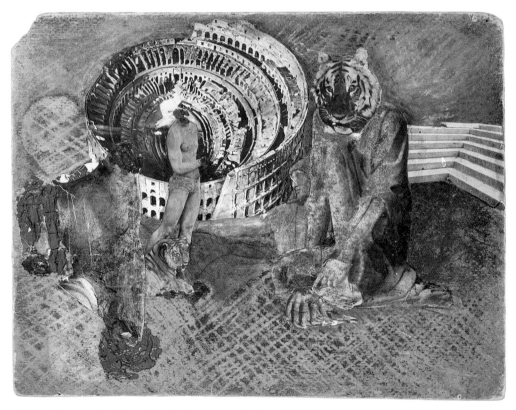

409 Jean Cocteau, *Orphée aux bêtes* [Orpheus among the beasts] 1926

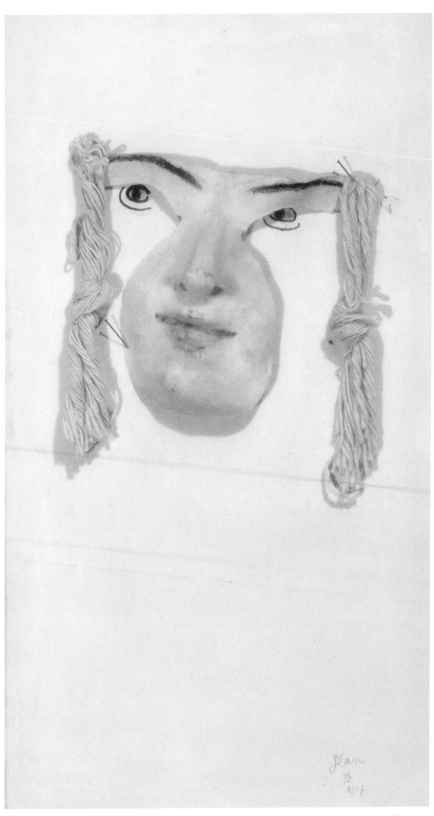

410 Jean Cocteau, *Untitled (Young girl)*, 1926

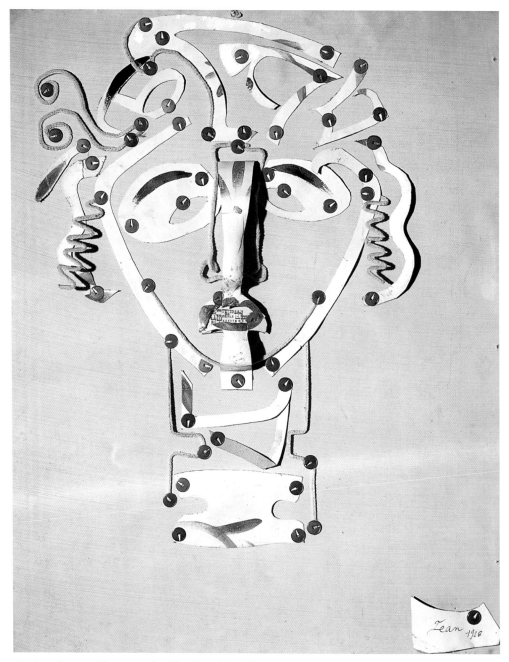

411 Jean Cocteau, *Tête aux punaises* [Drawing-pin head],1926

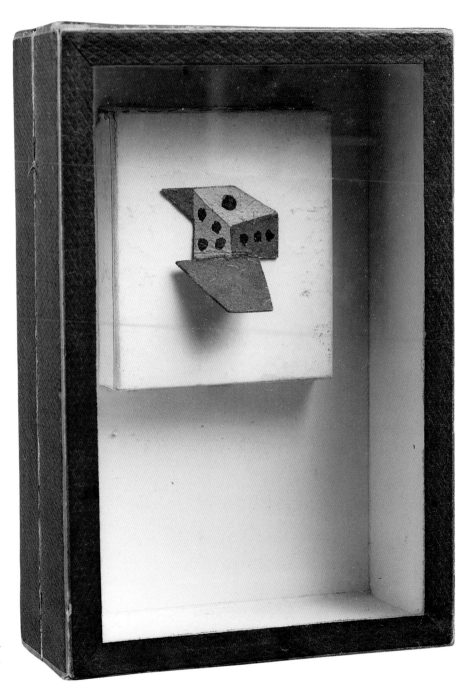

412 Pablo Picasso *Dé à jouer*
[Dice], undated (given to
Cocteau about 1917]

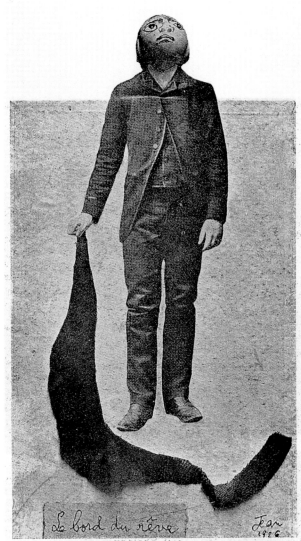

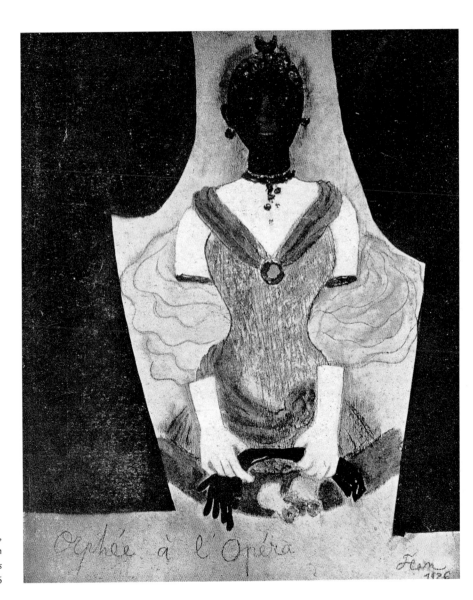

413–15 Jean Cocteau,
Three of the six objects in
the review *Echantillons*
[Samples], 1926

416-22 Jean Cocteau, Illustrations for *Dessins* [Drawings], Paris, Stock, 1923

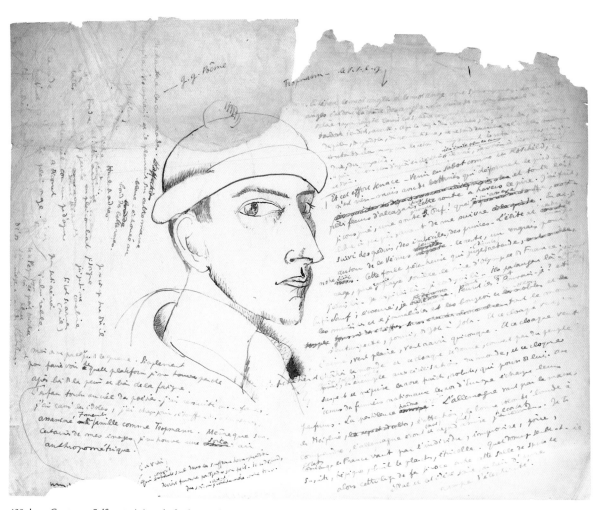

423 Jean Cocteau, *Self-portrait in a draft of a speech*, 1920

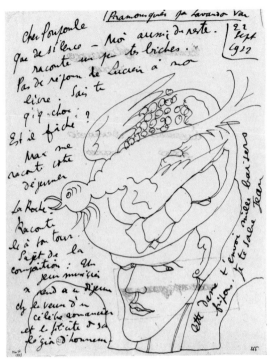

424 Jean Cocteau, Letter to Francis Poulenc, with drawing, 1922

425 Jean Cocteau, Drawing for *Opium*, dated 1930 but reworked for a new edition in 1950

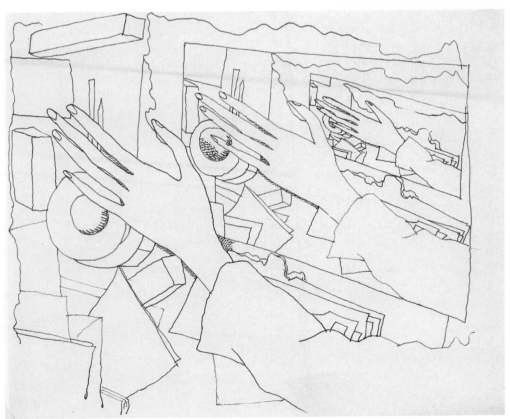

426 Jean Cocteau, Study for « *Porte du ciel* » [The door of heaven], about 1922–23

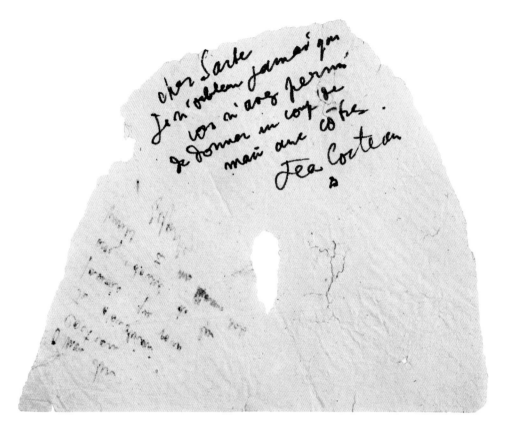

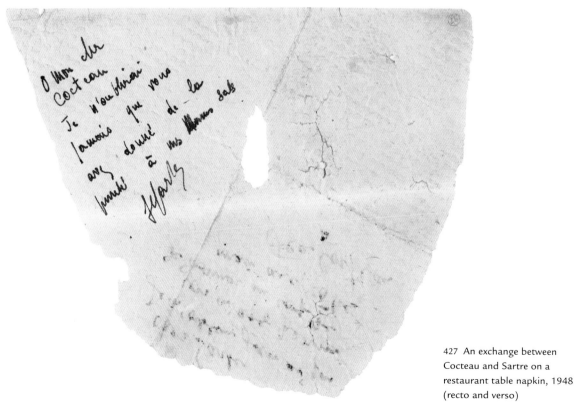

427 An exchange between Cocteau and Sartre on a restaurant table napkin, 1948 (recto and verso)

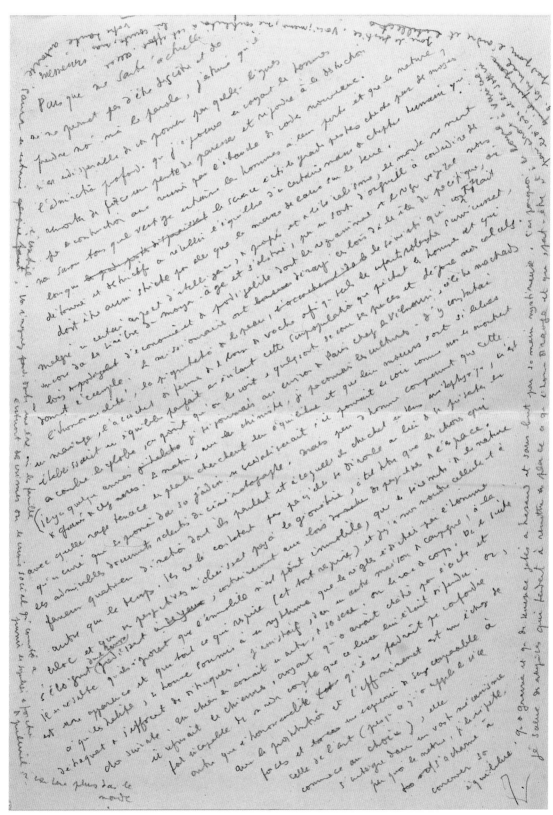

428 Jean Cocteau, Speech for the International Congress for Sexual Liberty in Amsterdam, 1951

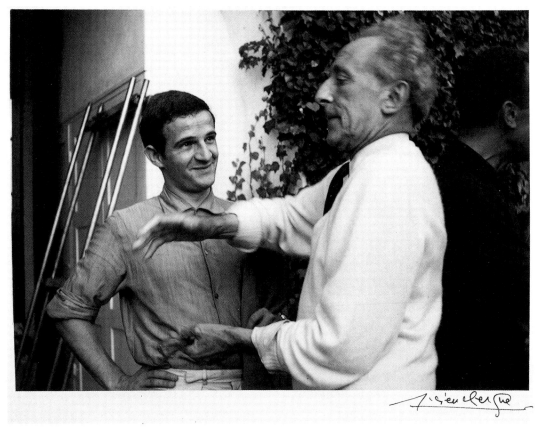

429 Lucien Clergue, *Cocteau and Truffaut*, during filming of the *Testament d'Orphée*, 1959

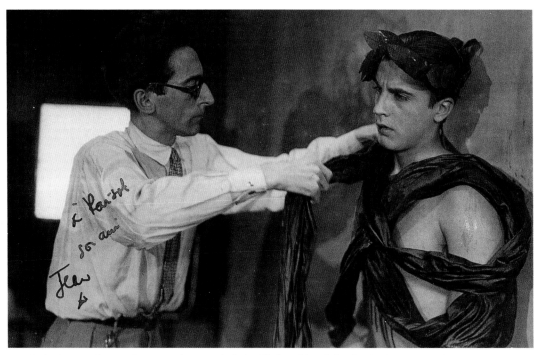

430 Sacha Masour, *Le Sang d'un poète*, photograph during filming with a dedication by Cocteau, 1930

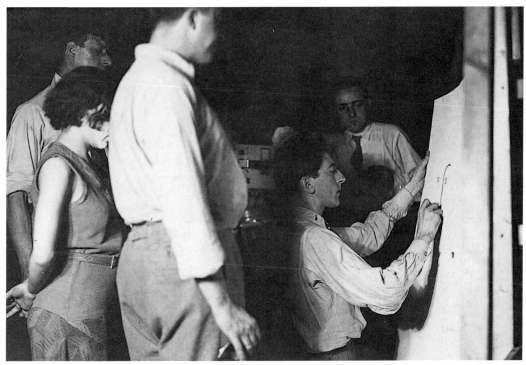

431 Sacha Masour, *Le Sang d'un poète: Cocteau makes the drawing for the opening of the film*, during filming, 1930

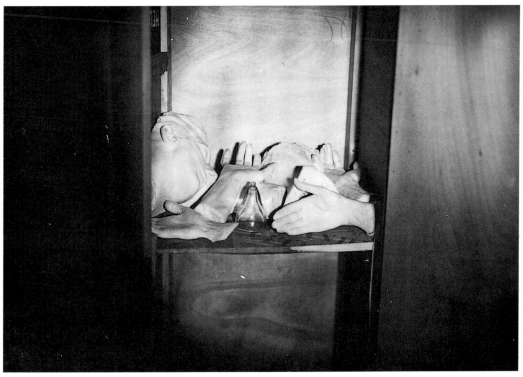

432 Sacha Masour, *Le Sang d'un poète: Plaster hands and heads*, during filming, 1930

Sacha Masour, *Le Sang d'un poète*: on set and during filming, 1930

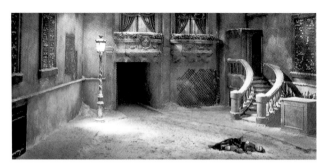

433 *The city of Monthiers, with Dargelos*

434 *The city of Monthiers, snowball fight*

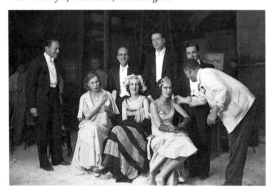

435 *Aristocrats in the boxes (extras, during a pause)*

436 *Aristocrats in the boxes*

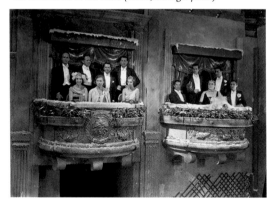

437 *Aristocrats in the boxes*

438 *Aristocrats in the boxes*

439 *Preparation of the black angel*

440 *The statue with silk stockings (Lee Miller)*

441 *The cow and the cowherd*

442 *Lee Miller as the statue with a cigarette*

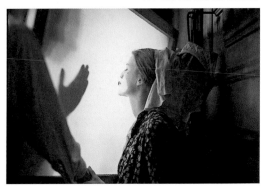

443 *Lee Miller making up*

444 *The transparent statue*

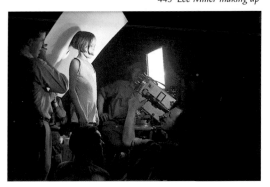

445 *The flying lesson, close-up*

446 *The flying lesson, the little girl on the wall*

447 *The flying lesson, the little girl on the wall*

448 *The flying lesson, the little girl on the wall*

Sacha Masour, *Le Sang d'un poète*, during filming, 1930

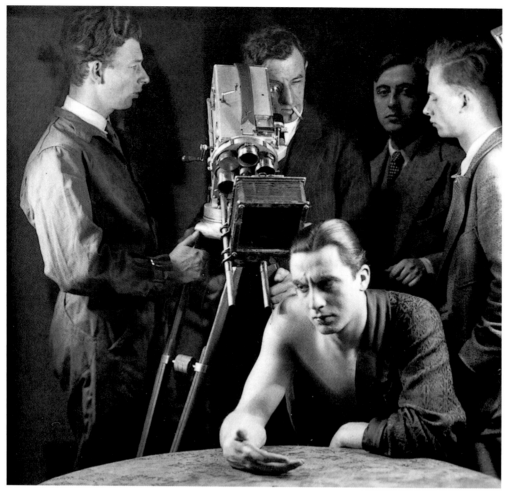

449 *The poet (Enrique Rivero) studies his hand*

450 *Cocteau painting Rivero's eyes*

451 *Cocteau painting Rivero's eyes*

452 *The crew on the roof*

453 *The aristocrats in the boxes, the crew in silhouette*

454 Sacha Masour, *Le Sang d'un poète*, during filming: *Cocteau working on set*, 1930

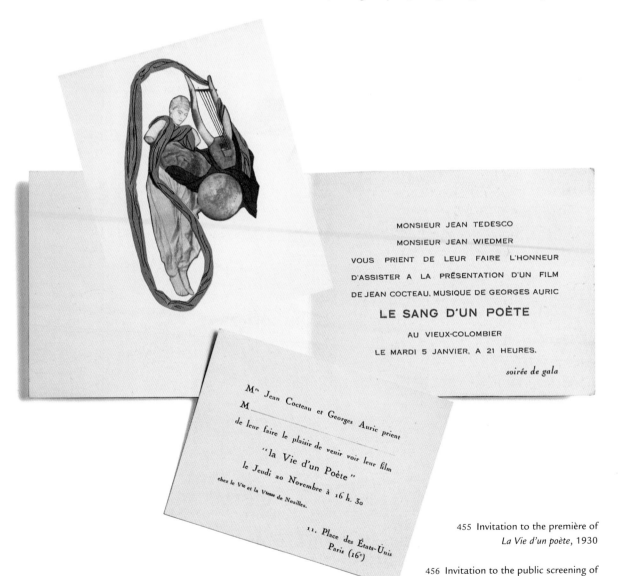

MONSIEUR JEAN TEDESCO

MONSIEUR JEAN WIEDMER

VOUS PRIENT DE LEUR FAIRE L'HONNEUR

D'ASSISTER A LA PRÉSENTATION D'UN FILM

DE JEAN COCTEAU, MUSIQUE DE GEORGES AURIC

LE SANG D'UN POÈTE

AU VIEUX-COLOMBIER

LE MARDI 5 JANVIER, A 21 HEURES.

soirée de gala

Mᵐ Jean Cocteau et Georges Auric prient

M⸻

de leur faire le plaisir de venir voir leur film

"la Vie d'un Poète"

le Jeudi 20 Novembre à 16 h. 30

chez le Vᵗᵉ et la Vᵗᵉˢˢᵉ de Noailles.

11, Place des États-Unis

Paris (16ᵉ)

455 Invitation to the première of
La Vie d'un poète, 1930

456 Invitation to the public screening of
Le Sang d'un poète, 1932

457 Jean Cocteau, *Les Enfants terribles*: plans of the children's apartment, about 1949 (verso and recto)

458 Jean Cocteau, *Danse des acrobates* [The acrobats' dance]: choreographic sketches, undated

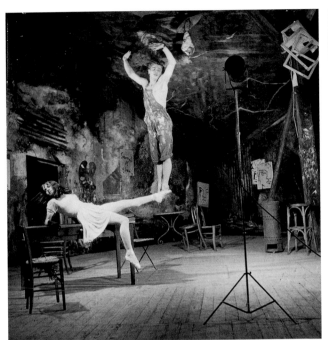 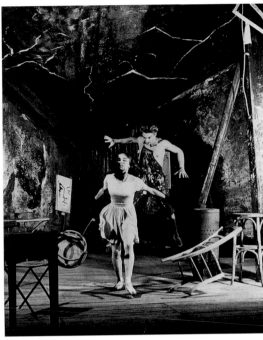

459-60 Boris Lipnitzki, *Le Jeune Homme et la Mort* [The young man and death]: *Jean Babilée and Nathalie Philippart*, 1946

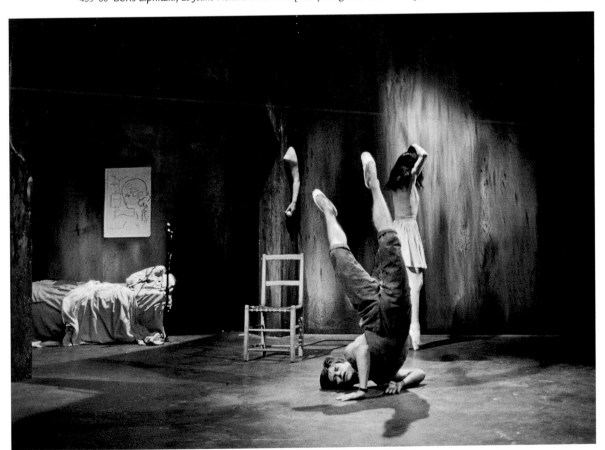

461 André Le Coz, *Le Jeune Homme et la Mort*: *Jean Babilée*, 1946

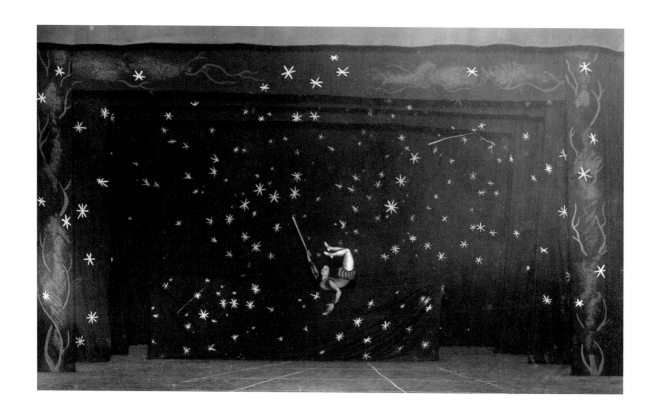

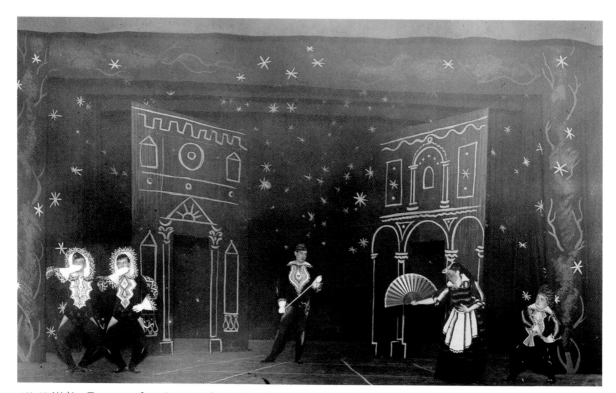

462–63 Waléry, Two scenes from *Roméo et Juliette*, adaptation and sets by Cocteau, 1924

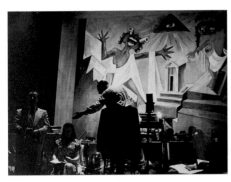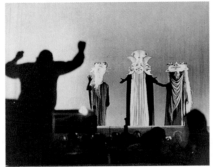

464–66 *Œdipus Rex*, production of May 1952, sets by Jean Cocteau

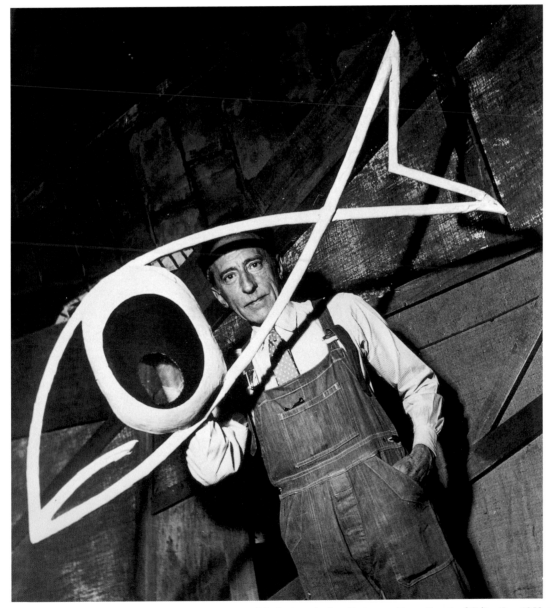

467 P.A. Constantin, *Jean Cocteau working on the sets of Œdipus Rex*, 1952

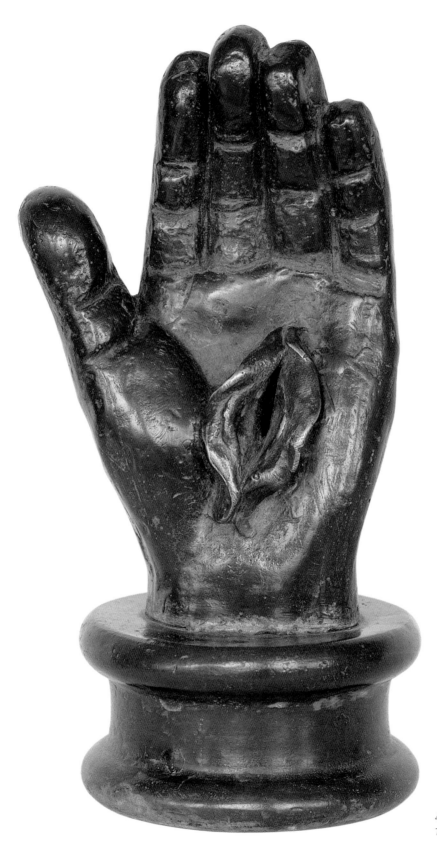

468 Mark Brusse,
The Primal Hand, 2001

469 David Hockney, *Peter posing for Model with Unfinished Self-portrait*, 1977

470 Michael Brynntrup, *Narziss und Echo* [Narcissus and Echo], 1989

471 Alice Anderson, *Seance*, 2003

472 Markus Raetz, *Nightface n° 8/18*, 1980–2002

List of illustrations

Abbreviations

• CNACGP: Centre national d'Art et de Culture Georges Pompidou, Paris
• BHVP: Bibliothèque historique de la Ville de Paris, fonds Jean Cocteau
• BnF: Bibliothèque nationale de France
• BUPV: Bibliothèque de l'Université Paul-Valéry, Montpellier, fonds Jean Cocteau
• BIFI: Bibliothèque de l'Image et du Film, Cinémathèque française, Paris, dépôt Jean Cocteau
• Doucet: Bibliothèque littéraire Jacques-Doucet, Paris, fonds Jean Cocteau
• Mnam: Centre Pompidou, Musée national d'art moderne, Paris
• Carton Lake Coll.: Carlton Lake Collection, Harry Ransom Humanities Research Center, The University of Texas at Austin, USA

• The initials J.C. indicate Jean Cocteau
• All measurements are in centimetres

Poetry/ Poésies

• **1** Philippe Halsman, *Jean Cocteau,* 1949, photograph (Magnum Photos).

• **2** Man Ray, *Jean Cocteau,* 1926, photograph in black and white, silver salts (Mnam. Photo CNACGP/B. Prévost).

• **3** J. C., *La Famille Rufus*, 1934, drawing, 42 x 63 (Coll. Liliane and Etienne de Saint-Georges).

• **4** Berenice Abbott, *Jean Cocteau and the mask* [from the prologue of *Antigone*], *ca.* 1927, four photographs, 15.2 x 21.2 [the photograph above is inscribed *le chercheur dort* in Cocteau's hand], (Private collection. Photos CNACGP/J.-C. Planchet).

• **5** J. C., *Le Sang d'un poète,* 1930 (mirror scene), 15 frame stills from the film.

• **6–9** J. C., *Le Secret professionnel.* First edition, Paris, Au Sans Pareil 6 « *Je ne me compare à aucun des princes de la terre* », 1925, with an original drawing, 24 x 19 (Private collection. Photo CNACGP/J.-C. Planchet). 7 « *Chaque fois que le poète en coupe une, son cœur bat* », 1925 (BUVP). 8 « *Le moindre joueur déplace plus de mystère qu'il n'apparaît* », 1925 (BUVP). 9 « *Revenons à l'arrivisme...* », 1925, 17.6 x 23.7 (BUVP).

• **10** J. C., *L'Inspiration,* undated, ink on paper, 27.3 x 21 (Carlton Lake Coll.).

• **11-18** J. C., *Le Mystère de Jean l'oiseleur* (*recueil*), Paris, Champion, 1925, Illustrations. 11 n° 15. 12 n° 18. 13 n° 13. 14 n° 6. 15 n° 4. 16 n° 5. 17 n° 10. 18 n° 16, original drawings, *ca.* 1924, 27 x 21 (Coll. Liliane and Etienne de Saint-Georges).

Parades

• **19** Isabey, Jean Cocteau in the role of the narrator at the megaphone in *Les Mariés de la tour Eiffel,* 1921, photograph (BnF, Bibliothèque-Musée de l'Opéra).

• **20** J. C., *Dessins,* Paris, Stock, 1923, series of 106 drawings. « *Diaghilev, Misia Sert, Nijinski à la première du Spectre de la Rose* », 37 x 28.5 (Photo CNACGP/J.-C. Planchet).

• **21** J. C., *Diaghilev*, drawing, undated (Coll. André Bernard. Photo CNACGP/ J.-C. Planchet).

• **22** J. C., *Nijinski in Le Spectre de la Rose,* 1911, black ink on tracing paper stuck down on board (Private collection. Photo CNACGP/J.-C. Planchet).

• **23** *Nijinski in Le Spectre de la Rose,* 1911, photograph (Photo Roger-Viollet, Paris).

• **24** J. C., Letter to Francis Poulenc, 22 September 1912, with a drawing [Stravinsky and Nijinski rehearsing *The Rite of Spring* at the piano], manuscript (BnF, département de la Musique, fonds Francis Poulenc).

• **253** Anonymous, Indications for the make-up of Death, acted by Mireille Havet, in *Orphée, ca.* 1926, manuscript, 21 x 18 (BUPV).

• **254** J. C., *Men in masks*, undated, drawing (Private collection. Photo CNACGP/J.-C. Planchet).

• **255** Germaine Krull, *Jean Cocteau* (face in hand), 1930, photograph (Doucet. Photo Suzanne Nagy).

• **256** J. C., *Hand over eye, ca.* 1923, ink, 26.1 x 20.3 (Coll. Kinzel, Schilling, Basle. Photo Martin Bülher, Basle).

• **257** J. C., *Orphée holding his head*, undated, pastel, 34.3 x 26 (Carlton Lake Coll.).

• **258** J. C., *Mystères des chambres vides*, undated, ink, wash and pencil, 34.3 x 24.5 (Carlton Lake Coll.).

• **259** J. C., *Orphée: La Mort and ses deux assistants*, undated, black and brown ink, wash and pencil, 34.3 x 26 (Carlton Lake Coll.).

• **260** J. C., *La Machine infernale*, Paris, Grasset, 1934, five illustrations, 19 x 12 (Photos CNACGP/J.-C. Planchet).

• **261** Jean Hugo (?), *Sirène avec ancre*, undated, ink, 4 x 7.3 (Carlton Lake Coll.).

• **262** Jean Hugo, *Siren, ca.* 1918, linotype, 27.3 x 19.2 (Carlton Lake Coll.).

• **263** Anonymous, *Altered printed illustration of a bird in flight in front of a boat with three Harpies*, undated, ink, 3,6 x 6.8 (Carlton Lake Coll.).

• **264** Anonymous, *Greek siren*, undated, ink over press cutting, 9.1 x 13 (Carlton Lake Coll.).

• **265** Raoul Dufy, *Male figure with mermaid in his arms, ca.* 1917, ink on folded paper, 22.3 x 14 (Carlton Lake Coll.).

• **266** Pablo Picasso, *Siren with anchor*, undated, ink, 21 x 27.2 (Carlton Lake Coll.).

• **267** J. C., *Two sirens*, undated, ink, 20.8 x 27 (Carlton Lake Coll.).

• **268** J. C., *Siren*, undated, ink, 18.4 x 12.7 (Carlton Lake Coll.).

• **269** J. C., *Sirène avec rouleau*, undated, ink, 8.7 x 21.4 (Carlton Lake Coll.).

• **270** J. C., Six sketches, undated, ink, 30.5 x 24.3 (Carlton Lake Coll.).

• **271** J. C, *« Silence ! ici j'ordonne... »* (Natalie Paley as a sphinx), 1932, photograph, drawing and manuscript notes, mounted on board, 33.4 x 24,6 (Private collection. Photo CNACGP/J.-C. Planchet).

• **272** Lucien Clergue, *Le Testament d'Orphée: Cocteau before the sphinx*, 1959, set photograph.

• **273–75** Germaine Krull, Berthe Bovy in the role of the single protagonist of *La Voix humaine*, 1930, original signed photographs, nos. D, E, B, 39 x 29.5 (Private collection. Photos CNACGP/ J.-C. Planchet).

• **276** Anonymous, *Cocteau in the role of the angel Heurtebise*, 4 June 1927, photograph, 17.8 x 23.8 (Private collection. Photo CNACGP/J.-C. Planchet).

• **277** Man Ray, 'Rayogramme' illustrating Cocteau's poem *L'Ange Heurtebise*, original edn, Paris, Stock, August 1925, 35 x 20 (Galerie Dominique Bert, Paris. Photo CNACGP/J.-C. Planchet).

• **278** J. C., *The Annunciation*, photographic montage with Jean Cocteau and the comtesse de Beaumont, 1918, 12.7 x 16 (Private collection. Photo CNACGP/J.-C. Planchet).

• **279–80** J. C., *Maison de santé*, first edition, Paris, Briant-Robert, 1926, drawings n° 27 and 30, 28.2 x 22.4 (Photos CNACGP/J.-C. Planchet).

• **281–84** J. C., Illustrations for *Imaginary Letters* by Mary Butts, 1928, brown ink. 281 n° 1, 25.5 x 19 ; 282 n° 3, 26.5 x 20 ; 283 n° 4, 26 x 19 ; 284 n° 5, 25.5 x 19.5 (Galerie Dominique Bert, Paris. Photos CNACGP/J.-C. Planchet).

• **285–92** J. C., *Jean l'oiseleur. Ad Usum Delphini, ca.* 1925–26, pen drawings, stuck on to thick cardboard, *ca.* 27 x 21. 285 n° 3: *« Le Militaire and la Balayeuse, ou la présentation des "hommages" »*. 286 n° 4: *« Trio: deux femmes and un homme »*. 287 n° 6: *« La Bretonne and le Marin. Scène du bord de mer »*. 288 n° 17: *« La Bretonne and le Marin »*. 289 n° 13: *« Duo: homme noir and femme »*. 290 n° 10: *« Duo: un homme, une femme »*. 291 n° 14: *« Duo. Pudeur. Un homme, une femme »*. 292 n° 25: *« Duo. Deux hommes »* (Private collection).

• **293** J. C., *Bébé aux extrémités phalliques*, undated, ink, 26.7 x 21 (Carlton Lake Coll.).

• **294** J. C., *Mandragore et mains chevalines* (II), 1936, graphite on board, 27.1 x 24.1 (Private collection. Photo CNACGP/J.-C. Planchet).

• **295** J. C., *Mandragore et mains chevalines*, 1936, drawing, 26 x 23 (Coll. Kinzel, Schilling, Basle. Photo CNACGP/ J.-C. Planchet).

• **296–97** J. C., *Hands – studies for a screen*, 1940, two drawings, 30 x 23 (Coll. Emmanuel Basse).

Cocteau s'évade/ Escape

• **298** Cecil Beaton, *Cocteau* (smoking opium at the hôtel de Castille, 37 rue Cambon, Paris), 1938, photograph Castille (detail), 8.3 x 13.4 (Private collection).

• **299** Cecil Beaton, *Marcel Khill* (smoking opium at the hôtel de Castille, 37 rue Cambon, Paris), 1938, photograph, 8,6 x 13 (Private collection. Photo CNACGP/J.-C. Planchet).

• **300** J. C., *Marcel Khill* , 5 mai 1936, graphite, 22.8 x 29.5 (Coll. Kinzel, Schilling, Basle. Photo Martin Bülher, Basle).

• **301** J. C., *Rêverie d'opium*, 1923, Chinese ink, 27 x 21 (Private collection. Photo CNACGP/J.-C. Planchet).

• **302** J. C., *Le Poète fumant l'opium* (IV), *ca.* 1923, Chinese ink, 27 x 21 (Private collection. Photo CNACGP/J.-C. Planchet).

• **303** J. C., *Fumeur d'opium*, undated, pencil on paper, 20.5 x 25.5 (Carlton Lake Coll.).

• **304** J. C., *Adam et Ève chassés du Paradis*, undated, drawing, 24.5 x 34.5 (Coll. Liliane and Etienne de Saint-Georges).

• **305** J. C., « *Feuneige* », drawing for *Opium*, Saint-Cloud, 1929, ink on paper, 33 x 25.5 with frame (Private collection).

• **306** J. C., *Le Taureau parlait corne*, Saint-Cloud, 1929, ink on paper, 30 x 25 with frame (Private collection).

• **307** J. C., Original drawing for *Opium*, *ca.* 1929, 24 x 19.5 (Coll. Liliane and Etienne de Saint-Georges).

• **308** J. C., *La Vie est une*, *ca.* 1926, black ink, 21 x 17.9 (Private collection. Photo CNACGP/J.-C. Planchet).

• **309** Man Ray, *Jean Cocteau*, 1922, photograph (Doucet. Photo Suzanne Nagy).

• **310** J. C., *Maison de santé*, first edition, Paris, Briand-Robert, 1926: frontispiece, printed matter, 28.2 x 22.4 (BHVP).

• **311–17** J. C., *Maison de santé*, first edition, Paris, Briand-Robert, 1926, printed subjects: **311** n° 4: « *Le bain de lumière* ». **312** n° 24: [Untitled]. **313** n° 12: « *J'ai mal* ». **314** n° 8: « *Hommage à mes ennemis* ». **315** n° 15: « *Mes anges, venez à mon secours* ». **316** n° 14: « *Les gants du ciel* ». **317** n° 21: « *Electrodes* » (Photos CNACGP/J.-C. Planchet).

• **318–25** J. C., *Opium*, 1928–29: selection of eight drawings, unpublished, from original manuscripts: **318** « *Il faut présupposer quelque chose de parfait* ». **319** « *Oh ! oh ! oh !* ». **320** « *Tristan, vous irez beaucoup mieux sans Yseult* ». **321** « *Marbre de Noël* ». **322** « *Je crève !* ». **323** [Untitled]. **324** « *Bien punis furent-ils pour avoir laissé partir l'oiseau* ». **325** [Untitled] (Société des Manuscrits des Assureurs français).

• **326** J. C., *Jean Desbordes*, study for *25 dessins d'un dormeur*, summer 1927, Chinese ink, 20.9 x 27.3 (Private collection. Photo CNACGP/J.-C. Planchet).

• **327–28** J. C., *25 dessins d'un dormeur*, first edition, Lausanne, H.L. Mermod, 1929, printed matter, two drawings, 30 x 20 (Photos CNACGP/J.-C. Planchet).

• **329** J. C., *Raymond Radiguet asleep*, dated 1922 but reworked in the 1950s after *Dessins*, Stock, 1923, Chinese ink on tracing paper, 22.2 x 21.1 (Private collection. Photo CNACGP/J.-C. Planchet).

• **330** J. C., *Sommeil hollywoodien*, 1953, oil on wood, 46 x 55 (Private collection. Photo CNACGP/J.-C. Planchet).

• **331** J. C., Poster for the exhibition *Pouchkine 1837-1937*, 1937, lithograph, 70 x 50 (Galerie der Moderne, Munich).

• **332** J. C., *Portrait de sa mère sur son lit de mort*, 1943, graphite, 25.4 x 42,6 (Private collection. Photo CNACGP/J.-C. Planchet).

• **333** Raymond Voinquel, *Jean Cocteau sur son lit de mort*, 1963, photograph, 19.2 x 25.1 (Coll. Serge Tamagnot. Photo CNACGP/J.-C. Planchet).

• **334** J. C., *Orphée: Death gazing at Ophée asleep*, 1950, six film stills.

• **335** J. C., *La Belle and la Bête: The Beast gazes at Beauty asleep*, 1945, film still.

• **336** Lucien Clergue, *Le Testament d'Orphée: The dead man smoking*, 1959, two photographs.

• **337** J. C., « *La mort accomplit son œuvre* », proof of the illustration for *Le Grand Ecart*, 1926, printed, 18.5 x 23.5 (BHVP).

• **338** J. C., Postcard of Le Piquey sent to his mother, 1918, letter n° 330, manuscript, 8.9 x 13.7 (BHVP).

• **339** Anonymous, *Cocteau working at Le Piquey*, 1923, photograph (Private collection. Photo CNACGP/J.-C. Planchet).

• **340** J. C., Manuscript letter with drawing in ink sent from Le Piquey to his mother, 3 October 1917, letter n° 261, 21 x 27 (BHVP).

• **341–47** Anonymous, *Cocteau at Le Piquey, ca.* 1917, photographs: 341 5.7 x 18. 342 17.5 x 12.5. 343 8 x 5.5. 344 8.5 x 5.5. 345 17.5 x 12.5. 346 12.5 x 17.5. 347 9 x 12.4 (Private collection. Photos J.-C. Planchet).

« Jean Cocteau, sur le fil du siècle »

25 September 2003–5 January 2004
Centre Pompidou, Galerie 1, Paris

6 May–29 August 2004
Montreal Museum of Fine Arts,
Jean-Noël Desmarais pavilion

EXHIBITION

Commissaire général
Chief curator
Dominique Païni

Commissaires
Curators
François Nemer
Isabelle Monod-Fontaine,
assistés de Valérie Loth, chargée d'étude,
recherches documentaires et iconographiques

Conseillers scientifiques
Scientific committee
Pierre Caizergues
Pierre Chanel
Annie Guédras

Chargé de mission
pour les relations internationales
Representative for international
relations
Joël Girard

Chargés de production
Production
Hervé Derouault, Sara Renaud

Scénographes
Exhibition designers
au Centre Pompidou:
Nathalie Crinière
assistée d'Hélène Lecarpentier
au Musée des beaux-arts de Montréal:
Christiane Michaud

Régie des œuvres
Administration
Anne-Sophie Royer, Pascale Samuel

Réalisations audiovisuelles
Audio-visuals
Gérard Chiron,
responsable artistique and technique
Murielle Dos Santos,
gestion des productions et des droits
Paolo Moretti, assistant de production et
coordination du montage
Didier Coudray et Philippe Puicouyoul,
mise en images et réalisation
Nicolas Joly, ingénieur du son
Yann Bellet, infographie
Jacques-Yves Renaud,
duplication, numérisation
Patrick Arnold et Bernard Lévêque,

design visuel et animation
Vahid Hamidi, Eric Hagopian,
Patrick Gapenne, Emmanuel Rodoreda,
exploitation
Guy Carrard, Bruno Descout, Valérie
Leconte, Francine Mingot, Daniel Valet,
Hervé Véronèse, laboratoire photographique
Jean-Claude Planchet, photographe

Régie des espaces
Gallery administrator
André Toutcheff

Eclairage et lumière
Lighting
François Austerlitz assisté de Mathieu Blaise
Michel Boukreis, Jacques Rodrigues,
Thierry Kouach

Signalétique
Signage
c-album, Tiphaine Massari

Restauration
Conservation
Dagna de Cornulier Lucinière
Pierre-Emmanuel Nyeborg

Stagiaires
Trainees
Perrine Albrieu
Anne-Laure Letellier
Ludivine Rousseau

Service juridique
Legal advice
Marie-Christine Alves-Condé, chef de service
assistée de Gabriel Ballif, Caroline Petit

Coordination du colloque
Organization of the colloqium
Françoise Salaün

Direction de la Production
Administrative and technical staff

Directeur
Director
François Belfort

Chef du service administration et finances
Head of finance and administration
Cléa Richon, adjointe au directeur

Chef du service des manifestations
Head of exhibitions
Martine Silie